OLD VENETIAN PALACES

The *OLD* VENETIAN PALACES *And* *OLD* VENETIAN FOLK

BY THOMAS OKEY

WITH FIFTY COLOURED AND OTHER ILLUSTRATIONS BY TREVOR HADDON

LONDON: J. M. DENT & CO.
NEW YORK: E. P. DUTTON & CO.
MCMVII

VENETIANO E FORESTIERO

Ven. Ditemi per cortesia gentil' huomo che vi par di questa città?

For. S' io vi dirò il vero voi nŏ lo crederete.

Ven. Dite pur il vero, percioche dicendolo si loda Iddio.

PREFACE

Bella Italia, amate sponde,
Poi vi torno a riveder;
Trema il petto e si confonde
L' alma oppressa dal piacer.

IF there is one experience more delightful than a first visit
to Venice, it is a second; the urgent pre-occupation of the
nuovo peregrin to pretermit nothing of importance amid the
wealth of beauty and historic interest offered to his gaze,
gives place to a calmer enjoyment; objects fall into their
due perspective; ideal preconceptions are corrected, and the
sojourner may turn to the study and appreciation of some
particular phase of the manifold attractions of the city: to
such returning lovers the ensuing pages are directed.

This slight and necessarily imperfect sketch of the palaces
of Venice has grown from a pilgrimage made about the mazy
streets and intricate canals of the city for the purpose of
identifying, and precisely indicating the position of the
various remains of domestic architecture referred to and
illustrated in the works of Ruskin, Street, and Fergusson;
in those of "that blessed man called Cicognara," and his
colleagues Diedo and Selva; in the admirable volumes of the
later and no less important authority, Prof. Pietro Paoletti,
and other writers on the subject. The chief existing ex-
amples of old palatial architecture are described, so far as
possible, in the order of their erection, and grouped into the
three main divisions—Byzantine, Gothic, and Renaissance—
of their style. Some acquaintance with the main features of
Venetian history being assumed in the reader, an attempt
has been made to draw from the writings of the three great
Venetian diarists a picture, in some detail, of life in the

lagoon city during the critical period of its history which elapsed between the closing decades of the fifteenth and the first half of the sixteenth centuries, when the more important and magnificent of the patrician mansions which still survive were being raised.

The proud appellation of Palazzo, in place of Ca' or Casa, to designate the home of a Venetian noble, is of comparatively recent date, and appears to have first been applied towards the end of the sixteenth century. Francesco Sansovino[1] states that the Venetians from modesty were wont to call their dwellings *casa*, and to limit the term *palazzo* to the ducal mansion; it is clear, however, that when folk out of modesty consciously began to refrain from applying the more pompous term, the transformation was not far off, and indeed Fynes Moryson,[2] who visited Venice at the end of that century, informs us that the palaces of gentlemen were called houses, but are, and worthily deserve to be, called palaces. The word Ca' for the more important patrician houses has, in the course of time, fallen gradually into desuetude, and we have therefore, with some few exceptions, preferred to retain the later designation.

Of all the great towns of Italy, Venice, despite much lamentable destruction, has, during the past half-century, suffered least from the devastating "improvements" of modern ediles; but that in the future extensive changes are impending admits of small doubt. The city is sharing in the recent marvellous economic awakening and increased prosperity of Northern Italy; ample electric force, water-driven, has been introduced from the mainland for industrial purposes; it is proposed to spend twenty million lire on the improvement of the ports of Chioggia and Venice, and since any large increase in commerce is impossible in the present

[1] "Venetia Città Nobilissima," 1581: the same writer in his "Delle Cose Notabili," etc., 1596, uses *palazzo* when referring to the more marvellous patrician houses.

[2] *Itinerary*, 1617.

isolation, and with the obsolete methods of transit in vogue, more rapid facilities are called for. Already complaints are made that the congestion of traffic in the rii renders the loading and unloading of goods and the passage of gondolas difficult, and that the inadequate means of communication with the mainland is a grave impediment to trade. A scheme for uniting the city with the terra firma by a broad causeway,in order that electric trams, motor cars, and other vehicles may have direct access, has long been elaborated and persistently urged upon the authorities by leading commercial houses such as the Signori Jesurum and others, and has indeed been recently (1906) approved in principle by the Provincial Council. From this to active realisation is perhaps a wide step, but it must be remembered that every consideration which in the past rendered isolation desirable, now operates in a contrary direction, for the prosperity of Venice is indissolubly bound up with that of the new kingdom of United Italy, whereof she is a part.

The old Italy of the operatic stage and of romantic art, with its picturesque *contadine* and classic ruins, the Italy our fathers regarded as a museum of antiquities and of old masters has gone for ever, and a new Italy has arisen, whose sons are eager to take, and do worthily take, their place in the industrial, scientific, and social developments of modern Europe. Older Venetians complain that the new generation is oblivious of a glorious past, irresponsive to artistic sentiment and impatient of antiquarian considerations. But the change is inevitable, and while there is, we believe, little reason to fear the loss of any important heritage of architectural beauty, it is certain that the picturesque, but narrow, dark, and insanitary alleys and canals are doomed to disappear. Those *tristes sine sole domos*, wherein the people of Venice have too long crowded, will no longer be tolerated ; already a large area of slum dwellings between the Campo S. Luca and the Teatro Goldoni has been cleared ; a further *sventramento* is contemplated between S. Zanipolo

and Sta. Maria Formosa, and model dwellings are to be erected on the island of Sta. Elena. Enlarged commerce, expanding industry, and increased traffic will cause the ways of Venice to approximate more and more to those of an ordinary modern town, and it may well be that at no very distant future the gondola as a means of locomotion will become as obsolete as the sedan chair.

Within the past quarter of a century the cost of living at Venice has increased thirty per cent., and its standard has advanced; it is comparatively rare now to see children without boots or shoes in the streets, and alcoholism—that lamentable concomitant of industrialism—is only too grievously in evidence. Rents have risen in even greater ratio. It is a far cry to the forties of last century, when Mrs Trollope almost shuddered at the aspect of many of the palaces along the Grand Canal, which, including the beautiful Foscari, then dangerous even to enter, had been suffered to fall into such decay that there appeared no rational hope of saving them from utter ruin; or to the autumn and winter of 1858-9, when the patched-up Foscari was an Austrian barracks, and the magnificent pile of the Grimani only rescued from the housebreaker's pick to be used as a post office; when Richard Wagner, for a small sum, was able, a solitary occupier, to rent the whole of a Giustiniani palace, whose vast spaces at first scared him, whose immense hall afforded him his morning promenade, and in whose still and melancholy grandeur the greatest poet-musician of all time composed the major part of his masterpiece, *Tristan and Isolde*. Owing to the appreciation in value of Venetian palaces, especially those on the Grand Canal, the more immediate danger lies rather in their exploitation as hotels or occupation as mansions of the *nouveaux riches*, and a consequent expenditure of capital on their fabric with small regard to historic or æsthetic considerations. Happily, however, a vigilant municipality has more than once in recent years intervened to restrain mercenary purchasers from

destroying or degrading monuments of ancient magnificence, and all lovers of Venice will fervently desire that such admirable civic piety may long continue.

A short bibliography of the principal works consulted by the writer is appended to this volume, but beyond his indebtedness to the labours of the supreme master whose imaginative virtue first opened the eyes of his own and future generations to the charm and beauty and significance of Venice, an especial acknowledgment is due to the patient erudition and artistic insight of Prof. Paoletti, whose two noble volumes on the early Renaissance architecture and sculpture in Venice have too long waited for the wider appreciation that an English translation would confer on them. To that rich quarry of Venetian lore, bound within the covers of Tassini's " Curiosità," obligations are also due.

October 1907.

CONTENTS

CONTENTS

CHAPTER XI

CHAPTER XII

CHAPTER XIII

CHAPTER XIV

CHAPTER XV

CHAPTER XVI

LIST OF ILLUSTRATIONS

ILLUSTRATIONS IN COLOUR

REPRODUCTIONS OF PICTURES, ETC.

ILLUSTRATIONS IN THE TEXT

OLD VENETIAN PALACES AND OLD VENETIAN FOLK

CHAPTER I

The First House at Rialto—The Nature of the Soil—The Great Conflagrations—The use of Brick and Marble— The Byzantine Period—Remains of Byzantine Architecture at Venice

> " Questi Palagi, e queste Logge or colte
> D'Ostro, di Marmo, e di figure elette
> Fur poche, e basse Case insieme accolte
> Deserti Lidi e povere Isolette.
>
> Ma genti ardite, d' ogni vizio sciolte
> Premeano il Mar con picciole Barchette,
> Che qui, non per domar Provincie molte,
> Ma fuggir servitù s' eran restrette."
> —*Giovanni della Casa.*

" THE firste that ever inhabited upon that Island called Rialto," says an old Venetian chronicler in the quaint English of his Elizabethan translator,[1] "was one *Giovani Bono*, a poore man that having there a simple cottage did live with his family by taking fish : afterwards *Radagasso* with an army of *Gothes* entring into *Italy*, sundrie from the firme land fled into this poore man's house for safety of their lives, and among the rest one *Eutinopus* a carpenter of *Candia*, who found means to build himselfe there a house, maintaining himselfe afterwardes by the making of small barkes and boats. After *Radagasso*, *Alaricus* coming like a

[1] " The Commonwealth and Government of Venice," Sir L. Lewkenor, 1599.

A I

tempest into Italy, there fled so many over thether as that
at length there were built foure and twenty severall houses
of bordes and reeds: but in the yeare of our Lorde 418
the furie of the warres being somewhat mitigated, the most
part of the fugitives had gotten themselves into *Padoua*
whereof a suddain, hearing great and fearful rumours of
newe intended entries into *Italy* by *Ainlfo* king of the
Vissigots with a mighty multitude of Barbarians, by a
generall consent they agreede to make some firme place
within these lakes and thereupon to build a citty which
they presently effected upon the foresaid Island, gathering
into the same the people that were dispersed about the
other Islands, withall making it of the best defence they
could, they called it by the name of Venice, and the
beginning of this citties foundation was laide in the year
421 upon the 25 day of March about noon. Afterwardes
the ruine and desolation of manie fayre citties upon the
maine land, grew a speedy mightinesse to this new erected
cittie, insomuch that many of the noblest land inhabitants
fled thither with their treasures and richest moveables,
transporting even their goodly pillers, carved stones and
other matter to build withall to Venice, erecting thereunto
themselves new and stately mansions." Thus far legend.
History, however, while unable to indite with the same
imperturbable and naïve precision, makes it pretty clear
that for centuries after the transference in 810 of the seat
of government to *la seconda Venezia*, the aspect of the
capital on the Rialtine Islands was that of a city of many
mean and few stately dwellings, a city of narrow, low-lying,
often isolated houses and factories, built of timber and thatch
from which emerged the fortified walls and turrets of the
Ducal Palace and the arsenal, the watch tower and the
domes of the principal churches. These, with perhaps a
few edifices of brick and stone raised by the more wealthy
patricians, were the only architecture with any claim to
external beauty or dignity. The lovely villas of Altinum,

which, according to Martial, rivalled those of Baiæ; the fair
palaces that Cassiodorus saw, strung like pearls along the
shores of Istria, had long been devastated by Hun and
Lombard; and where Roman nobles had reposed in stately
magnificence and luxurious splendour, lay ruin and desola-
tion. The frequency of the conflagrations recorded by early
historians, of which those in the years 1105, 1114, 1115,
1120, 1149, and 1168 were of appalling extent; the pro-
hibition of lights in houses after the first hour of the night,
bear testimony to the inflammable nature of the materials
employed in building. One of the oldest documents extant,
dated 1176, refers to a loan of twenty soldi, advanced by
one John the dyer to Carlotta of S. Zulian, on the security
of her house of wood, situated on the "land of our lord the
doge." Ecclesiastical edifices, too, were constructed of wood.
The church dedicated to St Paterniano by the Andrearda
family, and endowed by Doge Pietro Candiano IV. in 959,
and indeed all the earliest parish churches, were timber
structures, and fell to the flames many times. Even down
to 1365, when it was first covered with tiles, the church
of S. Salvatore was thatched with straw, and many timber
houses are known to have existed in the fifteenth century.
The *Marangoni,* or carpenters, were so numerous in the
earlier centuries that the great bell of S. Mark's, which at
sunrise called folk to their daily toil, was known, as late as
the fall of the Republic, as *the Marangona.* The craftsmen
were subdivided into four classes, of which the first were the
Marangoni da Case or house carpenters. The admirably con-
structed Rialto Bridge, so familiar to us in Carpaccio's picture
in the Accademia, was not replaced by stone until 1588.

The nature of the soil, and the mediocrity of the
resources of the earlier settlers, did not tolerate more than
isolated, one-storied dwellings on the more emergent of the
islands and mud-banks, through which a river, in geologic
times, had scoured out a deep and serpentine channel.
Owing to the rapid increment of wealth and population the

more favoured islands were soon occupied; little huts were lightly lodged on the higher shoals, busy hands excavated the smaller channels around and alongside their homes for ease of access, and the proud boast of Sanazzaro in his famous epigram to the effect that if men founded Rome, the gods founded Venice, is singularly irrelevant: little had the gods done for the foundations of Venice. As the poor Irish peasant of the West carries the soil with his own hands to make the little patch whence he derives a scanty subsistence, so the early Venetians built up in large degree the very land they dwelt on by excavations of the soft mud and ooze that lay around them or that they carried from the mainland. As early as the sixth century, we learn from Cassiodorus that the earlier Venetians in their first migration made use of the basket-maker's art, and opposed dykes made of woven and knotted osiers to the fury of the waves. The first Doge who sat in the new capital of Rialto after the defeat of King Pepin's host appointed one of the three best, wisest and greatest magistrates of the Commune thoroughly to reclaim and level up the mud banks and marshes (*bene benificare et munire le velme et le palude vicine*[1]), and sent many of the citizens to dwell on the more emergent *dossi* or humps of land; in short time such betterment was effected that on these *dossi* not only private dwellings but even churches were erected. Indeed, so precious was the slime and mire for the purpose of raising and levelling the islands and little aights and shoals that dotted the lagoons, that stringent ordinances and severe penalties were needed to prevent private persons appropriating such mud as the government required for public use, and it was not until the sixteenth century, when the *fondamente nuove* and the fondamenta of the Zattere were completed, that the excavated mud was carried outside the boundary of the city.

By a decree of the Great Council, dated April 1, 1303, it is enacted that the faculty of taking earth from the *rivi*

[1] "Cronaca Cornero di Candia," cited by Temanza.

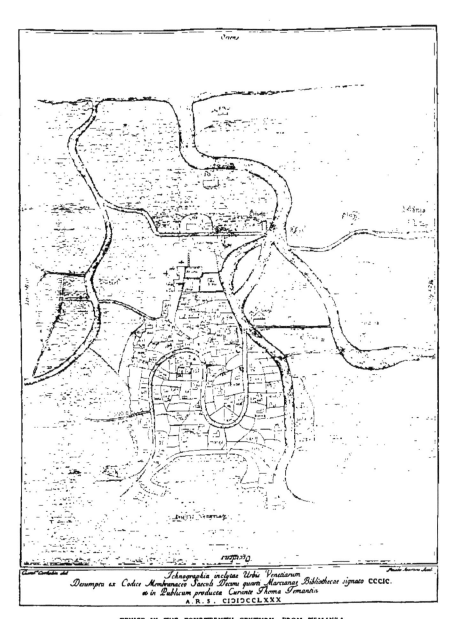

Oriens

Ichnographia inclytae Urbis Venetiarum
Desumpta ex Codice Membranaceo Saeculi quarti Decimi Marcianae Bibliothecae signato CCCIC.
et in Publicum producta Curante Thoma Temantia
A.R.S. CIƆIƆCCLXXX

VENICE IN THE FOURTEENTH CENTURY, FROM TEMANZA

be wholly abrogated and that the said earth be all taken to
the piles at Sta. Elena (the island beyond the present public
gardens), save that if any person be excavating within the
boundaries of a parish, the men of the parish may use the
land within the said parish only: copies are extant of con-
cessions made by the government to private persons to use
the shoals and excavated mud for the betterment of the city.

The soil was, however, so valuable that little found its
way to Sta. Elena, for on September 3, 1305, the Great
Council fulminated against the contraveners of their ordin-
ances and resolved that inasmuch as their former decree,
that all the excavated soil from the *rivi* should be carried to
the piles of Sta. Elena alone, under penalties, was unheeded,
and no one carried it there, but rather bore it away
wherever he willed, and the Signori di Notte took no care
to enquire as to the contraveners, nor to exact penalties
from them, saying that, accusations failing, they were unable,
nor ought they, to exact such penalties; therefore a clause
be added to the constitution of the Signori di Notte to the
effect that they be held to enquire diligently into the matter,
and that they shall visit all who carry away the said soil
elsewhere than to the aforesaid place with such penalties
as the Council decrees, and especially their watch shall
denounce any whom they see carrying soil away in contra-
vention of the law.

One of the most striking instances of the creation of
land to form the *stupenda mole di questa metropoli*, by the
Venetians, is afforded by a glance at the old map published
by Temanza and believed by him to be a copy executed in
the fourteenth century of an earlier map made in the twelth,[1]
in which the island of the Giudecca is seen to be only one
half its present area, unchannelled and bounded on the east
by the lagoon where the present rio del Ponte Lungo flows,

[1] The drawing may be seen at the Library of St Mark: there is little
doubt that it is a fourteenth century original, and not a copy as Temanza
supposed.

and in which the church of Sta. Croce is seen standing on a shoal or aight far to the east with a broad space of water between it and the land. The whole of that large area between the present rio del Ponte Lungo and the point of land bounded by the Canale di S. Georgio has therefore been created by the Venetians, and on this, as on the inner and main area of Venice, the channels or *rii* have been largely excavated by her citizens. The first decree known, conferring the privilege on one Marco Passera of the Giudecca to *bonificare* a portion of the lagoon to the E., is dated 1328. Many others followed, and by 1340 the betterment of the land had so far progressed that a bridge was made to the island of Sta. Croce. As late as March 29, 1502, we find a note in Sanudo's diary to the effect that the first stone of Sta. Maria Maggiore was laid on a new island lately reclaimed (*exsiccata*). Little indeed had nature done for the founders of Venice, and small was the seduction that attracted her builders from the mainland to its desolate salt marshes.

If one would in some small degree imagine the feelings of the early settlers as they were pushed over the edge of the empire by invading barbarians, and, so to speak, were made to tread the plank from the mainland, let him contrive to lose his train, wander alone from some spot of fertile rural felicity, some solidly founded homestead on the mainland, on a dull and darkening autumn or winter evening towards the lagoons, in search of a boat, and hear the wind soughing along the reeds and the plaintive estuary birds' cry chilling his heart ; let him peer dimly across the squalid and forbidding expanse of black lagoon, unstable soil and shallow waters, which stretch before him, and then reflect that on these the fugitives founded a maritime state which, for magnitude, wealth and amplitude of domination, had not been seen since the days of Carthage in her pride and glory. And precarious indeed, despite the indefatigable industry and vigilance of the lagoon folk, was their hold on the treacherous

shoals in the abyss of waters. Whole islands and cities were sometimes engulfed, and when Doge Ziani proposed, in 1222, a third migration, to Constantinople, one of his most potent arguments was based on a dramatic reminder of the fate of their old capital, Malamocco, over which, when he spoke, the salt waves washed, and of the total disappearance of the two island parishes of Amiano and Costanziaco, whose loss was yet fresh in the minds of his hearers.

During the twelfth century practically the whole city of Venice had been incinerated. If the reader will take a map of Venice and follow the course of the great fire of 1105, he will have a vivid conception of the desolation wrought by those terrible disasters in a city built mainly of wood. It began in the east, in the house of the Zancani in S. Severo, burnt the whole parish, passed to S. Lorenzo, thence took its raging course to S. M. Formosa and S. Giovanni Nuovo; fanned by an easterly wind it devoured the parish of S. Zulian and swept westward along the Piazza to S. Moisè and S. M. Zobenigo. A fierce blast drove fiery brands across the Grand Canal, and the whole quarter from S. Gregorio in the east to S. Barnabà in the west, and southwards to S. Agnese, S. Trovaso, and S. Angelo Raffaelle, became involved. It traversed the Canal again, swept over the parishes of S. Maurizio, S. Paterniano, S. Luca, S. Vitale, and S. Samuele, until nearly the whole of the eastern half of Venice was left a smoking cinder-heap. In 1149, sixteen parishes were destroyed; in 1174, 3000 houses were devoured. Temanza, in a passage curiously reminiscent of a classic essay on the fortuitous discovery of roast pig, gravely remarks that the accidental baking and hardening effect on the soil of Venice produced by these terrible and recurrent conflagrations consolidated it to the degree necessary for the toleration of heavier buildings, precisely at a period when the growing wealth, the naval victories, and eastern commercial expansion enabled her citizens to meet the cost of substituting brick and stone for their fragile timbered houses. There were

few brick kilns in Venice in those days, and much of the
material for the new architecture was derived from the
ruined Roman metropolis of Altinum. "Even in my days,"
says Temanza, writing in the closing decades of the Republic,
"I have seen many houses and palaces demolished whose
walls were formed of those old bricks which were still known
as *altinelle*. They were of good clay, well baked, but small
in size."

The original timber houses were one storied, built
round a court, and furnished with a well and oven. On the
roof was a raised loggia, also of wood, called the liagò,
derived, etymologically and structurally, from the Greek
heliacon (of the sun), a representation of which may be seen
in a miniature in the Skylitzès MS. of the eleventh century
illustrating contemporary architecture in Constantinople and
reproduced by L. de Beylié;[1] it was closed on three sides and
open on the fourth, which generally gave to the south. The
liagò, which should not be confused with the *altana* or open
roof-terrace of later days, has subsisted, but built of brick or
stone, all through the history of Venetian domestic archi-
tecture; some within the knowledge of the present writer
having been transformed into nurseries or other modern
requirements. The early Venetians contrived such structures
for the use of their women folk, who, according to eastern
usage, were rigidly secluded from public gaze, and they
corresponded to the peculiar use of the domestic roof in the
East to-day.

During the period of storm and stress when the young
Republic was growing into lusty manhood, the influence of
Byzantine art was paramount. Byzantium, when her
architects and her craftsmen were called in to rebuild S.
Mark's and the Ducal Palace after their destruction by the
political incendiaries of 976, was in the zenith of her fame,
and remained until the end of the eleventh century the
artistic, intellectual, and commercial capital of the civilised

[1] See "L'Habitation byzantine," 1902.

world. Although little of their work now remains, the school of architects thus formed fixed the main lines upon which the patrician palaces of Venice were planned throughout the whole of her history. So far as is at present known, the earliest application of the columnar arcade, with its arches resting directly on capitals and without the intervention of the classic impost or entablature, that is so characteristic a feature of the façades of the earliest Venetian houses, is found in the northern gateway of the great palace of Diocletian at Spalato, built in 305, which, though despoiled by the Venetians, remains the most complete monument of the Roman decadence, and of the new style which, gradually modified by their architects, later became known as Byzantine. And if we would seek the origin of the beautiful polychromatic incrustations which relieved the monotony of Venetian wall spaces, we may find it in the Eastern traditions introduced into Europe by Alexander the Great and his generals, who, in building palaces and houses, substituted brick for stone, and borrowed from Persia the art of applied decorations of mosaic and other casings,—an art yet further developed by the Ptolemies, who employed incrustations of ivory and glass and the precious marbles found in Egypt. All these and many other Oriental influences encountered at Byzantium the architectural traditions introduced by the Roman emperors; a fusion of styles took place, and the future basis of ecclesiastical and civil architecture was laid. Venice, with her face set eastward, was the open portal through which this architecture made its way into Central and Western Europe.

The glorious and prodigious epoch that elapsed between the later decades of the eleventh, and the earlier years of the thirteenth centuries saw the foundation of the naval and commercial supremacy of the Venetians, who made

"The seas their servants, and the winds
To drive their substance with successful blasts."

By the astute exploitation of the crusading enthusiasm of

the West, Venice tightened her grip on the East; wealth streamed into her public treasury and into her private counting-houses; frugality and simplicity gave place to comfort and luxury; wants were multiplied, desires grew, and new demands on life clamoured to be satisfied. Her political prestige had increased; a Pope of Rome, God's spiritual vicar on earth; a Holy Roman Emperor, His supreme secular minister, had chosen her sanctuary for a solemn reconciliation. It was the period of the early chroniclers, of popular legends and ballads, when the lagoon State laid the prestige of a divine call and a noble lineage as a majestic drapery, over her lowly origin. Meanwhile a subtle change was operating that transformed a turbulent democracy into a well-ordered oligarchy of merchant princes. Secure from internal faction and external spoliation, Venice was the first State in Christian Europe to develop an orderly civic life and the social amenities of a prosperous trading community; the first in which an intimate and beautiful domestic architecture became possible; the first in which the gentleman of the modern world was evolved. *Nihil domestica sede jocundius* (Nothing is more delightful than one's own hearth and home) runs a favourite inscription on old Venetian houses.

The general plan of an early Venetian mansion was as follows: The ground floor, or as Ruskin terms it, the sea story, was composed of a columnar arcade or portico, open at front to facilitate the landing and expedition of merchandise. This gave on to a large covered atrium or vestibule, to the right and left of which lay various offices, warerooms, and other chambers. Beyond this was an uncovered courtyard, furnished with a well, its head finely sculptured, and surrounded on three sides by other subordinate rooms and offices. The first floor, or upper story, was similarly disposed. Its outer arcade formed the windows of a large central hall, or reception room, built in the form of a crutch (*a crucciola*) or of a **T**, the arms of which extended along the façade. At each side of the hall were grouped a number

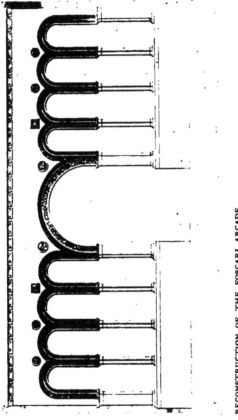

RECONSTRUCTION OF THE FOSCARI ARCADE

of private apartments and chambers, and, since the houses were detached, lighted by lateral windows, which in the earliest buildings were small and protected by external stone shutters, such as may be seen to-day outside the cathedral at Torcello. The building was flanked by two towers, much as we now see in the restored Fondaco de' Turchi: its core was of brick and the façade adorned with incrustations of

STA. FOSCA, TORCELLO

many-coloured Oriental marbles and carved medallions and crosses. The two cornices and the arches and capitals were rich with beautiful reliefs. The sculptures were, according to Ruskin, probably grounded with mosaic of gold in the richer palaces, in the lesser ones with blue, the edges only of the leaves of the sculpture being gilded. The arcade of the sea-story is derived by Street from the apse of Sta. Fosca at Torcello, and there is a remarkable similarity between the treatment of the stilted arches. It is much more likely, however, that both the ecclesiastical and domestic

forms are derived from Eastern sources. No remains of an early interior have come down to us, but judging from the analogy of surviving ecclesiastical architecture, the internal as well as the external wall spaces were decorated. In

 the Skylitzès Byzantine MS. of the eleventh century, already referred to, a miniature reproduced by De Beylié shows the interior of a private house at Constantinople whose walls are veneered with symmetrically veined marbles; the analogue of a Venetian house with its superposed arcades and lateral towers is also portrayed. (See figure 1.) A subtle proportion in the spacing of the arches and columns of the sea-story, the central arch being

FIG. 1

balanced by smaller ones answering each other on either side; the majestic and richly carved central capital of the upper arcade with responding lateral ones of smaller dimensions and less elaborate designs, breaking into one unique capital at either extremity, all contributed to give, as Ruskin's careful measurements have proved, an exquisite symmetry to the perfected edifice. The Venetian factory or Fondaco was derived from the Arab Fondouk, which will be familiar to all travellers in North Africa or the East to-day.

Even granting the site, foundations for these brick or stone edifices had to be made at an expense exceeding that of the erection of a complete house on more stable soils. The method, which has survived with but little modification to modern times, may be thus briefly summarised: The builders began by enclosing the site in a stout cofferdam of two or more lines of quartered poplar or oak piles, bonded by transverse and oblique ties and packed with clay. The mud was then excavated from the enclosure to a depth varying with the nature of the basin, and the water was

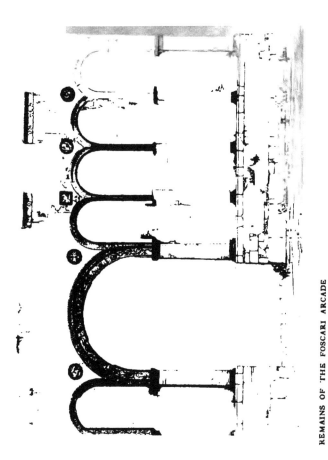

REMAINS OF THE FOSCARI ARCADE

exhausted by pumps. If any infiltration ensued from the bottom, hydraulic contrivances of great ingenuity and cost were requisite. The space being cleared, thousands of un-quartered piles were driven in by a heavy iron-bound hammer, which was alternately raised and let fall with a tremendous thump, to the accompaniment of a rythmic chaunt; it is interesting to note that the ramming of the piles, in 1905, to strengthen the foundations of the new campanile was done to the tune of the same quaint old-world chaunt which the early pile-drivers sang as they hoisted and dropped their iron-bound ram. The spaces between the piles were then filled with heavy rubble or fragments of stone closely rammed in, and upon this bottom a *zatterone*, the literal meaning of which is a big raft, composed of two [1] layers of stout oak, or later of larch quartering, was laid crosswise and bedded in cement; the mortar used was made from white Istrian limestone mixed with sand. Upon this was again laid the second foundation, from two to four feet below the common level of the tide, and if such foundation was to remain exposed to the water the outer part was faced with Istrian stone. Another method employed on the larger islands, and specifically on the foundations of the Ducal Palace, was to excavate down to the bed of stiff clay which is found about 10 to 16 inches below the surface of the islands; on this a stouter and broader zatterone of red larch was laid which bore the actual foundation of blocks of Istrian stone, in several layers, broad at base and closing in stairwise to the bases of the columns, the intervening spaces being packed with smaller stones. So firm in texture is this basic clay that when the foundation of the old campanile was laid bare in 1885, it was only with much difficulty that a small steel tube could be driven through it, and, when excavated, its consistency was that of half-baked bricks, due partly to the immense pressure of the superstructure: the

[1] Three layers have been used in the foundations of the new campanile.

zatterone was found to be composed of oak, and the piles of white poplar had even retained their colour after a thousand year's of burial in the clay. The timber was derived from the near mainland, larch from Cadore only being used in later times.[1]

If the sojourner in Venice will bid his gondolier row him up the rio di Ca' Foscari, alongside of the unhappy Doge's Palace, and stop opposite the fifth house on the left hand beyond the Ponte Foscari, he will observe incorporated in its walls some of the most interesting relics that now survive of an early Byzantine mansion. They are the remains of its sea-story, from which Ruskin, in the beautiful drawing here reproduced, was able to reconstruct with slight chance of error the whole arcade in its primitive splendour. The fragments as they appeared in his time were also drawn by the master, and although the carvings have suffered some-what since he copied them, a careful inspection with the aid of an opera-glass will reveal much of their marvellous wealth of invention and delicacy of execution.

We may now return to the Grand Canal, make our way through the Rialto Bridge, and, a few boats' lengths beyond the Fondaco de' Tedeschi, pause before the Ca' da Mosto. The house, like all the Byzantine dwellings in Venice, has been wholly modernised and enlarged, but some remains of three of the old arches of the sea-story will be observed; and above the restored Saracenic windows with their stilted ogee arches, some admirable ninth-century marble reliefs and medallions will be seen. Above them runs a fine cornice of the same date. This edifice is no less remarkable for its historic than for its architectural interest. Hence, on August 1454, set forth Alvise da Ca' Mosto, a scion of one of the oldest Venetian families, to sail with the Flanders galleys, and being held up by adverse winds at Gibraltar, met there the famous geographer, Prince Henry of Portugal, who fired his imagination by wondrous stories of the dis-

[1] Il Muro di Fondazione del Campanile di S. Marco.—*Arch. Ven.* xxix. 355.

REMAINS OF THE FOSCARI ARCADE

coveries of Portuguese mariners, and invited him to take charge of a caravel and sail down the coast of Africa. Alvise, leaving Venetian service, accepted the commission, and after touching at Madeira and the Canary Islands, pushed south to Senegal, where he met a Genoese adventurer, he too plough-ing virgin and uncharted seas. Together they reached the mouth of the Gambia, and but for a mutiny among the sailors, would have ascended the river and explored its shores. Again setting forth the following year, the intrepid voyager sailed up the Gambia for seventy miles, discovered the Cape Verde Islands, doubled Cape Roxo, reached the Rio Grande, and many another unmapped shore, and indicated to the Portuguese the Cape Route to India: the heaviest blow to Venetian commerce was thus dealt by one of her own sons.[1] In the seventeenth century the Ca' da Mosto[2] became the famous inn known as the Leon Bianco, where many princely guests of the Republic were lodged, including the Emperor Joseph II. on the occasion of his two visits to Venice.

Returning bridgewards, we soon reach, on the same side of the Canal, the little Corte del Remer,[3] at the end of which stands one of the most picturesque agglomerations of old domestic architecture in Venice. A bold external Gothic staircase, now unhappily disfigured by the addition of an ugly rampe, leads to the first floor, which is entered by a fine Byzantine portal, on either side of which are Transitional ogee windows of two lights; and in the patchwork façade above, to the left, beneath a modern window, will be seen a decorated Byzantine cross imbedded sideways in the wall.

[1] In Fra Mauro's map at the Ducal Palace, composed 1457-59, a little ship is seen sailing south of the African coast, her prow turned toward Asia.

[2] The Ca' da Mosto may be reached on foot by turning down the Corte del Leon Bianco, at the foot of the Ponte SS. Apostoli, to the ferry in front of the palace. See p. 94.

[3] This, too, may be reached on foot by turning down the Calle della Stua on the L. just before crossing the Ponte S. Giovanni Grisostomo, going westward from the Campo S. Bartolomeo. See p. 94.

B

This curious old house exhibits, in a profoundly interesting manner, the first dawn of the new Gothic style introduced from the mainland, which, modified and adapted by the genius of the Venetian masters, was destined to eclipse the old and to give an essential character and abiding glory to Venetian architecture. We may ascend the stairway, and, by the courtesy of the occupiers, enter the iron grille to examine more closely the carvings on the archivolt of the doorway, which are among the most beautiful and well-preserved remains of Byzantine domestic art. The design of wreaths of flowers, enveloping in their coils quaint fighting beasts, and the lovely basket capital of the window shaft to the right, will arrest the spectator and cause him to linger over this charming relic of ancient decorative splendour. The *Remeri*, who were incorporated among the old guilds of Venice, were the makers of oars, and from one who practised his craft in this court its name doubtless is derived. The venerable mansion is believed to have belonged to the Leoni, one of the oldest and richest of Venetian families, and to have been spared when the traitor, Maffeo Leon, was found guilty, in 1542, of betraying State secrets to the King of France, because part was held as security for his wife's dowry and part belonged to his brother Lodovico.

Re-entering our gondola, a few strokes of the oar will carry us through the bridge, and we will bid our gondolier rest awhile in front of the Palazzo Bembo, next to the Palazzo Manin which is now occupied by the Banca d'Italia. It is fourteenth-century Gothic, but incorporated in its wide façade, just above the sea-story, we shall discern the remains of a beautiful Byzantine cornice of the same style as that of the Ca' da Mosto, and probably part of the older edifice, which occupied the site : such cornices were not employed for the crowning cornice but only above the sea-story of the building. By making a slight detour north-wards and entering the Corte del Milione [1] by the Teatro

[1] To find the Corte del Milione on foot, see p. 92.

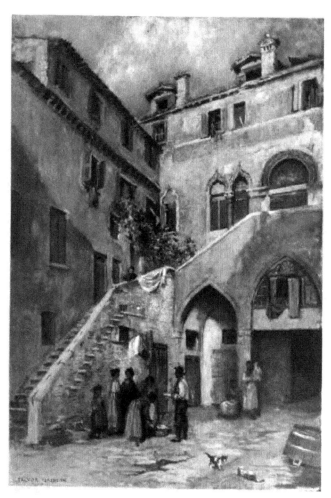

CORTE DEL REMER.

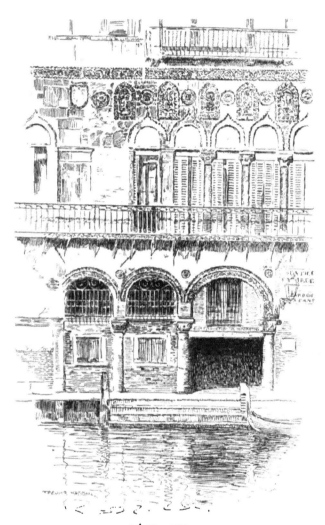

CA' DA MOSTO

UPPER ARCADE LOWER ARCADE

PAL. LOREDAN—CAPITALS

THE BRAIDED HOUSE—CAPITAL

DOORWAY—PAL. CONTARINI DEL FERRO

Malibran, we may examine, embedded in the wall of a house, a cornice of a later type, termed by Cattaneo, Neo-Byzantine. Here the leaves of the thorny acanthus are multiplied, and translated into long courses of continuous running foliage, arranged in a triple design, the central leaves overhanging, while the lateral leaves are extended flatwise. Returning to the Grand Canal, a little beyond the Palazzo Bembo on the Riva del Carbon, stand the twin palaces Loredan and Farsetti, whose stilted arches proclaim them to be of Byzantine origin. They are now occupied by the offices of the Municipio of Venice, and little remains of their earlier architecture save the restored arcades and some reliefs incorporated in the façades. Two floors have been added, the flanking towers have been demolished, and the interior altered beyond all recognition. Ruskin devoted much loving care and study to these two palaces, and his measurements of the spacing of the arcades have demonstrated the subtle feeling for harmony and proportion in the minds of their unknown builders. Four of the lovely capitals of the Loredan, two of the upper and two of the lower arcades, have been drawn by him. This famous palace, which passed successively from the Boccasi to the Zani, the Corner, and the Loredani, has housed the Duke of Austria, the King of Cyprus, Valentina Visconti, Francesco Gonzaga, Marquis of Mantua, and many another exalted guest of the Republic. Its neighbour, the Farsetti, was formerly the home of the Dandoli, and dwelling of the scholar Doge, Andrea Dandolo, whose calm, peaceful effigy in stone lies recumbent on his fine sepulchral monument in the Baptistery of S. Mark's. Artistic associations, too, cling around this edifice. The Farsetti, a Tuscan family, into whose possession it came in 1670, adorned its halls with pictures and casts of the most famous of classic statues at Rome and Naples, freely open to students, who were attracted thither by prizes offered to the most successful copyists. It was here that Canova first studied, and two reliefs on the stairway, the first essays in

his art, are still preserved. Two magnificent well heads,
one of which is an excellently preserved example of
Byzantine work, are to be seen in the cortile of the
Loredan palace.

Continuing our journey down the Grand Canal, we pause
to examine, opposite the imposing Renaissance Palazzo
Grimani, a group of old houses with Byzantine remains,
familiar to readers of Ruskin as the Terraced House, the
Palazzo Businello, the Braided House, and the Madonetta
House. The first, known to Venetians as the Palazzo
Mengaldo, may easily be distinguished by the " great seam
like a scar " between the old part and the new, and the small
terrace in front. Of the original Byzantine structure some
arches of the two central groups of windows, a few capitals,
and the arch of the weather-worn water gate remain. To
the left of this and next but one stands the Palazzo
Businello, with two series of stilted arcaded windows,
largely restored, and next, after passing the garden of the
Renaissance Palazzo Papadopoli with its two eminent
obelisks, we come upon the Braided House (Palazzo Sai-
bante) : five of the old window arches with some Byzantine
reliefs, and a typical Byzantine cornice above them, are
all that remain, and are precious to us by reason of the
lovely basket capitals with braided borders of the arcade,
which are illustrated in the "Stones of Venice." Next to
this, and over the Traghetto della Madonetta, stands the
Madonetta House (Palazzo Sicher) : it was under restoration
in 1906, has been scraped, and no longer answers to Ruskin's
description. The house once belonged to a branch of the
old patrician family Donà, which gave three Doges to the
Republic.

Scattered about in nooks and corners of Venice are other
fragmentary relics of early domestic architecture: some
cornices on the little house next the Palazzo Corner della
Regina, where the painter Favretto died ; on a house near
the Calle Sansoni, and on others near the Ponte Storto at

CORTE BOTTERA.

S. Appollinare and near the Palazzo Widman at S. Canciano. In the Campiello Angaran detto Zen,[1] to the right of the church of S. Pantaleone, is a curious Byzantine medallion in marble with a relief of an Emperor holding staff and sceptre said to have formed part of the spoil brought from Constantinople in 1204; and in the Corte Bottera,[2] near

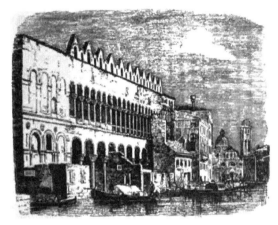

FONDACO DE' TURCHI BEFORE RESTORATION, FROM SELVATICO

S. Zanipolo, amid poverty and dirt, a Byzantine portal, with its reliefs almost effaced, still may be seen *in situ*. In the Salizzada Sta. Giustina[3] (No. 2924) is an excellently pre-

[1] See p. 112.

[2] The Corte Bottera may be reached from the Calle Lunga (which leads to S. Zanipolo from the Campo S. Maria Formosa), on the L. of which, near its further end, is the Calle Bragadin o Pinelli. Following this we cross the Ponte Storto o Pinelli, turn immediately R. and descend to the Corte Bottera.

[3] The Salizzada Sta. Giustina will be found by turning to the left just before reaching the Ponte S. Francesco della Vigna on the way to the church of S. Francesco. The doorway formed the entrance to the old Palazzo Contarini.

served stilted arch over the doorway of the Palazzo Contarini del Ferro, with beautiful romanesque carvings on the archivolt, typical of the earliest Venetian portals. In the centre is the usual hand in the attitude of blessing, and an angel over the lintel holding a scroll invokes peace to this house—PAX HUIC DOMUI.

The Fondaco de' Turchi, once the palace of the Dukes of Ferrara and the principal Guest House of the Seigniory, that most magnificent and picturesque relic and precious heritage from ancient times so dear to lovers of old Venice, is now hopelessly lost. Its aspect before its profanation by the restorers of last century may be partly imagined from Selvatico's drawing in his "Architettura e Scultura in Venezia," published in 1847. The old fabric has been rebuilt rather than restored, and its lovely capitals and shafts have been scraped and devastated, when they have not been renewed. Some place names and documents in Venice recall to us the sites of other Byzantine palaces which were standing as late as the sixteenth century : yet others are mentioned by Temanza as existing when he wrote towards the fall of the Republic. The rio delle due Torri was thus called from a house with two towers standing near and still existing in 1514 At the corner of the Rio delle Torreselle once stood an old palace with a tower ; and the modest house (*unam non magnum sed honestum domum*), assigned by the Republic to Petrarch for himself and his books, the site of which is commemorated on the present Riva degli Schiavoni, was known as the House with the Two Towers: the house is seen in the map of Venice, variously attributed to[1] Albrecht Dürer, to Mantegna, and others, but now generally ascribed to Jacopo de' Barbari. All traces of these lateral towers, even in such Byzantine buildings as survive, have long since disappeared : some were demolished, others incorporated in the added upper stories.

[1] The original wood block is still exhibited in the Museo Civico.

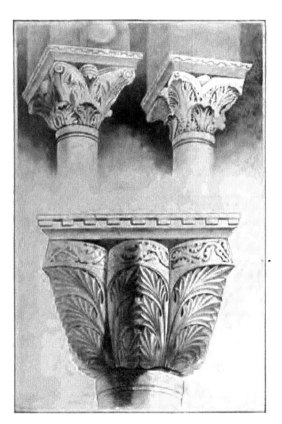

CAPITALS OF FONDACO DE' TURCHI
BEFORE RESTORATION

CHAPTER II

The Ducal Palace—Street, Parker, and Fergusson's theories—
Was the upper story of the Palace an afterthought and a
disfigurement of the original design?—Saccardo's plea for
the restitution of the old capitals

"O paleys, whilom crowne of houses alle!"
 —*Chaucer.*

OF the master or masters who wrought the epoch-making
revolution in architecture which is associated with the Gothic
Ducal Palace of Venice, and who laid down the lines along
which her future architects should work, nothing definite is
known. Pietro Basseggio, who according to Zanotto was con-
firmed in his appointment as chief architect (*proto*) by a
decree dated September 29, 1361, is by some writers
believed to have designed the South façade; but this is a mere
conjecture, and the famous Palace, in its most essential and
characteristic feature, remains as impersonal as the powerful
and astute oligarchy for whose seat it was raised.

We do not purpose here to trace the venerable Gothic
edifice from its origin to its final form. But on the very
threshold of any appreciation of Venetian Gothic archi-
tecture we are encountered by an arresting and startling
problem, first tentatively raised, we believe, by Street in
1855 in his "Brick and Marble Architecture," and, later,
dogmatically solved by Parker and by Fergusson, to
their own satisfaction at least. In 1853 a view of the
Piazzetta at Venice in the fourteenth century, taken from
the frontispiece miniature of a MS. existing at the Bodleian
Library, was engraved by Orlando Jewitt, and published by
Parker at Oxford in the second volume (p. 26) of Turner's

"Domestic Architecture of the Middle Ages." The en-
graving has been reproduced in the second edition of Street
(p. 204); again in Parker's "Introduction to Gothic Archi-
tecture" (4th edition), and yet again in Col. Yule's "Marco
Polo" (p. 17.) It will be seen by a glance at the engraving,
which we here lay before our readers, that the Palace is en-
closed on four sides by arcades, which support, not the upper
story, but merely an open terrace with a balustrade, whereon
spectators are leaning: the upper story rests on the inner
walls. Are we then, assuming this to be a fourteenth-century
representation of the Ducal Palace as it was seen by the artist
who painted the miniature, to conclude with Parker and Fer-
gusson that the essential feature of the edifice which we have
been taught by Ruskin to regard as the Parthenon of Venice
and the central building of the world, formed no part of its
original design; that it is a disfigurement and the result of
an afterthought, which, according to Fergusson, in an evil
hour[1] occurred to a later architect when it became necessary
to enlarge the Hall of the Great Council, or when, according
to Parker, the restoration was in progress after the fires of
1574 and 1577? Parker's assertion, which is repeated in
quite recent text-books[2] of architecture, may be at once dis-
missed as untenable, for unless the cartographers[3] and painters

[1] See Fergusson's "History of Architecture," vol. ii. p. 236, 1867.

[2] See "A History of Architecture on the Comparative Method for the
Student, Craftsman, and Amateur," by Prof. Banister Fletcher, F.R.I.B.A.,
and Banister F. Fletcher, F.R.I.B.A., fifth edition, revised and enlarged,
London, 1905, which is stated in the preface to have been adopted as a text-
book in the leading Colleges and Technical Institutions of Great Britain, the
United States of America, and Australia: "The latter (the main building of
the Ducal Palace) was partly destroyed by fire in the sixteenth century, but was
rebuilt and *extended over the double arcade*" (p. 411). Among other curious
information in this book, which a cursory glance reveals, we note that
Sansovino is said to have erected the Giant's Staircase in 1554, that the
Venetians called their open top stories, belvederes, and that Dante aided in
the spread of the newly-discovered classic literature.

[3] See the map of Venice attributed to Jacopo de' Barbari (1500), already
referred to, and Gentile Bellini's Procession in the Piazza (1496).

PALAZZO SICHER AND TRAGHETTO DELLA MADONNETTA.

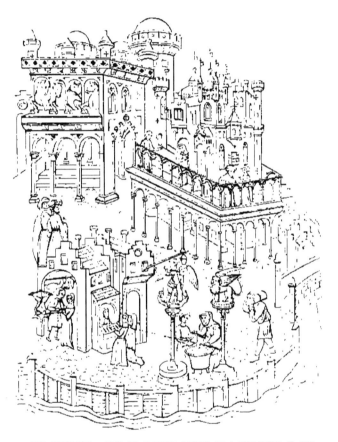

THE PIAZZETTA: COPY BY ORLANDO JEWITT OF A MINIATURE IN THE
BODLEIAN

of the late fifteenth and the early sixteenth century conspired
to mislead later generations, the south and the west façades
in 1500 stood in form exactly as we see them to-day.
Street's suggestion, and Fergusson's dogmatic statement,
that the problem which faced the fourteenth or fifteenth
century architects, who were called upon by the authorities
to enlarge the Hall of the Great Council, was solved by
extending the upper story horizontally and not vertically;
and that the increased accommodation was obtained by push-
ing out the upper story laterally over the arcades below,
which arcades were overpowered by its ill-proportioned mass,
are, however deserving of careful attention, making, as they
do, an almost irresistible appeal to the professional architect.

It ill beseems the layman to decide where experts differ,
but certain historical data are available which have a direct
bearing on the point at issue, and these we will now briefly
review: The Hall in the Ducal Palace, built in 1301-1309
to accommodate the Great Council, soon became too small
to contain the increasing number of members,[1] made
eligible by the law of 1297 and the subsequent enactments,
which opened its doors to all the legitimate descendants of
the powerful oligarchy that had made itself the governing
body of the Republic. On December 28, 1340, therefore,
it was decided, after expert advice had been taken from the
master builders, to construct without delay a Council Chamber
such as the fame, honour, and utility of the city required,
and that it "be erected over the Hall of the Signori di
Notte in such fashion that it should extend lengthwise as
far as the whole length of the said Hall, and so much farther
as the Camera de' Cattaveri was distant from it." And it
was further decided that it be "as wide as the existing
ambulatory, which is supported by the columns that face the
Grand Canal" (*et lata tanto quantum est ambulum existens*

[1] From 317 members in 1264, the members of the Great Council had
increased to 1017 in 1311, and to 1212 in 1340.—See "Venice and its
Story," pp. 120-122.

super columnis versus Canale respicientibus). Moreover, al-
though the said masters asserted that the proposed Hall
would be solid enough without erecting pillars in the Hall
of the Signori di Notte beneath to support it, nevertheless,
for greater security, the builders were counselled to place
there as many columns as might seem necessary. Zanotto,
who in his monumental work on the Ducal Palace[1] quotes
the decrees in full, remarks that some of the columns placed
for this purpose were still to be seen in the old Hall of the
Sigrori di Notte.

The work thus initiated progressed but slowly, retarded
as it was by the plagues of 1348, 1357, 1359, and 1361;
by the Falier Conspiracy and the Genoese and Dalmatian
wars. In 1362 complaint was made of the neglected and
desolate condition of the Chamber, whereupon the Senate
ordered, on December 12 of that year, its immediate com-
pletion. Rapid progress appears to have been made, for in
1365 Guariento was painting his Coronation of the Virgin
over the Ducal throne on the end wall of the Great Council
Hall, and at the same period Pisanello and other painters were
at work there: in 1400 the Hall was ceiled with a starry
firmament of gold. The Republic cast her net widely, and
sought for artists wherever a great master was to be found,
for we learn from a letter of the Seigniory of Florence, dated
June 8, 1403, to the *excelse domine frater et amice carissime*
the Doge of Venice, that the Republic had her agent in
Florence, who had tried in vain to obtain the services of
Nicolo Lamberti, pupil of Ghiberti, and the associate of
Filippo Bruneleschi, Masolino da Panicale, Paolo Uccello,
Pollaiolo, and other rising masters in the decoration of the
gates of the Baptistery. The great south window was added
in 1404, and at length, on the 3rd or 23rd of April 1423,
eighty-three years after its construction had been ordered,
the members of the Great Council of Venice met in their
magnificent new Hall: Doge Foscari presided for the first

[1] Zanotto, " Il Palazzo Ducale," 4 vols., 1841-61.

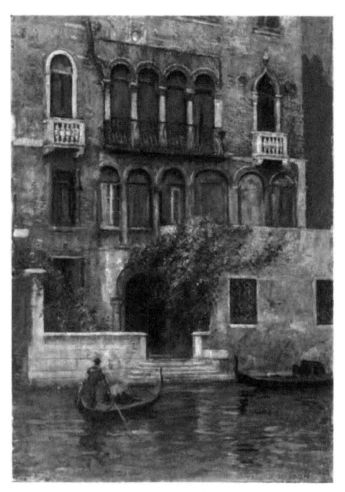

PALAZZO MENGALDO.

time, and the Marquis of Mantua was present. The old Ziano palace, ruined by fire, still stood against the new Gothic work on the west façade.

The above facts are, we believe, incontrovertible, and it is therefore clear that Fergusson's assertion that the "evil hour" when it was decided to bring the upper story level with the front was in 1480, is disposed of by the decree of 1340, which proves the existence at that date of an arcade along the sea front adequate for the support of a superimposed story, which story was immediately put in hand. Moreover, the Hall in which Guariento painted his fresco of the Coronation of the Virgin in 1365 is undoubtedly the very same Hall, restored and redecorated after the fire of 1577, which we admire to-day, for the removal of Tintoretto's great canvas of the Paradiso, in 1905, disclosed the remains of Guariento's fresco behind, injured, it is true, by the fire, but sufficiently well preserved, as the present writer can testify, to prove that the wall on which it had been painted was the wall erected by the builders of the great Chamber in the fourteenth century. Further confirmation is afforded, if any be needed, by Furlano's engraving of 1566, reproduced in Zanotto, of a full sitting of the Council, where Guariento's fresco is seen symmetrically placed over the ducal throne.

Let us, however, scrutinise more closely the drawing on which Fergusson relies as "sufficient to set the question at rest." The tall, castellated building, with its loopholed and machicolated towers, its turrets and vanes, bears a striking resemblance to many a mediæval castle of northern Europe as depicted by French and Flemish illuminators of the fourteenth and fifteenth centuries; and the drawing of St Mark's, which bears no relation whatever to its aspect at any period of its existence, can hardly have been the result of actual observation. The date of the drawing given by Parker (1360) is open to serious question. The first part of the vol. (MS. Bodley, 264) was undoubtedly executed

in 1338-44, and almost certainly at Bruges, but the learned librarian of the Bodleian, Mr E. W. B. Nicholson, who has made a very full study of the work and to whose courtesy we are indebted for these particulars, assigns the third part of the volume (the French text of Marco Polo's travels) [1] in which the miniature is found, to the fifteenth century ; and inasmuch as the same scribe who wrote the second part (which is in West Midland English) also wrote the third, it may be presumed that the Venice picture was painted in England, and about a century later than the date assigned to it by Parker. Street's theory that the "chilling waste of unbroken wall" placed above the extremely rich arcade

FIG. 2—FROM PAOLETTI

below was due to an architect of the period (1340), when it was decided to enlarge the Hall of the Great Council ; and that the original Gothic master of 1301 began with some portion of the sea façade and carried on the greater part of the building to the height of two stories, leaving his building finished in precisely the same way as the corresponding Halls of Padua and Vicenza, with arcades covering the outer walls of the upper as well as of the lower chambers, cannot be accepted if Mr Nicholson's dating of the Bodleian MS. is correct and the Palace there represented was painted a century later. If there is anything in this theory, may we not rather suppose that the original design involved a third arcade, as in the Ca' d' Oro, and that as the work progressed and greater room space became imperative, it was decided to suppress the third arcade and extend the Council Hall over the second? The whole question is, however, further complicated by Paoletti's discovery in a fifteenth-century chronicle, recently acquired by the Marciana, of a rough marginal design

[1] The MS. is stated by Street to be the " Romance of Alexander."

(figure 2) of the upper part of the Gothic west façade of the Palace, at the time (1422), when it was decided to pull down the old Ziani portion and complete the western façade in accord with the Gothic design. The demolition, adds the chronicler, of the old Palace was begun on March 27, 1424, and Sier Nicolo Barbaro of Sta. Giustina was the master *fato sora la dita fabrica* at a salary of 10 ducats of gold a month. This curious drawing shows no trace of an upper story over the arcade.

Much has been made by professional architects of supposed dangerous settlements in the façades, owing to the assumed insufficient bearing power of the arcades, as evinced by the walling up of the five arches of the lower south arcade at its eastern end, and the practical rebuilding of a portion of the arcading in our own times. This last operation was, however, as Saccardo has proved, due not to any settlement in the façades, for the walls of the upper story were wholly uninjured, but to the deplorable mania that possessed the modern restorers for replacing any and every cracked or broken detail of the capitals or the tracery. So profoundly was the late eminent engineer of St Mark's impressed by the loss inflicted on posterity by the hasty rejection of the old capitals (twelve out of thirty-six of the lower arcade) which still exist among the lumber of the Palace, that he pleaded eloquently for their restitution in the places of the new ones.[1] The walling up of the five arches of the lower arcade was effected by Da Ponte during his masterly restoration of the Palace after the terrible conflagration of 1577, and so admirably had the fourteenth-century builders designed and executed their work, that one of the fifteen architects who were then appointed to advise on the possibility of a restoration, reported that the fire had done no more harm to the walls than the bite of a fly to an elephant. It is curious to note that the severe strictures

[1] Nuovo Archivio Veneto, 1899.—*Sulla Convenienza di restituire al Palazzo Ducale di Venezia i suoi capitelli originali istoriati.*—P. SACCARDO.

c

passed on the façade of the Palace by architects such as
Joseph Woods, and later by Parker and Fergusson, were
anticipated by those members of the Commission of 1577
who favoured the demolition of the gutted Palace. Paolo
da Ponte and Andrea della Valle declaimed against the
ugliness (bruttezza) and barbarous style of the building;
against the heresy of raising the solid over the void, and the
broad and heavy over the narrow and feeble; against the
deformity and weakness of the architecture. Happily, the
views of Francesco Sansovino, Giovanni Antonio Rusconi,
and the official architect, Antonio da Ponte, prevailed,
enforced as they were by motives of economy in the minds
of the Seigniory. Sansovino was loud in his eulogy of the
Ducal Palace; it was the strongest and firmest edifice he
had seen in the whole of Italy; its marvellous composition
and structure had withstood many an earthquake without
sign of hurt or of the slightest settlement. These and other
considerations, therefore, such as the improbability of any
architect designing a building which would involve so much
wasted space as is implied by Parker's and Fergusson's views,
in a city like Venice where the value of land was higher
than in any other capital in Europe, and where the one
absorbing problem of the builders was to cover a minimum
of surface with a maximum of room space, embolden us to
reject as historically inadmissible and technically improbable,
all theories that would depreciate the inventive skill and
æsthetic feeling of the nameless builders who raised the
strong and fair Palace that even in its vacant magnificence
and fallen grandeur entrances us to-day. That the masters
of the fourteenth and fifteenth centuries knew little and
cared less for the " canons of architecture " which dominated
later architects is evidenced by the asymmetrical windows of
the S. façade: they thought less of external harmony than
of internal convenience; and that the criticism passed by
technical pedants on the upper story was anticipated by its
designers is obvious if we regard the admirable manner in

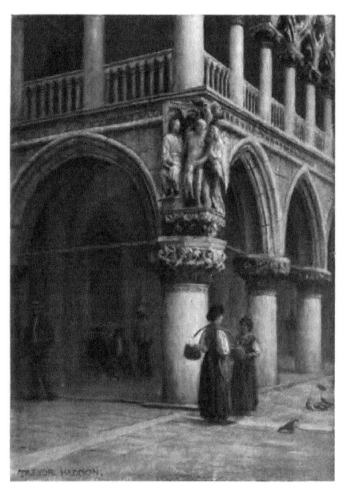

DUCAL PALACE ARCADES.

which the impression of heaviness has been disguised by the ingenious and pleasing geometrical designs and variegated colours formed by the blocks of Verona marble which embellish and lighten its aspect.

With what accurate science and consummate beauty the builders designed the continuous tracery that supports the superstructure! Whether, as Street suggests, the treatment was derived from the peculiar shape and great projection of the capitals of the shafts and the narrow span of the arches, in the Fondaco de' Turchi, which, when seen from a distance, give the whole arcading almost the effect of a series of trefoils; or whether it was derived, as Ruskin believed (Fig. 3), from the window traceries of the apse of the Frari, the circle of quatrefoils being set between the arches instead of above them, and the whole masonry increased in strength and its joints re-adjusted to bear a 40-feet

FIG. 3.—FROM THE "STONES OF VENICE"

wall, it none the less remains a master-stroke of inventive genius, and was imitated, with unimportant variations, by every subsequent architect of the Gothic style in Venice, and fixed the norm of palatial architecture for whole generations.

The story of the completion of the Piazzetta façade, as told by Sanudo, is familiar to all readers of the "Stones of Venice," and the noble figure of the wise old Doge, Tommaso Mocenigo, magnanimously offering after the fire of 1419 to meet the fine of a thousand ducats which the fathers of the Republic had condemned him to pay who should dare to propose the demolition of the old Ziani Palace, is one of the most affecting scenes in Venetian history. On the 27th of March 1424, the old building "*essendo molto vecchia e quasi rovinosa*," the pick of the housebreaker gave its first stroke,

and in a few years the last remains of the "great and marvellously fair" Byzantine Palace, which evoked the admiration of the Emperors Otho the Great and Henry V.. gave place to a new Gothic fabric which harmoniously completed the south and west façades. In 1438 the richly-decorated Porta della Carta was begun, and on February 10, 1441, the occasion of the marriage of the ill-omened Jacopo Foscari, the sumptuous Hall of the Great Council resounded to the first great festa celebrated within its storied walls, and Sanudo tells that on November 23, 1463, the first gentleman, Girolamo Valaressa, was hanged at the columns of the new Palace. The Doge's private apartments, which were so small and inconvenient that his family could scarce find room to turn in them, had been enlarged in 1409 : they too in 1483 were destroyed by a conflagration, the Serenissimo escaping to the Ca' Trevisan on the opposite side of the Rio del Palazzo, whence the fire was first observed. The Renaissance architect Antonio Riccio or Rizzo was commissioned to rebuild the E. wing; the Lombardi, Guglielmo Bergamasco, and other masters assisted in the building of the cortile, and from this time forward, either on the E. façade or in inner courtyard, nearly every architect of repute has left his mark on the fabric of the Palace.

On March 19, 1492, the Doge, after celebrating the event by a supper to one hundred poor folk, returned to sleep for the first time in his new apartments. Pietro Casola, who saw the restorers at work in 1494, ventured to declare that the Palace was the most beautiful he knew, although he had seen many other princely palaces both in Italy and in Rome. He was never weary of looking, and so rich was it in carved work and everything gilded that it was a marvel. But the vicissitudes of the Great Hall were not yet ended; in 1497 it was falling into disrepair, and by March 1499 our trusty master Zorzi Spavento had restored it. The mural decorations, however, were still uncompleted as late as 1515, for we learn from Sanudo's Diary that on

December 30 a resolution was passed by the Senate, that since the expenses for painters in the Hall of the Great Council were still going on, Francesco Valier, one of the Commissioners of the Salt Office, should look to it; whereupon Valier reported that, although 700 ducats had already been spent, two of the paintings were not yet even designed, and it was decided that the said painters be dismissed and better ones be chosen and approved by ballot in the Collegio. And note, says the diarist, that it was a futile resolution, because the painters explained everything away to the Seigniory: but by deliberation of the Collegio it was approved that a new bargain be made with "that same painter called Titian." The E. wing, completed in 1550, was again devastated by a fire in 1574, which was discovered while the Doge was sitting in the Senate listening to the reading of despatches, and in 1577 a fiercer conflagration swept through the whole structure and gutted the Halls of the Scrutineers and of the Great Council. Of the thirty-seven capitals of the south and west façades reported as injured by the fire, some had been already cracked before by reason of the rusted iron ties fixed in them, and Da Ponte, who had been appointed to superintend the rebuilding, strengthened the whole of the defective capitals by iron bands and clamps, and so they remained (with the exception of one renewed in 1731) until 1873 and 1876, when the modern restorers took the building in hand. Saccardo[1] has severely censured their work, and asserts that many of the renewed capitals passed through two or three hands and were even worked on by young beginners (*qualche giovane principiante*); that some of the symbols were misunderstood and deformed; that some inscriptions were inaccurately reproduced, and that the new capital of the S.W. angle was so badly executed that the engineers refused to pass it, and its unhappy sculptor died of a broken heart. Some of the most glaring errors were however corrected, owing to a vigorous exposure

[1] *loc. cit.*

published in *La Difesa* in 1886, and it is only fair to the restorers to add that Professor Alessandri informed the present writer that Ruskin, during his last visit to Venice, expressed to him his satisfaction with the results of their work.

CHAPTER III

The New Gothic and its Application to Domestic Architecture

"Venice the most beautiful and romantic city of Europe is also the city where Domestic and Palatial architecture can be studied to the greatest advantage. Florence presents only one form of the art and that confined to one century. The Romans soon lost what little originality they ever had, but Venice from the thirteenth to the eighteenth century presents an uninterrupted series of palaces and smaller residences, all more or less ornamental, all appropriate to their purposes, and all in exact conformity with the prevailing feelings and taste of the age in which they were erected. While other Italian cities have each some ten or twelve prominent structures on which their claim to architectural fame is based, Venice numbers her specimens by hundreds, and the residence of the most humble citizen is often as artistic as the palace of the proudest noble."—*Fergusson.*

THE beauty of the Gothic style, the dignity conferred on its authors by their appointment to supervise the work on the new Ducal Palace, its convenience and adaptability for domestic architecture, made a direct appeal to the merchant princes of Venice, and in the course of the thirteenth and fourteenth centuries the whole aspect of the city was changed and a new glory transfigured her architecture. By a curious irony the age known to moderns as "dark" was precisely the age when northern builders brought light and grace into men's sanctuaries and senates and homes; the age when Venetian masters, adapting the Gothic style from the mainland, moulded its native form to their own requirements and evolved a characteristic type of architecture which for utility, comfort and structural beauty has never been surpassed in any age of the world.

Before, however, proceeding to admire some of the numerous Gothic houses that yet exist on the most famous sites of the city, it will be opportune briefly to indicate their chief points of difference from the Byzantine structures they

superseded. If we compare the façades of the Palazzi Bernardo and Foscari on the Grand Canal with the Loredan or Farsetti we shall discover that while symmetry and balance are, with some curious exceptions to be referred to later, maintained by the Gothic masters, the subtler sense of proportion in spacing has been lost. The Byzantine arcade along the sea-story is broken up into one central portal, or pair of portals, flanked by one or two lateral windows; the arcade of the first floor is modified to a central group of balconied windows of from three to eight lights, balanced on either side by one or two simple one-light windows; a second or even a third floor is added ; the carved circular medallions give place to disks of porphyry, serpentine and verde-antico ; the lateral towers are absorbed in the upper stories; the delicate cornices become bolder in projection and sturdier in design. The corners are blunted and decorated by a vertical course of cable moulding or superposed plain or twisted columns, with capitals marking the level of the floors, carved in relief on the quoins, whereby the whole fabric seems knit together from foundation to roof. The incrusted marbles partially disappear and the blank brick wall spaces are covered with chromatic geometrical designs or pictorial fresco ; the archivolts are turned with stone and not with brick faced with marble. Fireplaces are set in the living rooms but not in the great state chambers : even the bedrooms in later times were furnished with fires, [1] because, says Sansovino, fire not only dries up the damp that the sleeper draws to himself but warms the room and thus purges bad vapours away. According to Filiasi, as early as 1069 chimneys are referred to as existing even in mediocre houses, and in 1284 a great earthquake is chronicled which is said to have ruined nearly all the chimneys in Venice. The Venetian chimney pot with its characteristic spring and

[1] A comparison with the apartments in Holyrood Castle, allotted to Mary, Queen of Scots, nearly two and a half centuries later than the date of the early Venetian Gothic palaces is instructive : in the whole suite of her rooms there was only one fireplace.

EXTERNAL STAIRCASE, A.D. 1500 (CA.): BENEDETTO DIANA?

quaint decorations became famous throughout Italy, and Villani, the historian of Florence and later contemporary of Dante, notes that during the earthquake of January 25, 1348 an "infinite number of chimneys were destroyed in Venice where they are many and beautiful." The very word for a fireplace with chimney, *camin*, is claimed to be of Venetian origin. An excellent representation of the variety and wealth of design employed in chimney decoration is afforded by Carpaccio's "Miracle of the Holy Cross," no. 566 in the Accademia and here reproduced, and in Gentile Bellini's picture of a similar subject, no. 568. Anticipating by centuries a modern innovation, the early Venetians designed their kitchens on the top floor of the house above the living rooms and carried the smoke and smell directly into the air. Boldly designed external staircases supported on pointed, or later on round arches, led from the courtyard to the upper story, examples of which we shall find surviving in our further peregrinations ; a contemporary external stairway, carried on round arches, is portrayed in the painting ascribed to Benedetto Diana, no. 565 in the Accademia and reproduced in this volume.

The earliest land portals, as in Byzantine times, were charged with ornament and the tympanum generally enclosed a shield with the arms of the family supported by angels ; sometimes an angel is above the shield holding a globe, indicating, says Ruskin, the Angel of the Lord or of His Presence ; sometimes the shield is suspended by a leather thong and a cross introduced above : the Renaissance, adds the master, viciously, cut away both cross and angels and substituted heads of Satyrs, "the proper presiding deities in the Renaissance period."

In all but the earlier Gothic arcades the Byzantine treatment of an elaborately carved and larger central capital, with its answering smaller capitals on either side, passes away, and so generally is this the case that in every group of five-light windows examined by Ruskin wherein this centralisation is

preserved, technical evidence was found, proving them to be anterior to the Ducal Palace arcade; and in that very façade the master discovered that despite the manifold designs and lack of correspondence in the capitals of the upper arcade, the central capital was accentuated by its noble and pure material of Parian marble, whereas the remainder were formed of Istrian stone. Another curious Byzantine trait may be seen in the two circular decorated medallions in the spandrils of the lower south arcade and traces of a third one in the west arcade of the Ducal Palace; but whether the whole of the spandrils were intended to be thus decorated is a matter of speculation. The close relation between the façades of the Ducal Palace and those of private houses is proved by the fact that the arcades of the latter are designed on the lines of the former and support, not the glazed windows, which are set back from the masonry and framed in wood, but the superstructure. The aim of the Venetian builders was to combine strength with lightness and grace, and nothing demonstrates more clearly the difference between the palatial architecture of the faction-ridden mainland and that of peaceful and wealthy Venice than a comparison between their relative window and wall spaces. To compare two later examples; in the Palazzo Riccardi of Florence the proportion of window to wall surface is as 1 to 13: in the Vendramin Palace at Venice it is as 1 to 3. The more ornate Gothic palaces were crowned with glittering parapets of marble decorated with gilded balls, as at the Ca' d' Oro, and often the single window spaces were framed in oblong slabs of Greek marble, with delicate dentil mouldings and rich encrustations of porphyry and serpentine; in some, the decoration of the whole group of the central windows is veneered on to the façade. In other houses, as will be seen from the accompanying reproduction of Mansueti's picture of a miracle of the Holy Cross, no. 564 in the Accademia, which gives an admirable idea of a Gothic diapered façade, the brick façades were simply pointed.

VENETIAN CHIMNEYS, A.D. 1494—MIRACLE OF THE HOLY CROSS: CARPACCIO

One of the most gracious features of these Gothic houses
were the richly designed and elaborately carved balconies
projected over the salt waters that washed their foundations,
whereby the architects were able to steal from the air what
was too precious to be taken from the land; a place where,
during the soft, delicious summer evenings, their patrician
owners might rest in sweet refreshment and intimate con-
verse after the day's work was done; where their household
might contemplate the ever-moving pageant of a busy
metropolis, the throbbing heart of western commerce, with its
fervent, strenuous citizens, and water ways crowded with
shipping; the setting forth and arrival of deep-laden
argosies. which,

> " With portly sail,
> Like signiors and rich burghers of the flood,
> Or, as it were, the pageants of the sea—
> Do overpower the petty traffickers,
> That curtsey to them to do them reverence
> As they fly by them with their woven wings."

There they might watch the gathering of embattled and
bannered galleys whose victories had made Venice respected and
feared all over the middle seas; the going and coming of her
200,000 inhabitants in their daily business and pleasure; the
departure and advent of mighty princes, potent envoys and
lordly prelates, seeking her friendship or neutrality; and
all the pomp and circumstance of a wealthy and puissant
State. The old liagò is retained, but becomes a more solid
structure of brick and stone; the altana—a raised wooden
platform on the roof where the women folk might dye their
hair and catch from the sun some of its golden glory—
becomes a part of every mansion. Hither, when the sun was
hottest they would repair with their domestic pets, bathe
their hair with a sponge soaked in a specific known as
acqua di gioventù, dry it in the sun's rays, and again ply the
sponge, repeating the operation several times, meanwhile cover-
ing their shoulders with a combing cloth of white silk and

circling their heads with a straw hat without a crown (solana)
over whose brim the hair was drawn. So common and
essential do these Oriental features remain that to this day
the Venetians are reproached by Italian purists for using the
word *balcone* for *finestra* and *altana* for *terrazza*.[1] Un-
happily but few of the original Gothic balconies have sur-
vived, most having been replaced by the baldest type of
Renaissance monotony. Obviously, as Ruskin has pointed
out, the projecting balconies were the first portions of a
palace to suffer dilapidation and repair, and it is only in the
smaller non-projecting balconies between the window shafts
that some of the original work survives: a few priceless
examples will be revealed to us in our subsequent wanderings
about the city. And what a scene of architectural splendour
and aërial glory the Venetian gazed upon as at eve he sat at
his palace window! The Aretino, in a letter to his gossip
Titian, has left us an eloquent word-picture of the sunset he
beheld as he sat one summer evening, convalescent from
fever, in pensive contemplation at the balcony of his house on
the Grand Canal: Never since God created the heavens
were they embellished with such lovely tones of light and
shade; the very palaces themselves, although wrought of
stone, appeared like a fairy vision; he was thrilled by the
marvellous effects of cloud-form and colour, the nearer
masses burning with flames of solar fire; the far, ruddy with
vermillion though not so deeply kindled. With what lovely
touches, Nature, with her magic brush, used the air for
a background to the palaces, even as Titian did in his land-
scapes; now a blue bordering on green is seen, now an in-
describable azure of Nature's own phantasy—Nature, master
of masters. She, with her light and shade, deepens and
heightens her effects so that, "dear friend, I recognise how
truly thy brush is spirit of her spirit, and as I gazed, thrice
did I exclaim: O, Titian, where art thou now? Verily,
hadst thou painted what I am describing to thee thy canvas

[1] De Amicis, "L' Idioma Gentile," 35° migliaio, 1906.

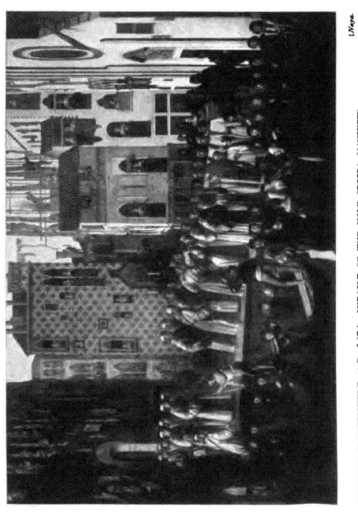

DOMESTIC ARCHITECTURE, A.D. 1494—MIRACLE OF THE HOLY CROSS : MANSUETI

BALCONY

PALACE OPPOSITE THE
SCALZI — WINDOWS OF
THE FOURTH ORDER

would evoke in men that same amazement which now over-whelms me."

A most explicit and valuable statement as to the minimum accommodation required for the house of a poor gentleman is furnished by an entry in Sanudo's diary, dated April 1501. In these times, writes the diarist, Sier Nicolo Moroxini, *quondam* Sier Jacomo da l'Ochio, restored at his own expense the Campanile of Sta. Maria Nuova and built thirty houses at Sta. Trinita. The houses were to have on the upper floor two rooms and a kitchen, a *portego in soler*—probably a kind of loggia on the roof,—and below, an *albergo*—probably a place in which to stow the felze, oars, cushions, and other furniture of a gondola—a place for wood, a wine store (*caneva*), an open cortile with two wells, and a landing-place (*riva*). They were to be completed in one year, as Morosini desired to give them during his life time for the reception of poor noblemen. From another note it would appear (February 1498) that it was the custom to advance sums from the Salt Office to the citizens for the rebuilding of houses destroyed by fire, or of ships wrecked. We read that in those days—and the entry has a double interest for us in that it mentions Zorzi Balarin, the famous glass worker of Murano, whom Marion Crawford has introduced so drama-tically in his fascinating romance, "Marietta, or the Maid of Venice "—the house of Bernadin da Riva *quondam* sier Vinzilas (Wenceslaus) at Murano was burnt, and he, desiring to sell it to Zorzi Balarin the glass worker for 500[1] ducats, thought within himself to ask the Seigniory for a grant from the Salt Office, in order to be able to (re) build the same, as was the custom to grant to those citizens whose houses had

[1] The worth of the gold ducat of Venice of that period has been variously computed, but may be taken as about equivalent to ten shillings English: the proper multiple to be used in estimating its present value is still more hazardous of computation. According to Prof. Molmenti 6500 ducats equal 250,000 lire, which would make the Venetian ducat equivalent to £1, 10s. 10d.: Prof. Boni estimates the modern value at 12·03 lire, or nine shillings and sevenpence. Probably the former is the more accurate.

been accidently destroyed by fire. *Unde* it was decided by the Council of the Ten with the Zonta, that *de cætera* it was no longer possible to grant the Seigniory's money to anyone whether by reason of fires[1] or of wrecks, *sub pœna*.

Sleeping apartments were, in the great palaces, confined to the second or third floors; and the lateral chambers of the piano nobile, or ceremonial story, communicated with each other, so that on state occasions the whole floor might be open to the free circulation of the guests. The central long Sala was never warmed, and to this day during a severe winter, residents, when leaving their sitting-rooms to pass to their bedrooms, find it advisable to put on a warm coat or cloak before they traverse the long icy Sala. The Hall of the Great Council at the Ducal Palace, the Senate and other legislative and executive chambers were unwarmed, and the members during the winter sittings came wrapped in fur cloaks. Sanudo notes that on an exceptionally cold first of May in 1513, the Doge came to the Great Council dressed in velvet trimmed with beaver.

[1] In Malipiero's annals (August 1496), several grants of money by the Ten ranging from 1500 ducats to 3000 are noted for the rebuilding of houses destroyed by fire. There was much grumbling in the city, says the annalist, at the advance of 3000 ducats to the Venieri who were rich and had given a marriage portion of 7000 ducats to a son-in-law.

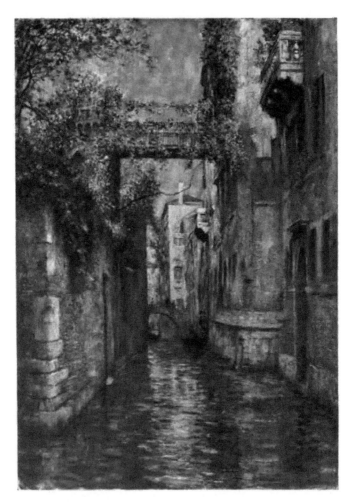

PALAZZO ALBRIZZI AND GARDEN.

CHAPTER IV

The Gothic Palaces on the Grand Canal—The Palazzi Sagredo, Erizzo, Priuli, Morosini, Bembo, Cavallini, Bernardo, Pisani-Moretta, Foscari, Giustiniani, Ambasciatori, Contarini dagli Scrigni, Cavallo, Barbaro, Da Mula, Contarini-Fasan, Dandolo

" I never saw palaces anywhere but at Venice : those at Rome are dungeons to them."—HAZLITT.

As a preliminary to our wanderings in search of the Gothic palaces that remain in Venice, all more or less restored, decayed or modified, it will be found opportune to make ourselves acquainted with Ruskin's six main divisions of their fenestration—illustrated in the accompanying diagram—from

VENETIAN WINDOW ARCHES FROM THE " STONES OF VENICE "

the " Stones of Venice." Figure 1 is the starting-point— Byzantine of the XI. and XII. centuries ; figures 2 and 3 are transitional of the XIII. and XIV. centuries ; figures 4 and 5 are pure Gothic of the XIII., XIV., and early XV. centuries ; 6, late Gothic of the XV. century. Various modifications of these are given by the master, but the traveller, by confining his attention to the salient features of the specific forms and ignoring varietal differences, will find his examination simplified. Bearing in mind, therefore, the distinctive characteristics of the six orders of Venetian windows, we

47

will resume our gondola and proceed to appreciate one of the earlier Gothic houses, the Palazzo Sagredo which stands on the Grand Canal, a few boats' lengths beyond the Ca' da Mosto. This once beautiful building has been much defaced, and the remains of the charming diaper pattern of crimson quatrefoils and winged cherubim which decorated the façade in Ruskin's time have been wholly blotted out; but the fine arcade of thirteenth century transitional windows of the third order on the first floor, and the fourteenth century windows of the upper floor framed in a lovely frieze of Byzantine pattern outside the dentil moulding, are yet left to us, their spandrils adorned with disks of porphyry enclosed in rope mouldings. Ruskin refers to the lower floor windows as a most important example of their kind, remarkable as having the early upright form with a somewhat late moulding. The (restored) balconies are characteristic : delicate little columns with carved capitals support a series of ogee trefoils boldly cut through a bar of stone, and at either corner on the top of the angle pilaster, repose two quaint little seated lions, the whole being supported by brackets decorated with lions' heads. The tracery of the central group of windows, anterior to that of the Ducal Palace, should be noted, the quatrefoils being placed above the arches and not set between them.

The Palace, formerly a Ca' Morosini, came but late into the hands of the Sagredi, who were members of an ancient Dalmatian family that settled in Venice in the ninth century, and for distinguished military services were admitted to the Great Council in 1100 : they gave a saint to Hungary, a doge and a patriarch to Venice, and only became extinct in 1871.

Somewhat higher up the Canal, and nearly opposite the Palazzo Battaggia with its two crowning obelisks, is the charming little Palazzo Erizzo, unilateral in design, which is worth a visit for the sake of the beautiful tracery of the Ducal Palace period and boldly carved capitals of its first floor windows: as in its prototype the spandrils below the tracery are decorated with

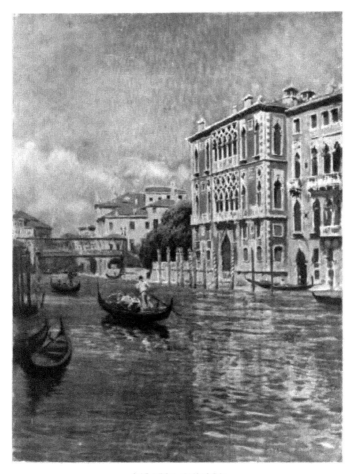

PALAZZO CAVALLO.

small lions' heads. Formerly belonging to the Molini it only came into possession of the Erizzi by marriage in 1656. This ancient and heroic family numbered among its ancestors one of the tribunes of the first Venice, and became for ever famous in the annals of *la seconda Venezia* by Paolo Erizzo's stubborn defence of Calcide, of which he was Governor, against the Turks in 1469, and his terrible martyrdom. Having surrendered to Mahomet II. (the Sultan whose cruel countenance painted by Gentile Bellini may be seen in Lady Layard's Collection) on condition that the lives of the garrison should be spared, and by a despicable act of treachery having been forced to witness the butchery of his soldiers, he was himself sawn in two. Venetian chroniclers have embroidered the story, as is their wont, with a pathetic incident: unhappy Paolo's only daughter, Anna, being captured among the prisoners, was for her matchless beauty awarded to the Sultan as his prize. Yielding neither to threats nor material seductions, she rejected the conqueror's advances, who in a fit of rage hewed her to pieces with his scimitar. A portrayal of Erizzo's torture will be found among the decorations of the Hall of the great Council, and a sumptuous monument in the Church of S. Martino to Doge Francesco Erizzo and many place names in Venice, bear witness to the importance of the family in history. Traditionally they were a wealthy and scholarly race, of a stern and hard temperament, and it was said there had never been a rich Balbi, a poor Mocenigo, nor a compassionate Erizzo. The last of the house, Nicolo Guido Erizzo, died childless in the first half of the last century; true to the family tradition he stoutly opposed the surrender of his fatherland to the French invaders. Higher still up the Canal and opposite the church of the Scalzi will be seen a group of fourth order windows, referred to by Ruskin as one of the purest of their kind, and noteworthy for the great depth of the arches and the clear detaching of the shafts from the glass behind.

D

As we are impelled in our gondola along the return course
by the Grand Canal, other monuments of Gothic art may
be briefly noticed all more or less maimed and mauled by
subsequent restoration. On our right immediately before
reaching the church of S. Stae, stands the Palazzo Priuli,
and, beyond the Monte di Pietà, the little house where the
late Venetian painter Favretto had his studio. A larger
structure, and one of the old Palazzi Morosini, just before
reaching the Fish market, may claim more careful attention
for the sake of its fine upper window tracery of the Ducal
Palace period. The third order windows of the old ruined
palace of Marco Querino, the most perfect of their kind
according to Ruskin, are now improved away, and the body
of the old building has been incorporated in the new Fish
market. On our left beyond the Palazzo Sagredo is the
Palazzo Foscari with remains of similar arcading. Beyond
the Rialto bridge and still on our left is the ample Palazzo
Bembo, whose Byzantine cornice we have already noticed :
even in its degradation it is a noble edifice, and of old was one
of the glories of early Gothic architecture. The Bembo
family traced their ancestors to the earliest dawn of Venetian
history : a Giovanni Bembo was tribune of Heraclea in 527.
They were one of the four families, known as the Four
Evangelists, whose progenitors, with the twelve apostolic
founders of the Republic, signed in 800 the contract for the
foundation of the abbey of S. Giorgio Maggiore : a brilliant
and heroic line of statesmen, hierarchs, and scholars have made
the name of Bembo illustrious. The magnificent and erudite
humanist and historian, Cardinal Bembo, was probably born
in this very mansion. Yet farther, and beyond the great
renaissance Palazzo Grimani, we observe in passing the
Palazzo Cavallini, and on our right, rest awhile before the
Palazzo Bernardo, with its tall graceful windows. This
noble edifice of the Ducal Palace period came in 1694
into the possession of the Bernardi, a rich merchant family,
who formerly traded in colours on the Giudecca, and subse-

quently near the Rialto at the sign of the Pumpkin, and
was retained by them until sold by auction in 1860: at
length it became and now remains the property of the
Salviati Company of Mosaicists. Beyond the rio S. Polo
we may pause to examine another and later example of
palatial Gothic, the Palazzo Pisani-Moretta, with the char-
acteristic interlacing arches affected by the later architects.
Hazlitt, when travelling in Venice in 1820, was much im-
pressed by this palace, which he places next to the Grimani
for elegance and splendour: "a flood of bright day was
admitted through glittering curtains of pea-green silk into
a noble saloon enriched with an admirable family picture
by Paul Veronese, with heads equal to Titian in all but the
character of thought." This famous canvas, known as the
Family of Darius, and containing contemporary portraits
of the Pisani family, was esteemed by Ruskin to be the most
precious Veronese in the world; it was happily acquired
for the National Gallery in 1857 for 15,000 gold napoleons
(£12,000) by the English Consul, after several public
bodies and private individuals had been competing for it
for thirty years. Veronese, it is related, painted it during
his enforced detention by an accident at the Villa Pisani
at Este, and at his departure remarked that he had left
behind something that might compensate his host for the
expenses of his entertainment. Ruskin describes the capitals
of the first floor arcade as singularly spirited and graceful
and very daringly undercut. The water-gate—a double one—
is placed by Selvatico among the earliest architecture in
Venice bearing traces of the Renaissance; the bossed
base, with its egg and dentil mouldings, dating from the
end of the fifteenth into early sixteenth century. The
long balcony which disfigures the uppermost story is a
later addition in 1742.

The Pisani were the descendants of one of the original
members of the Great Council, and their last male descendant,
Count Vettor Pisani, who died in 1870, was he who sold the

famous Veronese. Much indignation was aroused by its alienation from Venice, but the Count, who was a million-aire, excused himself by saying that, having three married daughters and no male heirs, he had disposed of the picture to remove all danger of dispute as to its possession after his death. No contract was drawn up for the sale, the whole negotiation being concluded by word of mouth. The Count, having received the 15,000 napoleons, invited his three daughters to dinner; when the time for dessert came, he prayed them to look in their finger bowls, where each found 5000 napoleons.

The Pisani were the owners of the Villa Strà, on the Brenta, the most rich and luxurious of the mainland palaces of the decline, which was frescoed by Visconti and Tiepolo, and in the early years of the nineteenth century was bought for the viceroy by Napoleon. The villa is now a national monument, and its lovely grounds one of the favourite resorts of the Venetians in the summer months.

At the corner of the rio di Ca' Foscari we turn to examine the majestic group of the Palazzo Foscari and its two sister mansions to the left, known as the Giustiniani, which ennobles the finest reach of the Grand Canal. The Foscari palace, in earlier times also a Giustiniani, was purchased by the Seigniory in 1429 for 6500 ducats, and presented to the Marquis of Mantua. It was a battlemented Byzantine edifice, referred to as the House with the Two Towers, and stood, as we learn from Priuli, on a site somewhat further removed from the corner of the rio. In 1438 the Marquis was dispossessed, and the house was in the following year given to the illus-trious Count Francesco Sforza, Gonfalonier of the Church, Captain of the League, and their new Condottiere, on his election to the Great Council on November 30. When, however, Francesco seized the dukedom of Milan in 1450, it was confiscated, and, being put up to auction in 1452, was bought by Doge Foscari, who rebuilt it in a more sumptuous style, and raised it higher than its neighbours that it should

PALAZZO PISANI-MORETTA.

no longer seem to be one of the Giustiniani houses. Priuli says that the Doge transported the building "from the place where the courtyard now is to the corner on the Grand Canal of the rio which leads to S. Pantalone, where it may now be seen with the new courtyard behind it, where the old house formerly stood." In the seventeenth century, however, the palace was enlarged towards the courtyard, nearly a new palace being added, which backed on to the existing fabric, involving the destruction of a beautiful Gothic external stairway. We will pass up the rio and observe the quaint battlemented parapet of the courtyard, imitated by the Gothic builders from earlier Saracenic forms, and the tympanum of the portal giving on the courtyard still bearing the scutcheon of the Foscari.[1]

A Francesco Foscari, one of Napoleon's Italian Guards and known as the *ultima gloria della Ca' Foscari*, perished in the Russian Campaign, 1813. Two of his brothers were comic actors; a cousin, Luigia, was married in England, and when Count Litta wrote was living at Dunkirk. The last of the male descendants of Doge Foscari to inhabit the old palace was Luigia's father, Federigo,[2] who, born rich and having served as ambassador at St Petersburg and Constantinople from 1788 to 1792, squandered his patrimony and died in poverty in 1811. Count Litta writes of the immense palace in his day (the early nineteenth century) as abandoned and *cadente*.

[1] The amazing insensibility of the authorities to nuisances renders an inspection of the sea-story almost impossible to delicate senses, the malodorous latrines for the use of the students having been contrived on this floor.

[2] The Litta genealogy gives four descendants to Federigo, daughters, all of whom found husbands: one, the Luigia married in England; another married a Frenchman; a third, an Austrian; the fourth, Count Annibal of Crema. The genealogist, however, adds that "Il commercio delle donne" made Federigo father of four [other?] daughters, whom, by a sentiment of *antico pudore*, he called Carifos, an anagram of his name. See *Famiglie Celebri Italiane*, 1819-1872.

One of the most touching examples of fallen grandeur is afforded by the memoirs of Lady Dorothy Nevill, who, in the forties of last century, was introduced by Rawdon Brown to the Contesse Foscari, two old maiden ladies, then living in the Ca' Foscari. These, the descendants of one of the most potent and wealthy of patrician families in Christendom, Lady Dorothy beheld living in a sad state of squalor in what once had been the state bed-chamber; and of its former splendours all that remained were a few miserable, broken chairs, a table, a settle, some carved and gilded figures that once supported the canopy of the large bed, terribly worm-eaten and poor-looking, but scrupulously clean. It was a scene, says Lady Nevill, of chilling desolation. One of the sisters sat gloomy and sad, the other gay and lively, but toothless and crooked. Their dresses were of the poorest make and quality, and they complained that of their small annuity (about three shillings a day) the Jew who paid it cheated them of one-half, and reduced what might have kept them in tolerable comfort to a mere subsistence. Lord Alvanley, then in Venice, to whose compassionate ears the story came, generously increased their income, and enabled the forlorn old maids to end their days in peace and comfort. There is still, we believe, a Contessa Foscari *de la main gauche* in Italian society.

The old palace, which Francesco Sansovino declared, although built according to the "German style" (*maniera tedesca*), by its imposing site and grandeur surpassed even the four greatest Renaissance palaces on the Grand Canal and contained more rooms than any other in the city, has had a chequered history. Its princely, but ill-fated, builder, whose tragic fall from the highest pinnacle of mortal glory is known to every reader of English dramatic poetry and of Venetian history, could hardly have seen it finished before he came, in 1457, a disgraced and broken-hearted old man of more than four score years, to die within its walls. In 1574, when in possession of Senator Luigi Foscari, dubbed Il Gobbo

(the Hunchback), it was the scene of probably the most sumptuous and famous of all Venetian festivals, when the Republic, with lavish hospitality and fulsome adulation, entertained the despicable Henry of Anjou, who left its walls to assume the crown of France polluted by a Bartholomew massacre; to betray and butcher the Duke of Guise, and himself to perish by the assassin's hand. Many another guest of the Republic has lodged within its fair architecture, and at length, fallen into decay and wretchedness, it was acquired by the municipality of Venice, and is now used as a School of Commerce.

By a curious asymmetry, often met with in Venetian architecture, the water-gate is not built in the centre of the façade. The builders have concentrated all their art on the traceries of the two central stories, the second and not the first floor being in this example the *piano nobile*, the noble floor, or chief suite of apartments, including the long state salon which traversed the whole depth of the palace. The arcades are enclosed in a rectangular frame of marble with dentil mouldings, giving, as Street remarks, the effect of panels veneered on to the front, with windows pierced into them. Several of the window shafts are of Greek marble, others of Verona marble, and a marked decline is readily observed in the workmanship of the capitals and tracery of the top floor, which is similar in design to that of the Ca' d' Oro. On the broad band of stone above the piano nobile two bas-relief figures of angels hold forth the Foscari scutcheons.

With the Giustiniani, if tradition tell true, we reach the most famous and, in its origin, the most exalted of Venetian families. They traced their proud descent back to the Imperial builder of Sta. Sofia and the great lawgiver of the western world; scions of two emperors, on the inglorious fall of their house they founded the city of Justinianopolis, afterwards known as Capo d' Istria, at length settled at Malamocco, and finally in Rialto. In the twelfth century

three of their number filled the important office of Pro-
curator of St Mark; and the whole of their male descendants
having, save one Benedictine monk, perished in the calami-
tous expedition of 1171, the Republic sent a Morosini and
a Falier to Rome to implore of Pope Alexander III. the
release of Nicolo Giustiniani from his vows, that he might
return to secular life and raise up seed, in order to avert
the extinction of a noble house. Their prayer was granted:
Anna, daughter of Doge Vitale Michael II., was given him
to wife, and the union was fruitful of nine sons and three
daughters to the State. But, still yearning for his cloistered
life, their progenitor returned to his cell at S. Nicolo del
Lido, and his consort took the veil at the Convent of S.
Adriano di Costanziaco, on the island of Amiano, subse-
quently submerged, in the diocese of Torcello. *Bon chien
chasse de race:* the military prowess and fervent piety of the
Giustiniani were renewed in two sons, who played a glorious
part in the capture of Constantinople under blind old Dan-
dolo, and in one son and one daughter, who became religious.
The sainted Lorenzo Giustiniani, whose ascetic features are
dimly seen in the painting of him by Gentile Bellini in the
Accademia, was the first Patriarch of Venice, and the Blessed
Eufemia, abbess of Sta. Croce, maintained the traditions of
the race; a cloud of prelates, procurators, senators, and
warriors, together with Doge Marcantonio, witness in
Venetian story to their exalted virtues.

If we may believe panegyrists and historians, never since
the days of Abraham was there a founder of a family so
fruitful in multitudinous progeny as the monk of S. Nicolo.
Their genealogies occupy no less than twenty large folio
pages in Count Litta; in the palmy days of the Republic
fifty heads of families were numbered among Nicolo's de-
scendants, and it is said that two hundred Giustiniani sat
in the same period in the Great Council—probably an ex-
aggerated way of saying that so many had the *right* to sit
there. Doubtless the very fact of their extraordinary range

and power and wealth acted as a bar to the elevation of more than one member of the family to the dogeship. At the end of the seventeenth century forty families had become extinct, and when Count Litta wrote, only four survived. The two palaces before us date from the Ducal Palace period of Gothic, and were probably partly rebuilt about 1450, for in 1451 Nicolo and Giovanni Giustiniani obtained permission to acquire, at a valuation, a small house which stood in the way of the rebuilding they had undertaken on the Grand Canal. Some old capitals may be distinguished in the façades. The piano nobile is on the third floor, as in the contiguous Foscari palace. The upper cornice is less elaborately treated, and two of the single-light windows are decorated with pendant tracery. Both palaces have met the fate of so many of the patrician mansions along the Grand Canal, and have fallen into the hands of dealers in antiquities.

A few houses beyond the huge Palazzo Rezzonico is the Palazzo dell' Ambasciatore, so called from the fact of its having been occupied by the Cæsarean Ambassadors. It belonged to the Loredani, and is worth attention for the fine proportions of the floors and typical cable and dentil mouldings: the Renaissance niches are a later addition and contain statues from one of the Lombardi workshops. A fire in 1891 having destroyed the roof, the municipality of Venice vetoed some ill-advised restrictions proposed by the owner. Passing the first of the two palaces of the Contarini of the Coffers (which is also a Gothic fabric with some Renaissance modifications in its sea-story), just beyond the iron bridge and on our left we shall not fail to remark the renovated late Gothic Palazzo Cavallo, now the property of Baron Raimondo Franchetti, with bold tracery, similar in style to the Pisani-Moretta. The façade is finely proportioned and the aspect of the edifice, standing as it does, in one of the finest reaches of the Canal, is imposing: of the merciless restorations of the façade and the erection of the new wing towards the Campo S. Vitale *il tacere è bello.*

At the opposite corner of the rio stands the Palazzo Barbaro, which has suffered much from incongruous additions and the insensibility of former owners. Since its devolution to the present cultured possessors, Mr and Mrs Curtis, much has been done to preserve and to disclose its more ancient features. If the traveller will direct his gondolier to row up the rio he will perceive an exquisite fourteenth century arcade embedded in the side wall of the palace. This, which once formed the outer side of an arcaded public passage leading in olden days from the Campo S. Stefano to the Grand Canal, was in the eighteenth century filled in and wholly concealed by coarse brickwork: to the thoughtful and public-spirited present owners is due the gracious impulse to discover it. The Renaissance wing to the left was added by the Barbari in the late sixteenth century, and the rooms still retain most of their Renaissance decorations of paintings and other work on the walls and ceilings by Roman artists. On the top floor of the older palace, a library, contrived by the Barbari in the days of enthusiasm for the new learning, still remains with its empty book-shelves—a charming sanctuary, remote, peaceful, about which still seems to linger a subtle aroma of learning—where the passionate humanists (one of the Barbari is said to have learned Greek when he was sixty years of age) would retire to pore over their Greek manuscripts and revel in the new found treasures of Hellenic philosophy.

Francesco, who died in 1454, was one of the most famous humanists among the Nobili of his time, and in the small leisure of an active life—he was a hard-working public servant and brave warrior—kept in touch with the great scholars of the Renaissance. He studied Greek with Giovanni da Ravenna and with the renowned Guarino, from whose school more scholars were said to have come out than armed men from the Trojan horse; he induced Georgios Trapezuntios to come from Crete and settle in Venice, procuring him a professorship at Vicenza. Equally renowned

was Daniele Barbaro (1513-1570), author of the *Storia Veneziana*, published as a supplement to Malipiero's diary, a patrician of extraordinary versatility and profound learning, who translated and commentated Vitruvius, wrote a commentary to Aristotle's Rhetoric, and a famous philosophic poem the *Predica dei Sogni*. An excellent mathematician and master of the natural sciences he founded a Botanical Garden and the Accademia degli Infiammati at Padua. He served with much distinction as ambassador to Edward VI. of England, and in 1550 his theological and scholastic erudition won for him a high position in the church: he became the coadjutor of the Patriarch of Aquileia, the famous Giovanni Grimani, and subsequently took part in the Council of Trent. This venerable sanctuary of learning is not without its literary associations to-day, for here John Addington Symonds wrote his Introduction to, and Translation of the Memoirs of Carlo Gozzi ; and Henry James, one of his best known novels.

On the opposite bank of the Canal and adjacent to the Palazzo Barbarigo, the property of the Venezia-Murano Company of Mosaicists, with its brazen *sfacciata*, rises the Palazzo da Mula, a late Gothic edifice now in the possession of two sisters, the last of the direct line of the Morosini, under whose auspices the palace has been restored internally to something of its former aspect. According to old Venetian custom the atrium is hung with galley lamps, scutcheons, helm and sword ; and the great hall of state traverses the whole depth of the building with its communicating lateral chambers as in days of old. It need hardly be said that owing to the changed requirements of modern life and the vicissitudes of patrician fortunes few of the old mansions retain their original internal distribution. The Morosini sisters are, we believe, the only surviving patricians who trace their descent from the apostolic twelve, the tribunes who concurred in the election of the first doge, of whom the Contarini and the Morosini were the most influential. There are few examples in Europe of a descent so

venerable. The rapidity with which the Republic used up her chief noble families is strikingly illustrated by the list of the patrician houses whose members had sat in the Great Council, but who had become extinct in 1522, prefaced by Sanudo to his " Lives of the Doges." They amount to no less than 269.

It was at this Palazzo da Mula that the Countess Bermani, née Cholmondeley, modelled a bust of Ruskin in 1877 when he was staying at the Calcina. Count Zorzi, whose mother was a Morosini, has described the overwhelming joy of the author of the " Stones of Venice " at the idea of meeting her—a real Morosini, who was not only the great-granddaughter of the last Procurator of St Mark, but descended in a direct line from Doge Domenico Morosini (1148-1156). "I shall never forget," writes the Count, "the moment in which, after stopping a while in the Corte Bottera[1] to admire a precious Byzantine arch *in situ* which had escaped the clutches of the robber speculators, and lay on our way to S. Zanipolo, where I then lived, he entered my study and bowed before my mother, kissing her hand as he would have kissed the hand of a queen. Never, so long as I live, shall I forget the veneration with which, stretching out both arms wide he bent down and laid his forehead on the pile of parchments, documents, wills, etc., belonging to the Morosini family, which I held out for his inspection on a large table. All the way as we went back to S. Moisè, and all that evening, he was never weary of talking to me of the charm of my mother's gentle dignity of manner and of the supreme importance of those venerable documents."[2]

Noting to right and left other fragmentary remains of the Gothic period, again we rest on our oar before the little Palazzo Contarini-Fasan, straitly hemmed in between the Grand Hotel and its other broad-fronted neighbour.

[1] See p. 23.
[2] *Cornhill Magazine*, August and September 1906.

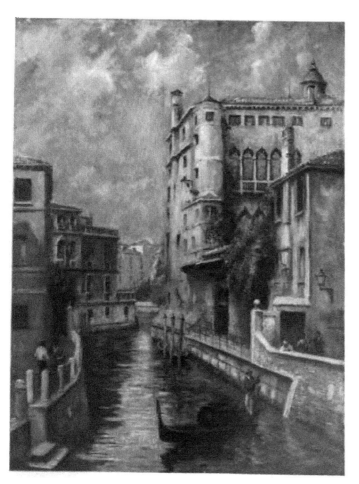

PALAZZO CONTARINI-CORFÚ.

The peculiar decoration of the archivolts, the rich flamboyant tracery of the balconies, and the exuberance of the architectural embellishments generally, betray the decadence of the Gothic style ; and, indeed, the Renaissance brackets that support the balconies are evidence enough of the lateness of its erection. Paoletti, by analogy with the choir of the Frari, dates it about 1475.

Whether or not we are housed in the famous Hotel Danieli, we will, before we turn to our last and crowning Gothic edifice on the Canal, proceed to admire that historic and venerable palace which was originally erected by the Dandoli, and later used by the Republic of Venice to entertain foreign ambassadors and other exalted guests. Many are the references in Priuli's and in Sanudo's diaries to the arrival of important envoys and their reception at the Ca' Dandolo, Calle della Rasse. Many, too, were the brilliant festivals held within its walls: at the wedding of a Mocenigo and a Giustiniani in 1629, one of the first performances of opera, the Proserpina Rapita, by Giulio Strozzi, was given, there. Ruskin, who more than once lodged in the hotel, dwells on the delicacy of the cusps in the central group of windows "shaped like broad scimitars." The ground floor of the palace has of course been wholly modified, but enough remains of its stately and restrained architecture to render a visit interesting to the lover of Venetian Gothic. If the traveller will ask his gondolier to row him down the rio to the right of the hotel, he will discover, just beyond the side entrance, a unique arch of the fifth order, which Ruskin succeeded in having disclosed by a removal of the brickwork which masked it.

CHAPTER V

The Ca' d' Oro and its Builders

"Come più m' avvicino ai muri illustri,
L' opra più bella e più mirabil parmi."
—*Ariosto.*

A CAREFUL appreciation of the Ca' d' Oro, the very flower and culminating achievement of domestic Gothic in Venice, demands a separate chapter, and may fittingly conclude our survey of the Gothic palaces on the Grand Canal. There is small need to indicate its position: it is probably the most lovely patrician mansion in Europe, and inobservant indeed must be the eye that can pass along the great waterway and not be arrested by this exquisite gem of the builder's art.

Of this, happily, we possess, unlike other Gothic palaces of which no documentary history exists, a unique and priceless series of records discovered in the Archivio di Stato, by the former Director, Signor Cecchetti, among the papers of the Procurators of St Mark and published by him in the Archivio Veneto in 1886: these have been supplemented by further discoveries published by Paoletti in his magnificent folios.[1] The papers comprise a number of formal contracts between the masons and decorators and the proprietor of the house, Procurator Marin Contarini, who appears to have managed the whole business without any intermediary or agent. The accounts begin in 1421. In May of that year certain payments were made to Master Matteo Reverti of Milan, stonecutter (*lapicida*), for specified work on the great house of Marin Contarini in the parish of

[1] *Architettura e Scultura in Venezia*, 1893.

Sta. Sofia; in August 1421, the name of Marco di Amadeo, mason (*murator*), appears, and in 1423 the names of the Boni, who it is known worked on the piazzetta arcades and the Porta della Carta of the Ducal Palace, are met with. On January 1 of that year, Zuan Bon, stonecutter (*taiapiera*), his son Bartolomeo, and their two assistants, Zuan and Rosso, are engaged at a yearly salary of 140 gold ducats and . . . quarts of wine to work on the great house of Miser Marin di Miser Antonio, Procurator of St Mark; and although their work appears not to have been begun until August 4, 1424, Marin Contarini had advanced, on March 25, 1424, forty ducats on account to Zuan, that he might buy a house, and since Zuan could not write, Bartolomeo made out the receipt in his father's name. In August 1424, a further agreement repeats the terms of that dated January 1423. Some interesting details of mediæval procedure in settling with craftsmen are found in the accounts of the first year's payments in 1425. All lost time, whether resulting from holidays, or sickness, or from work done elsewhere, is estimated and deducted from the amount agreed upon, the masters being mulcted in various sums for work on the Ca' Barbaro; on a tomb, and other extraneous employment. Contrary to the inference drawn by Prof. Boni, the further documents brought to light by Paoletti tend to prove that the Professor's ancestors, up to 1430 at least, were but subordinate craftsmen, and that Reverti, with the numerous and capable group of Lombard artists under his superintendence, were the more important factors in the rebuilding of the Ca' d' Oro. Among the masons working under Reverti of Milan were Master Gasparino Rosso of Milan, and no less than five masters from Como, whose names are given. Zuan Frison, and another Frison, son of Guglielmo of Milan, were employed in 1425 and 1426; in 1431 Master Tomaso di Cristofolo of Florence enters the lists; and in 1432 Master Cristofolo dei Orsigny of Milan, one of three Orsini, who were all well-known

Lombard architects, was added. In 1426 Zuan Piero, a
local artist, received 43 ducats for carving nine brackets
with lions' heads to support the balconies, and in 1426-1428
Master Antonio Buranello of Murano was employed under
the Boni ; in the latter year, their assistant Cristofolo
worked on the windows of the *mezado* or small rooms of
the entresol used by Venetians as business offices, and in
September, Nicolo Romanello had wrought four lions'
heads "under the windows of my *mezadi* over the Grand
Canal."

One of the contracts with the Boni, dated April 20,
1430, indicted, as they all are, in Venetian dialect, and
containing many obsolete Gothic terms which have been
analysed and interpreted by Prof. Giacomo Boni, is published
in Vol. xxxiv. of the "Archivio Veneto," and in the
"Proceedings of the Institute of British Architects," for
the year 1887. On April 1, 1430, Mistro Zambon contracts
to execute certain specified sculptor's work (*maistranza di
taiapiera*), on the façade, and ten feet at each side, of Miser
Marin's *Chaxa granda* at Sta. Sofia. He was to carve a
foliated capital for each angle of the said house (a *calle* then
bounded it at *both* sides) to be placed at the top of the
mouldings existing at each angle. They were to spring in
due proportion so as to look well, and the abacus was to
bind with "my old cornice, and if any repairs or additions
were needed to the old cornice the said master was to
execute them." Details and measurements of the running
trefoiled arcade or *archetti* below the cornice, springing
from the corbels, are then given; at each side of the angle
of the house there was to be half an arch (*archetto*) and on
the corners a sitting lion was to be placed "holding my
scutcheon in its paws," as large as the *archetto* would permit.
The *archetti* were to consist of not more than two or three
pieces. The arch was to curve outwards so as to form
a series of niches, and above was to be a cornice all along
the façade and sides, chiselled with a spiral scroll or ribbon

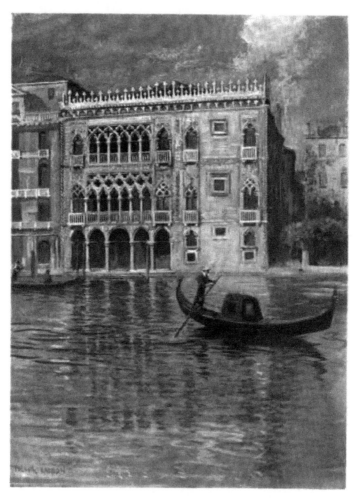

CA' D' ORO.

similar to that of the cornice of red (Verona) stone between
the first and the second floor: this was to be six inches
deep and above it was to be a dentil three inches deep.
A parapet of sixty-four pinnacles was then to be fixed plumb
with the wall, one half of them to be five feet high and one
foot and a half wide, or a trifle more (*qual chosetta plui*);
the other half, three feet high and one foot wide, or a trifle
more. They were to be placed along the whole façade and
ten feet along the sides, and were to be executed according
to the design of one already submitted. Each of the three
lobes of the trefoils at the top of the pinnacles was to be
decorated with a ball of red stone, polished and bright, so as
to bring out its colour. Specifications follow for a gutter, for
iron ties and cramps and leading, and in a subscription,
Bortolomeo,[1] son of Mistro Zambon, declares that he wrote
out the contract with his own hand, and, at his father's
request, who was to receive from the said Miser Marin of
Miser Antuonio el precholador 210 ducats of gold. The
contract is endorsed by Contarini: Written by the hand of
the son of Zane bon, *taiapiera*, as the conditions and price of
the *merlatura* (parapet) of my house.

In 1431 the carvings were ready for the painters and
gilders, and on September 15 of that year, a further contract,
also analysed by Prof. Boni, specifies that this is the
painting which Miser Marin desires to have done by Maistro
Zuan di franza (John of France), painter, on the façade of
his house at S. Sofia. All the balls of the parapet decora-
tions were to be gilded, the foliage of the two large corner
capitals bearing the lions, was to be gilded and the plain
fields of the capitals were to be coloured with fine ultra-
marine blue. The lions resting on the capitals were to be
gilded; the escutcheons held in their paws to be coloured
with fine ultramarine, and the abacus whereon the said lions
rested was to be gilded in front, and its soffit coloured with
fine ultramarine fretted with stars of gold; of the moulding

[1] We retain the quaint variable spelling.

E

so much only was to be gilded as surrounded the capitals.
The disks or rope mouldings that framed the circular slabs
of porphyry and verde antico, together with the balls of
stone riveted in their centres were to be gilded; also the
foliated finials of the window traceries were to be gilded.
The great escutcheon with its dentils and foliage was to be
gilded, and the bands were to be well painted with two coats
(*ben dopiado*) of fine ultramarine so as to show well, and
there the gilder's work was to end. The arms of the
Contarini were three azure bands on a gold field, and
were obviously intended to stand out boldly from the
façade.

Then follow some precise directions for the employment
of supplementary fakes, familiar enough among modern
restorers, but rather disquieting to the Ruskinian reader
when discovered in full practice during the palmy days of
Gothic architecture. All the crowning cornice was to be
gone over with white lead and oil, the pinnacles were to be
veined to make them look like marble and touched up with
black oil paint about their edges if it seemed proper. The
fields of the cusps of the *archetti* beneath the cornice were
to be touched up with black (the cusps in the windows
below are pierced and inasmuch as they were only lightly
incised in the cornice, by blacking the field they were made
to appear as if pierced). All the red stone was to be
anointed with oil and varnish and smeared with red paint to
heighten its colour. All the rose and vine decoration of the
said façade was to be painted with white lead and oil, and
black oil colour (the vertical bands of Byzantine carvings
are here meant). Lastly, there was to be a tarring (*impeccia-
tura*) with black oil colour, of the background of the cornice
foliage of the sea story, with its return on the flanks, and
the four sills in the *calli*.

Zuan di Franza, too, seems to have been unable to write,
for the subscription states that *Mi Franzesco*, son of the said
Maistro Zuan di Franza, have written out the contract at

my father's request, who is to have sixty gold ducats for the work, and agrees to employ the finest ultramarine (it was made of pounded lapis lazuli) at the price of eighteen gold ducats the pound. From a subsequent memorandum, it would appear that Contarini found the gold leaf, for we learn that Miser Marin paid to Maistro Antonio di Bartolomeo one gold ducat for 100 large gold leaves. The painting of the interior was entrusted in 1432 to Master Nicolo di Zuan da S. Sofia and Master Girardo da S. Luca, local artists, and Master Vasco, the Spaniard. Nicolo Romanello, the mason, was again working from 1436 to 1440, and in 1437 another Lombard master, Maistro Piero of Milan was assisting. Heavy expenses for larch timber were incurred by the master carpenter, Zuan Rosso. That the actual result of all this collective work by Lombard, Comacine, Tuscan and native craftsmen was so admirable, is doubtless not a little due to the artistic taste and sagacity of the magnanimous and wealthy patrician who presided over the whole, and who succeeded in driving so various a team of artists.

The gorgeous home that Miser Marin built for himself was enjoyed by his descendants for but few generations. In 1484, the resplendent edifice passed into the possession of Pietro Marcello, subsequently known as Peter of the golden house, as the dowry of his wife who was a Contarini ; in 1620, Elizabetta Marcello married a Loredan and that famous family became co-proprietors of the house ; towards the end of the century it passed into the possession of the Bressa family, and in 1780-1784 a school of dramatic art was founded there. In 1847, it fell—a sad declension—into the hands of Mlle. Taglioni, the famous ballet dancer, for whom it was structurally debased and altered ; the fine old well-head, attributed to Bartolomeo Bon, was sold, the single-light sea-story windows to the right of the arcade were changed to two-light windows and an ugly balcony was added. Ruskin relates in the Venetian Index that when

last in Venice he saw the beautiful slabs of red marble which formed the bases of its balconies, and were carved into noble spiral mouldings of strange sections half-a-foot deep, dashed into pieces; its glorious internal staircase, by far the most interesting Gothic monument of its kind in Venice, had been carried away piece by piece and sold for waste marble two years before.

The Contarini, who rivalled the Giustiniani in the nobility of their lineage, their numbers, their historical prestige and fabulous wealth, were the first and most important of the apostolic families: they gave eight Doges to the Republic, among them the heroic defender of Venice during the supreme struggle with Genoa; they furnished forty-eight Procurators, owned palaces in every part of the city and only became extinct in this twentieth century. The last of his race, a mysterious and pathetic figure, living in obscure lodgings, and retaining all the charming politeness and dignity and grace of the old Venetian patrician, was a familiar sight in the city and might often be seen using the Canal steamers. His invariable phrase—*tutta Venezia è la mia casa*, uttered with exquisite courtesy, is recalled by his acquaintances.

It is, however, but a pallid phantom of all this magnificence that now rises before us on the Grand Canal. The cusped arcades under the cornice had disappeared in 1887 when Boni took the photograph that illustrated his paper read before the Institute of British Architects, although it still existed in the mezzotint engraving of 1800 also reproduced in the published Proceedings: since that time, as we see, the cornice has been restored. But a careful examination by Professor Boni has clearly established the fact that the crowning parapet now standing, is the original one erected by the Boni bearing still the marks and initials of the old Gothic masons. Reverti's tracery of the *piano nobile* remains; the red cornice is there, dimmed by time; the disks of coloured marble may still be seen on either side of

the foliated finials of the single-light windows of the first and second floors; the four lions' heads, carved by Nicolo Romanello, support the sills of the lower one-light window to the right; the great shield or escutcheon is now plain; the triple and elaborately carved and chevroned angle mouldings or shafts, which Street declares to be unique in architectural decoration, remain, as well as the vertical bands of Byzantine vine and flower tracery and the coloured marble encrustations of the façade. But all are stripped of their glittering vesture of azure and gold which made the whole façade once resemble a beautiful carved and coloured diptych and must have impressed the contemporary traveller as an enchanted vision: the incredible richness of the decorations and mouldings can now be but faintly imagined.

At a first glance the general design of the house appears asymmetrical, and authorities differ as to whether a left wing was intended to be added to balance the right wing. This, however, can hardly have been the case, for the whole space between the two *calli* which in old times bounded the site was utilised by the builders, and the angle shafts or mouldings to the left are designed and executed with a finished art equal to those of the right angle. More careful observation will incline us to believe that the designers (who evidently set themselves to lavish on the structure all the wealth of invention and originality of design they could command) regarded the façade as a double one, each part of which was treated as a central composition, the vertical bands of old Byzantine carvings forming the dividing lines between the parts, and the whole being knit together by the angle shafts and the elaborate continuous cornice and parapet. An obvious departure from the typical Gothic palace and reversion to Byzantine and Romanesque models is—besides the vertical band already referred to—the rounded archivolt and wider span of the central arch of the sea-story which instead of being entered by a door or doors has an arcaded

recessed portico. Since the palace has come into the possession of Baron Giorgio Franchetti, its enlightened owner has cleared away the unsightly balcony to the right hand of the sea-story, admirably restored the original single-light windows, and brought back and replaced the original well-head sold by Mlle. Taglioni.

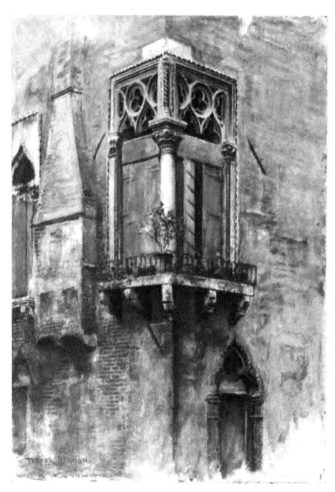

PALAZZO PRIULI ANGLE WINDOW,

CHAPTER VI

The Gothic Palaces di quà dal Canale [1]—The Palazzi dell'
Angelo, Priuli—The Arco detto Bon—The Palazzi Badoer,
Morosini, Loredan—The Virgin of the Amadi—The
Palazzo Sanudo van Axel

" Stop rowing ! This one of our bye canals
O'er a certain bridge you have to cross
That's named " Of the Angel "; listen why !
The name " Of the Devil " too much appals
Venetian acquaintance, so—his the loss,
While the gain goes . . . look on high !

An angel visibly guards yon house :
Above each scutcheon—a pair—stands he,
Enfolds them with droop of either wing :
The family's fortune were perilous
Did he thence depart—you will soon agree,
If I hitch into verse the thing."

—Browning.

WE may now opportunely set forth on foot to visit some of
the Gothic mansions scattered about the *Sestieri* of the city.
Starting from the north side of S. Mark's at the Piazzetta
dei Leoni and passing along the Calle di Canonica, we soon
find on our left the Ramo di Canonica, which will lead us
direct to the Ponte dell' Angelo : facing us stands the
picturesque little Palazzo dell' Angelo, of small import
perhaps architecturally, but of profound and melancholy
interest to the reader of English from its association with
the poet Browning, who, in well-nigh the last poem he
wrote, set to verse of unabated energy and humour the
story of the relief sculptured on its façade. The volume
"Asolando," which contains among "Fancies and Facts"

[1] The old Venetians divided the city primarily into two divisions separated
by the Grand Canal—*di quà dal Canale* the S. Mark's side, and *di là dal
Canale* the Rialto side.

the poem entitled "Ponte dell' Angelo," was brought to the stricken poet on the very eve, and was published on the very day, of his death. It is founded on a favourite legend of the Venetians derived from Alfonso de Liguori's "Glories of Mary," and retold by Friar Boverio of the Cappuccini, to the honour of the founder of his order, the saintly Mathew of Bascio. A certain lawyer of great devotion to the Blessed Virgin, but of a soul polluted by dishonest gains, who lived in the palace, invited Friar Mathew to break bread with him, and before sitting down to the repast informed his guest in confidence that all his domestic service was admirably performed by a marvellous ape. Now by grace divine the friar was warned that this ape-like form disguised a wicked devil, whom he at once conjured to come from his trembling concealment under a bed and declare for what evil end he had entered the house. The ape straightway confessed that he was in very sooth the arch enemy of souls, and was there to watch an opportunity of bearing the lawyer away to eternal perdition. "Why then," demanded the friar, "O familiar spirit, has thou not ere this, slain and borne him forth to hell?" "Because," answered the ape, "before he lies down to sleep at night he ever calls on the name of the Blessed Mary: if he but once forgot to utter her name he is mine. As yet I have watched in vain." Hearing this, Friar Mathew commanded him to depart from the house, but the recalcitrant fiend stood immoveable, and declared it was permitted him not to issue forth without wreaking some hurt on the house. Pondering an instant the saintly friar forbade him to do other damage than to breach the wall: whereupon

> "'Here goes'! cried the goblin, as all—
> Wide bat-wings spread, arms and legs, tail out a-stream,
> Crash, obstacles went, right and left, as he soared
> Or else sank; was clean gone through hole any how."

The friar descended to his place at table with his host, and seizing a corner of the tablecloth wrung it in his hands:

streams of blood gushed miraculously forth, and he warned
the affrighted lawyer that the blood wrung from the poor
was gurgling accusation against him, and bade him to his
knees to implore forgiveness for his heartless extortions.
The penitent sinner, with tears in his eyes, thanked his soul's
preserver, but expressed his fear lest the gaping hole in the
wall might afford an easy return to the fierce demon foiled
of his prey. The saint advised him to baulk his entrance
by placing over the rent an angelic image, since evil spirits
infallibly fled at the sight of holy angels. And there stands
the image to this day under a small tabernacle of marble,
with outspread wings, the right hand raised in the act of
blessing, the left holding a globe surmounted by a cross.
Below are two shields. The style of the sculpture, and the
fact that the papal bull constituting the order, with Matteo
da Bascio as its first superior, is dated as late as 1528, will
enable the judicious observer to form his own conclusion
as to the *post factum* origin of the pious legend. The
scutcheons [1] bear the arms of the Soranzi, and shadowy
remains of the façade frescoed by Tintoretto may be detected
to the right of the palace. The Venetian love for a good
story is also evinced by the tradition that the magnificent
and superb artist, on hearing that his rivals had said he
would need to use both feet and hands to complete the
work to contract, and who, according to Vasari, was *nelle
cose di pittura stravagante e capriccioso*, set resolutely to
work, figured a mass of feet and hands grasping and sus-
taining the cornice, and, all being finished to time, made a
jest of his envious critics.

Returning to the Calle di Canonica and continuing our

[1] We cannot too strongly impress on the wayfarer in Venice the import-
ance of looking for the reliefs, in stone, of all periods from the Byzantine
downwards which are embedded in the street architecture. C. A. Levi has
catalogued no less than 287 pieces in the Sestiero of S. Marco; 295 in
Sestiero Castello; 295 in Cannaregio; 246 in S. Polo; 344 in Dorsoduro;
74 in Sta. Croce; and in the Island of the Giudecca, 25—in all, 1566.
Le Collezione Veneziane, C. A. Levi. 1900.

eastward way we cross the Ponte di Canonica and fare over
the Ponte S. Provolo, to the Campo of the same name ; a
turn to the left by the Calle S. Provolo will bring us to the
Fondamenta dell' Osmarin and the principal façade of the
stately Palazzo Priuli, dating back to the best period of
Gothic architecture and occupying a unique position at the
corner of a rio, thus permitting the four sides of the edifice,
two on sea and two on land, to be seen. The lower arcade
before us consists of four early fourth order windows, of
which one is loftier than the others: the upper, of four
lovely fifth order windows, with the original delicately carved
balusters and parapets between the shafts. Single-light
windows at either side have the usual projecting balconies
(restored) ; the rich veneer of fine marble in which the
windows are cut is adorned with medallions and discs of
porphyry in the spandrils of the arches. Ruskin calls
attention to the penetration of the cusps of these windows,
which in earlier examples are solid, as evidence of the late
period of the construction. The whole forms one of the most
precious relics of past magnificence in Venice. The angles
of the rio façade are also remarkable by reason of their
curious and daring windows, which Ruskin believes to be
of a comparatively later date, whose isolated shafts boldly
support the upper fabric. The window to the left is more
elaborately decorated with cable mouldings and quatrefoil
traceries, the whole being framed in the universal and
characteristic Venetian dentil moulding.

Crossing the Ponte del Diavolo, and observing the relief
of St Lawrence to our right, we pass the lateral doorway of
the palace and emerge on the Campo and Fondamenta S.
Severo, on which the main land-portal opens. This handsome
entrance, grievously debased even in Ruskin's days, is still of
noble aspect; traces of the winged lions remain in the
spandrils, and the windows and medallions above are
strikingly beautiful. The Priuli, who also possessed a
magnificent palace at the foot of the Ponte Priuli, unhappily

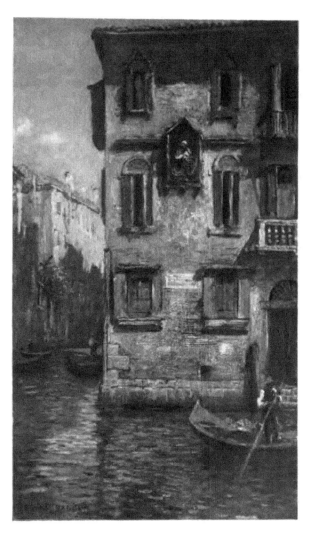

PALAZZO DELL' ANGELO.

destroyed by fire in 1749, were of noble Hungarian lineage, and, as has befallen many another stranger, coming for temporary purposes, were seduced by the rare beauty and delightful climate of the Queen of the Lagoons to fix their permanent abode within her sea-girt fold. Admitted to the Great Council in 1100, excluded in 1297, they were readmitted in 1310 for their services to the State during the Bajamonte conspiracy. The Republic owed them three doges, a goodly array of stout and victorious captains during her long struggles with the Turks, and innumerable public servants. Four cardinals' hats were bestowed by the Church on their family.

There are few finer architectural prospects in Venice than the line of palaces that stretches along the rio opposite the Fondamenta whereon we now stand, from the ample renaissance Palazzo Zorzi (Giorgio) of the Lombardi period to the massive and imposing late renaissance portal of the Palazzo Grimani at the further end, to both of which we shall return in our later journeyings. The restored Gothic palace contiguous to the Lombardi palace was also a Palazzo Zorzi, and is probably that referred to by Ruskin as one of the most interesting examples of transitional Gothic in Venice, and unique for the magnificence of its veined purple alabaster and manly simplicity of its capitals. It is stated in the "Stones" to be behind the renaissance Palazzo Zorzi.

We cross the rio by the Ponte Nuovo, continue to the Ruga Giuffa, and turning left, reach the tall, gabled entrance to the Calle dell' Arco detto Bon, at the back of the Gothic Pal. Zorzi, bearing the scutcheon of the Zorzi family, such arches being often constructed to indicate that the houses on either side belonged to the same owner; the name in this instance arises from the fact that a certain tenant of the Zorzi, named Bon, lived there in the early eighteenth century. At the end of the Calle is a most precious and lovely fragment of Gothic architecture, the upper portion of a small two-light window of the third order, above which is a square later window divided by a stout column, the whole being

unique in its fair setting and exquisite details; the remains
of the wall-veil decoration of diamond-shaped red and white
marble at the sides of the upper window are especially worthy
of notice. We may now retrace our steps to the Fondamenta
dell' Osmarin, and pursue our way eastward as far as the
Ponte dei Greci, to the left of which is a Gothic edifice,
whose façade over the Rio S. Lorenzo, smothered with red
wash, has a main group of sixth order windows.

Crossing the Ponte dei Greci, we may pause to compare
the architecture to the left along the Rio S. Lorenzo
with its representation in Gentile Bellini's picture of the
Miracle of the Holy Cross, referred to later,[1] and pro-
ceed eastward by the Calle della Madonna to the Salizzada
dei Greci and the Ponte S. Antonin. This we cross, and at
the end of the Salizzada S. Antonin turn to the right by the
Campo Bandiera e Moro and the Calle del Dose, and reach
the Riva degli Schiavoni and the Piazzetta. As we traverse
the Campo Bandiera, we may turn to examine the once
magnificent, but now restored and devastated, Palazzo Badoer.
When Ruskin admired it, and drew a portion of its richly
carved, inlaid and coloured façade, it was one of the most
perfect of the Gothic palaces anterior in date to the Ducal
Palace.

Again we set forth from the Piazza: passing along the
Merceria we turn right by the Ramo S. Zulian and proceed
by the Campo della Guerra, behind the church, and over the
Ponte of the same name direct to the Campo S. M. Formosa.
Traversing the Campo we follow the Calle Lunga,[2] opposite,
to its end, turn left by the Fondamenta Tetta, cross the
Ponte and enter the Calle Tetta which leads to the Ponte
and Calle Ospedaletto.[3] Before crossing this latter bridge
we turn to the right at its foot, and a few yards along the
Fondamenta cross a small bridge which gives access over the
rio to the Pal. Morosini (no. 6596) containing in a beauti-

[1] See p. 277. [2] See note to p. 23. [3] See p. 148 note.

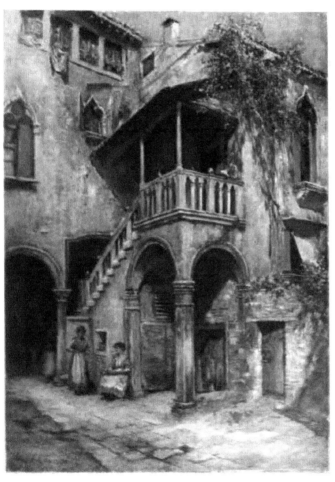

STAIRCASE PALAZZO LOREDAN.

ful *cortile*[1] a noble Gothic external stairway now unhappily disfigured by a superposed wooden roof. We cross the Ponte Ospedaletto, turn left by the Salizzada and emerge on the Campo S. Zanipolo. Opposite the west front of the great Dominican church is the Ponte del Cavallo which we cross: the first on our right in the Calle Larga Giacinto Gallina, is the Calle della Testa. Entering the doorway of no. 6359, the Palazzo Loredan, we shall find in a picturesque *cortile* another external Gothic staircase, unrestored, and one of the best preserved in Venice. We return to the Calle Larga Giacinto Gallina and continue our way (from a second bridge we obtain a view to the right, of the late renaissance Pal. Widman) to the Ponte S. Maria Nuova which we cross and pass direct to Calle Castelli, to right of which is the charming Gothic portal with saracenic battlements which gives access to the Corte delle Muneghe[2]: the arms of the Amadi (a bird on three hills) are seen in the tympanum of the portal. Entering the cortile we note the fine capital, also carved with the Amadi arms, supporting a decorated beam; a magnificent well-head which stood here was sold in 1885. The whole aspect of this little nook of old Venice is most delightfully picturesque. Many branches of the Amadi (originally of Bavarian origin) came at various periods to seek fortune in Venice and wrote their names honorably in the annals of the Republic.

During the late fifteenth century one of those popular and local outbursts of devotion to the Virgin, with which the history of Christian Europe is filled, took place near this very house of the Amadi. A distinguished member of the Sta. Marina branch of the family, Francesco Amadi, who was a great devotee of the Madonna, had a painting of her executed by a famous artist of his day, which was placed in a taber-

[1] The traveller who rings at any portal that may be closed and courteously entreats permission to enter will rarely be refused.

[2] *Muneghe* is Venetian for *Monache* and always recalls the localities of old nunneries.

nacle at the corner of a street near his house and which in time became known for its miraculous powers. In a memoir of his grandfather, Francesco, written by Angelo Amadi, which has come down to us, partly in the original MS. and partly in a printed version quoted by Paoletti, we are able to be present at the development of this characteristic phase of old Venetian piety and religious enthusiasm, and learn more of the intimate life of the citizens of Venice than any formal history could afford. The story is told with the most ingenuous simplicity and demonstrates how spontaneous were the expressions of popular religious feeling which moderns are pleased to regard as mere superstition engendered by calculating priestcraft. "In 1408," says Angelo, "my grandfather, Francesco degli Amadi, had a little shrine painted with the effigy of Our Lady with her Child and with St James the apostle and St Anthony at the sides, and caused it to be placed, according to our Venetian fashion,[1] at the corner of a house very near to his own, and it was painted by Master Nicolo,[2] the painter who was very famous in that day." And there the little shrine remained for some time and no miracles were associated with it.

At length, in 1480, some vows were answered and in gratitude Messer Marco de Pasti, who lighted the lamps, placed wax candles there and, especially on Saturday, adorned it with flowers and greenery. Soon its fame grew and from the remotest corners of the city those who were sick in body or soul, or in pain and tribulation, came to make their vows and pray for help from the mother of God, whose tender eyes and compassionate countenance seemed to look down on

[1] The *Cesendoli* or little shrines of the Virgin decked with flowers, before which burned a lamp to light the wayfarers in the tortuous calli and to assist the watchmen to keep order in the city by night. They were erected and tended by the piety of Venetian citizens.

[2] The artist is believed to have been the same who painted a Virgin and Child and donor, no. 19 in the Accademia, which bears a Latin inscription stating that it was painted by Nicholas, son of Master Petro, the painter, who lived at Venice at the head of the Ponte Paradiso.

ENTRANCE TO CORTILE OF THE CA' AMADI.

them from this corner of the Corte Nuova, as the Corte by
the house of the Amadi was then called. So great was the
crowd of devotees that the narrow calle became impassable
and the Amadi were forced to build two bridges: one
towards S. M. Nuova: one towards Sta. Marina. Now
Lodovico Barozzi, owner of the house where it stood,
determined to remove it to the church of S. Moisè. "And
I, Angelo," says the writer of the memoirs, "one night in
August 1480, about the fifth hour, took the aforesaid shrine
home which was painted with our Lady and her Child by
Master Nicholas, and I had a sort of altar made of wood,
covered with tapestry and adorned with much verdure, such
as laurel, cypress, juniper, ivy and other worthy foliage, and I
placed it in the cortile of our house in the parish of Sta.
Marina, Virgin of Greece. Now the aforesaid altar was
alongside our well or cistern as you enter the main portal
and at the left of the cistern.[1] On Septemper 6, 1480,
Lodovico Barozzi formally claimed possession of the Virgin
and the suit came before the Doge, whereupon Barozzi
"said many and conclusive things and said the image was
his and he, Barozzi, was elegantly answered by me, Angelo,
and proved to be in great error, for by the memory and at
the advice of my most revered nurse and mother who was then
of the age of 96, I, seeking, did find a certain book of writings
concerning the expenses when my grandfather bought these
our houses, in the which book was written: In the name
of God, amen. The 26th day of January 1408. Table of
the expenses for the houses at Sta. Marina. And among
these payments: I maestri Intagliatori e Dipintori de' Santi
for an ancona to be painted by Master Nicolas for the street
corner, lire 14.15." Barozzi lost his case, and so increasingly
famous did the Virgin of the Amadi become, so many prayers
were answered by her intercession, that by the advice of the
parish priest of Sta. Marina, and with the approval of the
Patriarch, who had his own axe to grind, the Amadi and

[1] This was the well-head sold in 1885 in spite of protest.

their neighbours, with the help of the offerings of the faithful, decided to erect a temple and to found a nunnery in her honour.

It was the time when the perennial controversy as to the Immaculate Conception was raging and had attained such bitterness that Sixtus IV. was constrained to impose on both defenders and opposers the obligation of mutual charity and toleration. The Patriarch was a staunch defender of the dogma and used the popular enthusiasm for his own purposes. Four houses were bought for 700 duca s, and early in 1481 the first stone of the rich and lovely little church, now known as Our Lady of the Miracles, was laid, and dedicated to our Lady of the Immaculate Conception; but to the common people it still is and ever was known as Our Lady of the Miracles. "On February 25, 1481," writes Angelo, "in the name of Meser Gesu Cristo and of the glorious Virgin Mary they bore away the glorious image and placed it in the *Tugurio* or house of wood (a temporary wooden oratory) where the new church is to be built; at which translation all the Guilds were present and the Fraternity of the Flagellants: to wit, the Scuola of Madonna Sta. Maria of the Misericordia in which I am, the Scuola of the Carità, the Scuola of S. Marco, the Scuola of S. Giovanni Evangelista, and that of S. Rocco, which has newly been founded, and whose brothers are clothed in sackcloth, ever beating themselves with disciplines and iron chains. And all the procurators of the said Church were there, together with an infinite number of knights and doctors and a large part of the most illustrious Seigniory of Venice; and there, too, was the most reverend Monsignor Maffeo Gerardo, the Patriarch, clothed in pontificals, with the bishops and all the canons and chaplains, and there was our parish priest and many other priests and clerks all decked with worthy adornments of great price. And for the said image we had made a tabernacle of wood all covered with crimson cloth of gold and cloth of silver, and a candelabrum of silver and

certain oriental profumigations. And it was carried under
an umbrella of crimson and cloth of gold, and was borne by
the men of the Amadi, who were called to that office for
the honour of their posterity. And we, Alvise and I,
walked under the umbrella with the tabernacle on our
shoulders as our own thing, desiring to carry it as the men
of Constantinople did that most devout and prodigious
image called the Panora; and all we clothed in purple and
scarlet, in Syrian fashion, with our children, Geronimo the son
of Alvise, and Lelio son of me, Angelo, did carry the same
image, nor would we that any other should carry it, for
public demonstration that it was our very own and by our
ancestor made. Now to sustain that tabernacle and its
worthy pomp, four honorable citizens were near us with
certain wooden supports in their hands to bear up the said
tabernacle when we crossed the bridges, or when we rested
in the streets. And Monsignore the Patriarch followed with
his cross and mitre and staff, and the Canons and the
Seigniory and the priests and all the people of Venice. And
we issued forth from our house with trumpets and fifes, and
the procession reached to the bridge of Sta. Marina; and
this church we entered and many lauds were sung. Coming
out from the main portal, we walked round the Campo
towards the Ca' Marcello, and along the Calle called Para-
diso,[1] and the Salizzada of the Caselleria and over the stone
bridge of Sta. Maria Formosa; and know that ever as we
went through the streets and around the campi of the
churches, all people did kneel devoutly on the ground,
uttering most loud exclamations and cries, and with many
tears, and with hands crossed on their breasts asked mercy
of God. Thus faring in like manner with chaunts and
praises, we passed along the Calle Lunga di S. M. Formosa
and over by the Salizzada and Campo of SS. Giovanni
e Paolo, and by the stone bridge and the little Calle di Ca'
Diedo to the Ponte di Sta. Maria Nuova, and by the Ca'

[1] With few exceptions all these place names remain.

F

Loredan, where is the portico with columns; going around
the church of S. Canciano by the little Calle di Ca' Rimondo
and the bridge, we went towards our house, and to the place
prepared for the said miraculous image; and since the place
was not large enough for all the great company, guards and
captains were set about lest scandal should arise because of
the great multitude of people. And then Monsignore
blessed the place and marked it with holy cross, laying the
first stone with his own hand, we all standing around him
with the holy image, towards the altar, ever singing lauds in
praise of the Virgin. Then with a loud voice all the clergy
sang *Te Deum laudamus*, and we all departed, leaving the
image over the altar in sight and liberty of all the people, who,
through devotion to it, all day did place alms in the chests
for the building of the church. And so they remained till
late evening which, being come, this image was placed within
a grille of iron, all gilded, with many silver offerings which
had been given."

Models of the new church had been made, and on
March 4, 1481, "we, Alvise and Angelo, with the magni-
ficent Messer Francesco Diedo, the Doctor, Messer Fran-
cesco Zen, in whose house the model was, and Messer
Mario Soranzo, concluded a bargain in the name of God and
of the Glorious Virgin Mary with Maistro Pietro Lombardo,
who had made the tomb of Messer Pietro Mocenigo, Prince
of Venice; and on May 2, 1481, I had a large bronze medal
placed on the first pilaster to the left with the image of me,
Angelo Amadi, carved in relief from the life with ancient
lettering around to this tenour, ANGELVS DE AMATIS; and on
the obverse, a festa or garland of wheat ears within which
are the Arms of the Amadi." The origin of this design,
Angelo tells us, was, that "in the spring of 1480 just over
the great portal of our Corte di Ca' di Amadi, and under our
scutcheon there germinated a grain of wheat which ripened
into two ears of corn even as if they had grown in a fertile
field, which ears I did gather and preserve in memory and in

PALAZZO SANUDO VAN AXEL LAND PORTAL.

good augury of our house." The contract specified that all
the church was to be lined (*fodrata*) outside with marbles
from basement to cornice, to wit, tablets of marbles of Pisa
from the place called Carrara where the most beautiful are
found, which are to be veined and fair; or Greek marbles
fair and veined, and all bonded with stone of Verona, black
and red, of the best that can be found. Master Pietro and
his masons wrought faithfully and well. All men praised
him, the nobility came to venerate and admire, and the
annalist, Malipiero, who was a contemporary witness of the
scene, notes that the *grandissime* offerings of money and
silver and statues and wax amounted to 400 ducats a month,
and in process of time to a sum of 30,000 ducats.

Public opinion seems to have been too much for Barozzi:
he sold his houses, which before he had obstinately refused
to part with, and the erection of the nunnery was rapidly
pushed forward. On December 30, 1489, with the approval
of the Patriarch, the wonder-working picture was taken from
the temporary wooden oratory by night and placed on the
high altar of the new church, and on December 31, the
Procurators of the new foundation (among whom was
Leonardo Loredan), two hours before dawn, were in the new
Convent awaiting the Patriarch and the *donne muneghe* from
Sta. Chiara at Murano, who had been selected to take charge of
the new house. They were twelve, being the number of the
apostles, and Mother Margarita, the oldest and most experi-
enced, was chosen first abbess. Gondolas had been sent to
fetch them, and at six o'clock of that dark, chill December
morning, they disembarked and the Procurators went forward
to meet them. They came bare-foot, clothed with coarse
hooded cloaks, and large black veils covered them from head
to foot. At once they passed to the Altar of the Chapter
and knelt in prayer. And there was St Francis on one side
and St Clare on the other. Seats were placed for the
Patriarch and his clergy: benches for the sisters. At dawn
the Patriarch arrived, blessed the church, prayed before the

image, and passed to the Convent, the sisters still kneeling, six at either side of the altar. Having read the papal bull, invested the abbess, and handed her the keys, he departed.

This is the story of the miraculous madonna of Ca' Amadi and of the origin of the little church of the Miracoli, which although much restored and with inferior marbles, yet remains one of the loveliest productions of early Renaissance architecture in Venice. Nothing could more vividly convey to a modern reader the naïve piety, combined with gorgeous and magnificent display, of these old Venetian days. Pietro, says the chronicler, was praised by all for his diligence and eager industry, ever seeking the fairest stones and sparing no cost to make the building more and more remarkable. Some fair marbles destined to adorn the church of our Lady of the Miracles brought ill-hap to two Genoese mariners, for on April 17, 1487 the Venetian Captain-General caught Antonio Tortorini and Felipo dalle Palme, ship-masters, and hanged them, for having, among other piracies, seized a cargo of marbles from Pisa on their way to Venice to be used at Sta. Maria dei Miracoli. The faded, worm-eaten and forgotten old picture that evoked this sumptuous casket for its preservation is now in the church of S. Canciano.[1]

Quitting the Corte delle Muneghe let us pursue our way by the Calle Castelli to the Fondamenta Sanudo, to the left of which is the old land portal of the Palazzo Sanudo van Axel. This finely decorated door, with its wooden valve, is unique in Venice, and gives on to a spacious cortile which contains a superb external Gothic staircase admirably preserved. It will be noted that here, as in the Loredan stairway, the small columns which support the sloping parapet are without capitals or arcading, due, Ruskin says, to the Venetian mason's horror of arches not on a level; indeed so clearly is this the case that in every Gothic external staircase we know in Venice, as soon as the landings are reached and the parapet

[1] See Boni's article in the "Archivio Veneto," vol. xxxiii. p. 244, which includes a photograph of the picture and of Angelo's medal.

becomes level, the trefoil arcading is introduced: the piers which relieve the arches at regular intervals are surmounted by heads. In this same cortile are two Byzantine cornices and some characteristic marble decorations, incorporated in the walls, carved in relief with lions attacking stags, and other favourite Byzantine and Romanesque motives such as are found in the façade of St Mark's. This noble palace has two façades, which will be best observed from a gondola.

We may now retrace our steps along the Fondamenta, pass direct to the Ponte del Cristo, noting as we cross many fine patrician mansions of various epochs to right and left, and proceed by the Campo Sta. Marina, the Calle Marcello o Pindemonte, and the Ponte Borgoloco to the Campo Sta. Maria Formosa.

CHAPTER VII

The Gothic Palaces di quà continued—The Palazzo Orfei—The Ca' Satori—LaVecchia di S. Luca—The Palazzi Bragadin and Falier

> " I said that like a picture by Giorgione
> Venetian women were, and so they *are,*
> Particularly seen from a balcony,
> For beauty's sometimes best set off afar."
>
> —*Byron.*

BOARDING the *Vaporetto* at any convenient station, we will disembark at the S. Angelo pier, pass direct before us, turn left by the Ramo Corte dell' Albero, cross the Ponte dell' Albero and, yet further, the Ponte Michiel, which will bring us to the Campo S. Benedetto. On our right rises the superb late Gothic Palazzo Orfei, fronting the Campo. Happily this noble house, standing somewhat remote from the main arteries of the city, has suffered less from the deforming hand of man than from temporal decay. The neglected building, though late and almost transitional in style, has a peculiarly virile character, and is one of the most satisfying remains of domestic architecture in Venice. The decorative details, no less than the impression of the whole design, are, in their diversity and richness, worthy of careful study. The low balcony between the shafts of the piano nobile is undoubtedly original, and the exquisite low reliefs with their delicate carving that adorn the parapet, are unsurpassed in Venice, and are believed by Paoletti, together with some of the smaller columns and pilasters and all the parapets of the projecting balconies, to have been executed by Renaissance artists of the late fifteenth century.

PALAZZO ORFEI

BALCONY—PAL. ORFEI

The present appellation of the Palace is a comparatively recent one, derived from a musical society known as the Accademia d' Orfeo, which in September 1786 gave its opening performance in this *vasto Palazzo*, which was furnished with singular elegance: the piece performed was "Deucalione e Pirro," a poetical composition, set to music by the choirmaster of St Mark's. The Palace, which formerly belonged to the Pesaro family, was traditionally celebrated for its sumptuous festivals, and in February 1514, the famous Guild of the Calza performed the *Miles Gloriosus* of Plautus, with comic interludes, to a distinguished company in the cortile, which was splendidly adorned and ceiled. The play lasted late in the evening, and, after a sumptuous supper, dancing was kept up till the morning. Other and similar festivals are noted by Sanudo in his diary. The ground floor of this lordly edifice is now occupied by a hide factor.

We cross the Campo diagonally to the Salizzada del Teatro, and on our left pass along the Calle Andrea, turn an angle by the Rossini Theatre, and cross a bridge to the Church of S. Luca.[1] Continuing to right of the church by the Ramo a Fianco la Chiesa to the Campiello S. Luca, at No. 4038, the Casa Satori, is an ancient and lovely steep-gabled portal of terra-cotta with exquisite mouldings and designs. No more striking evidence of the decorative possibilities attending the use of brickwork in architecture can be found in Venice. It has been carefully drawn by Ruskin in the "Examples of the Architecture of Venice," and is here reproduced. This remarkable and priceless relic of early Gothic times was the entrance to a courtyard. The stone carvings have been effaced, but the brickwork is unchanged, and its composition has been carefully analysed by Ruskin:

[1] To the left of the bridge, along the Fondamenta, is the entrance to the cortile of the Palazzo Grimani: a fine view of the Terraced House (p. 22) may be enjoyed from the steps in front of the palace, and an equally fine view of the Palazzo Contarini at S. Luca from a window on the first landing of the staircase leading to the first floor (p. 145).

There are five kinds of bricks, all in regular lengths of about 10 inches. The first kind is quite plain, but straight or curved, according to the requirements of the design; another has a pattern of raised triangles; another of raised squares and circles alternating; another of a chain of small squares; and another of little oblique rhombs. The sloping courses of brick are gradually set at a less and less angle, so that the whole radiates, like branches of a fir-tree, becoming less and less inclined as the ground is neared. Other relics of Gothic times may be observed in this little campo; to the right, over a group of third and fourth order windows, is a charming relief in marble enclosing the symbol I. H. S., and yet higher a fine Gothic cornice.

Traversing the Campiello in its length and turning to the Salizzada S. Luca on our right, we pursue our way to the Campo S. Luca, in the midst of which stands a marble pedestal whence, on festas, in republican days, a flag-staff was raised, and a standard of S. Mark used to flutter in the breeze in memory of the signal defeat inflicted on the Quirini contingent of the Bajamonte conspirators by the members of the Guilds of the Carità and of the Painters in 1310.[1] The monogram of the Carità, a cross enclosed in circles, may still be observed on the pedestal. On the left of the Campo, the very narrow Calle del Teatro will bring us to the Corte del Teatro with some most picturesque bits of old Venice; and, against the wall of the corte on our right as we enter is placed, among other reliefs, a curious, weather-worn, female head known as La Vecchia, which is said by Venetians to be the upper part of a relief of an old woman at her spinning-wheel. Whether the spinning-wheel ever existed or not, certain it is that Venetian imagination has spun the following story relating thereto: A miserly old woman, who, in days long past, was living in the parish of S. Paterniano, was wont to conceal the proceeds of her labour in the lining of an old cloak, which she placed in a

[1] See "Venice," Mediæval Town Series, p. 131.

DOORWAY—CAMPIELLO DELLA CHIESA, S. LUCA

recess of the roof of her house. One cold winter's day her scapegrace son, Vicenzio Quadrio, who was no less tender-hearted than dissolute, being moved by the sight of a half-naked beggar in the street, resolved to give him the ragged old cloak he had noticed stowed away in the roof; he drew it from its place and bestowed it on the poor, shivering wretch. It was not long ere the mother, desiring to add to her hoard, became terror-stricken to find it had vanished, and learned from her ne'er-do-weel son what had happened. Telling him the gold was destined for him at her death, the couple sought for the beggar all over Venice, but in vain. At length Vicenzio resolved to disguise himself as a poor idiot, and take his station at the foot of the Rialto bridge, slowly turning a spindle, while crooning a pitiful ballad and asking alms. Scrutinising every figure in the crowds that passed, his eyes at last were gladdened by the sight of the beggar wearing the worn-out cloak, whom he accosted ; and, feigning fraternal anxiety that the poor creature should be so ill clad in the hard wintry weather, offered to exchange his own warm cloak for the beggar's rags. : The needy wretch, no less amazed than grateful at the generosity of the fool, accepted the proffered garment, and, divesting himself of his old cloak, thanked his benefactor, and with many benedictions went his way. The happy Vicenzio hastened home, and with mutual rejoicings mother and son gloated over the recovered treasure, which was found untouched in the lining. When the graceless youth inherited the pre-cious gold, he established a chemist's shop in the Campo S. Luca, at the sign of La Vecchia, which shop extended to the Corte del Teatro, and there, over the entrance, placed a relief in stone of his mother sitting at her spinning-wheel, and himself at her feet winding the thread on the spindle.

Tassini tells us that in his youth the popular celebration of the burning of La Vecchia—a sort of Guy Fawkes night —was held in the Campo di S. Luca. The Campo was decorated with flags and hangings, a platform some fifteen

feet in height, raised, on which a stuffed figure of an old woman with a mask on her face was placed, and amid much strident music, shouts, fireworks, and other revels, the platform was set on fire and the figure burnt to ashes.

We may now cross the corte, and issue by the Ramo e Sottoportico del Carbon to the Riva del Carbon, and take steamer homewards; or we may continue along the Riva to the foot of the Rialto bridge.

In the Campo S. Bartolomeo, opposite the bridge, will be seen one of the best preserved examples of thirteenth century windows, in the second story of a house, with capitals of great beauty and variety of design. The windows, according to Ruskin, are pure third order, and below them is a lovely old Byzantine cornice " remaining or perhaps introduced from some other ruined edifice." Following the stream of pedestrians to the left, we emerge from this, the busiest Campo in the whole of Venice, where more of the characteristic traits and activities of Venetian folk may be observed in five minutes than in the Piazza during five hours, we make our way over the Ponte dell' Olio (noting a charming old balcony to our right from the bridge) to the Church of S. Giovanni Grisostomo. The Calle Ufficio della Seta to the right of the church and the Calle del Teatro will lead us (past the entrance to the Corte Milione) to the Ponte del Teatro, opposite which projects, from the Palazzo Bragadin over the rio Malibran, one of the best preserved and most lovely of late Gothic balconies in Venice. The symmetry and proportion of the whole design are admirable, the details exquisite. Graceful little shafts with carved capitals bear a series of small trefoiled arches, in whose spandrils charming winged cherub faces smile on the spectator; the angle pilasters are decorated by a pair of cherubs. The cornice, with cable mouldings, is surmounted at the corners by seated lions, and over the piers which vary the columns and break them into groups are three classic heads, virile in treatment, of which two have been renewed; the

WINDOWS OF THE PAL FALIER

scutcheon of the Bragadini faces us above the windows. This palace was restored in Renaissance times by Sammichele, who, as we learn from Vasari, repaired (*rassettò*) the house of the Bragadini opposite Sta. Marina, made it most commodious, and greatly embellished it; in 1875 it was again restored by Count Papadopoli.

The Bragadini, one of the four Evangelist families, were domiciled here in 1362 in the person of Matteo Bragadin, of the parish of Sta. Marina; the most famous of their race was the heroic defender of Famagosta, Marcantonio Bragadin, who, after surrendering to the Turkish Commander in 1570 on honourable terms, was treacherously flayed alive, and his skin, stuffed with straw, sent—a ghastly trophy—to Constantinople. The skin was in 1596 secretly conveyed thence to Venice by a patriotic Venetian, and transferred to the church of S. Zanipolo, where the hero's monument will be familiar to visitors.[1]

To return to the Palace before us—a magnificent festival took place here in 1734 to celebrate the appointment of a Bragadin to the office of Procurator. So numerous was the company expected that it was deemed advisable to underpin the piano nobile; and indeed the assembly appears to have been numerous rather than select, for the celebration was rendered notorious by a scandalous incident typical of the manners of decadent Venice. The French ambassador, who had been invited, brought with him his mistress, Maria da Reia, a professed nun, from the Convent of S. Lorenzo, disguised in male attire, and escorted her back in the early dawn to her Convent. The later pages of this book will throw some light on conventual manners in the late fifteenth and early sixteenth centuries, and if the traveller will examine,

[1] Another palazzo Bragadin stands near S. Zanipolo, number 6480, in the Barbaria delle Tole (Tavole) to the right of the Calle dell' Ospedaletto: on the façade that looks on the Barbaria delle Tole is a relief in Greek marble of Daniel in the lions' den, and over the portal, a medallion placed there in the early nineteenth century by the then owner of the house: it now belongs to an American family.

when next in the Museo Civico, two contemporary pictures by Guardi, numbers 169 and 185, representing visiting days at fashionable convents, he will have small difficulty in understanding the corruption of monastic life towards the fall of the Republic. In this Palace dwelt for a time that superb scoundrel, Casanova, under the protection of a famous jurist, Matteo Bragadin, who died there, the last of his race, in 1767.

We may now retrace our steps to the church of S. Giovanni Grisostomo, and crossing the Ponte[1] of the same name, follow the stream of people westward by the 'Calle Dolfin to the Ponte dei SS. Apostoli, which will lead us into the spacious Campo of the Apostoli. Turning round we observe over the bridge, the façade of the Palazzo Falier, home of the traitorous doge, whose story is better known than perhaps any other tragedy in Venetian history.[2] The windows of the second order with Byzantine reliefs between the ogees have been reproduced in one of the most beautiful illustrations to the "Stones of Venice." The master believed them to be part of the original Falier house of the thirteenth century, and to afford a distinct idea of the order in its most perfect form. According to the Savina chronicle, quoted by Tassini, after the execution of Falier, the "Casa grande with columns, at the Apostoli, which was Marin Falier's, the whilom unworthy doge," was bestowed on the Beltrame who divulged the plot. According to other authorities it was given to the Church of the Apostoli, and subsequently bought back by the family. This is rendered the more probable by the fact that the inventory made of Falier's effects after his decapitation was drawn up by John the priest of the Church, an inventory of great interest, forming as it does one of the earliest catalogues of a private collection

[1] Before crossing the bridge, and on the left, is the Calle della Stua: see p. 17 notes 3 and 2.

[2] Recent investigations have somewhat modified the details of the story, as told by Romanin and all subsequent historians. For an excellent summary of the evidence see *Edinburgh Review*, July 1906.

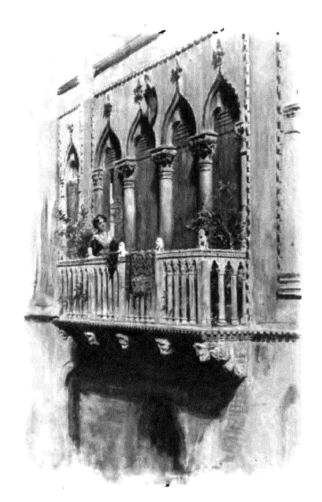

BALCONY PALAZZO BRAGADIN.

of antiquities and works of art in Venice. It has been published by Levi, and the thirty-two objects catalogued in the "Red Room" comprise some pictures; two most beautiful candelabra of alabaster and gold; a ring with an inscription given by Kubla Khan to Marco Polo; a wondrously ancient sword with inscriptions; two heads of savages which Jacobello the mariner brought from Africa; some sculptured marbles with inscriptions; some manuscripts with miniatures; a figure in gold; a wondrous three-edged sword which Marco Polo carried in his travels; the book of the voyage of the aforesaid Marco, in white leather with many figures; a volume which is called Of the wondrous Lands of the Tartars, written by the hand of the aforesaid Marco, and other curios given to his friend Falier by this famous traveller; four camisoles of chain armour; fifty coins of wondrous antiquity; a sphere of the world in bronze, which belonged to Master Antonio, the astrologer; a glass phial containing gold and colour; a bed of red wood carved with many figures.

The Venetians had long memories, and although Marin's mother was a Loredan, and his family one of the apostolic twelve, and had, besides Tribunes, given two famous doges to the Republic—Vitale, who re-discovered the body of St Mark, and the heroic Ordelafo, his son, who met a soldier's death in Hungary—never a Falier attained to eminence after Marin's treachery. And what a magnificent record of public service lay behind this childless old patrician, ripe statesman, and brave warrior, whose motives in attempting the supreme act of treason are still as great a mystery as they were to Petrarch, his friend, and to all his contemporaries: In 1315 he was chief of the Ten; in 1320, dealing with English affairs, and member of a Commission charged to track Bajamonte, Quirini, and other conspirators of the Bajamonte insurrection; 1323, Governor of Negropont; 1334, of Lessina and Brazza; four times between 1337 and 1349 Podestà of Chioggia; 1339, First Governor of Treviso; twice chosen by the Paduans, for his incorruptibility, Podestà of their city; 1349,

feudal lord of Val di Marena. He served as ambassador to the Courts of Avignon, Austria and Genoa; as Commander of the Black Sea galleys; played a prominent part in the siege of Zara; gained a victory over the king of Hungary in 1346; in 1348 he was Chief Commissioner of an expedition to Capo d' Istria; in 1352, fighting the Genoese and holding Tenedos for the Greek Emperor. In home affairs he had served on a Commission appointed to widen the Merceria, and on another body to suppress usury. It was during a last mission to the papal court at Avignon that Falier was chosen to fill the ducal chair. As we meditate on this fallen grandeur we may make our way westward along the Via Vittore Emanuele to the Calle della Ca' d' Oro, at the end of which is a station of the Vaporetti.

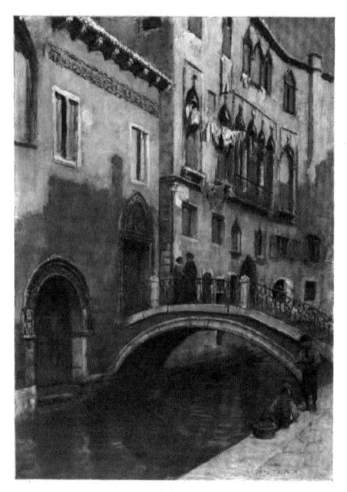

PALAZZO GOLDONI.

CHAPTER VIII

*The Gothic Palaces di là dal Canale—The Palazzi Goldoni,
Bernardo, Bianca Cappello, Sanudo, Quattro Evangelisti
—The Campo Sta. Maria Mater Domini*

> " And from her chamber-window he would catch
> Her beauty farther than the falcon spies ;
> And constant as her vespers would he watch,
> Because her face was turned to the same skies."
>
> —*Keats.*

THUS far our peregrinations di quà dal Canale: we may
now cross by a vaporetto *di là* and disembark at the
S. Tomà pier. Passing along the Calle del Traghetto
Vecchio, a turn to the right will bring us to the Campo
S. Tomà ; skirting the façade of the church and traversing
the smaller Campo obliquely, we reach the Ponte S. Tomà,
over which to the right stands the rio façade of a Gothic
house known as the Palazzo Goldoni. To our left, im-
mediately over the bridge, will be seen a lovely old Gothic
portal of terra-cotta, in the tympanum of which is a square
panel of stone, decorated with a beautiful relief of ogee
quatrefoils, enclosing the flaming monogram of S. Bernadino :
a Byzantine arch in the watergate to the left with reliefs
similar to those we have seen in the Corte del Remer, invites
our admiration before we cross the bridge and enter on our
right the neglected Cortile of the Casa Goldoni in the Calle
dei Nomboli (No. 2793) : a portrait bust and inscription are
over the door. We enter for the sake of a well-preserved
Gothic external stairway raised on the typical arcade (now
bricked in), broadening in span as the arches rise with the
slope of the staircase. The small columns that support the

sloping, decorated parapet are, as at the Palazzo Sanudo van Axel, without capitals or arcading, and relieved by piers at regular intervals: a small seated lion decorates the first, and carved bosses, the remaining piers. Continuing our pilgrimage along the Calle dei Nomboli we turn left along the Rio Terra dei Nomboli, then right by the Calle dei Saoneri to the Ponte S. Polo, noting, as we stay our way on its crown, a lovely early renaissance balcony, to the left, over the rio.

We pass on, and at length emerge on the ample Campo S. Polo, which we traverse obliquely to the N.E. angle, and reach, by the Rio Terra S. Antonio and the Ramo Calle Bernardo, the Ponte Bernardo: turning round we see the grand, virile façade of the Palazzo Bernardo towering over the rio, contemporaneous with, and similar in style to, the Palazzo Orfei in the Campo S. Benedetto. This too, now occupied by the Società Musiva Veneziana, has suffered little from restoration, and is characterised by Ruskin as the noblest palace in Venice after the Ducal Palace. It is late in date, as the two groups of four-light, sixth order windows indicate; it has the usual disks of porphyry in the spandrils, and a lavish use is made of dentil and cable mouldings in its decoration. The Bernardi, for whom this impressive pile was raised, claimed Roman descent; they gave tribunes to the first Venice, and many high officers and brave captains to the second: the fine renaissance monument to the memory of Pietro Bernardo by Leopardi in the Frari will be familiar to all lovers of Venice. The last surviving Bernardo died in 1868.

Making our way back to the south-east corner of the Campo S. Polo, and noting as we pass other two Gothic palaces on our left, we turn by the Calle della Madonetta, at the corner of which is a fine renaissance angle window, and continuing our way in a direct line reach, by the Calle del Perdon, the Campo S. Apollinare; whence the Calle Bianca Cappello on our left will bring us to the Ponte

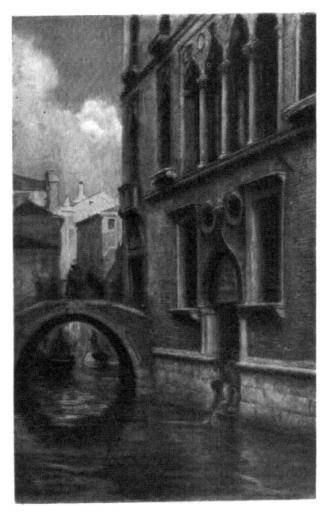

PALAZZO BERNARDO

Storto, over which the reputed and not very palatial birth-
place of the notorious Grand Duchess of Tuscany stands,
and to the Fondamenta e Sottoportico Salviati, beyond
the bridge.

Tradition attaches to this spot one of the most extra-
ordinary social scandals and political intrigues in the history
of the Republic of Venice. Bianca, only child of Bartolomeo
Cappello by his first wife Pellegrina Morosini, on her father's
second marriage with Lucrezia, sister of Giovanni Grimani,
the famous scholar and art-loving patriarch of Aquileia,
became subject to the novercal tyranny and the ill-will of
the new mistress of the house. Brooding over her unhappy
lot, Bianca, a rich and lovely heiress, as she sat at her
window, often met the gaze of the young and handsome
Piero, son of Zenobio Bonaventura, agent in Venice of the
wealthy bankers, Salviati of Florence, whose office was easily
seen from the Ca' Cappello. Piero was of graceful and
noble bearing and arrayed, in the magnificent Florentine
fashion of the day. He possessed a pale countenance,
slightly tinged with love's proper hue, a lofty and spacious
brow, framed in luxuriant golden hair, which fell about a
marmoreal neck in rich profusion; dark eyes flashed forth
fiery shafts of passion,

> " E ciò che lingua esprimer ben non puote
> Muta eloquenza ne' suoi gesti espresse."

Bianca, who had been subjected to the oriental seclusion
of Venetian maidens, uneducated, credulous, ignorant of the
world, fell an easy prize to her subtle Tuscan lover. Owing
to the slack guardianship of an uxorious father, and by the
aid of domestic bribery, the lovers soon contrived to meet
and talk with other tongues than those of flaming eyes and
languishing looks. Piero, true child of the land of Boccaccio
and Petrarch, was skilled in *versi d'amore*, which, breathed
in a warm and gentle voice, fell on her ears from a sweet,
seductive mouth. Small wonder that Bianca's budding

womanhood opened at the hot fragrance of a poetical passion; and it is said that Piero assumed the kinship, as well as the garb, of the Salviati. On the night of November 28, 1563, the lovers eloped; Bianca, who was but sixteen years of age, taking all her jewellery. Fortune favoured their flight, and before long the pair were safely housed with Piero's parents in the Piazza S. Marco at Florence. They were married, and Bianca found herself meanly lodged in a poor, middle-class home; her mother-in-law discharged the only servant, and compelled Bianca to do menial work; and so the daughter of a rich and proud patrician, in whose veins coursed the blood of a Cappello and of a Morosini, became a common household drudge.

Meanwhile the news of Bianca's flight had rendered her father furious; he called on the Ten to do justice on the fugitives and on their accomplices. The gondoliers who rowed them away were put to the torture; an uncle, Giovanni Battista Bonaventura, and two boatmen were flung into prison, and perished of gaol fever; the Avogadori set a price on the seducer's head, and the father added a further sum of 6000 lire to the official reward for Piero's body, alive or dead; Bianca too was banned. No small stir was caused at Florence by the dramatic story of Bianca's flight and degradation. Francesco de' Medici, son and heir of Cosimo, Grand Duke of Tuscany, intervened. Smitten by her beauty he made her his mistress, and installed her in a palace near his own: Bianca's husband consoled himself by a liaison with Cassandra, a Ricci by birth, and wife of one Bongiovanni. The Ricci, instigated it is said by Francesco, wiped out their kinswoman's shame in Piero's blood, and Bianca, now a widow, was free to marry her exalted protector, who, in 1574, ascended the ducal throne. On the death, in child-birth, of his consort, the Archduchess Joanna of Austria, in 1578, Francesco consulted a learned theologian and casuist as to his relations with Bianca, disclaiming all complicity in Piero's assassination: contrary to the ghostly father's advice he secretly married her on June 5, less than two months

after his consort's death. The Grand Duke, after the ceremony, retired to his country seat near Pistoia, and seems to have had some misgivings at the consequence of this step; but passionate letters from Bianca pursued him, and at length the urgent presence of his new wife impelled him to return to Florence and publicly avow the marriage. Francesco used his influence with the Pope, and Bianca hers with the Doge, promising to employ her new position to favour the political interests of the Republic at Florence. The whole attitude of the Vatican and of the Seigniory of Venice was changed, and Bianca's once fiercely hostile parent, Bartolomeo, went in state to meet the Florentine envoy, Count Maria Sforza, who brought the official announcement of the marriage, and lodged him sumptuously in the Palazzo Cappello. The Patriarch Grimani, who had been no less furious in his persecution of Bianca, stood on the threshold of the Palazzo Grimani, at S. M. Formosa, in full pontificals to welcome the Count, and subsequently went to Florence officially to grace the coronation of the new Duchess: an effusive and flattering state document was sent by the Venetian Senate to Bianca, declaring the most illustrious and most excellent Lady, the Signora Bianca Cappello, Grand Duchess of Tuscany, to be by the authority of the Senate the true and particular daughter of the Republic of Venice, and that, by reason of the most rare and brilliant qualities which rendered her most worthy of the highest fortune. The Ten cancelled the past from their records; honours and favours were showered upon her father Bartolomeo; her brother Vettore was created *Cavaliere*, and received from his sister a munificent present of the Palazzo Trevisan, behind the Ducal Palace. The Court of the new Grand Duchess became the centre of the beauty, the intellect, the art of Florence; she extended her exalted patronage to Tasso, and presented him with a silver cup; herself received from the Pope at Rome the highest honour that could be conferred on a woman—the supreme favour of the Golden Rose.

But all was not well with Bianca. She had borne her former husband a daughter, but to Francesco no heir, and her brother-in-law Cardinal Fernando, the heir-apparent, hated her with quite absinthian bitterness. In 1576, before her marriage, she had tried supposititiously to affiliate on Francesco, the child of her favourite maid, who was packed off to Bologna and soon died, but who avowed the truth before her end. In 1586, by the aid of philtres, vows, and drugs, she declared herself at length in a condition[1] to satisfy her lord's desire for an heir, and plotted the substitution of the fruit of her daughter's womb, who had been married to a Bentivoglio. Ferdinando at least was not to be duped: he persuaded the Grand Duke to keep her apartments locked and to hold the keys. Bianca, checkmated, gave up the game, and a reconciliation with the Cardinal was contrived by influential relatives.

At the time of the vintage, in the gorgeous Italian autumn, Francesco and Bianca retired to their magnificent villa at Poggio da Cajano on the slopes of the Apennines, where Ferdinand joined them and where the curtain falls on this sordid drama with terrible suddenness. On October 19, 1587, the Grand Duke, and on October 20, the Grand Duchess, died mysteriously, rumour defaming the Cardinal of their death by the administration of poison. Bianca, while still uncertain whether she would survive her husband or not, had written to the Pope, praying that in the event of her widowhood his Holiness would permit her to seek safety at Rome. Ferdinando, it is said, submitted the bodies for post-mortem examination in the presence of impartial witnesses.[2] No honour was suffered to be done to Bianca's

[1] Bianca for some time had been suffering from dropsy.

[2] Saltini has relieved Ferdinand's memory from any suspicion in the matter of the deaths of Francesco and Bianca by the publication of documents which prove beyond all doubt that the Grand Duke and Duchess died of fever, or rather of a complication of organic diseases, aggravated by intemperate eating and by the merciless and lethal medical superstitions of the age. The post-mortem examination was held on the two bodies in accordance

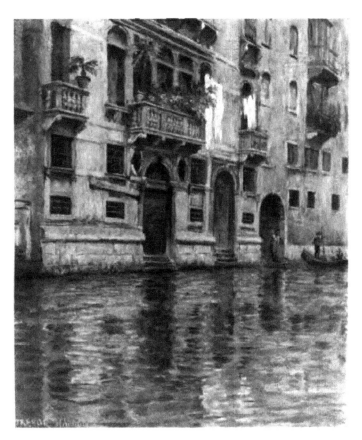

RIO S. STIN.

remains ; her scutcheons were defaced or removed from public places, and the Seigniory, whose policy it was to stand well with Tuscany, followed Ferdinando's lead by forbidding any funeral celebration in Venice. So runs the *sconcia novella* of Bianca Cappello. She was but thirty-nine and her consort forty-seven years of age when they died.

The Cappelli were one of the most influential of the second class of nobles, those who were members of the Grand Council at the time of the Serrata, and so numerous and powerful were they in the sixteenth century, that Sanudo notes in December 1510 that no less than seven of the Cappelli filled simultaneously every possible high office in the State.

We return to the Campo S. Apollinare and note over the Calle dei Sbianchesini an arrow indicating the way to the S. Silvestro pier ; facing us at the end of the calle is a charming two-light window divided by a graceful column of Verona marble with a lovely capital. From the vaporetto station we may either steam back to S. Marco, or, by disembarking at the Museo Civico pier, pursue our architectural pilgrimage. If the latter be our choice, we will pass to the end of the Salizzada del Fontego de' Turchi, and at no. 1740, find the weather-worn and effaced scutcheon of the Sanudi in the tympanum of the doorway. By turning along the Calle del Spezia we may reach the other façade of the house, on the Fondamenta del Megio, where an inscription (over a fruit shop) prays the wayfarer to stay awhile and contemplate the house in which the greatest of diarists lived and died.

From this spot we descry the hand indicating the way

with custom at the death of sovereign princes, and the details given by the operator of the state of the vital organs in each case are sufficient to set the matter at rest. The Duke was taken ill on the 8th, the Duchess on the 9th of October. They were continually surrounded by relatives, confessors and physicians. See "Archivio Stor. Ital.," Nuova Serie, vol. xviii. pp. 19-81 ; "Della Morte di Francesco I. de' Medici e di Bianca Cappello," G. E. Saltini.

to the Galleria dell' Arte Moderna. This we will follow as far as the Ponte della Rioda, cross, turn immediately to our left along the Fondamenta Rimpetto Mocenigo, and on our right soon find, at the end of an obscure blind-alley, another steep-gabled terra-cotta portal engaged in the wall, similar in style to, but less perfectly preserved than, the one

WINDOW : PALAZZO QUATTRO EVANGELISTI

we observed in the Campiello S. Luca; it is described by Ruskin as the simplest type of perfect construction he found in Venice. Continuing our way along the Fondamenta, and following the indicator, we cross the Ponte del Forner which gives on to the Fondamenta Pesaro: turning round we behold one of the most original and beautiful gothic windows of the third order in Venice, excellently preserved, on the façade of the palace opposite, which by reason of its decorations is known as the Palazzo dei

WINDOW—CAMPO S.M. MATER DOMINI

Quattro Evangelisti. In the spandrils of the arches are admirably sculptured the symbols of the Four Evangelists—the Eagle of S. John, the Lion of S. Mark, the Angel of S. Matthew, the Ox of S. Luke,—flanked on either side by the Anunciation: Gabriel to the right, the Virgin to the left. Above the water gate, with its beautiful moulding is carved the Lamb of God. At no. 2060 to our left, over the bridge, is a lovely doorhead framed in a dentil moulding ; the slightly pointed arch is finely decorated in Byzantine style, and in the tympanum an escutcheon, sustained by an angel, and supported by other angels on either side, gives an excellent example of a favourite design of Venetian sculptors. Traces of the lions that filled the spandrils may still be seen. We now return to the Ponte Rioda, cross the Ponte del Cristo and reach, to the right, the Campo Sta. Maria Mater Domini, and facing the length of the Campo, observe a magnificent group of fourth order windows characterised by Ruskin as one of the earliest and loveliest of its kind in Venice. As in the arcade of the windows of the Four Evangelists, two columns are balanced on either side by two piers ; above the ogees of the arches, carved medallions are inserted and remains of the spandril decorations may be distinguished : on the spaces below are two shields (restored) and some traces of a relief of the Lion of S. Mark. The whole scheme is worthy of the closest study, and of careful comparison with the slightly earlier work on the House of the Evangelists. To the right of the Campo some remains exist of the old Zane houses, which in 1310 were marked with the Lion of S. Mark, to indicate that their owner had been implicated in the Bajamonte conspiracy. The windows are of the second order, and some fine Byzantine reliefs are embedded in the wall. In a small, quaint cortile opposite, now used as a cooper's shop (no. 2177) are an old external staircase, and a well-head of the late fifteenth century, bearing the arms of the Barbaro family ; at no. 2125 is a fine spacious cortile with a restored external stairway carried

on round arches. We may conclude our ramble by following, in a reverse direction, the indicator which points the way from the Rialto to the Museo Civico, and so along busy streets, and passing many a picturesque relic of old Venice, reach the great bridge and betake ourselves homeward.

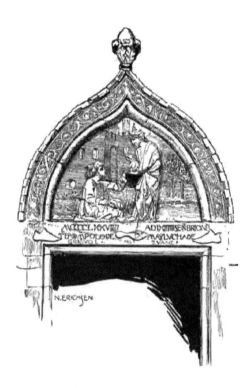

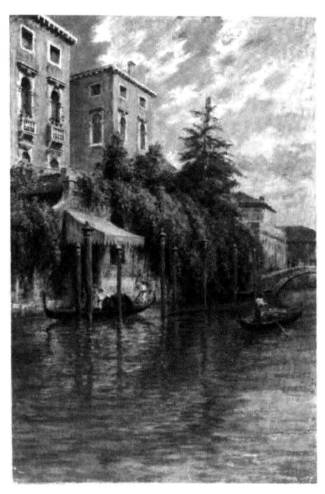

GARDEN PALAZZO CLARY.

CHAPTER IX

The Gothic Palaces di là continued—The Palazzo Nani-
Mocenigo—The Ponte delle Maravegie—The Palazzi
Ariani and Zen—The Gardens of the Palazzi Cappello
and Gradenigo—The Gothic Palaces concluded—The
Palazzi Faccanon, Sanudo van Axel, Mastelli, Giovanelli

"Filled am I with waters and gardens and groves and vineyards and the joyous-
ness of the bordering sea, and fisherman and farmer from different sides stretch forth
to me the pleasant gifts of sea and land; and those who abide in me, either a bird
singing or the cry of the ferryman lulls to rest."—"Greek Anthology": MACKAIL.

WE may conclude our survey of the Gothic palaces di là
by disembarking at the Accademia pier, and thence direct
our steps to the remoter quarters of the city. Leaving the
Accademia to our right, we pass direct along the Rio Terra
Antonio Foscarini, turn by the Calle Larga Pisani, the Rio-
Terra Carità and the Calle Larga Nani, to the Ponte S.
Trovaso, and cross to the grass-grown campo, with its shady
acacia trees, in front of the church. Opposite to us, on the
Fondamenta Nani, stands the Palazzo Nani-Mocenigo, one
of the few palaces in Venice still inhabited, in part at least,
by the family whence it derives its name. A picturesque
edifice, it is much disfigured by additions, but displays a fine
group of sixth-order windows and a modified liagò on the roof.
The edifice formerly belonged to the Barbarigo family, whose
shields still remain on the façade. Two doges, Marco and
Agostino Barbarigo, were born within its walls. The latter
bequeathed the property, in 1501, to his nephews, Bernardo
and Paolo Nani, Bartolomeo Pisani, and their male descend-
ants. In the course of a few years the house came exclusively
into the hands of the Nani, who traced their descent back to

Roman Altinum, whence they claimed to have taken part in the first great exodus to Torcello and subsequently in the second migration to Rialto. Original members of the Great Council, they were no less conspicuous for civic, military, and hierarchical eminence than for pride of birth : the names of two Nani-Mocenighi appear to-day in the Directory of Venice. Turning down the rio towards the Grand Canal, we pass the Palazzo Bembo, which we may enter for the sake of the charming and spacious garden, one of the three finest in Venice, which is courteously shown to strangers, and exemplifies a dominant passion in Venetian patricians, who dearly loved the refreshment of greenery and flowers, doubly precious by reason of the limited area available and of the absolute severance from the rural delights of the mainland. How often have we, in the glorious resurrection of spring, amid the narrow streets of the congested city, yearned for a sight of the sweet fields and burgeoning trees, and sought the nearest solace for eye and ear in the exiguous verdure of the Lido, now, alas, rapidly disappearing before the encroaching architectural vulgarities of a growing popular seaside resort.

A love of flowers and gardens is one among the many charming traits of Venetian folk, and the rose, one of their best-loved flowers. A pretty legend, that of the Bocolo, is associated with the rose-bud, which Venetian youths were wont to give to their sweethearts on S. Mark's day in memory of Vulcana and Tancred : To Maria, only daughter of a proud Venetian noble, Orso Partecipazio, a sweet, golden-haired maiden, known as Vulcana, because of the ardent flames that flashed from her coal-black eyes, there came one day a brave and handsome troubadour named Tancred, a child of chance, and sang of heroic deeds, of knightly prowess, and maiden troth. And love was quickly kindled in the breasts of lowly minstrel and proud patrician's daughter. Vulcana, who knew right well that her haughty sire would never consent to a union with a poor singer, thus

addressed her lover: "Fare forth, brave Tancred, to the King of France, and cover thyself with glory; thus shall my father bless our love. I will await thee evermore." And so the troubadour set forth to fight with the Moors; and soon wandering minstrels came from France, and began to sing of the marvellous deeds of Tancred, invincible in battle, supreme in sweetest songs of love. But one day there arrived in Venice envoys from Charlemagne, and at the head of the Frankish knights stood forth Roland, the brave paladin, and entreated speech with Vulcana. Bending the knee before her, he said: "Fair damsel! Tancred, breathing your name, expired in my arms; and, as ensanguined with mortal wound, he fell on a rose-bush, he gathered a rose, and prayed, O Vulcana, that I should bear it to thee. Behold the flower, O blessed thou among women and fortunate, that wast beloved by the greatest soul that ever Roland knew. Pray for him, and remember me in thy prayers. Adieu!"

Vulcana, blanched, even as snow, stood mute, and accepted the flower without shedding a single tear: on the morrow, S. Mark's day, she was found dead with the rosebud clasped to her heart. And so, says the legend, in memory of the loves of Vulcana and Tancred, our youth on S. Mark's day, offer rosebuds to their beloved ones.

The bridge which crosses the rio S. Trovaso just below the Palazzo Bembo is named the Ponte delle Maravegie, and also about this appellation, popular tradition has woven a romantic story. In times of old there lived in a house opposite this bridge, seven sisters, of whom six were beautiful and the seventh ugly. A stalwart young gondolier began to visit the sisters, but from that hour forth, he, who was so healthy and robust, fell sick and feeble and was unable to gird himself for a forthcoming regatta. Suspicions of witch-craft haunted him and fell upon the seventh ill-favoured sister, named Marina, who, whenever she caught sight of him, always sought to avoid a meeting. The youth deter-mined to be avenged, and on Good Friday eve, when the

father and the six other sisters were gone the usual round of
the churches, made his way towards Marina's dwelling; but,
terrified at the deed he was about to commit, hesitated
awhile on the bridge before he entered. He gazed at the
window, and lo, there, before a crucifix in her room, knelt
the suspected witch in fervent prayer; at the same moment
he raised his eyes to the sky, and beheld six refulgent stars
of great magnitude set in the form of a wain, with wheels
and pole, preceded by a seventh star that was small and
faint. But as he gazed, little by little the glory of the six
bright stars waned, the seventh grew more fair and lucent,
until the six vanished and the seventh remained alone,
resplendent in the sky. The sight of her who prayed, and
the miraculous vision of the stars, which by secret admonition
seemed to have some relation to his own fate, wholly
changed the young boatman's mind and caused him to enter
straightway into the house. Having questioned Marina
whether she had bewitched him and would bring about his
death, she, weeping, manifested the sweet love she had
nurtured for him in her heart and told him in that very
hour she was praying God that He would accept the
sacrifice of her life rather than harm should come to her
beloved. The young fellow's heart was melted by such a
token of supreme devotion and, since strait is the boundary
between pity and love, returned her affection, and, having
regained his former vigour, won the regatta and took Marina
to wife. And so henceforth the bridge was called of the
people, the Bridge of Marvels.

Let us now retrace our steps to the Campo S. Trovaso,
cross it obliquely, and turn along the Fondamenta Bonlini,
passing the picturesque garden of the late Renaissance Palace
Clary over the Rio Ognisanti, and continue direct along the
rio past the Campiello dei Morti to the Fondamenta S.
Sebastian. Here we turn to our right, and, following the
Fondamenta to its end, find amid the squalor of this poor
quarter of the city, one of the most remarkable of all the

DOORWAY—CAMPO STA. MARGARITA

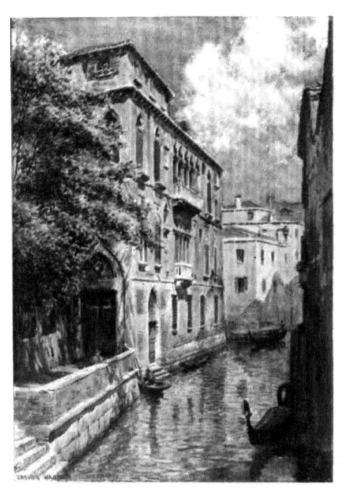

PALAZZO SANUDO VAN AXEL.

Gothic palaces of Venice, with unique and lovely tracery above the windows of the *piano nobile*.

The design is defined by Street as a complicated system of intersecting circles, pierced at regular intervals by quatrefoils, and inclosed in an indented or billeted string course. Indeed, the whole scheme of the façade is most peculiar and irregular; a solitary column at the left angle, where a small loggia opens, supports the superstructure of the *piano nobile* with the bold, cusped arcading of its six-light windows, to right of which are two single-light windows of the fifth order with restored balconies : a poorly designed four-light window is seen below the *piano nobile*. The impression left on the spectator by this curious relic of experimental late Gothic is most extraordinary, and the queer little edifice is well worth a journey to the somewhat remote parish of the Arcangelo Raffaelle where it stands in solitary elevation.

The Ariani family were of Istrian origin, and their founder one of the early settlers in Rialto after Pepin's defeat. In ancient times they owned nearly the whole parish of the Arcangelo Raffaelle, whose church they founded and more than once restored. Their palace on this site dated back to the ninth century, and was rebuilt in the fourteenth century. The Ariani, by the exclusion from the Grand Council, towards the end of the century, of their chief, who in revenge forbade any of his children to marry into a patrician family, had fallen on evil times and tried in vain for many generations to regain their lost privileges, until at length they became extinct in 1650. Their palace, restored in the early seventeenth century, passed to the Pasqualigli and subsequently one floor came into the possession of Lucia Cigogna, formerly a Benedictine nun, who opened a girls' school there in the early nineteenth century. Lucia had the Cigogna escutcheon carved on the vestibule, and hence the name of Palazzo Cigogna by which it is designated by Ruskin and other writers. It is now a boy's school.

Retracing our steps along the Fondamenta S. Sebastian

to the Calle Avogaria on our left (opposite the church of
S. Sebastian), we descend that street and cross the Ponte
Avogaria to the Calle Lunga: here we turn left by the
Calle Seconda delle Pazienze to the foot of the Ponte delle
Pazienze, which we cross, continue to the façade of the
Scuola Grande dei Carmini, where, turning right, we enter
the long and spacious Campo Sta. Margarita. As we pace
its length we soon remark on our left (no. 2931) a finely
decorated terra-cotta doorhead with a marble escutcheon,
supported in the usual way by three angels. This, too, has
been drawn by Ruskin: the richly-decorated tympanum and
arch are worthy of careful observation. We continue our
way to the end of the Campo, cross the Ponte Sta. Margarita,
and, passing along Calle S. Pantaleone to the right of the
church of S. Pantaleone opposite, find on our right the
entrance to the Campiello Angaran with the ancient relief
mentioned on page 23. Before we turn by the church, a
curious late Gothic window may be observed opposite over
the rio.

Resuming our stroll from the Calle S. Pantaleone, we
debouch on the Crosera, turn to the right, and by the
Sottoportico and Calle del Scaleter on the left, and the
Campiello S. Rocco, emerge opposite the apse of the Frari,
which we skirt to the right and reach the Campo dei Frari.
Let us now cross the bridge facing the main portal of the
church, and turning left over the Ponte S. Stin, pursue our
way to the Campo S. Stin by the Calle della Chiesa. The
Gothic palace to the right of the Ponte S. Stin, and
fronting the Rio S. Stin—it backs on to the Campiello Zen
—is said to have been the home of Carlo Zen, the saviour
of Venice in her last death grapple with Genoa, and the
hero of Marion Crawford's new romance " Arethusa ": it
was restored in the latter half of the sixteenth century and
its façade painted by the Veronese artist Paolo Farinato
with several fables. Tassini remarks that in his time the
palace was still occupied by a Zeno (1886). From the

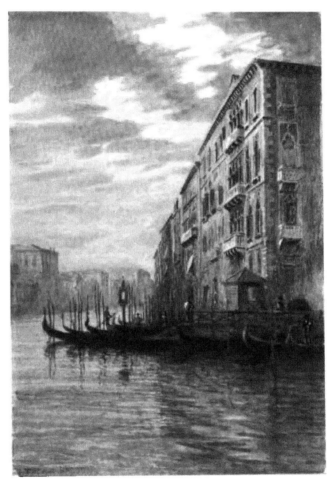

TRAGHETTO DEL SOLE.

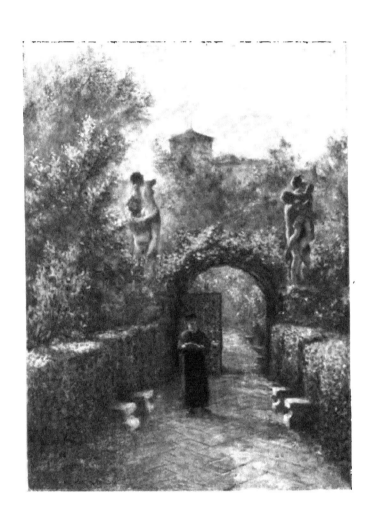

Campo we will make a slight detour by turning sharply to
the right along the Calle Donà del Spezier, traverse the
Ponte Donà, pausing to admire the delightful view on our
right along the rio S. Polo, and proceed direct by the Calle
della Chiesa (S. Agostino) to observe a most curious relic of
Gothic architecture on our left—a single-light Gothic
window with quatrefoil tracery, in the narrow façade of
a house forming a blunt angle at the junction of two
streets. Below the window is a scutcheon, held by an angel,
bearing a lion rampant, flanked by reliefs of Temperance and
Justice and framed in dentil moulding. Retracing our path to
the Campo S. Stin, we cross obliquely to the right, then pass
along the Calle del Tobacco, and turning right, pause on our
way to admire, since we may not again return thither, the
beautiful Lombardi architecture of the Porta dell' Oratorio
of the old Scuola of S. Giovanni Evangelista and the
picturesque courtyard to which it gives access.

Since we have interrupted the chronological sequence of
our pilgrimage, we may now, as our wanderings will not
lead us again to this quarter of the city, pass along the Calle
dell' Olio o del Cafetier, turn to our left over the Ponte
della Latte, and continue by the Fondamente Rio Marin and
Gradenigo as far as no. 770, the Palazzo Cappello, which
possesses a spacious and lovely Renaissance garden with a
fine classic portico at its further end—a striking and, in its
faded splendour, a pathetic relic of a grandeur that has
passed away. The original edifice on this site belonged to
the Bragadin and then to the Soranzi, one of the eight
patrician families who in prestige and antiquity were ranked
but just below the apostolic and evangelistic nobles : subse-
quently rebuilt by the Soranzi in late Renaissance times, it
was long famous for its artistic treasures, and is now, and
has been for some time, in the possession of the Cappello
family; the present owner, however, a lady justly proud of
her illustrious descent, and, we believe, the last of her race,
does not occupy the mansion. The halls of the piano nobile

H

and other floors are reputed to be the longest in Venice, and one, at least, retains its original rich, warm Terrazzo [1] flooring, whose polished surface mirrors the surrounding objects and reflects the varying play of light as it is flooded by the serene and sun-steeped Venetian atmosphere; and some remains of the polychromatic decorations of its once magnificent chambers may yet be seen. The lovely garden to the left was formerly the orchard : both are now in English hands. The vast palazzo beyond, the Gradenigo, has an even larger garden, and in the resplendent days of old its patrician owners are said to have taken carriage exercise round its ample area : this in its turn is surpassed in extent by the Papadopoli garden at I Tolentini.

Crossing the Ponte Cappello we turn to our left and reach the Campo Santo on our right, where we sight the indicator showing the way to the Museo Civico : this we follow, wandering through a curious part of old Venice—under a portico where hangs a large painted crucifix; past a terra-cotta Gothic portal whose once beautiful decorations have been replaced by plain brick, but which retains some of the most ancient Byzantine reliefs in Venice on the capitals of its jambs; past the restored old church of S. Zan Degolà, which is a curt Venetian way of saying S. Giovanni Decollato; and at length arrive at the Museo Civico pier, whence we regain the steamer.

We may now conclude our round of the Gothic palaces by hiring a gondola and, dismissing all concern of complicated ways and mazy streets, surrender ourselves to the enjoyment and comfort of a mode of progression doubly pleasant to the weary pedestrian. And first to the rio della Fava, over which rises the stately four-storied Palazzo Faccanon, a fine example

[1] The younger Sansovino gives the elements of this characteristic Venetian flooring in his "Venezia Città Nobilissima" : it is compounded of lime and well-powdered brick or tile, to which are added a portion of powdered Istrian stone and a top dressing of the same, coloured with cinnabar, the cemented mass being polished with oil till it shines like a mirror.

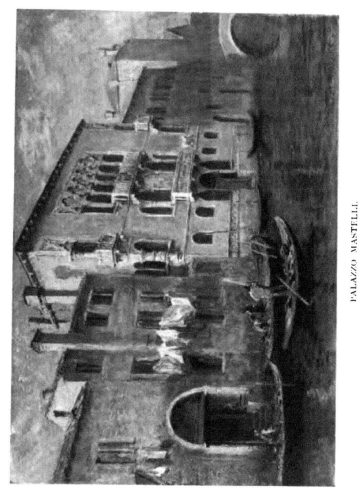

PALAZZO MASTELLI.

of the Ducal Palace period of Gothic, with its double water
gates (one now filled in), its spiral angle shafts and cable
mouldings: the piano nobile, in this case the second floor, is
distinguished for its bold tracery of the Ducal Palace period.
A line of statues on a Renaissance parapet has been added in
later times: this noble fabric is now the offices of the
Venetian newspaper, *Il Gazzettino*.

We next direct our course past many a striking piece of
domestic architecture to the two rio façades of the Palazzo
Sanudo van Axel, whose land portal and courtyard we
have already visited, somewhat later in style than the
Faccanon, with windows of the sixth order disfigured by
Renaissance balconies. A Byzantine string course will be
seen on both façades.[1]

Our boatman shall now urge us along (if indeed the
leisurely, feeble stroke of the hired gondolier merits such a
phrase) by the rio dei Santi Apostoli, the rio di Sta. Caterina,
past the huge bare fabric of the Church of the Misericordia,
round by the timber rafts safely harboured in the Sacca
della Misericordia after their long passage down the rivers
of the continent, to the rio della Madonna dell' Orto,—our
gondolier will not fail to indicate to us the lonely haunted Casa
dello Spirito at the northern angle of the Sacca—and stay in front
of the Palazzo Mastelli which is easily identified by the relief
of a loaded camel led by a Moor, embedded in the wall over
the rio. This large quadrilateral of palatial architecture, which
extends to the parallel rio della Sensa, is described by Filiasi
as having included the remains of the old fondaco of the
Moors, but there is small doubt that the old palace was erected
by the wealthy brothers Mastelli, surnamed Rioba, Sandi, and
Afani, who in 1112, according to an old chronicle quoted
by Tassini, came to settle in Venice from the Morea and were

[1] The Palazzo Faccanon may be reached on foot from the Merceria S.
Salvador by turning to the right (coming from the Piazza) opposite the
money changer's, just before coming to the side portal of the church. A
projecting quay affords a near view of the Palace.

known as the Mori by the common people. Many features are worth observation in this neglected fabric: the curious corner window to the left of the top floor with its

CORTILE : PALAZZO MASTELLI

crazy Gothic balcony and unique brackets; some remains of Byzantine reliefs on a frieze along the basement and the remarkable and original design of the moulding at the angle to the right, at the level of the first floor.

Disembarking at the Ponte della Madonna dell' Orto and bidding our gondolier await us at the parallel rio della Sensa we will make our way on foot to the other façade, entering, as we pass along the Campo dei Mori, the door of no. 3381, which opens on the picturesque cortile, or such of it as now remains, for the old staircase has been walled up and the fine well-head gone the way of so many relics of old Venice in recent years. We may explore the passage which gives on to the rio della Sensa, and returning whence we entered, observe the rude figures of the brothers Mastelli which stand at the corners of the Palace on the Campo dei Mori, one of which, carefully recoloured and inscribed Sior Antonio Rioba, affords a popular pretext for practical joking among the Venetians, who are wont to send greenhorns with messages and parcels to Sior Antonio Rioba. The Mastelli are said to have borne a brave part in the capture of Constantinople and later were engaged in the peaceful avocation of spice and drug merchants at the sign of the camel. In later years, following the lead of many another wealthy house, they gave up commerce, invested in real property on the mainland and lived in peaceful and affluent enjoyment, until the family became extinct in 1620.

Over against the Ponte dei Mori an inscription on a decayed Gothic house, which once formed part of the Mastelli Palace, perpetuates the memory of Tintoretto's residence and death there, and prays the wayfarer not to pass heedlessly by the old dwelling of Tintoretto, painter of *Tabulæ innumeræ*. This poor and rather squalid quarter on the northern skirts of the city conceals many a quaint vestige of old Venetian architecture, and well deserves a more careful survey than that afforded by a hurried visit in a gondola. To the west along the rii della Madonna dell' Orto and S. Alvise are two palaces with noble windows of the fifth order, and scattered about the district is many a relic of Gothic and early Renaissance times embedded in more recent structures. It is outside our present theme,

but we cannot resist the temptation to call the traveller's attention to the rarely visited church of S. Alvise, on the rio of that name. This remote temple holds one of the finest Tiepolos in Venice, and a curious series of daubs, attributed by Ruskin to the youthful Carpaccio; by Gustav Ludwig to the school of Lazzaro Bastiani, and by more severe critics to a clumsy modern forger. We well remember, some few years ago, after having with difficulty persuaded the sacristan to exhibit them, endeavouring to extract some information as to their history. The worthy fellow, with a contemptuous shrug of the shoulders, answered: "*Eh, Signore, chi sa? È roba vecchia, roba vecchia.*" (Who knows? It's only old stuff). Devoting what time we may to this district, we return by the rio della Sensa, past the fine portal of the Abbey of the Misericordia, with its beautiful relief, to the superb, commanding façade of the Palazzo Giovanelli, on the rio di S. Felice o Noal.

This impressive pile of early fifteenth century Gothic, with its bold virile tracery, similar in style to that of the Palazzo Cavallo, on the Grand Canal, was once the mansion of the Dukes of Urbino, into whose hands it came, a magnificent gift by the Seigniory to their Captain-General, Francesco Maria della Rovere, in 1538, and descended to his son and successor in the office, Guidobaldo II., who, on his marriage with Vittoria Farnese, was the hero of a memorable festival; the most excellent Prince and the most illustrious Seigniory of Venice going forth with *somma allegrezza* to welcome the exalted Roman bride to Venice. The Bucintoro, in addition to the highest officers of the State in gorgeous array, carried on its deck many gentle ladies, the finest of the city, all robed in white and adorned with glittering jewels and pearls of highest price. This, and a brilliant cortége of sumptuously decorated barges, bissone, and gondolas, conducted her to the Palace, to reach which a bridge of boats had been made across the rio. Their son, Francesco Maria II., was equally happy in his relations with the Republic, and on the extinction of the

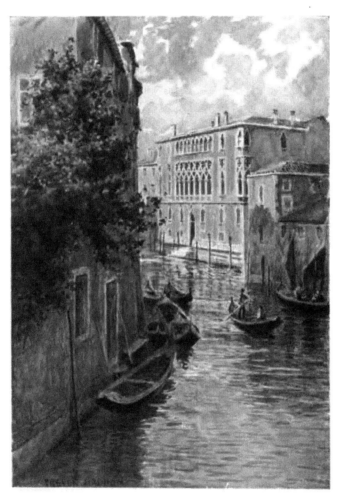

PALAZZO GIOVANELLI.

ducal house of Urbino, the Palace came into the possession of the Doria, who ceded it to the Giovanelli, in discharge of a heavy indebtedness, and the grand edifice, much modernised, and containing one of the most famous private collections of pictures in Venice, may be viewed by personal introduction. During the visit of Frederick IV. of Denmark in 1709 weekly revels were held there, and one winter night, when forty ladies were present, and dancing was kept up till a late hour, a sudden period was put to the revels by the announcement that the Canals were freezing over. Amid much excitement gondolas were hastily summoned, and the whole assembly sought to reach home before access was barred by the hardening frost. At a subsequent ball the king challenged a lady of the Morosini to a trial of endurance: after many a round the lady tired first, and Frederick was ungallant enough to win his wager.

CHAPTER X

*The Early Renaissance—The Lombardi—The Palazzi Dario
and Manzoni—The Ca' del Duca—The Palazzi Corner-
Spinelli, Vendramin-Calergi, Piovene, Vendramin a Sta.
Fosca, dei Camerlenghi, Gussoni, Contarini a S. Luca,
Grimani-Giustinian, Contarini dalle Figure*

> "Lo! how shulde I now telle al this?
> Ne of the halle eek what nede is
> To tellen you that every wal
> Of hit, and floor, and roof wythal,
> Was plated half a fote thikke
> Of gold, and that nas nothyng wikke,
> But, for to prove in alle wyse,
> As fyn as ducat of Venyse."
>
> *—Chaucer.*

DURING the earlier years of the fifteenth century the art
of the Gothic builders in Venice had attained to its most
luxuriant growth; its vigour became exhausted, and in the
exuberance of the Porta della Carta it declined to its end.
As yet Venetian architects were uninfluenced by the new
style which had seized on the imagination and reformed the
artistic ideals of the Tuscan and Lombard builders; for in
architecture, as in painting, the essentially material and
practical temperament of the Lagoon folk was impatient of,
and tardily responsive to, new ideas. It is a remarkable fact
that, although the compiler of the latest Greek Anthology,
Maximus Planudes, was sent as ambassador to Venice by
Andronicus II. as early as 1327, the Venetians seem to have
been insensible to the supreme literary import of the great
scholar's name, and it was in Florence that the first edition
of his Anthology was printed in 1484. Absorbed in state-
craft and in the pursuit of commercial expansion, they

possessed little of the artistic and intellectual subtlety of the Florentine; in oligarchical Venice the individual was sunk in the state, and her hard-headed, sagacious and peaceful merchants formed a marked contrast to the riotous individualism and alert spontaneity of the citizens of the free communes of Tuscany. While the first genuinely Renaissance architecture in Venice—the land portal of the Arsenal—is dated 1460, the Pazzi Chapel in Florence had been erected by Brunelleschi in 1420, and the Pitti Palace designed by the same architect in 1435. The Palazzo Riccardi at Florence was built by Michelozzo in 1430, yet it is not (if we except the cupids between the crocketts of the gable of the Porta della Carta) until the raising of the transitional arco Foscari, which faces the Giant's Stairway, that we reach the first indication of the intruding Renaissance. Its classic niches, its columns, the capitals of the upper order, the friezes are so many definite marks of the new spirit animating the builders' art, although even as late as the sixteenth century pointed arches are used in the cortile of the Palace. The broadening of human knowledge; the expansion of intellectual culture, consequent on the revival of classic learning and the study of ancient monuments; the revolution in the science of astronomy, which destroyed the mediæval geocentric theory of the universe and substituted for it the heliocentric theory, were translated into men's artistic activities and ideals; everywhere the young were stirred to eager search after new things and new modes of expression; and the waters of the sweet fountain of Greek culture, which from the earliest dawn of history had never wholly dried up, were by the advance of Ottoman fanaticism scattered over the classic land of Italy, to refresh and to revive the art and literature of Western Europe.

Unhappily, at the very outset, our appreciation of Renaissance architecture in Venice is, in the minds of those of us who have been nurtured on Ruskin, more or less warped by the perverted judgment of that most potent and seductive

critic, who has read into its development an ethical signifi-
cance alien to the subject, and has enforced his views with a
passionate eloquence and fierce rhetoric, natural enough in a
daring assailant of the fortress of architectural pedantry in
which the professional hierarchs of his age had entrenched
themselves, intolerant of everything but a debased classicism,
and contemptuously rejecting as barbarous and ugly the
Gothic masterpieces of Venice; but wholly unreasonable now
that the victory has been won, and that, with the usual
reaction of a hard-won fight, the danger in architecture has
been rather that of the substitution of a sham Gothic for a
sham classicism. Indeed many of the master's disciples have,
with more zeal than wisdom, advocated his theories with
an exuberance of fanaticism, forgetful that Ruskin himself
was continually qualifying his more violent judgments, and
has said some of the prettiest things ever expressed, of
Renaissance palaces in Venice.

The present writer has in a former work[1] quoted some
characteristic professional and lay abuse of the Gothic
architecture of Venice: the redoubtable Joseph Woods,
after eulogising the new prison by Da Ponte as a handsome
building, proceeds to deal with the palaces, of which a few
(of course the late Renaissance ones) are of good architecture,
some very bad, and others whimsical; Lady Craven, arriving
in 1789, was struck with horror rather than with pleasure at
the houses along the Grand Canal, which looked dirty and un-
comfortable, and the gondolas, like swimming coffins, added to
the dismal scene. But the epoch-making visit of the youthful
Ruskin in 1835 has changed all that, and although Fergusson
seems to regret the time when "all the world agreed in
thinking the Ducal Palace ugly," there is small likelihood of
any professional reversion to pre-Ruskinian canons, and a
more appreciative attitude is now possible towards the noble
qualities and originality of the Renaissance architecture of
Italy. Certain it is that if we are minded to regard, on the

[1] See " Venice," Mediæval Towns Series, p. 279.

one hand, Gothic architecture as the expression of a pure national faith and domestic virtue, and, on the other, Renaissance as expressive of material infidelity and domestic corruption,[1] we had better pack our trunks and speed away from Venice before we are swept into the "foul torrent of the Renaissance."

The moral corruption and political cynicism of her rulers had small, if any, causal relation to the decline of Venice, which was due, as has been the decline of empires since history began, chiefly to economic and geographical causes. Political and moral turpitude were no new phenomena in the history of Venice. The cynical exploitation for selfish ends of the pecuniary needs and religious enthusiasm of the Frankish crusaders in 1202 is unparalleled in the dark annals of statecraft, and such glimpses as we are able to catch throughout the dim perspective of early centuries into the morals of the Venetians, leave small doubt that the sexual immorality and unspeakable oriental vices, for which the city was reprobated in later days, were only too rampant in mediæval times : the savage enactments against offenders leave little doubt on that score. Traffic in slaves—white slaves—was a lucrative staple of Venetian trade, authorised, legalised, reputable. True it is that with the accumulated wealth and increasing numbers of an idle, rich class, which is always prone to vicious self-indulgence, social evils became intensified ; but he who shall impute an immoral significance, or deny originality, to the great artistic palingenesis known as the Italian Renaissance, will soon find himself entangled in impossible æsthetic theories and profitless speculations. We have already learned in our study of the Ca' d' Oro that Gothic masters were not averse from faking up Istrian stone with paint to imitate the veining of Greek marble, when the exhaustion of supplies from the East made it difficult to obtain : the façade of the Ducal Palace itself, like the face of a Georgian beauty, was plastered with white and raddled

[1] "The Crown of Wild Olive."

with red, for Professor Boni discovered on its wall-veil, traces of colour applied by the brush, and that some of the tavolette had originally been touched up with white lead. The vehement denunciation of the culpableness, as well as the baseness, of the wretched labours of the "Grainer" with his painted imitation of various woods and marbles, wrings the loins of some of the Gothic masters and those not the least renowned.

That the soaring Gothic, indigenous to northern and western Europe, was a foreign importation and never took healthy root in the classic soil of Italy, is a common-place of the history of architecture; and in Venice this is more absolutely the case than on the Peninsula. The consistent and ubiquitous horizontalism of Venetian Gothic forms a marked contrast to the characteristic vertical habit of trans-alpine Gothic, and nowhere was the transition to the new classical style easier and more natural. The tall gables,

> "And many subtile compassinges,
> As rabewyures and pinnacles,
> Ymageries and tabernacles";

the almost anarchic details of French and German Gothic, were never seen on the lagoons, and the Renaissance there, as in other Italian states, may truly be regarded as a re-awakening of a dormant style rather than the introduction of a new one; a revival rather than a revolution. So far from the Italian Renaissance having been a corruption, it may be more truly said to have been, as a recent writer[1] has observed, rather a purification of Italian Gothic.

The reader will already have remarked, and it will be increasingly evident as this story proceeds, how many of the masters working in Venice were of Lombard origin: it was by way of Lombardy that the Renaissance first entered the lagoon city. From Florence, in those days the artistic and intellectual capital of Italy, the new architecture had already advanced into Lombardy when the territorial expansion of

[1] W. J. Anderson, "The Architecture of the Renaissance in Italy, 1896."

Venice had attained to its utmost limits and when S. Mark's
Lion, like the wolf in the Inferno, who, after a meal was
hungrier than before, was turning his greedy eyes towards
Milan. Padua, Vicenza, Verona, Cremona, Brescia, Bergamo,
had been digested and absorbed, and it is only in accord
with the normal history of states that the superior artistic
development of the conquered provinces should have reacted
on their conquerors.

We may now fitly resume our gondola and make our way
to one of the earliest, if not the earliest, of the Renaissance
palaces in Venice,—the little Palazzo Dario on the Grand
Canal, a hundred yards or so above the Salute Church, and
erected by one of the Lombardi family of masters to whom
Venice owes so much of her architectural beauty.

That this invasion of mainland artists seriously threatened
the supremacy of the native craftsmen and stirred up bitter
professional jealousy, is only too evident from a petition to
the Senate by the Lombard master masons (*magistrorum
lapicidiarum lombardorum*), dated October 12, 1486, three
years after Antonio Rizzo had been appointed to superintend
the repair of the Ducal Palace, consequent on the great fire
of 1483. The masters complained that, owing to the rules
enforced by the native masons, they could neither buy nor
sell things appertaining to the exercise of their craft nor
keep servants to work for them as did other masters of this
city who have their workshops (*apothecas*); therefore, if the
government did not make provision, they must flee to other
states in order to live by their craft. Whereupon the
Senate, having heard their supplication and having consulted
the ingenious artist, Antonio Rizzo, architect of the palace,
who said it was necessary that the Lombard masters be
retained "for the building and restoration of our palace, did
deliberate and determine that these masons might keep
servants and buy and sell as the masters did who had work-
shops in the city; they might remain, notwithstanding the
masonic regulations, so that our palace be more speedily

completed." In 1491, the mason's guild protested against the increasing employment of foreigners in Venice, especially Milanese and other craftsmen from alien lands, who were stated to number 126 masters and 52 servants, and who "will not teach any of our subjects."

Eminent among these Lombard masters, in the latter half of the fifteenth century, stood forth Pietro Lombardo, who, in 1498, succeeded Antonio Rizzo (himself a Veronese master) as official architect of the Ducal Palace and is mentioned in the accounts for the last time in February 20, 1511. He it was who, as we have seen, designed the Church of the Miracoli, who had a large part in the building of the Scuola di S. Marco, and, in 1509, was director of the improvements and restorations in progress at the prisons in the public granaries on Terra Nuova (the site of the present Giardino Reale opposite the Salute). Pietro, who, in his will, dated September 8, 1479, describes himself as Piero Lombardo, son of Ser Martino of Carona (about five miles from Lugano in the Swiss Canton, Ticino) and living in the parish of S. Samuele, was already, in 1475, numbered among the most celebrated masons in Venice. Tullio, who made his will, November 14, 1532, and Antonio, sons and assistants of Piero; Sante, son of Tullio, who made his will, May 15, 1560, and was buried the same year in S. Samuele, leaving property to his sons, Tullio Lombardo, and Zuan Jeronimo Lombardo (called il Lombardino), were equally famous in their art. Sante, who was appointed chief architect of the Scuola di S. Rocco in 1524, designed and superintended the building of the Church of S. Giorgio dei Greci, 1536-1548, and many other Lombardi, whose names are inscribed in various documents seen by Temanza and published by Paoletti, testify to the inherited skill of this talented family. The former found many notices of the Lombardi in the eighteenth century, and adds: In my days I have known here (in Venice) a Pietro Lombardo of that family, a man of fine talent, but loquacious, mordant, and a

savage critic. Another active and outstanding master was
Moro Coducci of Lenna (about twenty miles from Bergamo),
described in the contract for the restoration of S. Giovanni
Grisostomo as Master Mauro of the late Master Martino dei
Codussi da Lenna; he it was who, among other works,
designed the Church of S. Michele in Isola, the Campanile
of S. Pietro di Castello, and, in 1490, was appointed chief
architect of S. Zaccaria. Moro, sometimes known as Moro
Lombardo or Moro Bergamasco, was born before 1445 and
died in 1504. Owing to the unfortunate disappearance of
patrician family archives, it is impossible to say how far any
one of these Lombard masters was concerned in the planning
or building of the fair palaces that were rising along the
Grand Canal when, in 1494, the French envoy, Philippe de
Comines, was rowed along the *Grande Rue* of the most
triumphant city, seated in a state barge sumptuously adorned
with satin cramoisy and rich carpets, between the Ambassa-
dors of Milan and Ferrara, and attended by twenty-five noble
Venetians arrayed in fine silk and scarlet cloth. Comines
describes certain houses faced with white marble and having
also many a great piece of porphyry and serpentine on their
fronts, as having been built a hundred years before, and
therefore can hardly have referred to the Lombardi palaces,
as has sometimes been supposed. There is little doubt that
Ruskin's dating of the Palazzo Dario (after 1485) is nearer
the mark than that of Fontana, who ascribed it to the year
1450. Ruskin, who devoted much time and study to the
palace, and had the almost effaced inscription: *Urbis. Genio.
Joannes. Darius*, renewed, relied for his date on contem-
porary references to the builder of it found in Malipiero's [1]
Diary.

On January 4, 1479, we learn that the news of the
Turkish successes, of the siege of Scutari, and the advance of
a most potent army on Venetian territory by the usual way
of the Friulian passes, having weighed down the Fathers

[1] See page 202.

with apprehension and despair, and the princes of Italy being
in conflict with each other, and the Seigniory alone bearing
the expenses of the war, it was decided, after much debate,
to send Secretary Zuan Dario to the Porte with full powers
to conclude a peace. Zuan was an able and expeditious
negotiator, and on February 21 news came that the disas-
trous peace with the Conqueror of Constantinople had been
concluded. On April 16, the Turkish Ambassador arrived
at Venice (although by order of the magistrates no one,
under pain of death, was to dare to call him Ambassador of
the Turk, but Ambassador of the Seignior), the peace was
ratified, and the envoy presented the Doge with a subtle
kerchief, saying that his Seignior had girt himself with it
and prayed that his Serenity too should do the like in token
of firm and close friendship. But an entry dated July 29,
1484, proves that Dario found his path a thorny one at
Constantinople; he was persecuted by Almoro Minio, the
Venetian Bailo and had returned to Venice. The grateful
Fathers bestowed a princely reward on their Secretary, who
was a Cretan by birth :-an estate at Noventa near Padua,
which had been purchased for 1500 ducats, and 600 ducats
ready money from the Salt Office as a dowry for his daughter,
"because the city calls herself well satisfied with him for
having concluded peace with the Turk." Two MS. letters,
however, acquired by Ruskin and given by him to the
Marcian Library, written by Giovanni Dario, Venetian envoy,
from the Turkish camp near Adrianople, are dated July 10
and 11, 1485, and would seem to prove either that Dario
did not return earlier than the following year or was again
dispatched to the east on another of the diplomatic missions
for which he was often employed by the Seigniory.[1] It is a
reasonable assumption that the Secretary was enabled by
the money grant to build the house subsequently known as
the Ca' Dario, and that its date is after 1485. The unilateral
leaning façade of this exquisite fabric, still retaining its

[1] See Malipiero, A.D. 1475 and 1487.

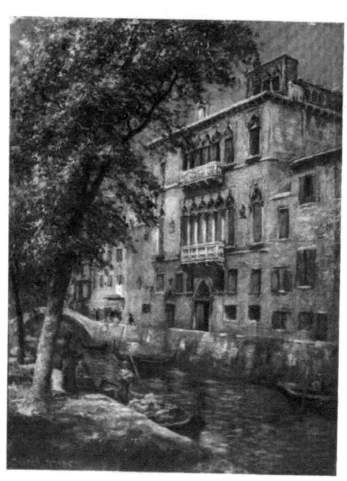

PALAZZO NANI-MOCENIGO

adornment of rich and precious marbles, and bearing a faint
semblance of its once brilliant coloration, is one of the most
picturesque objects along the whole range of the Canal.
The Gothic chimneys and the loggia at the back are recent
additions.

A few strokes along the Canal will bring us before the
Palazzo Manzoni, somewhat later in date and more regular
in design. The fine sense of rythym and proportion which
dominated the Renaissance builders is here more apparent;
the lateral symmetry is well maintained, the fenestration
harmoniously grouped and balanced. If we turn from
general impressions to study details, the result is less
satisfying. Selvatico inveighs against the lower cornice
with its clumsy (*goffi*) vase decorations, vainly imitative of
antiquity, and that *misera cosa* the composite capitals of
the basement. In truth, the whole treatment of the sea-
story in this, as in other early Renaissance palaces, is some-
what bald, the meagre decoration of the window apertures
being especially apparent. It should, however, be borne
in mind by the traveller that the lower story was the
business portion of a Venetian house where goods were
landed and warehoused and where the owner had his offices,
the finer art of the builders being always lavished on the
upper façade. Let us, therefore, turn to the lovely balcony
of the second floor which Selvatico declares will compensate
with usury for all other deformities. The Oriental marble
veneerings and discoid decorations are seen at their best
in this palace, and are especially pure and rich: the central
group of windows and the angles of the palace are framed
by pilasters—a characteristic feature of the Lombardi
designs.

Let us now cross the Canal and rest awhile opposite the
broad foundation and abortive structure of the Ca' del
Duca, a few houses beyond the Campo S. Samuele. The
former palace of the Venetian condottiere, Count Francesco
Sforza (the Palazzo Foscari), having been confiscated by his

paymasters, another home was found for the Duke on the Campo of S. Polo, four years after the peace of Lodi in 1454 had again brought about more friendly relations between the two powers. It was formerly the residence[1] of Gattamalata, another of the famous soldiers of fortune in the employ of the Republic who fought, or rather manœuvred, for their employers, since the losses of many an Italian battle scarcely exceeded those of a modern sham fight. Duke Francesco, however, coveted a more important position, and in 1461 exchanged his house in S. Polo with Marco Corner, father of Caterina, the future Queen of Cyprus, for a site on the Grand Canal, whereon the foundations of a grand new palace had been laid. The balance of the deal, 8000 ducats, which was to be paid in five yearly instalments, was still only partially acquitted at Sforza's death, although he had pawned his ducal crown to meet his debts at Venice. On January 15, 1461, Benedetto Ferrini, a Florentine architect, was despatched from Milan with two assistants charged by Sforza to execute models of the new house. Eleven days later Ferrini wrote to his patron, enclosing the design of the existing foundations and informing him that at Venice the masters were paid at double the rate usual in Milan, that he already had put in hand two designs on which three masters were at work, and that twenty days would be necessary for their completion: Corner was a magnanimous man and had already begun a magnificent and stupendous work and, so far as he, Benedetto, was concerned, will was not lacking on his part to raise a most beautiful edifice. On July 14 the architect was recalled to Milan, and though work on the palace was still in progress in 1462 the great project was never achieved and was probably abandoned on Sforza's death in 1466. This was the first attempt by a Florentine architect to import into Venice the rusticated façade already popular in Tuscany, and the disposition of the bold angle

[1] See p. 183.

GARDEN PALAZZO CAPPELLO.

shafts, the amplitude of the site, and the reproduction by Paoletti of a grandiose and original design from a MS. in the Marciana which bears indications of being one of those executed by the architect, only evoke an echo in a modern visitor's mind of the regret expressed by a canon of Milan, Cathedral, Pietro Casola,[1] who, in May 1494, found himself in Venice with some days to spare owing to delay in the departure of the pilgrim galley to Jaffa. Casola employed his time in visiting, under the guidance of the Milanese Ambassador, the chief sights of the city—a city whose beauty, magnificence, and wealth were so incredible that he felt unable to tell or write of them fully. The large and beautiful palaces splendidly decorated and furnished, worth, some a hundred, some fifty, some thirty thousand ducats, were too numerous for him to undertake to describe, but the foundations of the Sforza Palace he beheld with sorrow, and, as a Milanese, deplored that this most remarkable beginning of a magnificent palace for the Sforza family and to the honour of Milan, had not been completed.

A few boats' lengths beyond this reach of the Canal, we rest our oar before the Palazzo Corner-Spinelli, which, in its tall, stately basement, more nearly approaches the classical type of Renaissance architecture. Here, again, we observe the more simply designed business story, with its severe rusticated decoration, in marked contrast to the elaborate treatment of the superior stages. The fenestration of the two upper floors, obviously suggested by Florentine models, and especially by Michelozzo's Palazzo Riccardi, is admirable in its restrained simplicity and grace and balanced symmetry. A central pair of two-light windows, with their pear-shaped eyes and tracery, embraced by the broad and stately sweep of

[1] "Canon Pietro Casola's Pilgrimage to Jerusalem in the Year 1494," by M. Margaret Newett: Manchester University Series, 1907. The Italian text published 1865 by Count Giulio Porro is rare, and no copy exists in the British Museum. The English translation and introduction and notes are a most able and scholarly production.

the outer arches, are balanced on either side by single two-light windows, their spandrils decorated with disks of porphyry and serpentine ; the charming lateral balconies of the piano nobile with original trefoil projections are the only examples of their kind in Venice. The whole façade of this exquisite Renaissance edifice is knit together by superposed pilasters at the angles, and crowned by stately decorated cornice, in which disks of porphyry and serpentine, alternate with festoons of flowers. The façade is unsurpassed along the Canal for simple grace, and its beauty does but grow on one the more it is observed. Paoletti has plausibly suggested that Moro Coducci may have had some share in the ultimate design of this building.

With the impression of this fair palace fresh in our minds, we may now opportunely make our way to the Palazzo Vendramin - Calergi, at the further end of the Canal, opposite the Fondaco dei Turchi. This, one of the most perfectly harmonious and beautiful of domestic edifices, not only in Venice but in Europe, is placed first among the four chiefest palaces on the Grand Canal, which are singled out by Francesco Sansovino for the merit of their architecture, for the art of their decoration, the majesty and grandeur of their mass, their great cost, and for every quality that a well-conceived edifice demands. And these are selected because it is impossible to describe all the palaces, and equally impossible, as the younger Sansovino knew from experience, to satisfy one's eyes by beholding their beauty. This building, ordered by Andrea Loredan in 1481, and still bearing the Loredan scutcheon, can be fairly accurately dated, for, although some delay seems to have taken place in executing the commission, since no trace of the structure is discernible in the Jacopo de' Barbari map of 1500, it is clear that it was standing in 1509, for on August of that year an entry in Priuli's diary proves that Andrea Loredan *quondam* Nicolo was banished to Mazzorbo for six months, he having refused the charge of General Proveditor in the Friuli, and, being

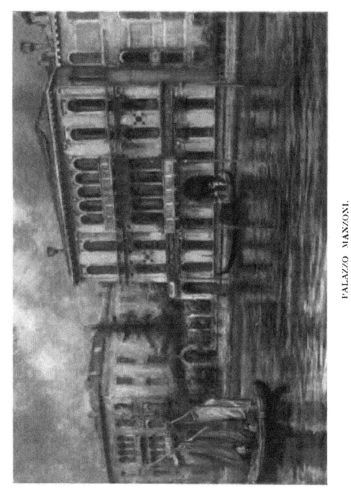

PALAZZO MANZONI.

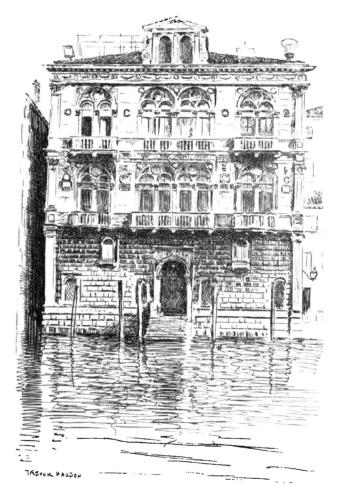

PALAZZO: CORNER-SPINELLI

rich, proposed to settle down comfortably in the place of his exile, although he had built that most noble palace in the parish of Sta. Ermagora, which is one of the most conspicuous in the city : a note in the margin by the copyist of 1726[1] adds, "The Palazzo di Ca' Loredan, now the Ca' Grimani-Calergi." The design, erroneously attributed by Temanza to Sante Lombardo, and believed by Paoletti to have been due to Moro Coducci, is a masterpiece of early Renaissance architecture. Its classicism is of a more advanced type than that of the Corner-Spinelli ; the three Corinthian orders of its façade are consistently maintained, and the window tracery of the basement, which is generally plainer in design, is uniform with that of the superior stories. The central fenestration of three pairs of two-light windows is balanced by lateral windows, also of two lights : the tracery bars are flatter than those of the sister palace, and the eyes have assumed a circular form. The columns of the first floor or piano nobile are fluted, and it is adorned by a series of decorated balconies running along the whole façade. The second floor is more simply treated, and the whole is crowned by a stately cornice, with reliefs of horses, eagles, classic vases, and scutcheons. Other reliefs of lions and Medusa heads adorn the façade, and two classic heads are carved in the spandrils of the sea-portal, whose keystone has a relief of an eagle. For this majestic structure the finest material was provided. The Istrian stone of the façade came from the best quarries ; the smaller columns are of veined Oriental marble ; the inter-columnar incrustations are of the same noble material ; and the decorations, of porphyry, serpentine, and other precious marbles. Temanza, whose sympathies are more generally evoked by the later Renaissance architecture, is eloquent in his appreciation of this edifice, "which for its amplitude, commodiousness, and mangnificence surpasses every other in the city." The majesty, symmetry, and elegance of all its parts together, and of each one in

[1] See pp. 203, 204.

particular, he declares to be almost inimitable; and "although there may be façades of greater bulk, and indeed of more correct architecture, this surpasses them all by a certain delicious relish in the composition which may be tasted but cannot be expressed in words." Fergusson is no less warm in his appreciation of the palace, which he eulogises as " being perhaps without exception the most beautiful in Venice." "Nothing," he adds, " can exceed the beauty of the proportions of the three cornices, and the dignity of that which crowns the whole. The base is sufficiently solid without being heavy, and the windows being all mullioned and the spaces reinforced with three-quarter columns, there is no appearance of weakness anywhere, while there is almost as much opening for light and air as in the Palazzo Trevisan or any building of the age." Both it and the Corner-Spinelli "are similar in design, and in both, the details are designed with singular elegance; and what ornament there is, besides being appropriate and good, is so arranged that it supplements the 'Orders,' and, as it were, links the parts together, so that the whole appears as one original design. There is, perhaps, no other modern building in which classical pillars are used with so little feeling that they are borrowed or uselessly applied; every part is equally rich and ornamental, and every ornament seems designed for the place where it is found."

The palaces we have now studied are placed by Ruskin in the period of the early Renaissance, when architecture, trying to retrace her steps, fell back to Byzantine types after the corruption introduced into Gothic. The grandiose example of Renaissance domestic architecture before us is not even mentioned in the "Venetian Index of every building of Importance in the City of Venice or near it," and is only casually referred to in passing in the text of " The Stones of Venice." The traveller's own artistic sense must decide whether the Palazzi Manzoni, Corner-Spinelli, and Vendramin-Calergi are to be regarded as betraying lack of

invention, artistic poverty, and a harking back to earlier types, or a new spirit manifesting itself in expanding artistic culture; and whether the Lombardi palaces evince feebleness and want of soul in the conception of ornament, marking them as belonging to a period of decline.

The Loredani were ranked among the second class of patrician families, those who were members of the original Great Council at its first constitution in 1296, and are best known to English folk by the wonderful portrait of Doge Leonardo Loredan in the National Gallery, by Giovanni Bellini. One, Andrea Loredan, an earlier and more worthy son of Venice than he for whom this palace was raised, and a typical example of the great heroic nobles [1] who built up the fabric of her power, stands forth from some pages of the diary of his contemporary, Girolamo Priuli, which may here be transcribed in all their quaint prolixity. The disastrous naval battle of Sapienza in 1499, which wrecked for twenty years the fortunes of the patriotic Antonio Grimani, will be familiar to readers of Venetian history. "Now Andrea Loredan, *quondam* Ser Francesco," writes Priuli, "that notable gentleman and worthy of perpetual memory, whose fame shall be sempiternal, was appointed by the Seigniory Proveditor at Corfù. Hearing that the Turkish forces had gone to Lepanto, and there being no danger of attack at Corfù, it seemed to him that he tarried in vain at that place, and being greedy of honour and of glory purposed to go to the fleet and fight. Straightway collecting eight light brigantines and four caravels, all in good condition, he joined the armata, for which in Venice he was greatly blamed. The admiral on beholding this most worthy gentleman received him joyously, because the crews of Loredan were in highest reputation and fame, and bade him choose whatsoever emprise seemed most fitting. Having heard the admiral's will, and being

[1] According to Malipiero, Andrea's ship was the best kept in the Venetian navy, and no gaming or blasphemy was permitted.

jealous of his country's honour (and such men are worthy of perpetual memory and of being rewarded in life and death), he would not remain behind nor flee the foe, as did some others, but purposed to seek out the hottest fight. Quickly he entered a small boat and flung himself on the ship *Pandora*, which already had set forth to attack the enemy. Having climbed to her deck he, even as a worthy patrician and lion-hearted gentleman, attacked the said enemy's ship on one side and Albano Darmier on the other. And then began a most cruel, bloody and bitter combat, and if all the other gentlemen had done the like, blessed were Venice that day for she would have obtained the most glorious victory that she ever won. What the fight on these three ships was, with bombards and with hands imbued in blood, I leave thee, reader, to consider. So well did the Venetian ships bear themselves that in a short space of time they were victorious, which thing the Turks seeing, purposed to die rather than be vanquished, and so they placed fire in some powder barrels and flung them on Albano's ship, where the fire took such hold that nought availed, and the Turks set fire to their own ship, willing rather to be burnt than be vanquished. O glorious hearts! The fire having caught, all those three ships were consumed most miserably, and what terror this thing caused to the Turkish fleet and to ours I cannot tell thee. The crews seeing there was no help flung themselves into the water. Ours were slain in the water by the Turkish brigantines and the Turks escaped, but what with the fighting and the fire many perished. Albano flung himself into the water and was taken alive by the Turks. And that worthy patrician Loredan beholding the fire on his ship, and that the admiral gave him no help, and that it behoved him to die either by the hand of his enemies or be burnt alive, purposed rather to burn than to fall into the hands of the enemy. And so taking the standard of St Mark in his hand he said: 'Born was I and have lived under this banner and beneath it will I die.' And he entered into the fire.

In such wise was the end of so great a man, who made the whole East to tremble at his name."[1]

The history of the Loredan mansion has been a chequered one. In 1581 it was sold by the Loredani to the Duke of Brunswick for 50,000 ducats, who in his turn disposed of it to the Duke of Mantua for 91,000 ducats. In 1587 it was sold by auction, and Vittore Calergi became its possessor for the comparatively small sum of 36,000 ducats; by the marriage of Vincenzo Grimani with Marina Calergi, Vittore's daughter, in 1608, it devolved to the joint owership of these two patrician families. But only to be disgraced later by an odious crime. Their son Victor, made Abbot of Mozzio in 1629, of Rosazzo, and of S. Zeno in Verona in 1639, was outlawed, together with his brothers John and Peter, from Venice for disgraceful crimes and factious conduct. Surrounded by their bravos and bullies, the three brothers continued to swagger insolently about the city in spite of the ban, and one January night in 1658 seized Francesco Quirini-Stampalia, a rich and cultured patrican who had aroused their enmity, as he was leaving the theatre near S. Zanipolo after a rehearsal, hustled him into a gondola and carred him to their palace. There in the white house in the garden, he was savagely done to death. The three brothers were cited before the Ten, whose summons they flouted and were sentenced *in contumacio* to outlawry again; their property to be confiscated; the portal of their palace to be branded with the Lion of St Mark; the *Casa bianca* to be razed to the ground, and on its site a column of infamy reared bearing the inscription: *Abbot Vetor, Zuane and Piero, the Grimani Brothers, were outlawed for having against public liberty barbarously conducted into their own house and killed by many arquebus shots, Ser Francesco Querini, son of Zuan Francesco.* But the Grimani and Calergi were rich and powerful; Maria, sister of the outlawed assassins, had in 1638 married Nicolò

[1] According to Malipiero, however, who took part in the battle, Loredan escaped from the burning *Pandora*.

Vendramin, and yet another patrician became their potent ally. Moreover, the Republic was engaged in her obstinate quarter-of-a-century duel with the Turk for the retention of Crete; money was needed and means were found ere two years had elapsed to free the brothers from the ban and to reinstate them in possession of their mansion. Probably neither the *Casa bianca* was razed, nor the column of infamy set up, for if by the *Casa bianca prospettante il giardino* is meant the garden wing, that, is said to have been added by Scamozzi half a century before the assassination, and is standing to-day. In 1740, the last male descendant of the Grimani-Calergi died, and the property passed to the Vendramini, who in turn became extinct in the person of Nicolo Vendramin, the palace having already been ceded to the Duchesse de Berry in 1844. Inherited by the Duc de Chambord it still remains in the possession of the Bourbons and is classic ground to lovers of music, from its association with Richard Wagner, who died here in 1883; many relics of the master's stay are piously preserved in the rooms he occupied. The inscription *Non nobis non nobis Domine* on the façade of the palace has won for it the title of the Palazzo Non Nobis, among Venetians.

The Vendramin were rich provision merchants and belonged to the *case nuove* or families ennobled after the Chioggian war, and Malipiero relates that on March 15, 1477, Antonio Feleto was sentenced to two years' imprisonment and then to be banished for having flouted the election of Doge Andrea Vendramin, saying that the Forty-one must have been hard put to it to choose a cheesemonger for doge.

The artistic treasures that adorned these private mansions and administered to the pride and sumptuousness of their cultured owners are in some cases known to us. An amateur of much taste and a connoisseur of painting known to moderns as the "Anonimo," has left us a catalogue of the chief works of art he saw in the house of Messer Gabrieli Vendramino in 1530, ancestor of the Nicolo Vendramin, who

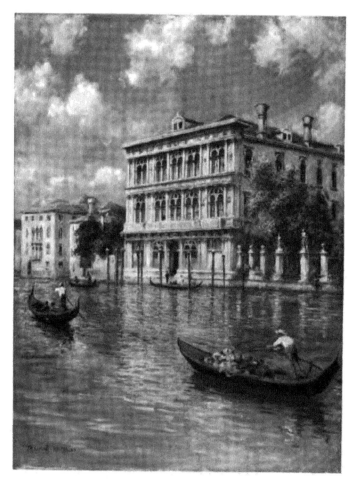

PALAZZO VENDRAMIN CALERGI.

married Maria Grimani in 1638. The list is of great interest and enumerates:

[1] Portrait of Messer Gabriel Vendramin in oil, by Giovannino del Comandader.

The little landscape on canvas, representing stormy weather and a gipsy woman with a soldier, by Giorgio da Castelfranco.

Picture of Our Lady and St Joseph, by John Scorel of Holland.

The dead Christ in the Sepulchre with angels supporting him, by Giorgio da Castelfranco, repainted by Titian.

Eight small pictures in oil, by Flemish masters.

Three small portraits in tempera, by Giovanni Bellini.

Small painting in oil on a panel of Our Lady, a perfect work, by Roger of Bruges.

Portrait by Giacometto.

Large book of drawings with a lead pencil, by Jacopo Bellini.

A vellum book in quarto with coloured animals, by Michelino Milanese.

Small vellum book in octavo with animals and candelabra drawn by the pen, by Giacometto.

Book in quarto with coloured birds, by ——.

Book in quarto of coloured birds, by the priest Vido Celere; two vellum books in quarto with fishes, two books containing the antiquities of Rome, by the same.

Small parchment book in octavo with pen drawings of the antiquities of Rome, and one in quarto, same subject, in silver print, by ——.

Two pen and ink drawings by Raphael: one on vellum, the History of Attila, the other on paper, the Nativity.

Antique marbles: The draped nymph asleep; bust of a girl; head of a boy; small nude statue of a woman, mutilated; colossal nude torso; small nude deprived of arms and head; head of a young satyr, from Rhodes; a little girl's head; bas-relief with four figures one foot high.

[1] Abstract from the translation by Paolo Mussi, 1903.

Of those catalogued by the Anonimo, the Giorgione is preserved in the Palazzi Giovanelli, the two small Flemish panels are in the Doria Pamphili Gallery at Rome, the Jacopo Bellini drawings are at the British Museum, the History of Attila by Raphael at the Louvre. The remainder of this priceless collection has not been traced. Sansovino says that Messer Gabriele, who during his life was a great amateur of painting, sculpture, and architecture, collected divers things by the most famous artists of his time, and made his palace the ridotto of all the virtuosi of Venice, and that paintings by Giorgione, Gianbellini, Titian, and Michael Angelo were preserved by his successors.

 We may now turn our prow Rialto-wards and observe for a few moments the Palazzo Piovene, adjacent to the Palazzo Erizzo: this is another of the Early Renaissance structures of the Lombardi type, unilateral in design and not without grace, although the heavy shafts and rather clumsy imposts of the three-light window of the piano nobile somewhat detract from the general effect. The oblong and discoid incrustations between the lateral one-light windows are curiously framed by ribbon-like decorations, which we shall find employed with greater art in the Palazzo Contarini dalle Figure. The repeated deviations from the general design of lateral symmetry in the façades of the Gothic and Early Renaissance palaces, in some cases, as in the Palazzo Foscari, the irregularity being of the subtlest character, cannot have failed to impress the spectator: it is too frequent to be due to caprice or chance, and various reasons have been adduced to explain the phenomenon. One suggestion, consistent enough with the Italian temperament, is that the break in symmetry was deemed to be a protection against the evil eye.

 A more beautiful and characteristic example of Lombardi decoration next claims our admiration, and we interrupt our journey down the Canal and turn by the rio di S. Felice o Noal and the rio di Sta. Fosca to the

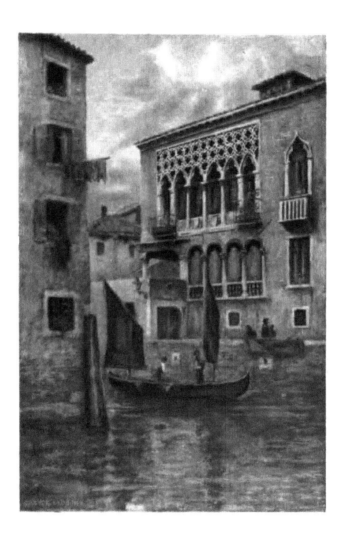

magnificent portal of the Palazzo Vendramin a Sta. Fosca (no. 2410), which stands over the Fondamenta to the right of the rio. The jambs in the upper portion (the lower has been restored) still retain the original rich and lovely decorations of the Miracoli type, executed with great refinement, and the exquisite corinthian capitals and graceful frieze of the old building, which was erected about 1500 for the patrician Leonardo Vendramin, survive in the later building.

Returning to the Canal, we pursue our course to the neglected fabric of the old Palace of the Lords of the Treasury, known as the Palazzo dei Camerlenghi, from which so fine a spoil of pictorial art from the brush of Bonifazio has been devolved to the Accademia of Venice. This rich and noble palace at the foot of the Rialto bridge, says Temanza, was completed in 1525, and is in the manner of Guglielmo Bergamasco. The mouldings, adds that writer, and the ingenious disposition of the Halls and Chambers, manifestly declare it to be one of his works: moreover, the architect has succeeded, by a masterly treatment of this most irregular site, in attaining to a fine symmetry of design. Paoletti, however, is inclined to seek for its author in Bartolemeo Bon of Bergamo, working in collaboration with Antonio Scarpagnino and some Lombard masters, to whom the friezes and other decorative details may be due. An entry, however, in Malipiero proves the palace to have been built in 1488 at the expense of the four banks that kept their money there,[1] and seems to exclude both Bon of Bergamo and Scarpagnino from any share in its construction. The excessive window space and consequent weakness in the design have been adversely criticised by Fergusson ; but, if it be permissible to say so, somewhat impertinently, for

[1] Quest' anno (1488) è stà rifatto l' officio delle Rason Vechie di Camerlenghi e di Estraordinarii a Rialto a spesa de i quattro banchi che luoga la i so danari.

precisely this aspect of lightness was what the Gothic and Early Renaissance architects aimed at and their patrons desired; it was a quality admirably consistent with the soil of Venice, with the requirements of Venetian life, and far more in harmony with the *genius loci* than the heavier structures of later masters. The fabric is raised on the site of the house of the old Protomedico of the Commune of Venice.

Again we will deviate from our course and get ourselves ferried along the rio opposite, to the rio della Fava, over which on the left hand just before we reach the Palazzo Faccanon, stands a most charming little palace of the Lombardi type—the Palazzino Gussoni. Unhappily this daintly little palace has been disfigured, as have so many early palaces in Venice, by the superposition of an ugly upper story, and has suffered much at the hands of careless owners —the sea-story is now occupied by a furniture dealer—but enough remains of the exquisite Lombardi decorations and other gracious features to repay a careful examination: the admirable design and lovely decoration of the stone lintel which supports the projecting upper story to the left, is a rare feature in Venetian architecture. We will now sweep round to the rio di S. Luca, over which, on the left, just before its opening on the Canal, stands the fine façade of the Palazzo Contarini a S. Luca, a more imposing edifice by the later Lombardi masters, and sometimes assigned to Sante. This, says Diedo, has an aspect of matronly composure, mingled with much grace, and combines an amiable variety of treatment with regularity of general design. Unerring are the proportions of its windows; the whole façade is resplendent with fine marbles and distinguished by originality of conception, exquisiteness of execution, and admirable effect. The palace, now occupied by the Compagnia Grande delle Acque, is sadly dimmed by the corroding salt of the sea; the virile design of the piano nobile, the varied details of the decorations, the bold upper cornice may be more con-

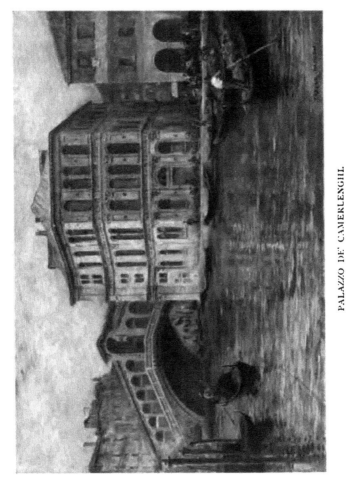

PALAZZO DE' CAMERLENGHI.

veniently studied from the side window of the Palazzo Grimani.[1]

Across the Canal and contiguous to the Palazzo Layard is the Palazzo Grimani—Giustinian, formerly a Vendramin, one of the most sweetly harmonious and simple in design of the Lombardi houses in Venice. We note the lovely designs of the capitals of the pilasters generally, and especially those of the piano nobile, the inlays of verde-antico and porphyry and serpentine, the peculiar ribbon-like decorations affected by the later masters, and the classic pediments over the single-light windows of the sea-story.

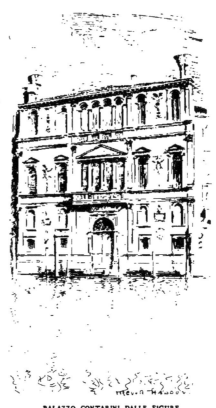

PALAZZO CONTARINI DALLE FIGURE

Our chronological and sequential plan will now lead us to the Palazzo Contarini dalle Figure, a little beyond the

[1] See note, p. 89.

Corner-Spinelli. Here the design makes a further advance towards classic models. The window tracery wholly disappears, and the central group of windows of the piano nobile, framed by pilasters, is divided by lofty and graceful Corinthian columns, surmounted by a pediment and balanced at either side by two lateral single-light windows, equally lofty, and also surmounted by pediments. Between the lateral windows are reliefs of shields with eagles above them; and torches attached, in the form of trophies, to the stems of trees, whose branches are lopped off, but with one or two faded leaves, delicately carved and scarcely perceptible, here and there between the projecting spur of the boughs, as if, says Ruskin, the workman had intended to leave us an image of the expiring naturalism of the Gothic school. Between the lateral windows of the upper and mezzanine floors are the usual discoid and oblong inlays of coloured marbles, here, charmingly framed in ribbon-like decorations over which winged cherubs hover. A rather weak cornice crowns the whole façade, which is knit by the characteristic angle pilasters. The date of the building is early sixteenth century. We may now dismiss our gondola, and set forth on foot to examine some of the early Renaissance palaces di quà dal Canale.

WALL-VEIL DECORATION—PAL. TREVISAN

CHAPTER XI

The Early Renaissance Palaces di quà—The Palazzi
Trevisan, Malipiero, Grimani—The great Venetian
Collectors of Antiquities—The Palazzo Zorzi—The
Cortile of the Ducal Palace

"Ye tradeful merchants that with weary toil
Do seek most precious things to make your spoil."

—*Spenser.*

FROM the Piazzetta dei Leoni we again fare to the Calle
di Canonica, and before crossing the bridge take our stand on
the Fondamenta Canonica, and with as much convenience as
the narrow point of view will afford, raise our eyes to the
magnificent front of the Palazzo Trevisan, which Bianca
Cappello gave to her brother Vettor. As with the other
domestic architecture in Venice by the Lombardi so with this:
nothing is known of its actual builder or builders, or of the
date of its erection. There can, however, be but little doubt,
judging by the style of the mural decorations, that it was
designed subsequent to the Ca' Dario and anterior to the
Vendramin: the year 1500 may therefore be accepted as a
proximate date. It is the largest of the Lombardi houses:
three water-gates open from its ample sea-story, designed
in accord with Venetian custom, more simply than the three
superior floors, which, in their admirable proportion, rhythmic
symmetry, and rich inlay of precious marbles, are unsurpassed
in Venice. The exquisite motive of the dove and olive branch
reproduced in the "Stones of Venice" will be seen to the left
of the first story: it is balanced to the right by a different
design, equally ingenious and pleasing: two classic Roman
figures in half relief bearing shields are placed above at either

147

wing. But the effect of the whole composition is sadly marred by the erection of a new bridge over the rio, opposite which, two windows have been disfigured by being made into doors in order to give easier access to the interior of the palace. Ruskin is lavish in praise of this stately fabric, and declares that the whole treatment of the façade attains to an ideal perfection which places the Lombardi Palaces among the most notable architecture in Venice.

The Trevisan were a comparatively late accession to the patrician class, and were ennobled after the Genoese war in 1381, they having been one of the thirty citizen families who had contributed to the success of the supreme struggle with the secular enemy of Venice.

We may now return to the Merceria, and again betake ourselves to the Campo S. Maria Formosa, noting in passing over the Ponte della Guerra behind S. Zulian, to our left, a fine early Renaissance portal on the Fondamenta (no. 5420), which, says Temanza, once formed part of a magnificent palace begun at Portogruaro by Guglielmo Bergamasco for the patrician family of the Tasca. Such was the magnificence of this beautiful portal with its channelled columns, adds Temanza, that a gentleman of that house hath deemed it a laudable enterprise to spoil Portogruaro of so fine an ornament. The Tasca were lovers of art, and some idea of the riches of a Venetian country house in artistic treasures may be conceived by the inventory of the possessions of Andrea Tasca at Mira Vecchio and Portugruaro taken in July 1675, and published by C. A. Levi, which runs to 133 items, many of them referring to seven or more pictures catalogued together.

Arrived at the Campo of S. Maria Formosa [1] we will direct our steps to its south-east end, and pause before the

[1] If we care to deviate from our way and walk to the end of the Calle dell' Ospedaletto (p. 76) we shall find opposite, in the Corte della Terrazza, amid dirt and squalor, the remains of a beautiful early Renaissance stairway, at the top of which is a finely decorated portal.

early Renaissance Palazzo Malipiero, over-looking the rio, now occupied by the Consulates of the Netherlands and of Brazil. The façade of this palace, says Diedo, is of a temperate nature, whereon, after having lifted our eyes and contemplated with amazement the conspicuous and imposing mass of the Grimani and the Cornaro palaces, we may lower them again, and dwell, as in sweet repose, on the inimitable grace of the Lombardi architecture. Its façade is jewelled, he adds, like a refulgent vesture, with circles and oblongs from which depend other circles made precious with choice marbles, with fair devices of fluttering bands of ribbon which invest its noble front with a character of most exquisite elegance. The more sober judgment of Paoletti, however, discovers a certain heaviness in the imposts of the central window shafts of the *piano nobile* similar to those of the Palazzo Piovene, and believes both palaces to have been designed by the same architect.

Apart from technical criticism the lay mind will be content to admire the simple and effectual design of the whole façade, the pleasing variation in the architecture of the two superior floors, and the noble cornice, decorated with medallions enclosing heads of excellent workmanship, balanced on either side of a central medallion enclosing the Christian symbol I.H.S. The lovely lower balcony, too, with its inlay of porphyry, serpentine and verde-antico, now sadly dimmed in splendour, is especially worthy of notice. Here, as in the Trevisan, the harmony of the façade is marred by the new bridge giving access to a door which has been contrived from one of the original windows. Temanza has ascribed the building to Sante Lombardo, and it was probably raised in the first half of the sixteenth century: the classic pediments over the arches on either side of the *piano nobile* confirm this.

The Malipieri in the fulsome and fantastic genealogy of the compiler of the Campidoglio Veneto are said to have descended from Messte, son of King Pelemene of

Paphlagonia, who, after the ruin of Troy, passed with Antenor to Italy, and settled on the island now called Castello, but then, Nova Troya; and this family, then called Mastropietri, adds the writer, is now called Malipieri. But the Malipieri had small need to draw on the toadyism of genealogists: they gave their fatherland the heroic doge Orio Malipiero, who subdued stubborn Zara and fought heroically in the Holy Land; a second doge of their race filled the ducal chair in 1457; and many a brave soldier and ripe scholar, including the famous annalist, have rendered their name illustrious: they only became extinct in 1856.

Crossing the rio by the Ponte di Ruga Giuffa on our left we descend to the classic portal, attributed to Sanmichele, of the Palace of Cardinal Grimani, at the end of the narrow Ramo Grimani; it is of stately proportions, and supports a tall graceful window framed by two Corinthian columns, below which the Cardinal's arms are finely sculptured: the spacious courtyard with its noble monoliths of Verona marble and Ionic and Doric capitals deserves a visit. But of its former magnificence how little remains! "Everything," says Temanza, writing towards the end of the Republic, "in this noble cortile breathes forth grandeur; around the colonnades of exquisite symmetry stand monuments of Greek and Roman antiquities and colossal statues which might adorn the most distinguished museums in Europe": the stairways, the ceilings and chambers, in his day, were decorated with lovely designs in stucco and marble, and with magnificent paintings by Giovanni Battista da Udine, Francesco Salviati, Francesco da Forlì, and other famous masters; and now the halls—where, for more than three centuries mighty princes of the church held almost regal sway, and spread themselves in lordly splendour; where doges and kings were entertained with lavish hospitality—are littered with the stock-in-trade of a dealer in masonry. The Grimani were among the most princely families of Venice, and renowned for their wealth of artistic treasures and classical

antiquities. Whole libraries have been written on their collections, which attracted amateurs from all Europe, and detained for a day Duke Alfonso of Ferrara and Henry III. of France during their visits to Venice, and which formed the nucleus of the present Museo Archeologico in the Ducal Palace. The founder of the collection, Cardinal Domenico Grimani, was the son of Doge Antonio Grimani, who, says Priuli, spent 30,000 ducats, ready money, to gain a Cardinal's hat for his first-born, when he reached the age of twenty-five. The young Cardinal lived at Rome, before the sack, in the great period of the Renaissance masters ; when Bramante and Michael Angelo were in the height of their fame, and Raphael, as he issued from his house to go to the Papal Court, fared like a prince, and never without a train of fifty painters or more, all worthy and good, who bore him company to do him honour. The enthusiasm for classic antiquity was at its highest ; daily, ancient statues, torsi and inscriptions were unearthed, and it was in the Cardinal's own vineyard that he delighted the Venetian Ambassador in 1505 with a sight of the abundance of marble figures and other antiquities he had discovered in his excavations, most of which found their way to his house at S. M. Formosa in Venice. Domenico died at Rome in 1523, leaving most of his artistic treasures to the Seigniory : in the inventory dated December 22, 1528, recently published by Levi, they consist of 47 items, including 8 chests of paintings. The great Cardinal, and famous humanist and scholar, to whom Erasmus dedicated his paraphrase of the Epistle to the Romans, is also known to have possessed a rich collection of Hebrew, Chaldean, Armenian, Greek, Latin, and Italian MSS. The Anonimo, who visited the Cardinal's palace in 1521, has given a catalogue of the paintings he saw there, which we may here summarise :—

[1] Half length portrait in oil of Isabella of Aragon, by Memling. Portrait in oil of Memling, by himself.

[1] Translation by Paolo Mussi, 1903.

Two unknown portraits, by the same.

Many other small pictures of saints in oil, all with shutters, by the same.

Some small pictures in oil, with jewels and precious stones very cleverly imitated, by Girolamo Todeschino.

Many small landscapes on panel, by Albert of Holland (A. van Ouvater).

Large canvas, the Tower of Nimrod, set in a landscape, by Joachim (Patenir).

Large canvas, St Catherine (of Alexandria) and landscape, by the same.

St Jerome, by the same.

Canvas representing Hell with a great variety of monsters, by Jerome Bosch.

Canvas representing Dreams, by the same.

Canvas representing Fortune, with the whale swallowing Jonah, by the same.

Some works by Barberino Veneziano (Jacopo dei Barbari).

Some works (not specified), by Albert Durer and Gerard of Holland.

A great cartoon, by Raphael, the Conversion of St Paul.

The celebrated "Book of Hours," sold to the Cardinal for 500 ducats, and now generally known as the Grimani Breviary.

Of these pictorial possessions, all that is known to survive is the Grimani Breviary preserved in the Library of St Mark at the Zecca, which is thus described by the Anonimo[1]: "The celebrated Book of the Offices which Messer Antonio the Sicilian sold to the Cardinal for 500 ducats, which was illuminated by many masters during many years. There are . . . sheets with miniatures by the hand of Zuan Memelin; by the hand of Girard da Guant, 125 sheets; and by the hand of Livieno, 125. Praised above all of them are the twelve months, and among them February with a *fanciullo che orinando nella neve la fa gialla*." This was left by the Cardinal to Marco Grimani, patriarch of Aquileia, at whose decease

[1] Anonimo, "Notizia d' Opera." Ed. G. Frizzoni, 1884.

it was to devolve to the Seigniory in perpetual possession. Marco's successor in the patriarchate, Giovanni Grimani, so coveted possession of the book that the Seigniory permitted him to retain it during his lifetime. At Giovanni's death it was placed in an ebony casket richly adorned with cameos and precious stones and sent to the Library of S. Mark. So enamoured was Giovanni of this sumptuous book that he always kept it near him and never would allow it out of his sight. The Anonimo's attributions do not however always commend themselves to modern critics and Dr Frizzoni, his modern editor, believes that Memling had no hand in its production and gives reasons for assuming Mabuse to have been its chief author.

Sanudo notes in his diary that at the annual ceremony of the Marie at the church of S. M. Formosa in 1526 he saw hangings of cloth of gold and silk, two portrait busts in bronze of the most Serene Prince, Antonio Grimani, and his son, the late Cardinal; and, among other paintings, some, most rich, done at Rome by Michael Angelo, also belonging to the late Cardinal.

But the most numerous and important additions to the classical antiquities of the Ca' Grimani were made by Cardinal Domenico's nephew the patriarch of Aquileia, Giovanni Grimani, il Grande, who is said to have designed the present palace in the style of the Roman Renaissance. Giovanni inherited all the artistic treasures not left to the Republic, gave 3000 crowns to obtain possession of those which had descended to Marco Grimani, and, during his long lifetime, was a most enthusiastic collector of works of art. It is related of him and a rival collector, Procurator Federigo Contarini, that having acquired together a colossal female statue and neither being willing to dispose of his claim to the other, it was decided that the upper half should be considered the property of the Cardinal, the lower of the Procurator. A further contest ensued as to the actual possession, which at length ended in a compromise: the

Cardinal was to have the use of it during his lifetime, the Procurator to have the actual proprietorship. Giovanni, too, left the greater part of his collection to the Seigniory, and the inventory taken after his death in 1593 has been published by Levi. On November 15, 1593, Pietro Pellegrini, secretary and most humble servant of the most Illustrious Seigniory, being informed that Chief Secretary Massa was indisposed and full of business was commanded to attend the most Illustrious Seignior Federigo Contarini the Procurator, and make an inventory of the effects given to the most Serene Seigniory by the late Illustrious Patriarch of Aquileia, Giovanni Grimani of good memory, taking special note of the bronzes and cameos in the small study; and then to do the like with the statues and marble busts. And so after mass Secretary Piero set to work and not having finished by dinner time locked up the study, put the key in his pocket and returned to complete his job in the afternoon; and it was not until two hours after sunset that the cameos and bronzes were safely packed in two walnut chests and stored in the Public Library of S. Mark; and a cameo being missing, Antonio Grimani, Bishop of Torcello, who was present at the inventory, gave one of his own to complete the collection. On November 16 the statues and busts were catalogued and Piero's task was done. Some conception of the range of this vast collection may be found from the fact that the bronzes and cameos included 111 items: the statues and busts 109 items. The secretary's classical equipment left something to desire, for the specifications are particular rather than scholarly: A Naked Woman tearing her Hair with her Hands; Head of a Youth without eyes and with a little bit of the breast; A Quadruped Animal; A Bird; Another Bird; Half a Woman with the Arms; Figure of a Woman half-dressed; Head of a bearded old Man opening his mouth—and so forth. The collection was subsequently arranged by Scamozzi in the atrium of the Libreria Vecchia, and now, in part, survives in the Museo Archeologico.

The palace remained in the hands of the Grimani, who all inherited the family passion for antiquities, until 1864, when the last Grimani, Count Michele, son of Giovanni Carlo and Princess Chigi of Rome, died a bachelor. Two of the old Cardinal's treasures, the statues of Marcus Agrippa, which formerly stood in the Pantheon at Rome, and the Augustus, remained in the courtyard until the later years of the Republic, when the family, seduced by a munificent offer from over the mountains, determined to sell the more famous of the two, the Marcus Agrippa. All fared well, the barge which was to bear the statue away to its northern purchaser lay at the water-gate of the palace; Marcus was being lowered into the boat, when, to the amazement of the family, the gondola of the Ten glided up and their officer in solemn tones said: On behalf of the most Serene Prince, I am come *per augurarghe bon viazo a Sior Marco Agripa prima che el parta*—to wish a pleasant journey to Signor Marco Agrippa ere he starts. Such, even in these later days, was the terror inspired by the Decemvirs that Signor Marco was hastily withdrawn to his old place in the court-yard and the boatmen were dismissed. This famous statue, left by Count Michele to the Republic at his death, now stands in the Museo Civico. It was proposed in recent years that the State should purchase the palace for a School of Architecture, but the eternal want of pence that afflicts most governments, when tribute is to be paid to the Muses rather than to Mars, forbade, and this venerable temple of the arts came into the hands of a private commercial company.

We may now continue along the Ruga and cross by the Calle di Mezzo to the Fondamenta S. Severo and examine more closely the rio façade of the Renaissance Palazzo Zorzi, with its three water gates, the fluted pilasters of the mezzanine, and the fine arcaded fenestration of the *piano nobile*, sparingly decorated by the usual inlays of precious marbles. This palace may be related in date to the Palazzo

Malipiero and, indeed, a document proving the sale of surplus disks[1] of marble by the owner, Domenico Zorzi, in 1500, published by Paoletti, is fairly conclusive on that point. Crossing the Ponte S. Severo, we enter, by the beautiful land portal, the spacious and picturesque Renaissance cortile with the graceful arcading and Corinthian capitals of its colonnaded portico and the lovely, tall two-light windows above it with their slender shafts and charming capitals; after contemplating this, one of the most beautiful remains of the early Renaissance in Venice,[2] we may make our way back by the Salizzada Zorzi, the Calli della Corona and della Sagrestia to the Campo S. Filippo and S. Giacomo, whence a turn to the right will bring us to the Canonica bridge. But before we cross, let us station ourselves awhile on the Fondamenta S. Apollonia and raise our eyes to what is generally regarded as one of the most admirable creations of the early Renaissance in Venice—Antonio Rizzo's rio façade of the Ducal Palace—before we proceed to the equally beautiful façade in the cortile which faces the west. These, with the giant's staircase, which Pietro Casola saw building in 1494, "a stupendous and costly work," and the smaller façade adjoining the basilica, form, in their wealth of design and varied treatment of wall spaces, a veritable museum of early Renaissance architecture. Nothing can exceed in charm and grace the reliefs in the spandrils of the arches to left and right of the great staircase, below Sansovino's Mars and Neptune, and although the interest of the Renaissance architecture of the palace is necessarily subordinate to that of the Gothic, it is to be regretted that so little attention is given by travellers to the exquisite decorative details and general harmony of this lovely cortile.

[1] These disks were obtained by slicing up old columns.
[2] "This (the Casa Zorzi) is a Renaissance building utterly worthless in every respect."—Ruskin's "Stones of Venice."

CHAPTER XII

The Central Renaissance — The Libreria Vecchia — The Corner Ca' Grande — The Palazzi Grimani, Manin, Corner-Mocenigo

"Where are gilded ceilings? Where are halls built by the wealth of private men on the scale of palaces, that the vile carcase of man may move among more costly surroundings and view his own roof rather than the heavens?"

—Paula to Marcella.

WE have seen that the early Venetian masters of the Renaissance, their eyes opening to the beauty of ancient forms, sought an escape from the rank exuberance of declining Gothic by the introduction of simpler designs, whose main features were harmony of proportion and a restrained use of tracery and ornament. They, with the stubborn conservatism and deep patriotism of the Venetian temper, subdued the Tuscan type to their own requirements and artistic ideals; they impressed upon it an individual and national character. The early Renaissance in Venice was a living progressive architecture, evolved from preceding Byzantine and Gothic types, and can no more be regarded as indigence of invention, reverting to and copying dead forms of classic antiquity, than Venetian Gothic can be envisaged as a mere copying of the Byzantine and Romanesque buildings, whose general lines and essential features were taken by its masters as the basis of their new style. In the Lombardo-Venetian Renaissance were interfused elements of Byzantine, Romanesque and Gothic, dominated by a new-risen comprehension of the rhythm, symmetry and imposing mass of classical models. Nor can we admit any inferiority in the treatment of decorative detail in the best work (and

it is by their best work the masters must be judged) of the early Renaissance architects. He whose artistic emotion is not thrilled by the simple naturalness, the exquisite grace, the wealth of invention and perfect execution of the decorative work on the chancel arch of the Miracoli, and other similar carving in Venice, has narrow sympathies indeed.

The early Renaissance architecture in Venice, as we have already noted, drew its inspiration from Florence by way of Lombardy : the central Renaissance was dominated by Rome. But its creators at Rome, none the less, were Milanese and Tuscan artists—Bramante of Milan ; Peruzzi of Siena ; Michael Angelo of Florence—who during the epoch-making period of the earlier decades of the sixteenth century had been drawn to the Eternal City by the magic of its historic past, by the resurrection of its buried architecture, and the magnificence of its great pontiffs. The result of this shifting of the artistic centre of Italy from Florence to Rome was undoubtedly that architecture thenceforth partook more of the nature of a revival of classic models, but it was a revival effected by some of the greatest artistic geniuses the world had ever beheld, who fused the old forms in the fire of their imaginations. Their recreated works are no mere slavish copies of past architecture ; not one of their masterpieces but possesses an individual inspiration ; not one but bears the divine impress of an original mind. We may be very sure that any sweeping and general denunciation of a movement initiated by mighty artists, such as those we have named, is misleading and unjust. A more judicious and profitable mental attitude, if less exciting than fiery declamation, is patiently to ask ourselves and humbly try to understand, what aim the masters had in view; what were their artistic ideals ; what they desired to express? Considerations of the subtle beauty of proportion and of rhythm ; of the nobility of a building, imposing by its austerity, virility, and dignity, dominated their minds : they cared less for decorative details and variety of design in ornament than for

composition in the mass. Their motto was the Napoleonic
one—let details be subordinate to policy ; their art was con-
cerned with subtle relations between surface and line, breadth
and height, and all the complex harmonies of noble form.

We began our study of the Gothic architecture of
Venice by some remarks on the building and design of the
Ducal Palace : in like manner we may fitly set about our
review of the central Renaissance period by an examination
of Sansovino's Libreria Vecchia, which bears much the
same relation to central Renaissance palatial architecture as
its rival does to central Gothic, and boldly confronting,
challenges comparison with it. Nor need the later fabric
fear to withstand our question. Few buildings have been
more admired, few have more profoundly influenced con-
temporary and later architects, than the Libreria Vecchia, a
masterpiece which moved Palladio to declare that nothing so
ornate and so rich had been raised since classic times. The
Venetians never wearied of singing its praises ; it satisfied
their inmost artistic ideals ; they loved its stately beauty, its
richness of decoration, its somewhat gentle charm and
exquisite grace. Indeed, the classic rhythm of its façade
evokes a like emotion in the beholder as the sweet music and
cadence of a Virgilian hexameter does in the reader of that
tenderest of Roman poets. "This marvel," says Vasari,
"according to the judgment of those critics who have seen
most of the world, is held to be peerless, and such were the
architectural power and science displayed by its creator, that
the Venetians, who up to that time had in their private
houses and palaces used but one order, each pursuing the
same method and the same measure according to old custom
and without any variation, according to site and convenience,
now began to erect private and public edifices of new designs and
better architecture, according to the teachings of Vitruvius."

It was in relation to the Doric frieze of this building that
Sansovino, taking advantage of the enthusiasm for classic
purity that possessed the minds of the scholar architects of

his day, started an architectural hare and sent in chase of it
the keenest of his contemporaries. According to his reading

LIBRERIA VECCHIA : ANGLE PILASTER

of a passage from
Vitruvius, it was
necessary in de-
signing the Doric
frieze that the por-
tion of the metope
which turned the
angle of the build-
ing should measure
exactly one half
of each of the
metopes which
alternated with the
tryglyphs; but in-
asmuch as accord-
ing to the modules
of the Doric order
the portion of the
corner metopes was
necessarily rather
less than one half,
this appeared to
be impossible.
How then should
the difficulty be
met and how should he contrive so that precisely one
half of a metope should fall at the angle of his frieze?
This ingenious problem excited the minds and absorbed
the attention of all the architects of the peninsula.
Roman, Tuscan, Lombard and other artists published
monographs and designs with contrivances for its solu-
tion, even erudite laymen such as Cardinal Bembo entered
the lists and contributed their suggestions. After having
stirred the fruitless emulation of his contemporaries, San-

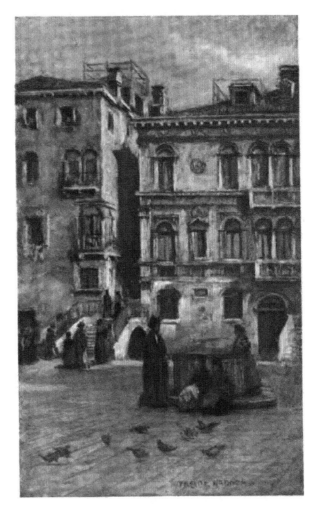

PALAZZO MALIPIERI.

sovino produced triumphantly his own solution, illustrated by a model, which met the difficulty by adding a little wing (*aletta*) to the corner pilasters, thus enabling him to increase the length of the frieze so as to find place for exactly half a metope at the corners. See accompanying drawing which shows the Doric frieze and winged pilaster. The construction, begun in 1536, progressed but slowly, and at length, during the carnival of 1540, the Aretino was able to invite the ambassador of the Emperor Charles V., Don Diego Mendoza, to come masked to the piazza and behold the *mirabili sudori* of his friend Sansovino. In 1545 the fabric was so far advanced that the roof was begun, and such was the artistic veracity of the architect that he determined to turn the flat, elliptical vault in masonry. But the work dragged so slowly that the winter frosts supervened before the vaulting was completed, and, at the first hour of the night of December 18, to the amazement of the whole city, the ceiling suddenly collapsed, and Sansovino paid for his zeal and error of judgment by a dismissal from his office, a fine of 1000 ducats, and detention in prison. On hearing of the disaster the Aretino indited an eloquent and sympathetic letter to his disgraced friend, describing his affliction at the news, how that he could not restrain his tears while writing, and had passed the whole night sleepless and pondering on the evil fortune which had transformed the great work that was to be the tabernacle of his glory, into the cemetery of his fame. All Sansovino's friends stood by him in his sorrow ; the Aretino wrote a letter of consolation to Madonna Paola, his wife ; the Imperial Ambassador used his influence with the procurators on his behalf, and although the too zealous official who had committed him to prison was punished, and the unlucky artist released, it was not easy to disculpate himself with the authorities, or to wipe out the disgrace of his dismissal, or to raise the amount of the fine. With touching resignation, however, he abandoned the stone vaulting and substituted an ordinary plaster coved ceiling,

L

working no longer as chief architect, but as an ordinary mason making good his own failures. The procurators loaned to him the 1000 ducats necessary to meet the cost of the work, and in 1546 the ceiling was completed, and the most famous painters of the day, under the superintendence of Paolo Veronese, were commissioned to decorate the vaulting. Sansovino was restored to his post and compensated by the payment of the whole amount in which he had been mulcted; the building, however, as we now see it, was only completed at the southern end by Scamozzi some thirty years after Sansovino's death. Scamozzi, while contemptuously regarding the pilaster trick as an unworthy architectural dodge, yet retained the *aletta* in his south corner. The finished palace is one of the most beautiful creations of the central renaissance in Europe. The superposed arcades of engaged columns, the lower of Doric, the upper of the Ionic orders, backed by square piers; the exquisite but subordinate designs of the decoration in relief, and the firm grasp and unity of the whole fabric are admirable; and sluggish indeed must be the artistic feelings of those who can contemplate this great masterpiece unmoved by its beauty. Experts have indeed adversely criticised the excessive depth of the entablature and the consequent disproportionate enlargement of the metopes. It is indeed sculptor's rather than engineer's architecture and lacks the massive grandeur and perfect command of the scientific principles of the art displayed by Sanmichele in the Palazzo Grimani; but its originality, its fine proportion and masterly application to local requirements of a classic inspiration, are qualities that more than compensate for trivial defects.

Sansovino's contemporaries complained of the lack of elevation in the façade, to whom the artist modestly replied, that it was undoubtedly low when compared with the Ducal Palace, but he would have his library judged, not in comparison with the height of the Palace, but in relation to the exigencies of the site; and that since, owing to the existing

Zecca, it was impossible to extend his building behind, and, without encroaching on the Piazzetta, equally impossible to extend it in front, he was compelled to relate the proportion of its height to its width in order that it should be symmetrical in all its parts and therefore more durable and strong. Renaissance architects are frequently blamed for neglect of detail in their designs, but there is small relevance in such criticism in the edifice before us. Scarce a surface—parapet, spandril, soffit, frieze, or metope—but is relieved by decorative carvings; the most lovely of all perhaps being the cupids holding festoons of flowers and fruits between the oblong apertures in the upper cornice. Ruskin, while admitting the grace and effectiveness of the whole building in its kind, severely denounces its grossest exemplification of the base renaissance habit of turning keystones into brackets, and the vulgar and painful mode of filling spandrils with naked figures in alto-relievo, leaning against the arch on each side and appearing as if they were in danger of slipping off—a criticism equally applicable to the well-known figures by Michael Angelo on the Medici tombs at Florence. Fergusson complains of the too profuse use of sculptured decorations, of the introduction of windows into the frieze, and other minor defects; but praises the grandeur of the range of arcades and the boldness of the crowning members, and "if the architect would only let us forget that he was thinking of the Florian amphitheatre, we must admit his design to be one of the most beautiful of its age and time."

The general aspect of the Piazzetta had already been much improved by the architect's skill. Jacopo Sansovino, says Vasari, employed the utmost diligence and zeal, and displayed extraordinary friendliness in his dealings with the procurators, applying himself wholly to their service and benefit. He added grandeur and beauty to their schemes for the adornment of the city and of the public Piazza by his inventions, by the alertness of his genius, and his ready wit. "Amongst which embellishments is this: in the year

1529 certain butchers' shops were standing near the two columns of the Piazzetta, and between the columns many wooden huts for the convenience of personal needs (*agi naturali*), a most hideous and unseemly thing as well for the dignity of the palace and the public square as for strangers, who, coming to Venice from the direction of S. Giorgio, beheld such filth at their first entry into the city." Jacopo, having explained to the Prince Gritti the honourableness and utility of his proposal, had the said huts and benches cleared away, and placing the benches where they now are, and erecting some stalls for the green-grocers, embellished at one and the same time the Piazzetta and the city, and increased the revenues of the procurators by 700 ducats. The same contemporary writer has left us a charming picture of this great Renaissance master as well as of Sanmichele, his friends both. Jacopo was above all beloved of his Prince, Doge Gritti, of Messer Vettorio Grimani, the cardinal's brother, of Marcantonio Giustinian, and all the procurators, so that these illustrious seigniors, of high intelligence and truly regal minds, experienced in the things of the world and having full knowledge of the noble and excellent arts, soon recognised his great work, and how precious he should be esteemed. Jacopo, as to his person, was of medium stature, by no means stout, and walked erect; he was of a pale complexion, with a red beard, and in his youth possessed of much beauty and winning grace; wherefore he was greatly beloved by divers distinguished ladies. When grown old his aspect was most venerable, his beard became white and beautiful, and he walked upright, even as a young man; so that, having attained the age of ninety-three, he was yet most robust and sound in body, and able to see even the minutest and most distant objects without the aid of spectacles, and when writing he held his head erect, not bending down as others are wont to do. He delighted to be clothed honourably, was ever most polite in his bearing and pleasing to

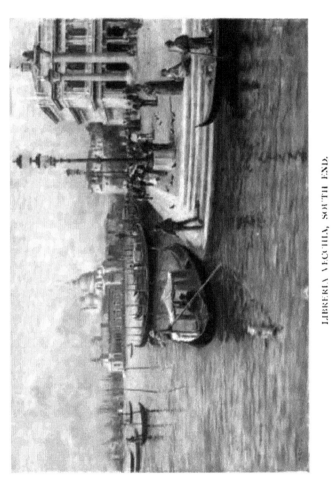

LIBRERIA VECCHIA, SOUTH END.

women, of whom he willingly discoursed. When he was indisposed, never would he consult a physician, nor take any medicine, and when, at the age of eighty-four, for the fourth time he had an apoplectic fit, he regained his health by simply keeping his bed in a dark and warm chamber for two months and despising physic. He had an excellent digestion, and in summer lived wholly on fruit, often eating three cucumbers with half a lemon, even in his old age. Prudent, provident, and diligent in his business, he never deemed any labour too great nor would neglect his work for any pleasure. He discoursed eloquently and well on any subject he understood, giving copious illustrations with much grace of manner, and was gladly seen of great and small. His memory was ever green; he remembered his youth and willingly would talk of the sack of Rome. Honour he prized above all things, was ever loyal, and a man of one word; affectionate and generous to his parents, often denying himself to assist them.

Many a great prince essayed to seduce Sansovino from his Venetian home, but never would he leave the city of his choice where he was so loved and honoured. The critics, adds Vasari, while conceding on the whole the palm to Michael Angelo, yet esteemed Jacopo superior in some things, forasmuch as in his draperies, in his children, and in the grace of his women he was unrivalled; his draperies were most subtly beautiful in their folds, and perfectly preserved the forms of the vesture and of the nude; his children he wrought delicate and tender, with none of the muscular development proper to adults, their little arms and legs so natural that they differed in no wise from real life.

This was the potent renaissance master who most profoundly impressed his genius on the architecture of Venice. He, a Florentine nurtured at Rome, when the Constable of Bourbon and his savage hordes were in 1527 suffered to humble the proud spirit, and, for six whole days, to scourge the fair body, of the mistress of nations with fire and sword,

escaped to the sure haven of peaceful folk on the lagoons, and, even as many a modern artist we have known, intending

CORNER CA' GRANDE

to make a brief sojourn there was held by the fascination of her beauty and potent enchantments for the remainder of his days. The Venetians idolised the master who at forty years

of age and in the maturity of his powers came to embellish their city ; they exempted him from the war taxes, gave him a house on the Piazza, and entrusted to him the maintenance and the creation of their fairest architecture.

Let us resume our gondola and station ourselves opposite the Corner Ca' Grande, now the Prefecture. Among the examples of private mansions referred to by Vasari, the foremost place is given to the *bellissimo palazzo* of Messer Giorgio Cornaro [1] on the Grand Canal, which without any doubt excelled all others in commodiousness and majesty and grandeur, and " is reputed the most beautiful perchance in the whole of Italy." This imposing edifice which dominates the eastern mouth of the Canal was known to the Venetians as the *Ca' Grande* for its size and magnificence, and occupied the site of one equally famous in the annals of Venice. On July 7, 1508, Sanudo notes in his diary that Zorzi Corner, returning after a great victory, crowds went forth to meet him; and as he entered the city with a chain of gold about his neck, preceded by trumpets, they shouted Corner! Corner! Victory! Victory! and so he was escorted to the Ca' Corner, where on the 12th a *bellissima festa* celebrated the event. A sumptuous banquet was prepared ; models of his victories made in sugar were served up; there was much dancing o masked ladies; plays were performed ; rope-dancing exhibited ; and the whole day was passed in similar delights. Messer Giorgio, who was the brother of Queen Caterina of Cyprus and had ably seconded the intriguing Seigniory to jockey her out of her dominions, purchased the fifteenth century house raised on this site by Bartolomeo Malombra, Count of Tisana, a wealthy Venetian known as Malombra of the fair house. This was the Ca' Corner destroyed by a memorable fire in 1532, of which Sanudo has also left us a vivid picture in his diary. We translate the somewhat rambling narrative as it was written down under the immediate excitement of the catastrophe.

[1] The name is written indifferently Cornero or Cornaro.

August 16, 1532: This night, at the fifth hour, there befell a most great mischance in this city, *molto miserabile e lacrimoso*, as much for the public as for the palace, or rather house, of the sons of the most renowned knight and procurator Domino Zorzi Corner on the Grand Canal at S. Maurizio, formerly the Ca' Malombra, of whom the aforesaid Domino Zorzi purchased it for 20,000 ducats and has since spent more than 10,000 ducats upon it, a most beautiful house and the most beautiful in Venice, and indeed it might be said in the whole of Italy, lordly, magnificent, and commodious, all burnt so that for . . . hours it was as the burning of Troy, only greater, so that nothing remained standing *solum* the foundations with the columns, all the rest burnt and ruined. There remained some of the side walls standing that filled one with fear to look at. The ill-hap was this : that Sier Zuane Corner, the son, holds the command of Cyprus, which brings him in . . . thousand ducats a year, and sugar[1] and cotton were sent to him. Now the sugar was damaged by water and it was placed in the chests to be dried in the upper story, in a chamber over the courtyard, where it was daily dried in the sun, and at night they brought hot coals to warm and dry it. Now as God or the devil would have it, the said Sier Zuane, because of the gout, which is a peculiar affliction of that house, and he has it ragingly, was bidden to take Indian wood and to keep very warm. And so he took it and that very evening there was brought much coal from the fire in his room and carried up, as had been done before, which great heat was smouldering perchance sometime before this hour under the beams, and the fire caught as in a moment and the roof and the chests of sugar began to burn, giving forth a great flare. And no one was in this room with the sugar. In Ca' Corner they sup late, so all were

[1] Canon Casola, who in 1494 visited the immense farm belonging to the Corner near Limasol in Cyprus, says that so much sugar was made there that it should suffice for all the world : no less than 400 persons were employed in its manufacture. He also saw much cotton in the fields.

asleep. The flames were seen and people knocked at the door, but they either did not or would not hear, and opened not. All along the Grand Canal folk shouted Fire! Fire! at Ca' Corner! About the fifth hour they rose up, white and dazed with terror, and some relatives and friends being come it was determined, as the lesser evil, to keep the great portal locked and to strive to save some of the property, for there was very great riches, and so they did and permitted none to enter. There was borne away a great number of basketfuls of silver to the Ca' di Sier Zuan Antonio Malipiero [1] their brother-in-law near the Ca' Zorzi, and three coffers with money and nearly all the furniture which was on the first floor and in the Mezzanine, with writings and other thing. Then came boats loaded with cotton and sugar which was in the warehouses, big bales being flung into the courtyard and then taken away. The Corneri were in despair, and still the house was burning at the top and none could prevent it, whereupon the children with their mother, wife of Sier Giacomo Corner, went to Ca' Malipiero, and the wife and children of Sier Zuan to his brother-in-law Sier Zuan Pisani the Procurator. Then came quickly Sier Nicolo Venier and his sons, Sier Antonio da Mula, Sier Agostino, Sier Antonio Dandolo, Sier Francesco Barbaro, and Sier Domenico Mocenigo who bore themselves bravely, for these stood at the door lest the house be looted. And when God willed the doors were opened, and some ran up to shout and some to steal. And ever the fire burned and began to work downwards; and there was much property which had belonged to their aunt the Queen of Cyprus and which was saved by valiant men to whom was promised a fourth; they were given 100 ducats and were satisfied. All the sugar above was burnt, 400 bushels of wheat, all the chests, the pictures, among them the Supper at Emmaus by Vianello, a most beautiful thing. The private chapel was burnt, the Roman head of marble, worth a province, was all cracked and broken by the fire. And still the fire went *girando* and burnt with most fierce

[1] See p. 149.

flames; and one who was in the upper floor and could not descend, for the stairs were burnt away, was saved by a rope. The fire lasted to the third hour of the morning, when the whole façade fell, and those columns of marble most fair fell down into the Canal, all at once, and none could help it. And by chance four men were under the portico, and three flung themselves into the water and the stones fell on them, nor were they seen any more; the one who remained there escaped half dead.

Now the fire went on burning continually and the chamber of gold was burnt which the Cardinal had made, who is now Bishop of Brescia, most beautiful; then the other on this side, where the most renowned Missier Zorzi Corner[1] used to live, and where now Jacomo his son lives, and where they kept their money and coffers in a most secret place and most safe, and because they were kept there they were saved: yet much property was stolen. *Etiam* much burnt but not things of great account. The fire then caught the timber stores, of which there were 600 loads, and many casks in the wine store. The fondamenta was full of people who only looked on and did naught, and the Grand Canal was crowded with boats all filled with folk watching the fire; and sparks went as far as the other side of the Canal. It was a most mighty fire. Tardily the alarm bells were rung at S. Maurizio and S. Maria Zobenigo and S. Vitale, and it was a most wondrous thing that in so short a time, to wit . . . hours, a house so fair and so magnificent and of great grandeur and fashioned so broad and high, should be all burnt, nor is any part thereof left standing *solum*—certain wings which must fall. And towards noon, having such great pain and grief, so much that I can say no more (as well for public as for private reasons for this family is of my dearest friends) that this the fairest house in Venice and at the beginning of the Canal should be burnt, I went in a gondola with Sier Gasparo Contarini to see the fire which was so fierce and of such great

[1] Brother of the Queen of Cyprus.

flames that I was terrified, nor all that day was it well with me. And since to-day was Council day, I went afterwards to Ca' Malipiero to visit Sier Jacomo Corner and to comfort him saying, *Deus deit : Deus abstulit* (the Lord gave : the Lord taketh away). These Corneri are most wealthy and have a revenue of 10,000 ducats and from three abbeys 10,000 ducats more. Then the Cardinal Missier Francesco who was a cavalier and a procurator and is Bishop of Brescia hath a revenue of 3000 ducats; and they have ready money and jewels and silver, etc. very much. They say the house is to be rebuilt and perchance made more beautiful but much time will be needed for the timber and freestone, and then the columns of the façade will not be recovered. To conclude, these of the Ca' Corner by the great fire have lost their house and the money they spent after they had bought it, and much property and merchandise burnt and withal they have been robbed of . . . ducats.

It was after this calamitous conflagration that Sansovino was commissioned to rebuild the palace and besought by his wealthy patrons to exert all his art in raising an edifice that should surpass in magnificence the fair house devoured by the flames. By a letter of the Aretino, written in 1537, in which the foundations are referred to whereon the proud roofs of the Cornari were to be raised, it is clear that the work advanced but slowly, and there are indeed some grounds for believing that Scamozzi had a hand in its completion. Another fire injured the fabric in 1817, and subsequent restoration was necessitated.

The finely proportioned rusticated basement, the harmonious, stately and restrained architecture of the superior floors, the rhythmic succession of engaged columns, Ionic on the first, Corinthian on the second floor, the spandrils decorated with trophies and torsos, the crowning cornice with its oval openings are characteristic features of Sansovino's style. The turning of the façade angles was always an important feature in a palatial building, and here

Sansovino has employed a group of four columns : only one angle, that to the right, appears to have been completed. The reproduction, with slight modification of the design of this palace, in the Army and Navy Club in S. James' Square, will be familiar to Londoners.

The younger Sansovino declares this to be memorable above all other palaces for magnificence, richness and symmetry, its capacity being sufficient for a Cardinal's household.[1] So eminent is its height that the lagoons can be seen all around, and the façade, with its Ionic double columns above and *rustico gentile* below, and its noble apertures, gives an impression to the observer of majesty and grandeur. Fergusson, while criticising adversely the excess of ornamental sculpture, the monotony caused by the coupling of the pillars of the upper stories, and the insertion of oval windows in the frieze, considers the defects of the design to be very far redeemed by the beauty of the details and the general grandeur of the whole.

The Cornari, four of whose members filled the Ducal Chair, were one of the evangelist families of patricians, and in the fourteenth century, were subdivided into two great branches distinguished as the Corner Ca' Grande and the Corner Piscopia, from the chateau and fief of that name, conferred, with a knighthood, on Federico Corner (of the Byzantine Palace, known now as the Loredano), in 1363, by Peter of Lusignan. To students of English literature, the Cornari are best known in the person of Luigi Cornaro, a descendant of this latter branch, born in 1464, and author of *La Vita Sobria*, which in its English dress " The Temperate Life or the Art of Living " was a favourite book with our forbears, and which, in one of its translations reached a fifty-fifth edition in 1832. The little book contains a series of lay sermons on the art of prolonging life, based on the

[1] To say in the sixteenth century that a palace was adequate to contain a Cardinal's household was the highest tribute that could be paid to its magnitude and splendour.

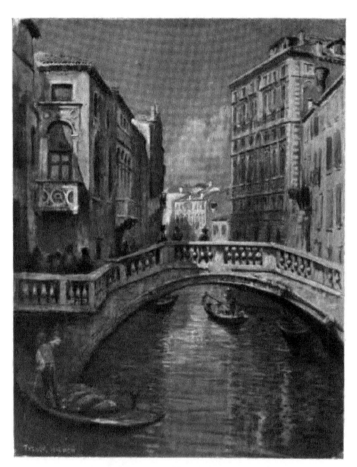

PALAZZO CORNER-MOCENIGO.

experience and practice whereby "Lewis Cornaro," who in manhood was almost a valetudinarian, contrived to reach a green old age, and prolong his life to within a couple of years of a century. This ripe old scholar and humanist is associated with the rise of Renaissance architecture in Venice, having been the patron and bosom friend of the witty and jovial architect Giovanmaria Falconetto, who, according to Vasari, was the first master that introduced the true method of building good architecture into Verona and Venice, no one in those parts having before his advent known how to make a cornice or a capital, or understood the due measurement or proportion of a column of any order of architecture. He it was who executed the monuments to Queen Caterina Cornaro and Cardinal Marco Cornaro in S. Salvadore. The scholarly traditions of the Cornaro family were ably maintained by the erudite lady Elena Lucrezia, who was so celebrated for her learning that on one occasion when engaged in a disputation before an illustrious and fashionable assembly, the Senate suspended its sitting and repaired in a body to hear her. When the degree of Master of Arts was conferred upon her by the University of Padua, on June 25, 1678, the whole scholarship of Europe is said to have been present.

It was the fame of the great Renaissance masters as military engineers that first won for them the patronage of the Venetian Republic. As early as 1509 Fra Giocondo was acting in that capacity, for Sanudo in his vivid story of the feverish excitement and military preparations at Venice consequent on the news of the conclusion of the League of Cambray, notes on Corpus Christi day "that Fra Giocondo, the engineer, was very busy." Even so was it with Michele Sanmichele, who, among other great works over the length and breadth of the Venetian dominions, erected that *terribile fortezza e meravigliosa* which defended the Lido, and which Vasari declared to be as marvellous in regard to the soil whereon it was built as for the beauty of

its masonry: it was the most stupendous fortress in Europe, raised at incredible expense, and vied in grandeur with the most famous of the edifices built by the Romans. Like all the Renaissance masters, Sanmichele had sought inspiration at Rome, and more than any of his contemporaries was characterised by an austerity of style consonant with his earnest, godfearing, grave, and virile temperament. Towards the end of his active service (1530-1550) under the Venetians, the master was commanded by the most noble Messer Girolamo Grimani to build for him a stately mansion on the Grand Canal, "the foundations of which marvellous palace," says Vasari, "were raised at incredible expense." Let us now direct our gondola up the Canal and pause before the Ca' Grimani at the corner of the rio S. Luca. Nothing in Venice can excel in calm majesty, breadth, and simplicity of design and architectural science this noble edifice, which is universally regarded as a masterpiece: it moved even Ruskin to admiration, who declares it to be the principal type at Venice, and one of the best of the school in Europe. The three stories of the Corinthian order, he adds, are at once simple, delicate, and sublime, but on so colossal a scale that the three-storied palaces on its right and left only reach to the cornice which marks the level of its first floor. The great critic dwells on the majesty of the fabric to which the whole group of neighbouring buildings owe the greater part of their impressiveness; on the finish of its details, no less notable than the grandeur of their scale; on its noble front with no erring line or mistaken proportion; on the exceeding fineness of the chiselling, which gives an appearance of lightness to the vast blocks of stone out of whose perfect unison the front is composed; on the delicacy of its sparing decoration: on its Corinthian capitals, rich in leafage and delicately fluted; on the bold shafts that look like crystals of beryl running through a rock of quartz. The eulogy is indeed *more suo* expressed in too exuberant a style, for unhappily, as Vasari relates, Sanmichele, overtaken by death, was unable

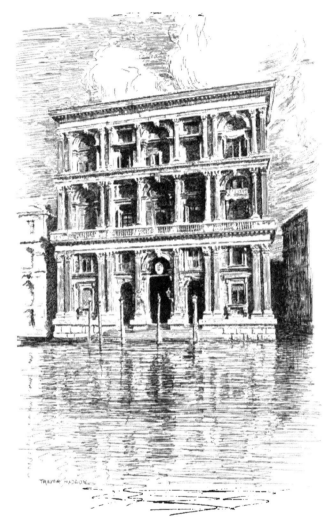

PALAZZO GRIMANI

to bring his work to completion, and other architects employed by Grimani debased somewhat the original model and design, giving more balanced and judicious writers cause for adverse criticism, especially in the matter of the lack of proportion of the upper story and the accentuation of the comparative lowness of the piano nobile by the balcony which traverses the whole façade and detracts from its actual columnar elevation—a defect which Sansovino obviated in the Palazzo Cornaro by breaking up and grouping his balconies according to earlier models. A comparison between the relative proportions of the two buildings in height and width is interesting, the Grimani being 98 feet by 92 ; the Cornaro 97 by 104.

The beauty and symmetry of the sea-story of the palace before us are admirable, and the whole treatment of the basement marks that complete revolution wrought in patrician architecture of which we observed the beginning in the Vendramin. The wealthy nobles were no longer content to accept the emphatic expression of the mercantile basis of their magnificence, and were growing ashamed of their commercial origin ; the basement here loses its primitive plainness and simplicity and is transformed into the most important of the three orders. But the greater triumph of Sanmichele's architectural science is yet to be observed. The ground plan, here reproduced from Cicognara, will enable the traveller to comprehend the masterly skill whereby the architect has triumphed over the extraordinary irregularity of the site and wrested disorder into symmetry; and if he will disembark and enter the portico he will be still better able to appreciate the result. It will be seen that the centre of the portico and that of the atrium are not the same, and that this irregularity has been masked by the ingenious device of three doors, only two of which give on the atrium. Standing in the portico no irregularity is observed, and passing thence to the atrium one is unconscious of the slight irregularity of the sides or of the intervals between

M

the angles. An ample and stately stairway leads up to the
piano nobile with its central hall traversing the whole depth
of the building, but, alas, how shorn of its once dazzling
splendour! When Hazlitt was in Venice in 1825 it was the
richest for internal decoration of any palace he beheld, and
"answered to all the imaginary conditions of this sort of
thing. Aladdin might have exchanged his for it and given
his lamp into the bargain. The floors are of marble; the
tables of precious stones; the chairs and curtains of rich
silk; the walls covered with looking-glasses; and it contains
a cabinet of invaluable antiques, sculpture, and some of
Titian's finer portraits. I saw no other mansion equal
to this."

The Grimani ranks as the second of the four chiefest
palaces mentioned by Francesco Sansovino, and is said by
him to excel the Vendramin by the more regal amplitude
of its halls, the design of its façade, abounding in exquisite
wealth of decoration, and the columns of the cortile so
remarkable for their magnificence; the carvings and folia-
tion and other *dilicatura* are exceeding rich in every detail,
and wrought almost down to the very foundations. Fergus-
son believes that the design would have gained by the
omission of the lower order altogether, and criticises the
divisions of the square openings in the upper stories; but,
apart from these rather minor defects, he esteems it to be one
of the most striking façades on the Grand Canal, and one
of the best buildings of the age in which it was erected.
"The most enthusiastic advocate of gothic may be induced
to admit that there is nothing of a palatial character out of
Venice, erected either in Italy or on this side the Alps so
beautiful as this façade."

Michele Sanmichele is one of the most outstanding
figures of the central renaissance, and his friend Vasari
has left us a noble tribute to his excellence as a man as well
as an artist. He was the most moral of men and honourable
in all his doings, of a cheerful temperament but mingled with

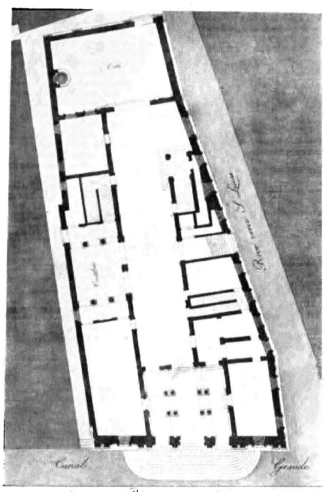

Canal Grande

Pianta terrena del Palazzo Grimani sul Canal Grande

gravity, in all his ways so noble and courteous and amiable that he won the affections of an infinite number of seigniors, of Popes Clement VII. and Paul III., the divine Michael Angelo, the Duke of Urbino, and a goodly number of Venetian senators and nobles. Profoundly religious, he would never set about any work in the morning without first having devoutly heard mass and spent some time in prayer, nor would begin any enterprise of great import without having had celebrated, the morning before, a solemn mass of the Holy Ghost or of the Madonna.

His patrons, the Grimani, were not of the first rank in the nobility of their birth, and only emerged into prominence in the State at the end of the fifteenth century, in the person of Antonio, who heads a long line of doges, senators, military and naval captains, and great churchmen, among whom was Antonio's son Domenico, the art-loving cardinal. But the most remarkable of the Grimani, and one who in his day filled the stage of public life, was Antonio, the disgraced of Sapienza. His contemporary Priuli has left us a vivid picture of his rise and temporary fall. In 1499, when Procurator and Captain-General, on hearing of the Turkish preparations for war he sent a light galley with 4000 ducats to Candia, in order that the arming of a fleet might be expedited and the archers paid ; and if money could not be raised on the credit of the Seigniory, he offered to back, in his own name, any bills that might be drawn. When the Standard of St Mark was given him, and he set forth to assume command of the fleet that suffered so disastrous a defeat at Sapienza, he sent the Seigniory 16,000 ducats to hasten preparations. "This most noble gentleman was greatly favoured by fortune during his life, and from a poor man in a short time grew very rich. For wealth, he was esteemed the first head in Venice, and, so far as men could see, he was worth 100,000 ducats in ready money, apart from his real estate, and all made in a few years. He was a most lucky merchant in his business, and the more part of the Venetian merchants were

governed by him in their dealings : if he sold they sold, and if he held they held. Mud and earth became gold in his hands. Without parentage nor of worthy blood, in a very few years he became the first senator of the Republic, and ever and continuously was among the highest who ruled Venice. And, truly, he was a man most wise in Council, great-hearted, of good speech, and of high repute, and so truly was he favoured, loved, and honoured, that few citizens excelled him in our city. He married his children honourably and in the first families of Venice, and with most liberal dowries. Blessed he who could approach him. Twice was he Admiral of the Fleet ; he was Procurator of St Mark, which, after the Prince of Venice, is the highest dignity. In his command he bore himself most worthily, and no captain ever excelled him in glory. He would have conquered the whole of the Puglie if the Senate had not changed his orders, and returned to Venice with such great pomp, and reporting such a glorious victory that all judged him worthy of the ducal chair, which is the highest dignity the city can confer. Latterly, the whole world being in confusion and the Seigniory being informed of the great preparations making by the Turks, Sier Antonio Grimani, the Procurator, was chosen with one voice as the sole stay and protector of the Venetian State ; and since the Seigniory had no money, he lent them 20,000 ducats from his own purse. And he departed from Venice with such honour, fame, triumph, and pomp, that no tongue can tell of it. He was almost worshipped by all, for the Venetians, having seen him so fortunate and that nothing had ever been contrary to him, had placed all their hope in him. Now he lies with gyves on his feet in the Forte prison, and all men cry, Crucify him ! And this is a noteworthy ensample to us all. He is a man of sixty-four years of age." Antonio's fortunes, however, rose again. Twenty years later he sat in the ducal chair, and was able to say to the Ambassadors of Spain, France, Ferrara, and Mantua, as he one day, with all the

princely pomp and pride of his office, was returning from mass in S. Giorgio Maggiore: "*Domini Oratores*, on this very spot irons were once placed on my feet and I was flung in the Forte prison, and now I am Doge of Venice."

The Grimani were a magnificent race: they built three theatres; five palaces yet bear their name in Venice, and one of their house has for many years now filled the chief civic chair of Venice. The curious may find in the Museo Civico a picture representing one of the most gorgeous and notable scenes in the history of the later Republic—the coronation on May 4, 1597, of the Dogaressa Morosina Morosini, consort of Doge Marin Grimani, son of the builder of this palace. The festival was one of more than usual pomp. Off the steps of the palace to receive the exalted lady, lay the Bucintoro accompanied by a grand, ornate, and symbolical vessel, designed by Scamozzi, the most renowned architect of the day, on which was a loggia raised on stately columns and ceiled with a majestic cupola, the whole lavishly adorned with paintings and sculpture by the best masters; this was followed by a whole fleet of festive gondolas and barges filled with the flower of the patrician youth and the official world of Venice. Arrived at the Molo amid salvos of artillery and music and song, Morosina alighted, and through arches of triumph on the Piazzetta and the Piazza, a gorgeous procession led her to the Ducal Palace:—three hundred halbardiers; the Scuole, Greater and Lesser, with banners, silver trumpets, and drums; a long line of young patrician ladies clothed in white, and of matrons arrayed in green and purple and rose-coloured silk; children apparelled in white dresses and adorned with silver and gold. Then followed the Dogaressa with her six maids of honour in green silk, her two most beautiful dwarfs, male and female, all of whose splendour waned before the queenly magnificence of her Serenity, who was crowned with a ducal cap, whence a rich and rare gossamer veil fell on her shoulders over a dazzling white mantle and a bodice of cloth of gold.

Procurators, Councillors, and the whole Seigniory closed the procession. After a solemn coronation in the Hall of the Great Council, the revels ended with a sumptuous refection modelled in the form of men, women, boats, allegorical pieces, and other monstrosities of the culinary art, which had first been carried round the piazza lighted by sixty wax candles.

There was much wagging of heads and prophecy of evil by old-fashioned patricians at all this gynæolatry in high places, which indeed has ever been the concomitant of decadence alike in empires, monarchies, and republics. The attitude of the Italian noble towards women, whether in the home or in the state, always has been and largely is that of absolute domination, and is expressed clearly and brutally by an old Florentine, Paolo di Sor Pace, in a collection of principles of worldly wisdom written in the fourteenth century. "If thou hast women in thy house," he advises his posterity, "keep them shut up as much as possible, and return thou home very often and keep them in fear and trembling."

The second of Sansovino's palaces on the Grand Canal, now the Banco d' Italia, was designed for Messer Giovanni Delfino, and erected at a cost of 30,000 ducats; it came later into the possession of the Manin family, who gave the last doge to Venice, and need not detain us long; nothing but the façade remains of Sansovino's work, the cortile and the stairway and the greater mass of the building having been reconstructed by other and later hands.

Crossing the Grand Canal, we row up the rio S. Polo, over which to our right towers the massive bulk of the Palazzo Corner-Mocenigo, whose noble façade has an austere grandeur which Sanmichele alone could have designed: here that excellent master has left to posterity one of his most admirable creations, one of the most remarkable monuments of the central renaissance in Venice, and second alone to the Grimani palace. Diedo assigns it

to 1548, a few years anterior to the latter edifice. The
building is of unusual elevation in proportion to its width,
the windows are tall, the basement Doric, the first floor Ionic,
the second Corinthian. The façade is partly constructed of
brick, only the rusticated basement, the quoins, and the
windows and friezes being of stone.

Much historical interest centres around this site. In
early times here stood an ancient palace named del Cognon,
which in 1349 was given by the Seigniory to the Carrara of
Padua, but, on their desertion of their suzerain and alliance
with the King of Hungary, was confiscated and given in 1388
to Giacomo del Verme, their new condottiere. In 1439 it
passed into the hands of Gattamalata, the predecessor of
Duke Francesco Sforza, who, as we have already stated,
exchanged it in 1461 with Marco Corner for a site on the
Grand Canal. The Corner, either because the old building
had suffered irreparable injury, which is not unlikely,
considering the succession of military condottieri who had
transiently occupied it, or desiring a more imposing and
spacious edifice, commissioned Sanmichele to design the
present mansion; and here again, as in the Grimani, the great
master has succeeded in raising on an irregular site a
structure of admirable symmetry. The S. Polo branch of the
Corner became extinct in 1799, the last to bear the name
having been one Giovanni, who in 1787 married his daughter
to a scion of the Mocenighi, and the palace, thus passing into
the hands of the latter, became known as the Corner-Mocenigo.
On Giovanni's memory is charged the disfigurement of the
fine land portal on the Campo S. Polo, modelled by San-
michele on the portal in the atrium of the Pellegrini chapel in
S. Bernadino at Verona. The story runs that Giovanni
altered the entrance to its present dual form, that the living
might enter by one door and the dead be borne out by the
other. The huge, neglected, cracked, and once lordly
mansion is now divided into tenements, and is inhabited by a
whole population of all sorts and conditions of Venetians.

How these stately central renaissance palaces, now
dimmed, grey, and sombre, looked when the polished white
Istrian stone glistened in the bright Venetian sun in all
its pristine candour, or was mirrored in the waters at
their feet, we can but faintly imagine.

CHAPTER XIII

The Decline — Palazzo Foscari a Malcontenta — Palazzi Pesaro, Mocenighi, Rezzonico

" My house . . .
Is richly furnished with plate and gold,
Basons and ewers to lave her dainty hands;
My hangings all of Tyrian tapestry.
In ivory coffers I have stuffed my crowns;
In Cyprus chests my arras counterpoints,
Costly apparel, tents and canopies,
Fine linen and Turkey cushions bossed with pearl."

—*Shakespeare.*

WITH Palladio (1518-1580), the Venetian renaissance reaches its zenith, and with Scamozzi (1552-1616) and Longhena (1631-1682) declines to a not inglorious setting. By the first-named master, whose "cold hand of virtuous poverty in architecture" lies so heavily on Vicenza, no important work of a domestic character was raised in the city of Venice, and the great monuments of his art must be sought in her churches, particularly in the Redentore, whose austere, stately interior, with its simple reliance on proportion and symmetry, evokes a solemn religious emotion in the sympathetic beholder. Palladio's highest ambition, to demolish and rebuild in more elegant symmetry the Ducal Palace after the fire of 1577, was thwarted by the inherent conservatism and economy of the Fathers of the Republic, and happily so, in spite of Temanza's opinion that the great Vicentine master would have designed his new palace with such subtle genius as to emulate the magnificence of Rome. On the mainland, however, if the traveller will employ a spare afternoon by journeying on the little steamer that plies between the Riva degli Schiavoni and Fusina, and thence by

train to Malcontenta, he will find in solemn isolation and melancholy decay, on the banks of the Brenta, the once sumptuous palace erected by the master for the brothers Foscari in 1558, and bearing the inscription: *Nicolaus et Aloysias Foscari Fratres Federici Filii*. This, according to Temenza, was the first Venetian edifice designed by Palladio, and won him much fame. It is fronted by a magnificent Ionic loggia, approached by two majestic lateral stairways, and for originality of idea and nobility of design, and the rare paintings that adorned its interior, was, even in Temanza's days, two centuries and more after its construction, a thing of great price and of noble aspect. Nothing speaks more eloquently of the vanished splendour of Venice than this stately pile of Palladian architecture which, with its tall pediment, seen from afar, has the similitude of some abandoned classic fane; or, indeed, than the whole aspect of the long line of the canal of the Brenta (especially in the vicinage of Mira Taglio), from Malcontenta to the imperial pomposities of the Villa Strà. There the traveller will behold many a fine renaissance palace, modified, debased, or decayed, where the luxurious, pleasure-loving patricians of the later centuries of the Republic passed their autumn villagiatura until the chill winds and rains drove them back to Venice; palaces, filled with a brilliant, gay, and dissipated society, leading a butterfly existence in a round of gambling and music and theatrical parties, in flirtation and gallantry and all the frivolities of the decadence, but now surrounded by the cheap stucco villas and garish decorations of the modern builder. The Palladian palace of Malcontenta has been sold this year (1907) to a wealthy Italian, and will doubtless soon present a changed aspect.

During the four decades of Sansovino's and Sanmichele's activity at Venice, the Central Renaissance had made a rapid advance in form and technique: then was its golden age, and what in those masters was reverent appreciation of classic models, dominated by a profound science and supreme

artistic sensibility, became in their followers lawless extra-
vagance, or rigid adherence to rules often ill understood
or slavishly followed. Idiosyncrasies were elevated into
principles, architecture lost vitality and adaptability; its
masters were absorbed in formal pedantry, in the measure-
ments and proportions of classic examples, mostly of decadent
Roman architecture; the tyranny of precedent lay heavily
on their minds to the neglect of actual requirements; men
asked not what are the exigencies of contemporary life, but
what did the Romans fifteen centuries before. The canons
of Vitruvius were invested with the authority of an infallible
Scripture, and to such extremes of superstition did his dis-
ciples descend that he was declared by Serlio, in his " Five
Books of Architecture," to be "our guide and infallible
director." And these, the only canons that had come down
to moderns from classic times, were the *dicta* of a master of
the decadent Augustan age, who never travelled even in
Magna Grecia, nor knew aught, at first hand, of Greek
architecture; of a writer, obscure in style and difficult of
interpretation.

The apotheosis of Vitruvius was the bane of subsequent
renaissance building, and although Palladio's erudition and
frigid purity restrained to a great extent Venetian architec-
ture from the license and swagger of the Roman and Genoese
decadence, neither the intellectual equipment nor the artistic
imagination of the later masters was powerful enough to
bear with ease the accumulated weight of Roman precedent,
nor adequate to mould and adapt classic models to local
needs and actual service. But, as in the history of Venetian
painting the magnanimous art of Tintoretto and Veronese
maintained its excellence, individuality, and power, when
elsewhere painting had declined to a sterile eclecticism, even
so in architecture, the potent genius of Palladio, and, to a
lesser degree, of Longhena, preserved Venetian masons from
the excrescent grossness of the mainland masters.

Palladio, too, like other great Renaissance builders, seems

to have been a most attractive personality, and is described as most pleasing and merry in conversation, so that he afforded the greatest delight to the nobles and gentlemen with whom he came in contact; he was, moreover, affable and familiar in his dealings with the masons, to whom he taught good principles of workmanship and the correct terms and modules of classic architecture, keeping them always in good humour by his joyous manner.

Before we take leave of the Grand Canal, we will turn to the renaissance Palazzo Contarini dagli Scrigni, by Scamozzi, whose Gothic neighbour we have already examined. This rather frigid and uninspired copy of Sansovino's Ca' Grande is of little interest to the traveller. We devote what attention we may, *pour nous acquitter la conscience*, and pass to the palatial masterpiece of the architect of the Salute, which proudly, almost insolently, thrusts its huge bulk beyond its neighbours, higher up the Grand Canal. There is an effrontery in the architecture of the Palazzo Pesaro which compels attention, and, although it, too, is obviously but a remodelling of Sansovino's Ca' Grande, coarsened in execution, it possesses a certain potent and gross majesty. Ruskin characterises it as the most powerful and impressive in effect of all the palaces of the grotesque renaissance : " the heads on the foundations are wrought with more genius than usual, and some of the mingled expressions of the faces and grinning casques are very clever." The palace is now used by the municipality to exhibit their collections of modern art, and although internally it is much modified, we may with profit (apart from the interest of the pictures and sculpture, which is by no means small) enter the stately portico, admire the view along the cortile, with the picturesque festoons of creeping plants trailing over its columns, and then ascend to the ample Sala of the *piano nobile*. This palace is highly esteemed by Fergusson, who regards it as the most typical example of the declining age of Venice, perfectly expressing the fact that it is the

PALAZZI MOCENIGHI.

residence of a wealthy and luxurious noble, and on the whole a singularly picturesque piece of palatial architecture. "Notwithstanding the want of purity in the design, and absence of repose, it is from water-line to cornice, rich and varied and appropriate, and so beautiful as a whole that any slight irregularities in detail may be well overlooked." The riches of the Pesaro possessions formerly housed here —pictures, statuary, books, medals, antiquities, etc.—are almost incredible.

Returning past the Rialto bridge we pause before the group of three Mocenigo palaces that stand between the Palazzi Corner-Spinelli and Contarini dalle Figure. None has any real artistic merit, but the literary and historic associations are of profound interest. The first is known as the Palazzo Mocenigo Casa Nuova; the last as the Casa Vecchia. The riotous fancy of later genealogists has had full play in dealing with this opulent and powerful family. They have been traced by some to the Roman *gens cornelia*, by others to the Capetian kings; they certainly were one of the original members of the Great Council and were probably of noble Milanese ancestry. Clouds of witnesses in Venetian story proclaim their exalted virtues. Seven doges bore their name, the first of them, the wise and patriotic Tomaso, whom in 1433 a great victory over the Turks exalted to the Ducal throne; who paid the fine that blocked the way to the completion of the Gothic Ducal Palace; and who with dying breath sought to restrain the imperial policy of Francesco Foscari; who prayed the weeping senators at his bedside to work righteousness and love peace, and look to commerce rather than aggressive war for national expansion. His nephew Pietro, he too a victorious captain, after long and heroic struggles against the Turks, became doge in 1474. Alvise, the fourth Mocenigo in the chair, ruled when the Venetian and Spanish fleets won the memorable victory of Lepanto; and of this heroic lineage was another Alvise who in 1647 defeated the Turks at Scio, stoutly defended Candia for two

years, and after many a stubborn fight died there in 1654,
a warrior of such noble and exalted courage that the very
infidel Turk decked his ships in black and dipped his crescent
banners in the sea in token of mourning. These and many
another scion of this warlike race have written their names
on the roll of Venetian worthies; wise statesmen, public
officers, and erudite scholars have added lustre to their
house.

The name of one member of the race, however, is written in
history under a less noble rubric, for it was in the Casa
Vecchia that the hunted knight-errant of philosophy and
humanism, Giordano Bruno, was delivered into the hands of
his enemies. After having been driven from Naples, Rome,
Geneva, Paris, Oxford, Wittenberg, Helmstadt, excommuni-
cated alike by Catholic, Calvinist, and Lutheran, Bruno in
1591 was invited from Frankfort to Venice by Giovanni
Mocenigo, who professed a desire to be instructed in the
Lullian formulæ of memory, in geometry and other arts for
which the philosopher was famed. Giovanni's motives are
doubtful. He had formerly served as a lay Commissioner of
Heresy, was a weak man and much dominated by his
confessor; but, setting conjecture aside, we may more
profitably recite his actions. For a while Bruno taught at
the University of Padua under the tolerant rule of the
Venetian Senate, and as he quitted its Halls to take up his
residence at the Ca' Mocenigo, Galileo, protected by the
Seigniory, entered them. One May day in 1592, Bruno, who
seems to have had suspicion of what was brewing, had taken
leave of his host to repair to Frankfort in order to see his
printer, when Mocenigo, accompanied by a few gondoliers,
seized him and confined him in an upper chamber: he left it
to enter the prison of the Venetian Inquisition. And so
on Tuesday, May 26, Giordano Bruno, a man of ordinary
stature, with a chestnut-brown beard, and aged about forty
years, appeared before their Tribunal to answer for his
opinions, or rather for a travesty of them, contained in the

Mocenigo affidavit. The accused defended himself at length, giving an eloquent exposition and poetical synthesis of his philosophical creed, and, "growing exceeding sorrowful," denied the coarser libels of his betrayer. The trial dragged slowly, and on July 30 Bruno offered retraction and penance if the illustrious Seigniors would set him free. Here probably the matter would have ended, but that Rome intervened and claimed his extradition. Some interesting documents published by Professor Fulin have lifted the veil of secrecy which hid the proceedings from contemporaries, and enable us to view the inner workings of the tribunal and of the Seigniory. On September 28, 1592, the Patriarch's vicar, the Reverend Father Inquisitor, and the lay Commissioner of the Tribunal of the Inquisition, the Clarissimo Signor Tomaso Morosini, appeared before the Doge and his Privy Council, stating that Giordano Bruno's detention at Venice was known at Rome; that he was not only a heretic but an heresiarch, and that the Supreme Inquisitor had written requesting his surrender to the Roman authorities: they therefore prayed to know what answer should be sent. His Serenity replied that the most excellent Seigniors of the Council would give the matter their convenient consideration and would report later. But Rome was imperious and urgent, and the same day, after dinner, the deputation returned and found the most excellent elders still considering; whereupon the Inquisitor desired to know their decision, since he had a boat waiting to start with the prisoner. The Seigniory was not to be hustled into compliance, and made answer that this was a thing of great moment and required much deliberation; that many and weighty matters of state were before them, and that they had not yet come to any decision: the Inquisitor might discharge his boat. On October 3, the Seigniory sent a dispatch to their ambassador at Rome, enclosing a copy of the request made by the Papal authorities to the Venetian Tribunal, that one Giordano Bruno, now in the prison of the Inquisition, should be sent for trial to Rome The

Seigniory pointed out that the prisoner in the ordinary course of proceedings ought to be tried at Venice, and that the authority of the Venetian Tribunal would suffer much prejudice, a bad precedent would be created, and their subjects much injured if the request were acceded to: their representative must, therefore, if spoken to on the subject, defend the jurisdiction and rights of the Republic.

The Vatican did not let the matter rest, and on December 22, the Papal Nuncio stood before the Privy Council, and, after reciting the heresies and sins of Giordano Bruno at great length, informed their Excellencies that his Holiness desired to have the prisoner brought to trial at Rome. Procurator Donato replied that the Venetian Court was quite competent to try him; it acted under his Holiness' authority; the Papal Nuncio might be present at the trial, and it was unreasonable to change the venue to Rome. The Nuncio rejoined that the prisoner was not a Venetian subject but a Neapolitan, and had already been tried at Naples and Rome; that he was a convicted heresiarch and defiled by basest (*pessime*) crimes. Their most excellent Seigniors closed the debate by professing a desire to afford every possible satisfaction to his Holiness, and by promising to meet and deliberate.

The year turned and they were still consulting, when, on further pressure from Rome, the Clarissimo Signor Procurator Contarini, by order of the Doge, attended him on January 7, 1593, and gave his Serenity a history of the prisoner. This friar, said the Procurator, was first arrested at Naples for the grave sin of heresy, whence he escaped and made his way to Rome; there he was tried for the former and many other accusations and detained. Again escaping— evidently the detention was more or less formal— he passed to England, where he lived "according to the usages of that island," and then travelled to Geneva, leading that same licentious and diabolical life. Finally, he took

PALAZZO FOSCARI AT MALCONTENTA.

refuge in the house of a gentleman at Venice, who,[1] "to satisfy his conscience as a Christian," denounced him to the Holy Office, whereupon he was arrested and put in prison. His sins in the matter of heresy were most grave, although, added the Procurator, "otherwise his intellectual qualities were of the most excellent and rare order that could be possibly conceived, and he was a man of most exquisite learning and science." The Procurator concluded by demanding the utmost secrecy, and advised the Doge that, seeing the extreme gravity of the case and that the accused was a foreigner, it might be seemly to satisfy his Holiness, and, moreover, since he would conceal nothing, he had seen the prisoner and informed him of the proposal to send him to Rome, desiring him to say or conclude what seemed best to him ; and that Bruno had answered it would be pleasing to him (*lui caro*) to be referred to the judgment of Rome, and indeed he had intended to memorialise the Seigniory to that effect. This, the Procurator suggested, might only be in order to gain time, but, in any case, he was in safe hold, and his Serenity could now determine what were best to do, for his will should be obeyed. Unhappily for poor Bruno, the Seigniory of Venice, for political reasons, was then desirous of standing well with the Vatican, and this most exquisite and rare scholar was sacrificed to considerations of statecraft. On the morrow the Senate decided by a majority of 142 to 10, as an exceptional and extraordinary case, to gratify the Pope's desire, and the heretical Dominican friar was delivered to his enemies. On January 9, the Venetian ambassador at Rome was ordered to make the most of the concession, and to assure his Holiness that it was done out of filial and reverent obedience to his desires. And so on February 27, 1593, the prison doors of the Inquisition at Rome closed on Giordano Bruno, and from that day until his trial, in July 1599, nothing is known of what befell him. Indeed, whether he was really burned in the Campo dei

[1] *Per pagare della sua Christiana conscienza lo manifestò.*

N

Fiori, where his statue now stands, has been disputed, although the evidence that he was executed there seems conclusive enough.[1]

In the central palace lived in 1622, Lady Arundel, who, being suspected of complicity in the alleged treason of the ill-fated Antonio Foscarini, was advised by Sir Henry Wotton to clear herself before the Senate, and there, the only woman ever suffered to address that august body, acquitted herself admirably. In this same palace, too, lived that vivacious letter-writer, Lady Mary Wortley Montagu, during her residence in the Venice she loved so well, from 1758 to 1761. There was no great city, she wrote, properer for the retreat of old age, nowhere did she find more affectionate friends, being especially intimate with the eloquent and wise octogenarian Senator, Antonio Mocenigo.

But of greater interest to readers of English is this palace from the fact that during three unwholesome years, from 1817 to 1819, it was occupied by George Gordon, Lord Byron, and his second mistress Margarita Cogni, the baker's wife; she, a dark, handsome virago, strong as an amazon, with a face like Faustina's and the figure of a Juno, tyrannised over her master, and, energetic as a pythoness and a very fury in her passion and ungovernable temper, led the author of "Don Juan" an intolerable life of alternate adoration and abuse. Here, too, on November 1818, he was visited by Mr Newton Harris, who has left us an unedifying picture of the palace and its temporary occupier. The basement was encumbered with his lordship's carriages and a menagerie of two or three kinds of dogs, birds, and monkeys, and a fox and a wolf in cages. Byron, although not more than thirty, looked at least forty years of age; his face had grown pale and bloated and sallow, he had become very fat, the knuckles were lost in the puffy hands and his

[1] See Théophile Desdouits, " La Légende tragique de Jordano Bruno," 1885; R. Fulin, " Giordano Bruno e Venezia," 1864; and J. L. MacIntyre, " Giordano Bruno," 1903.

shoulders had grown broad and round. Too much has been
made by some writers of the fierce egoism and intermittent
profligacy which, in early manhood, the poet flaunted in
scornful defiance of respectable hypocrisy: his failings were
those of his class and of his age; his life was compounded
of elements finer, not coarser, than those of his contem-
poraries; he lived in a period of unbridled licence among the
aristocracy of England, when a bestial old rake, raised to the
throne as George IV., was reputed the first gentleman in
Europe. Like Faust in the drama, Byron, even in the darkest
stress of passion was ever conscious of the better way and
fought through to the light at last.

> " Wer immer strebend sich bemüht
> Dan können wir erlösen : "

redeemed indeed was he; the defilement of early sin was
purged away like dross in a flaming enthusiasm and pure self-
sacrifice for a noble ideal, and amid the booming of Grecian
cannon and the echoing response of exultant Turkish guns
his stormy spirit was sped to its rest.

Byron, to whom in later life the memory of his stay
here became hateful, was in his youth passionately en-
amoured of Venice, which inspired some of the finest stanzas
of " Childe Harold." Here he wrote " Beppo," " Mazeppa,"
and the early cantos of " Don Juan "; to him one view of the
Rialto and of the Piazza, one chaunt of Tasso, were worth
more than all the cities on earth, save Rome and Athens ; to
him Venice

> " Was as a fairy city of the heart
> Rising like water columns from the sea."

To this palace came "one morn, rainy, cold and dim " the
poet Shelley, and while waiting began to play with Allegra,
Byron's natural daughter, and—

> " A lovelier toy sweet nature never made."

Her father descended and soon the visitor was involved in high

themes of human fate and choice with him "whose serious conversation held one as with a spell." Then—

> "Through the fast falling rain and high wrought sea
> Sailed to the island where the mad-house stands,"

and heard the piteous story of the madman, which he set to verse in "Julian and Maddalo" and dispatched to Leigh Hunt to publish or throw into the fire. Shelley, too, was fascinated by the potent charm of Venice, and but for personal ties would have formed some plan never to leave her. He loved to ride by the lone sea—

> "Or read in gondolas by day or night,
> Having the little brazen lamp alight
> Unseen, uninterrupted."

There, too, he planned to sit—

> "In Maddalo's great palace, and his wit
> And subtle talk would cheer the winter night
> And make me know myself; and the firelight
> Would flash upon our faces till the day
> Might dawn and make me wonder at my stay."

The Mocenighi, in the glorious days of Venice, had numbered some twenty separate branches; in the seventeenth century, fourteen had become extinct; in the nineteenth but two branches remained—that of the Angelo Rafaelle, whose last male descendant, Francesco III. Carlo, died in 1863, and that of S. Samuele, whose only remaining representative, Alvise III. Pietro, passed away a year later. The genealogies of the house, in Count Litta's volumes, fill twenty-four large folio pages, and now two married daughters of the S Samuele branch, alone survive of this once mighty patrician family. The fine collection of portraits of the Mocenighi, by great masters such as Giorgione, Titian, Palma, Tintoretto, have all been dispersed, and the historic gallery of Doges, Procurators, Senators, warriors and scholars; the sculptures and antiquities which, in the inventory of the works left by Alvise Mocenigo in 1759, amounted to 254 items; the sumptuous hangings of silk, of

GARDEN AT MURANO.

triple pile velvet and other decorations and adornments—all have disappeared and have been replaced by modern furniture, and for the greater part of the year these famous halls are said to be uninhabited.

With the Palazzo Pesaro may be compared the Palazzo Rezzonico by Longhena, opposite the Campo S. Samuele, so long associated with the name of Browning. The building was designed and erected on an elevation of two floors only, the third having been cleverly superposed by Massari in 1752; the dominating influence of Sansovino is again unmistakable. The Rezzonico family were of Comacene origin and settled in Venice during the seventeenth century: when money was urgently needed during the last and fruitless wrestle with the Turks, they, by a gift of a hundred thousand ducats, purchased their patrician dignity. In 1758 one of their descendants sat in S. Peter's chair under the title of Clement XIII, and in 1810, the family became extinct.

The Pesaro and the Rezzonico were the last great palatial architecture raised in Venice. Many another huge pile of stone and brick, during the seventeenth and eighteenth centuries, was laid on her patient soil:—the Palazzi Giustiniani-Lolin, Labia, Battagia, by Longhena; the Michieli delle Colonne, once the home of the last Duke of Mantua, by Sardi; the Balbi, by Vittoria; the Moro-Lin, by Mazzoni; the massive fabric reared on the site of the old mansion of Caterina Cornaro, Queen of Cyprus, by Rossi, now used as a Municipal Pawn Office, and others, all equally formal, all equally insipid and featureless. Indeed, nothing gives the wanderer about the city of Venice a more vivid impression of the wealth which the noble Venetians of the decadence could command, than the number of palaces of this type of architecture he meets with:—the Pisani and Morosini on the Campo S. Stefano, the Foscarini, and others on the rio Sta. Margarita, the Cappello and the Gradenigo on the rio Marin, the Condulmer at I Tolentini, and a huge

structure on the Fondamenta della Misericordia, are a few that occur to us as we write. Never had state a mellower sunset or longer twilight. Towards the end of her more than millennial existence, the venerable city seems, in her ripe old age, to have girded her loins and gathered her strength for a final and supreme expression of patrician architecture. A model was made—it may still be seen in the Museo Civico—of a palace which for magnitude, capacity, and classic stateliness, was to rival, if not to surpass, the magnificence of her prime. The foundations were laid and slowly the sea-story rose above the waters; but her powers were exhausted, her resources failed, and there it stands to-day, a pathetic, abortive fabric; an eloquent memorial of an empire that has passed away and of a grandeur and a splendour that have waned for ever; and beneath the trailing greenery that kindly veils its maimed and half-wrought basement one may feign to read .

> " Sic transit gloria mundi."

Even so hath departed the glory of those dainty pleasure palaces with their lovely gardens that studded the skirts of the city as with emeralds, their

> " Fronts demurely
> Over the Giudecca piled,
> Window just with window mating,
> Door on door exactly waiting."

Palaces, that on the once fair island of Murano, evoked such amazement and delight in Pietro Casola and in every other traveller who touched at Venice in the Renaissance centuries; pleasant gardens, trim and sweet and beautiful, with their classic peristyles and exhedræ, cool grottos and delicious arbours, where patrician scholars, their daily business done, would sit at eve with their Grecian friends and tutors discoursing of Plato and of divine philosophy and in imagination—

" . . . Hear the Muses in a ring
Aye round about Jove's altar sing."

Of these intimate splendours scarce a wrack remains—
a few fragmentary architectural survivals, smoke-begrimed,
neglected; the ruined portal and walls of the garden of
the still existing Palazzo da Mula, itself an interesting
and decayed late Gothic edifice; a broken column or
classic relic hidden away here and there in the few poor
gardens and mean homes of modern industrial Murano.

NERICHSEN

CHAPTER XIV

*The empty chambers of the Ducal Palace and their former
occupants—The Triad of Great Diarists, Malipiero, Priuli
and Sanudo—Career of a busy statesman and official—
Dismissal of the Marquis of Mantua*

> " Then sayde he thus : O paleys desolat !
> O hous of housses whilom beste yhight !
> O paleys empti and disconsolat !
> O thou lanterne of which queynte is the light !
> O paleys, whilom day, that now ert nyght ! "
>
> *—Chaucer.*

DURING the fifty years that elapsed from the end of the
fifteenth century, when Philippe de Comines, envoy of
France was rowed along the Grand Canal of Venice and
beheld with amazement and admiration the noble houses that
lined the Grande Rue of the most triumphant city in the
world, to the middle of the sixteenth, when the Cæsarean
Ambassador, Don Diego Mendoza, was invited by the
Aretino to gaze on the beautiful palace raised by the
genius of Sansovino to preserve the literary and artistic
treasures of the Venetian Republic, the splendour of her
merchant princes had touched its meridian and had already
begun to sweep slowly down towards its setting. They were
exalted by her political glory and commercial domination :
they were abased by her decline. During the closing
decades of the fifteenth century, besides many islands that
remained of her once vast possessions in the Levant, she held
a large and ample empery on the mainland from the Isonzo
to the Adda. Her arms threatened Milan in the North,
carried terror to Naples, and won cities in the Puglie in the
far South. Rich and populous towns : Padua, Vicenza,
Verona, Brescia, Bergamo, Ravenna, Rimini, Faenza, Imola,

and others in Romagna, were under her wise and tolerant rule. But from the humiliating peace with the Turk in 1479, to the loss of Cyprus a century later, her monopoly of levantine trade, won at a great cost of blood and treasure during the colossal duel with Genoa, had been seriously impaired by the advance of Ottoman fanaticism, precisely at a time when the opening up by Cão, Diaz, Covilhão and da Gama, of the Cape route to India, and the discovery of a new world in the west by Columbus, had revolutionised the conception of the universe and dislocated the commerce of the globe. Nor was this all: a coalition of jealous European powers was forming against her. Two transalpine monarchies, the one, France, welded into a mighty whole by the genius of Louis XI.; the other, Spain, with the united power of Aragon and Castile under the lead of Ferdinand and Isabella, overshadowed with dreadful menace the little states of Italy, their armies irresistible in the field, their naval power growing with the waning domination of Venice on the seas. But it was long, thanks to the sagacity and fortitude of Venetian statesmen, before the full force of these adverse conditions was felt, and even as a once rich and exalted family when its fortunes are impaired will sometimes seek to impose on its neighbours by an ostentatious display of external magnificence, so the Venetian Seigniory and the Venetian patricians vied with each other in the erection of sumptuous palaces and in the pomp of luxurious festivals. As Malipiero writes in his diary, the clock tower of the Merceria was begun in 1496, in spite of the war with Naples, "to show that the city was not without money," and Sanudo notes that on February 1, 1499, as the prince went to vespers at Sta. Maria Formosa for the first time this clock (over the street that leads from the Piazza to the Merceria) was opened and displayed ; "and it was wrought with great art and was most beautiful."

We have beheld, and, alas ! how much debased and shorn of their splendour, these empty cells of the human hive, but

what of their proud and magnificent masters? What of the merchant princes, senators, and magistrates, who once sat, ruling an empire, within the now vacant Privy Council Room of the Ducal Palace, the Senate, the closet of the Ten, the vast hall of the Great Council, and who held high revel in their gorgeous and glittering mansions? What of their intimate life, their hopes and fears, their sorrows and pleasures, the daily vicissitudes of council chamber and of home? Can aught be told of those? May we peruse the written record of the diurnal preoccupation of statesmen, and of the humbler concerns of domestic life? In a large measure we may, for a great triad of diarists has bequeathed to us contemporary records written with a fulness, sagacity and vividness unexampled in the history of states.

Senator Domenico Malipiero, born in 1428 of high patrician parentage, was a typical Venetian of the ruling classes, whose early manhood passed in commerce and navigation, fitted him for high office in a maritime state: he was made Senator in 1465, held high command in the Ferrarese war, fought in the relief of Pisa, was Admiral of the Fleet, podestà of Rovigo (1494), of Rimini (1505), and Treviso in 1515, the year of his death. He modestly notes in his diary that at the capture of Gallipoli the captain-general being shot down on the poop of his galley as he was commanding the assault, the body was covered up and the news put about that he was but wounded and gone for surgical help, "when the battle continuing, Domenico Malipiero gave great assistance so that our men forced the city before they knew of the death of their captain, and Malipiero used great diligence that respect should be paid to the chastity of the women of the city, gathering them into the churches and setting guards over them." Domenico could wield a skilful pen as well as a sword, and from the year 1457 to the end of the century wrote down in Venetian the events of his time in diaries, which in the latter half of the sixteenth century came into the hands of Senator Francesco Longo, who made of them

an abbreviated copy from which the printed edition has been published[1]: the originals unhappily have disappeared.

Senator Girolamo Priuli del Banco, a partner in the famous patrician banking house of the Priuli, was born on January 25, 1475, and for his financial knowledge was frequently consulted by the Seigniory. His father, he tells us, Lorenzo Priuli, was a valiant merchant and of great experience in matters of business and commerce, zealous for his fatherland, who never slept, but day and night sacrificed himself for the weal of the Republic. Girolamo set about his diary at the opening of the year 1494, and made his last entry on July 23, 1512. It is composed in Italian and is invaluable for the light it throws on the financial policy and fiscal practice of the Republic. The reference to the printed portion of this diary in the admirable and exhaustive bibliography in vol. i. of the Cambridge Modern History, is to Muratori, vol. xxiv.; but the student will seek in vain in this, or other of the great tomes of the Rerum Italicarum Scriptores, for any line attributed to Priuli. On the inner cover, however, of the first volume of the sixteenth century MS. copy of the diaries preserved at the Marciana is a note to the effect that that volume has been printed in Muratori, vol. xxiv., where it is wrongly attributed to Marin Sanudo, and "begins at the eighth line of this codex, which is the first part of the diaries of Girolamo Priuli." To vol. xxiv. of Muratori then the student may go and in the *De Bello Gallico auctore Marino Sanudo* peruse the first volume of Priuli's diaries: the second, fourth, fifth, sixth,[2] seventh, and eighth volumes of the sixteenth century copy are in the Museo Civico, the third volume having been lost. In the Marciana are also treasured a copy of the second volume in full, and abbreviated copies of the following volumes, made by Pietro Foscarini in the early eighteenth century, who also added indices. The weary old copyist tells us at the end

[1] Archivio Storico Italiano, tom. vii. 1843.
[2] This volume contains no less than 1202 folio pages.

of the three volumes into which he had compressed the
diaries that he completed his task on April 22, 1727, in his
seventy-sixth year, and but for other business would have
finished it more quickly: he complains more than once
of the digressions and exaggerations and obscurities[1] of
these voluminous diaries and their hateful style, all of
which, however, constitute no small part of their charm to
the modern reader. It is from these Foscarini MS. copies
and from vol. xxiv., of Muratori that our citations are taken.

But greater than these was Marin Sanudo the younger, a
scholarly and patriotic Venetian nobleman, descended from
one of the twelve apostolic families, who, from January 1,
1496, to September 30, 1533, applied himself to the
compilation of a diary, which is not only a daily record of
events in Venice but of the diplomacy of Europe and of the
then known world. Day by day he was at his place in the
Ducal Privy Council, the Senate, or the Great Council,
taking his part in the government of the State, or listening
to the informal talk of the patricians as they paced the
arcades of the Ducal Palace in the early morning; mixing
with the leading merchants on change at Rialto and gathering
the latest rumours; mingling with the citizens in the market
places and hearing their gossip. Moreover, its writer had
access to the reports of ambassadors and of provincial
governors and other official documents, and the result is a
diary which, for range of interests and copiousness, is
unparalleled in the history of literature.

Sanudo was thirty years of age when he began his self-
imposed task: he was sixty-seven when he laid down his pen.
These precious volumes, after many vicissitudes, now repose
in the library of St Mark in the old Zecca or Mint of Venice,

[1] *e.g.* "This passage is written with much confusion and not having been
able to copy it better I have transcribed it as nearly as I can. It is badly and
most confusedly expressed and I am not willing to cudgel my brains any more
over it. Let him who is curious about the passage go to the Chancellery
where he may see it *in extenso.*" May 1511.

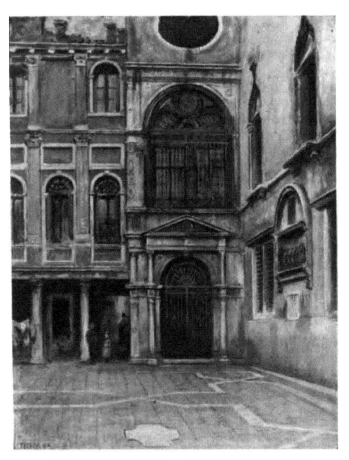

CORTILE AT SCUOLA DI S. GIOVANNI EVANGELISTA.

and it is impossible to turn over their worm-eaten covers and
venerable pages without a feeling of admiration and almost of
amazement, at the imperturbable industry and long-suffering
patriotism of this author who has written not only these, but
a voluminous story of the lives of the Doges; the itinerary
of a journey though the Venetian provinces; a history of
the French wars, and other literary works. The diaries,
composed in Venetian, are written in neat, close, upright script,
on symmetrical pages with wide margins, and rubrics in red
ink: scarce a blot, an erasure, or an interlineation mars the
beauty of the page. The later volumes are, however, less
clearly and neatly written; the disillusioned and disappointed
old patrician seems to have lost heart; his hand trembles; the
paper is not uniform, any available scrap being used; many
sheets are filled by other hands or inserted in print; the
writing sprawls; and blots, erasures and gaps betray a waning
interest and a perfunctory task. The writer complains that
he was often compelled to deprive himself of the necessaries
of life to buy paper and pay for binding, and it was not until
he had completed the fifty-fourth volume in September 1531,
in the sixty-fifth year of his age, that he was appointed by
the Council of the Ten to continue the history of his times
at a salary of 150 ducats a year; which "I swear to God, is
a mere nothing compared with the most mighty labours which
I have undergone all through the best years of my life and
solely out of love to fatherland and letters." For two years
and a half, after the last entry was made, the veteran
historian lived, and at death willed his fifty-six books of
histories, all bound and preserved in a cupboard, to the most
Illustrious Seigniory to be placed where convenient to them.
The Ten, on obtaining possession, stored them in a secret
chamber for the use of Bembo and other official historians,
and so carefully were they concealed that subsequently all
trace of the volumes was lost, Doge Foscarini himself having
searched for them in vain. At length they were discovered by
Francesco Donato in 1784, who obtained permission to have them

copied at his own expense and they were transcribed and in-
dexed in fifty-eight volumes.[1] After the fall of the Republic and
the spoilation of her treasuries, the originals were appropriated
by the Austrians and taken to Vienna, the Donato copies being
left at Venice, until 1866, when the originals were exchanged
for the copies and now are housed in their appropriate
home : thanks to the munificence of some Italian scholars and
gentlemen the diaries are at length[2] available to students in
printed form in the principal libraries of Europe. Some con-
ception of this stupendous work, before which every other
diary pales into insignificance, may be obtained by a count
of the number of pages, tabulated by Rawdon Brown from
the volumes of the Donato copy : including the indices, they
amount to 38,046 pages averaging about 48 lines of 65 letters.
The printed volume for the year, March 1st, 1510, to Feburary
28th, 1511, contains 1742 columns or 871 large quarto pages,
and the original of vol. ii. at the Marciana, from October 1st,
1498, to September 30th, 1499, consists of 1072 pages.

There is a touching reference in the old scholar's will to
his library of more than 6000 books, which cost him much
money "and are things most beautiful, and many not now to
be had." Those in the catalogue marked with a × had been
sold to meet urgent needs, and he prays, since evil fate has
granted him no legitimate heirs and all the result of his
labours and the works composed by him must be dispersed
among strangers, that the Signori Procuratori will look to it
that his books, especially those which are written with the
pen, and which indeed are worth much more than the price
he paid for them, having been bought in times of famine and
very cheaply,[3] may not be chucked away for any mean sum.

[1] It was from this copy that Rawdon Brown compiled his summary pub-
lished in 1838, 3 vols., whereby the real significance of the Diary was first
made manifest, as Italian scholars have admitted : *chi li fece conoscere
veramente fu il Signor Brown :* Arch. Stor. Ital., vol. ix. p. 48.

[2] 1879-1903.

[3] In 1509 Marin was returning from an inspection of the Camp at Mestre,
everybody being in tears at the disastrous news of the League of Cambray,

Messer Marin had a keen eye for a bargain, and in his will disposes of a dress of yellow satin which he bought for twenty ducats of Grazzin the Jew in the Ghetto, for the trousseau of his natural daughter Candiana. He died poor in this world's goods, but "I have," he adds, "lived as an honourable gentleman, paid all my debts, and dowered my two natural daughters: God be praised for all."

The genealogies of the Sanudi in the MS. Arbori de' Patr. Ven. in the Archivio di Stato are divided into six branches, the senior of which is traced back to a nephew of Doge Enrico Dandolo, who, being appointed first Duke of the Ægean after the capture of Constantinople, was known as Marco Sanudo the Duke. Our annalist was descended from the third branch, the Sanudi of S. Giacomo dall' Orio, whose ancestral mansion we have seen in our wanderings about the city. In the lives of the Doges, Marin is pleased to fabulize his descent from a king of Padua called Candiano and afterwards Sanudo; the Candiani were "*benevoli omnes*, most puissant in battle and great in stature, they were ancient tribunes and *superbissimi*, and Ser Tomaso Candiano went in 421 with Ser Alberto Faletro (Falier) and Ser Giovanni Daulo to found Rivalto."

The young Marin Sanudo having, in the year 1498, already sat for some years by right of birth in the Great Council, was charged with important offices: in March he notes "to eternal memory" that he was chosen Signor di Notte (Head Constable) for the Sestiere[1] of Sta. Croce, an officer, says Lewkenor, whose duty it was "to make rounds in his ward till dawn with weaponed officers to see that there be not any disorders doing in the darkness of the night, which always emboldens men, ill-disposed, to naughtinesse,

when he saw a most beautiful Hebrew Bible written on good parchment, worth at least twenty ducats. This he bought for a marzelo (fivepence), and put it in his library *per memoria*. The marcello, we learn from Malipiero, was coined during the reign of Doge Nicolo Marcello in 1474, and was worth ten soldi.

[1] One of the six wards into which the city is divided.

and was first in great estimation, but now (1599) diminished and deals with base and baggage matters as the suddes or lees of the rest." In the same year (1498) Marin was appointed one of the five Savii agli Orden and became ex-officio member of the Senate, but without power to vote.[1] This, a most ancient office of much authority, was usually the first to be conferred on a young patrician, and involved dealing with naval affairs. They, together with the five Savii di Terrafirma, a kind of Home Department dealing with the mainland provinces; the five Savii Grandi, who represented the Senate; the three chiefs of the Quarantia[2] Criminale or High Court of Justice for criminal cases; the six Privy Councillors of the Doge; the three chiefs of the Ten; and the three Avogadori di Commune, a sort of public prosecutors and tutors of the rights of the Commune, one of whom was present at every sitting of the Great Council with power to intervene in their deliberations, and who also kept the Golden Books of patrician families, formed the Collegio or Privy Council or Cabinet, over which the Doge presided. This body, second only in importance to the Council of the Ten, read all dispatches, heard ambassadors, and prepared all

[1] The Senators permitted to vote were: The Doge and his six councillors, the Ten, the Avogadori, the Procurators of St Mark, the Quarantia Criminale, the three councillors di basso, the Censors, the three Commissioners of the Trade Guilds, the three Commissioners of the Imports, the three of the Corn Office, the four of the Salt Office, the three of the Ragione Vecchia and those of the Ragione Nuova (magistrates who exacted returns from all officials that handled public moneys), the three of the Commune, the three Masters of the Arsenal, the three Commissioners of the Chambers, the three of the Ten Offices, and the three of the Cattaveri (magistrates who watched over the property of the Commune and who licensed the official guides to foreigners that were stationed at Rialto and the Piazza, and who supervised the pilgrim galleys). Those who had no vote were the ten Savii agli Orden and di Terrafirma, the three Commissioners of the Water Board, the three of Public Health, the three of the Octroi, and those of the Cotrini.

[2] The Quarantie Civil Nuova and Civil Vecchia for civil cases were not represented in the Collegio.

PALAZZO SANUDO.

the business for the Senate. The Savii, however, were dismissed from the Collegio when the Chiefs of the Ten were present, who only seem to have entered occasionally for important and secret matters of State.

From April 1501 to October 1502, Marin was acting at Verona as Camerlengo or officer of the Exchequer, who supervised the collection and custody of the public revenues, and on his return was made Savio agli Orden for the fifth time; in 1510 he served for the seventh and last time. In 1516 Marin failed to secure election as Avogador di Comune, to his great disgust. On March 2, he tells us, he attended the Great Council, and although he had 800 supporters, he was not even nominated. Of the four who were, Michiel Trevisan brought in two bags of gold containing 1200 ducats, and offered 300 more; Doctor Lorenzo Orio offered 2000 ducats; Gabriel Moro, the knight, offered 500; and Marco Foscari brought in two bags of gold containing 1000 ducats, and offered more. Trevisan subsequently added 500 ducats. Ultimately Zaccaria Gabriel was elected, because during the war he had advanced 7000 to 8000 ducats at a time, and now offered 8000. Alvise Pisani, who promised 100,000 ducats and had financially assisted not only the Seigniory but private persons, was unsuccessful—ungrateful city—he offered half more in ready money, and even had 10,000 ducats in gold brought to the Council; "but so things go nowadays." Then Zorzi Emo, one of the first citizens of Venice, offered 10,000 ducats and a gift of 3000: "*Nihil minus* then, if I, Marin Sanudo, who with great travail have already during twenty-four years written the history of this city, and have served seven times in the Collegio and in other magistracies and offices, who have made a library of 2,800 books at a cost of 2000 ducats, and am moreover born of such a family—son of one who died an ambassador of this Republic at Rome, and lies buried there—no wonder if I have failed; such is the way of Republics. Every office is filled for money, and I swear to God never to seek any office again."

o

In June the Doge's son, Alvise Loredan, compassed his election as Procurator of St Mark by offering a loan of 14,000 ducats and a gift of 12,000, which were laid before the Council in twelve bags. But the defeated Marin's passion for office was strong. He, too, shakes his money-bags before the electors; and in August of the same year, "having scraped together 500 ducats, God knows how," entered the Senate as a full member, with power to vote, at the age of fifty-one. "And so to-day," he writes (August 15), "I had licence to enter the Senate, and, in *nomine Domini*, was balloted for in the Great Council; and this day (August 18) is the first time I enter the *Senato ordinario*, and, please God, with more facility shall now be able to note down the truth of the things that happen day by day." In 1517, failing in his candidature for the office of Savio di Terrafirma, the annalist bewails his ill-fortune: "For I, Marin Sanudo, *zovene* (junior), have been seven times Savio agli Orden, and done excellent work for the good of this Republic, and gained much esteem"; and although Doge Loredan once took his hand, and said, "our magnificent Marin Sanudo deserved great praise, and ought to be in all our councils," he was subsequently equally unhappy in his candidature for the Senate, and bitterly railed against his exclusion.

It was on the first day of January 1496 (or, according to the Venetian calendar, 1495, for the old Venetians began their year on March 1) that Marin, having made an end of writing of the French wars, not without supreme and daily toil, and having reduced the work to a *magno volume*, purposed to note what happened in Italy from the time when King Charles of France returned to his realm beyond the mountains until peace was seen in Italy again, so that these things should not fall into oblivion. He would give *verissimo* news as it came to him, and when he had more leisure would reduce his book to another form of language (Italian). But the Angel of Peace, since King Charles

crossed the mountains, was a brief sojourner in Italy, and many a brave paladin and fair young lord were to bite the dust before the transalpine powers had ceased to make a cockpit of her fruitful and lovely land. For, to the indignation of Italian condottieri, the French knights fought to kill, and soon made short work of their military conventions, which once reduced the casualties of a long battle to an accidental fall from a horse.

Three years pass; the annalist already begins to weary of his task, and many a time thought within him to make an end of these lucubrations and labours not a few: but the affairs of Italy were in great turmoil, and "I am he who by the ordination of the heavens must write down the things that happen which are worthy of memory, and so I begin the third *deca* or *ephemerida*, and note day by day the news, without any polish of style. Let whoso will, read, and reprove me not." In 1509 having, not without great labour and continual solicitude to search out the truth, completed seven volumes, and the world being yet in great combustion, he girds himself to begin the eighth. In 1520 the times were still out of joint; the weary diarist had grown old in writing, and would have given up his self-imposed task and ill-requited labours, but that he was entreated to continue until the death of Doge Loredan, his friend. Loredan died, a new Doge sat in his place, and still the work went on. In 1523 he complains of the ill-fortune, envy, and spite, which have again excluded him from the Senate; years of sickness have weighed him down; much time he has passed in bed, in danger of his life, and in the hands of physicians and surgeons; yet has he never stayed his hand from writing day by day[1] the news delivered to him by his friends, hoping that his labours will bring him, if not some public recognition, at least the reward of a sublime, exalted, and eternal memory. God be praised for all. And when the

[1] Not absolutely true: some few entries are inconsequent in date, and some days are omitted, *e.g.* May 1502.

thought possessed him to renounce his task, friends came and said to him : " Marin, be not led astray, follow along the way thou hast so well begun, wife and magistracy are ordained in heaven." And so once more he takes up his pen. Some years later his spirits rise. He is again a Senator, God be praised, " and my heart knoweth all my concern is for the weal of our Republic and my dear Fatherland." On St Michael's day of 1529, having again failed in his candidature for the Senate, he will write no more but devote his small remaining span of life, which anyhow must be passed in bitterness, to prepare for his end. " I am now," he writes, " sixty-three years of age, the son of one who gave up his life for his Fatherland at Rome, where his ashes now lie ; and even as he said I will say : ungrateful country, thou shall not have my bones, and so to-morrow I will close this my last book." Two days later, however, we find the querulous old diarist beginning his fifty-second volume with the usual formula, ADSIT OMNIPOTENS DEUS, and on September 1531 the tardy official recognition was given him by the Ten.

It was a stormy time when Marin sat down before the first sheet of his diary. Venice, repentant of her fatal invitation of the French to Italy, was seeking allies against them, and one of the earliest entries is a reference to the proposal of the Senate to send an ambassador to King Henry of Anglia, *vulgare sermone re di Angilterra*, and the Senators' interest in that far-away realm is awakened.

Henry, we learn, had two sons: Arthur, Prince of Squales, which is the island, and the Duke of Yorcke. Further curious information concerning those remote regions is found in later pages : the houses of London are all of wood, and on the floors they lay a certain herb called *uesi* (rushes) which grows in the water, and this they change once a week ; gentle-women go to market carrying the train of their dress under the arm, servants following with theirs pinned to the back ; it is impossible to distinguish the colour of their hair, whether

it be fair or not, owing to their peculiar head-dress. Many details of costume are given, from which we learn that they wore black stockings, but no clogs; and if an English lady meets a male friend in the street, each kisses the other in the middle of the mouth, and they then repair to a tavern and eat together, and their people do not take this freedom amiss, because such is the custom. English ladies are most beautiful and pleasing, the men tall and stout, and the wind is always blowing in that land.

As the clouds thickened over Venice and mercenary armies were urgently needed, the Condottieri, on whom that maritime state was forced to rely, grew more and more rapacious. They literally battened on the wealthy republic, and, as Priuli notes, although the Senate was spending a well of ducats, and had an army in the field powerful enough to conquer the whole of Italy, nothing was done. And naturally so: the richer these soldiers of fortune grew, the less inclined were they to risk their skins in the service of an alien state. They could never be goaded to fight in earnest; to them it was never time, in Priuli's expressive phrase, to *insanguinare le camicie* (to bloody their shirts), and the Seigniory was never sure of single-hearted service.

There is a dramatic story in Sanudo and in Priuli of the sudden dismissal by the Ten, of Gian Francesco Gonzaga, Marquis of Mantua, their captain-general, who, command-ing the Venetian and Milanese forces in 1495, had won a dubious victory over the French at Fornovo, for practising with the King of France. One June afternoon in 1497, when the Senators met, they learned, to their utter amaze-ment, that they had been kept in ignorance of the fact for eighteen hours; and it was only on seeing Gonzaga's envoys returning from a fruitless interview with the Doge, with tears in their eyes, that they knew what had happened. Nor would the Ten open their doors to the Marquis himself. Again and again he was seen with arrogant mien passing along the Grand Canal, seeking in vain to bend the inexorable

decemvirs, all folk murmuring at his insolence, and saying our most excellent Ten would surely not have cashiered him if his treason had not been clear. Once more he sends his envoys, who offer wife (the famous and accomplished Isabella d'Este) and children as hostages, and urge that he should be heard, for *neque dyabolo est deneganda audientia*—even the devil should not be denied a hearing. Naught availed, and the Marquis left, owing the treasury 8000 ducats and the merchants at Rialto many thousands more. *Padre di ogni Traditore*, growls Priuli.

Twelve years later the pride of Marquis Gonzaga met another fall. In 1509 he had transferred his services to the Imperialists, and was hastening to their assistance at Verona when he was ingloriously captured at Isola de la Scala. Sanudo was at Padua on August 10, subsequent to its recovery by the Venetians, and stood at the Porta Sta. Croce watching the Stradiote mercenaries bring in their booty and prisoners, one leading a noble charger known as *il Favorito*, worth 1000 ducats, when the crest-fallen Gonzaga entered, wearing a velvet doublet embroidered with gold. It was a *bel veder*, and as the Marquis rode in, the crowd shouted, "Marco! Marco! Vittoria! Vittoria!" The chiefs of the Ten and the Captain-General met him on the Piazza; the latter, kneeling, said, "Seignior Marquis, I have always beheld you gladly"; to whom Gonzaga replied that he was pleased to be the prisoner of the Seigniory, "and then all we went to dinner." Our diarist heard the story from the four peasants who captured him. Searching for booty and concealed prisoners, they came upon the Marquis, barefoot and in his shirt, stretched on the bare earth in a barn, whither he had hid himself after leaping out of the window of a house near by, wherein he had passed the night. One of the four recognised Gonzaga, and, seizing him by the shirt, dragged out the wretched captive, who prayed to be let free, and offered his captors a ransom of 4000 ducats. But they swore they would deliver him to the Seigniory, and

the famous Condottiere, grieving to be thus basely caught, weaponless and without fighting, and by vile labourers, was handed to the Venetians at Padua. The rooms in the Torreselle of the Ducal Palace, "a most comfortable prison," says Priuli, over the Hall of the Great Council, were prepared and fitted with tapestry and with coverlets quilted with gold to receive him. He was brought in by night, for fear of violence from the people, and the whole Canal, from Fusina to Sta. Marta, was so filled with boats that it seemed bridged, and all the windows were illuminated, the people crying out, "Marco, Marco, Vittoria, Vittoria, hang him! hang the traitor!" accompanying their words with piercing shrieks and whistles, beating of oars, and volleys of stones, "and the said Marquis *molto si discomfortava.*" The Ten determined to hold him fast: three patricians and nine citizens stood guard on the stairs, ten others on the Ponte della Paglia, and two armed boats patrolled the Canal. As Querini, the chief of the Ten, took leave of Gonzaga at the prison, he said: "Seignior Marquis, be of good cheer, you are the prisoner of a most kind Seigniory." Next day when the prisoner was led in to the Collegio, he looked old and ill; bowing his head, he knelt down before the Doge, who gently raised him and made him sit beside the ducal chair, and the whole palace was full of gentlemen who had come to see him. His actual captor, Domenico di Venturin, was given a life pension of 100 ducats, and each of the three others one of 50 ducats.

On August 19, as Sanudo sat in the Collegio, a loud knocking was heard, and Carlo Venier, being admitted, related, angry and furious, how that he had just met a Mantuan envoy in the courtyard of the Palace, who asked if the Seigniory treated the Marquis well. On being answered by Venier in the affirmative, the Mantuan demanded, " Did they give his master oysters, for he was very fond of them?" " No," said Carlo, " oysters are bad now. but in September he shall have some "; whereupon the envoy

insolently rejoined that before September came Venice would
be captured. The Doge at once sent for the Mantuan and
administered a *grandissimo rebuffo*, and Master Secretary
Gaspar was charged to inform Gonzaga what disservice his
envoy had done him. The prisoner complained loudly,
saying, "God is against me. Here am I ready to sacrifice life,
estate, wife and children for the Seigniory, and my own
people use such bestial words." On the 29th the envoy was
permitted to visit his master in prison, and Master Secretary
Gaspar reported that the Marquis, having asked after his
children, immediately demanded: "and how are my horses?"
Many weary months, closely watched, though treated with
much consideration, Gonzaga passed, dining with Venetian
gentlemen in his rooms or in the Palace. On April 19,
1510, he was *disperato*, and said he would die if he were not
soon discharged, and desired to make his will; in June he
complained that he could not sleep because of the bugs, and
iterated complaints followed. At length, on July 14, 1510,
Marin, with three other Savii, were sent to conduct the
Marquis from the Torreselle to the Collegio, for his
daughter, Leonora Gonzaga della Rovere, had long been
using her influence with the Pope to obtain his release from
the Seigniory, and it had now been determined to set him
free. The Doge made a graceful and politic speech, saying
his Holiness desired the Marquis' person to act against the
French, and that a galley was waiting to carry him to Rimini
that night. Gonzaga returned a complimentary speech, pro-
testing his obedience to the most illustrious Seigniory and
his will to fight the French. The Marquis desiring to visit
the shrine of Sta. Maria dei Miracoli, Sanudo and his three
colleagues accompanied him thither in a small boat; the
Palace was full of officials and patricians, and as Gonzaga
came down everyone pressed his hand and rejoiced with
him: making his way through the Piazza, crowded with
people, to whom he made a short oration, he returned, not
to the hated Torreselle, but to the Doge's apartments, and

having dispatched a girl he had adopted (the daughter of Daniel the Fifer), who played excellently, by land to Mantua, and having borrowed 500 ducats from Piero Grimani, Gonzaga was accompanied by the Doge and the Collegio to the galley moored off the Ponte della Paglia one hour before sunset. On his way to Mantua from Rome he wrote a letter to the Ten, subscribing himself: "Your slave in chains," and offered to shed his blood for the Seigniory.

On June 13, 1511, in the pages of Priuli we hear of the Marquis again, and in no creditable manner. A favourite of Gonzaga, and excellent condottiere of light horse, was a certain Cavriana, who, once a peasant lad, had risen to military eminence. Of him, being a beautiful youth, the Marquis had been much enamoured, and had given him his natural daughter to wife, but, "as often falls out in vicious friendships," a fierce quarrel arose between Gonzaga and his son-in-law, who transferred his services to the Republic of Venice. Although Cavriana's new masters were pleased with his courage and enterprise, they soon began to suspect collusion with the French, and in consequence of some unseemly references to the Republic which had fallen from his mouth he was recalled to Venice, seized by order of the Ten, and closely prisoned. Later in the month a letter was forwarded to the Senate which Andrea Gritti had received from the Marquis, wherein he, Gonzaga, stated that having heard of the arrest of Cavriana, and *seeing that for his crimes his son-in-law ought to be put to death (che per suoi delitti dovesse anco esser fatto morire*), he commended the prisoner's wife, his own natural daughter, who was then in Venice, to the Senate, that she might be well treated, because in the event (*succedendo*) of the death of Cavriana his intent was to marry her again. No reply was sent to this contemptible letter.

CHAPTER XV

Scenes in Privy Council Chamber and Senate—A busy day—
Stories of Pope Borgia—The Doge's story of S. Paul the
Hermit's relics—Astrologers and Freaks—Power and
fortitude of the Ten—Personal details of Marin Sanudo's
life

"The government of Venice is rich and consolatory, like its treacle, being com-
posed of all the other forms: a grain of monarchy, a scruple of democracy, a drachm
of oligarchy, and an ounce of aristocracy."—*Mrs Piozzi.*

MORE than one eulogist has likened the State of Venice to a
happy family, but it was a family not without its domestic
jars. On Our Lady's Day, September 8, 1500, the need
for a forced loan to meet the *grandissimi bisogni* of the
Turkish wars was angrily debated in the Senate until a late
hour. Piero Cappello, entering the rostrum, declaimed
violently against the Doge's [1] parsimony, declaring that the
prince should be the first to set an example of patriotism by
offering a contribution. Whereupon his Serenity rose and
made a rambling, querulous speech, protesting that he had
already spent 80,000 ducats during his fourteen years of
office ; that he had always been the first to pay his taxes and
dues ; that he was at great expense for salaries and for presents
—everybody wanted presents; that he had spent much on
furniture for the palace and on his State costumes, his vest-
ments of gold and rich mantles, all of which to look on
broke his heart, for he could not bear to wear them because
of his great age and of the evil news of the Turks. He
swore by his soul that he had no money, not even 2000
ducats in cash, but would pledge his plate. At eighty years

[1] Barbarigo II.

of age his term of life was short, he had no resources, nor
could he borrow. Turning angrily to Cappello, he abused
him, for that being his kinsman he should serve him so ill a
turn, and denounced him for having contributed only 100
ducats to the forced loan of the past year, and even that
was wrung from him with great difficulty. Then, reciting
the sacrifices his ancestors had made for the State, he left
the chamber in a towering rage. After a heated discussion
it was decided to tax the Doge ; the closest secrecy was
exacted, and the chiefs of the Ten went round to each
member administering the oath of secrecy. *Tamen*, com-
plains Sanudo, all the city heard of it. On the morrow
Barbarigo entered the Privy Council, speaking and acting as
if nothing had happened, and paid the money. A significant
entry, September 20, 1501, informs us that this Doge died
in more evil repute than any since Cristoforo Moro, and it
was a marvel to hear the curses uttered by everyone on his
pride, avarice, rapacity, and corruption. On the 23rd, during
the funeral celebration in S. Zanipolo, a councillor delivered
an oration with *elegante pronuntiatione et gestu mirabile*,
during which, referring to the King of France, he charged
that monarch with coming to Italy out of lust of dominion.
Scarcely had the words left the speaker's mouth when
Domine Accursio, ambassador of France, rose from his seat,
and in a loud voice cried : Thou liest ! The oration, says
the diarist, was therefore not printed. A description, too
long and detailed to be even summarised here, is given of
the working of the complicated electoral machinery that was
employed in the election of a Doge. It is interesting to
learn that the older electors, after the final conclave of the XLI
had selected Lionardo Loredano, prayed to be permitted to
go home to bed and return in the morning to initiate him to
the office. This, however, could not be, and so the poor
weary old gentlemen were forced to remain all the dreary
wet night in the Palace. During the election of Doge
Andrea Gritti, in May 1523, Sier Alvise de' Priuli called

out from the benches that it was not well to make Doge,
one who had three bastards in Turkey. Whereupon Sier
Andrea strode across to Alvise, who was sitting with Sier
Zorzi (Giorgio) Corner, and said he wished to speak a word
with him. Say on before Missier Zorzi, answered Alvise.
Andrea then said it grieved him much that a near kinsman
should use such words of him. Alvise retorted that what he
had said was true, and although he meant him no ill, it was
undesirable to elect a tyrant Doge. Whereupon high words
ensued between them. Violent scenes in Council Hall and
Senate were not infrequent. In 1496, notes Malipiero,
Bernadin Minoto bought some silver-plate of a merchant who
was a friend of Domenico Calbo, and, discovering the metal
to be false, took the law of him, and he was sentenced to
make restitution. Domenico on hearing of the sentence
was so angry that, meeting Bernadin in the Great Council,
he smote him with his fist, and "made a great quantity of
blood to issue from his nose." A grave and scandalous
scene was that between a Councillor and a chief of the Ten
during a sitting of the Senate at which Priuli was present in
April 1511. The Doge was absent through sickness, and
insulting words were exchanged between a Councillor and a
Capo, the altercation lasting some long moments, until the
whole Senate was in an uproar. Soon as the storm was
over the Ten ordered that, such being the shame and dis-
honour of the event, the whole incident was to be kept
secret; no one was to speak of the motive or the fact of the
scandal under severest penalties, and the chiefs of the Ten
went round the benches administering solemn oaths of
secrecy. On another occasion Senator Francesco Erizzo
answered Sanudo *bestialmente*, and on June 5, 1525, a
member of the Great Council rushed towards the rostrum
with such fury that he knocked a brother Councillor from
his seat, during a debate on the proposal to introduce
changes in the standing orders of the Quarantie. A
Giustiniani, on attempting to speak, was received by a

stamping of feet, so that he could not be heard, " and I, Marin Sanudo, went into the rostrum, and, with the great attention of the Council, spoke saying——" The diarist gives a long report of his speech, which is interesting for a curious piece of biography. The effect of the motion being that no young patrician between the ages of thirty and forty could enter the Senate, Marin described to the Councillors how that, twenty-seven years ago, when he was their Savio agli Orden, a good father and worthy Senator, the magnificent Missier Ferigo Corner, the Procurator, was taking him round the Ducal Palace, and being in the old Senate Hall said : "Marin, my son, seest thou how this hall is painted? This was done in the days of Doge [1] Piero Gradenigo. Dost see these large and middling and small trees? They are symbolical of those who enter the Senate: the young to learn, the others to govern, and thus are the three ages of man included—youth, maturity, and old age." Marin was a consistent conservative, and in his very last speech in the Council, which was " brief and an excellent oration," praised those who would have things remain as they are and not work revolutions (*far cossa nuova*).

The diarist was present, in June 1521, at the lying-in-state and funeral of his dead friend Doge Loredan, of which he gives a long and detailed description, "for being of the Zonta it seemed fitting that I should go with the Seigniory." When the vast and solemn procession reached St Mark's, the four Scuole of the Batuti [2] lifted up the coffin nine times, crying "God have mercy," while the bells of St Mark and of all the parish churches in Venice rang nine times a double peal. Arrived at S. Zanipolo, Marin heard the funeral oration, " which was long," and recited by Andrea Navajer, "who was paid a public stipend to write the history of Venice."

[1] 1289-1311, the author of the Serrata of the Grand Council.
[2] Guilds of Flagellants instituted in the thirteenth century, who, with veiled faces and naked backs, went about the city flogging themselves with scourges and iron chains.

On July 6, Marin went to visit the new Doge, his second cousin, Antonio Grimani, the once disgraced Procurator and Captain-General, who sat in state surrounded by the Seigniory, the conclave of the Forty-one, the Avogadori, the chiefs of the Ten, all clothed in crimson silk and cloth of gold; four noble youths stood near with fans in their hands to keep his Serenity cool. Marin, who was much beloved by his exalted kinsman, received a *grandissimo* welcome: "he kissed me four times, and I, weeping for very joy, kissed his hand." There were not less than 50,000 people in St Mark's at the presentation and investiture, and so great was the noise that the senior of the Forty-one could not be heard. The Canon who handed his Serenity the standard of St Mark was given 15 ducats, and the usual scramble for money—ducats and half-ducats of gold, and pieces of 16, 8, and 4 soldi—took place when the new Doge was chaired round the piazza in a wooden pulpit painted red, with a St Mark figured upon it. There were speeches—many speeches—and "so we went to rest." During the rush for coins, one of the arsenal men struck a foreigner with a stick to make him clear off, and the foreigner, coming upon his assailant later, fell upon him and smote off his head, saying: Now go and beat folk with your stick. There was invariably some loss of life on these occasions, and Malipiero relates that, at the chairing of Doge Agostino Barbaro in 1486, seven lads were crushed to death.

During the earlier part of his official career Sanudo seems to have been listened to with attention, but soon his rigid conservatism, censoriousness, and love of speaking wearied his colleagues. On July 10, 1503, the young Savio agli Orden delivered a great oration in the Grand Council on the Turkish peril before a *grandissimo* audience, for which "everybody universally praised and blessed me, and the Doge, when I came down from the rostrum, called me to him and praised me; and during my speech so great was the attention that no one expectorated (*spudoe*)." More than once the annalist remarks as indicative of great attention that

no one *spudava* during a speech. But in later years we meet with complaints that, although no one spoke in Cabinet or Senate so often as he, *cum gran laude mia*, it was all in vain. On August 4, 1526, he notes : "I, Marin Sanudo, went to the rostrum and spoke *sapientissime*, but the Serenissimo suffered me not to complete my speech. Yet on the same day I, Marin Sanudo, to acquit my conscience, again ascended the rostrum, reciting the beginning of the Lamentations of Jeremiah, *Væ civitas*." Jeremiads are never popular, and since the times seemed out of joint, the orator grew more and more censorious, and became at last, we fear, somewhat of a bore. The formula, "I, moved by my conscience, arose and spoke against (*contradixi*)," occurs frequently in the later volumes. On October 30, 1530, he utters another wail over the sale of offices : "God help our poor Republic, unmindful of the ancient maxim, *urbs venalis cito peritura*—a venal state shall surely perish." Yet, amid his disappointments, the faithful servant of the State consoles himself with the reflection that all his labours are for his dear Fatherland, wherein he was born and for which he would die a thousand times, even though scourged, maltreated, and ill-requited.

It is pleasing to learn that Sanudo's consistent conservatism was applied to the preservation of ancient monuments. He protested against the unnecessary devastation of the old Senate Hall, under the guise of restoration ; and on September 9, 1530, he relates that, passing by the Baptistery of St Mark's, he had observed some staging erected there, and on asking what they were doing, was informed that Procurator Lando intended to remove thence two stone *marzochi* (lions) and place them over the two columns outside : "Now this was a shameful thing, to disturb works of such antiquity, and I cried out so loudly this ought not to be done, that the prince heard of it and would by no means suffer it, and so this day the beams were taken away."[1]

[1] Authorities are not agreed as to the lions here meant. See Rawdon Brown, *Ragguali*, vol. iii. p. 177.

Venetian statesmen did not spare themselves. Every day, Sunday and week-day, a few more important festivals alone excepted, Marin was in his place on the Privy Council—during important crises the Collegio met at half-past seven in the morning (*mezza terza*), and sat till the first hour of the night, dinner being prepared by the Ragione Vecchia [1]—in the Senate on Thursdays and Saturdays, and in the Great Council on Sundays and holidays, save when on special missions, or when welcoming ambassadors; reviewing mercenary troops, Turks, Stradiotes, and others; hiring bowmen at the butts at S. Zanipolo; testing artillery at Lido; or putting up the trading galleys to auction at Rialto. Stress of weather seems to have occasioned absences among some of the less sturdy Councillors. On February 26, 1499, only half the Collegio was present owing to a heavy snow-fall, and in the afternoon no one came to the Senate, so fierce was the storm. One July day in 1512 the Doge failed to attend the Grand Council owing to the great heat, and other special absences are noted: on May 22, 1532, his Serenity did not attend the Collegio, having taken medicine *per purgarsi*, and in the following year a further period of fifteen days' purgation at Murano excused his attendance. The day's work was no light one. Here is the summary of an average busy day (May 10, 1499), which occupies five pages in the diary: Morning, Collegio: Interview with the Army Commissioners; long report from the ambassador in Turkey concerning armaments, with elaborate details as to numbers of ships and men, and a carefully written judgment on the characters of the Sultan and the chief Pasha; a letter read from the Signior Turk himself; report read from the Captain-General of the sea forces at Zara; another from Ragusa; another from Zante (everybody in terror at the Turks, fortifications must be raised and money spent); another from Nauplia in Greece (Turkish terror again, send money to pay

[1] The magistrates whose duties included the provision of funds to meet expenses of public festivals. See p. 208, note.

soldiers who are dying of hunger) ; another from Crete (the Turks, the Turks ! help ! help !); another from the Admiral at Schio ; others from Pola, Feltro, Treviso, Rimini—they, too, clamant for money—and from the Commissioners of the Polesine and Rovigo. This business despatched, and it being the vigil of the Sensa, the Councillors repair to Rialto to put up the Aquamorte galleys to auction, but there were no offers. After dinner, meeting of the Senate : demands for forced loans ; the leading merchants are called in, and the amounts of the exactions noted ; money is sent to the officers of the Exchequer (the Camerlenghi) ; important despatches from Rome, Rhodes, and other places are read, also a long letter written from Pera (Constantinople) by a faithful friend (*fedelissimo amico*) with further information as to Turkish preparations for war and the resources of the Ottoman Empire ; ballots are taken for the appointment of three assessors of forced loans (*provedadori sora le exation di danari*). A critical period this in Venetian story. Her maritime pre-eminence was menaced ; her resources were inadequate for the maintenance of her consistent naval supremacy. Venetian statesmen had always upheld the imperative necessity of maintaining a more than two-power standard, and Malipiero records a speech made by Sebastian Badoer in 1457, in which that worthy senator, calling for increased armaments, reminded his colleagues that "when the Genoese or the Catalans fitted out ten galleys, our ancients fitted out twelve, and when they fitted out twenty, we fitted out twenty-five."

Grave and gay were sometimes mingled in the meetings of the Collegio. Shortly after the news came of the death of that indomitable and magnificent sinner, Pope Borgia (Alexander VI.), the French Ambassador was present and related a *bonne histoire* to the Doge and his Privy Council. His Holiness, having one day left his signet-ring on a window-sill, sent a servant to search for it, since nothing could be sealed *sub anulo piscatoris*. The servant found a boy

P

playing with the ring, who refused to give it up save to the Pope himself; and as the boy handed it over he warned the Pontiff that he should wear the ring but for a short time. Borgia, having put it on his finger, went into a chamber carrying the sacred Host when, lo! a baboon raced out of the room. A cardinal sought to capture the animal, but the Pope cried out in great terror: "Let him go! let him go! 'tis the devil." "And that very same night," said the Ambassador, "he died." The Doge and all the Council burst into loud laughter, and said: "Most certainly his Holiness has gone to the *Ca' del diavolo.*" The reverend seigniors were also informed by their ambassador at Rome of the manner of the Pontiff's death, and earlier despatches give many curious details of the life of this pleasure-loving and notorious successor of St Peter. There is no need to burden Borgia's overladen memory with the crime imputed in the despatches, but the statement found ready credence at Venice, and is characteristic of the times. "Being covetous," wrote the Ambassador, "of the great wealth of Cardinal Hadrian of Corneto, the Pope invited him to supper at his vineyard. The cardinal, suspecting his wicked purpose, called the papal seneschal secretly to him and bribed him with 10,000 gold ducats to disclose the plot; whereupon the seneschal informed him that three boxes of sweets had been prepared, one of which was poisoned, and this was to be given to him during the supper. Hadrian arranged with the seneschal that the boxes should be changed, and the poisoned sweets given to the Pope, which was done, and so he died. The body was the most horrible and hideous image the Ambassador had ever seen, and seemed that of a monster rather than of a man. On September 2, 1511, we learn from Priuli that his successor, the fighting Pope Julius II., lay dangerously ill at Rome of fever, a result of his most irregular habits, particularly in the matter of wine, in which his Holiness indulged without the least regard to temper-

ance (*s' abandonava senza la minima temperanza*). *Papa amalato ubriaco*—drunken Pope ill—bluntly summarises the copyist.

In December of 1502 the French Ambassador attended the Collegio, and entreated that part of the relics of St Roch might be given to his master (Louis XII.). Doge Loredan diplomatically replied that so far as he and his Council were concerned they were willing enough, but the relics were the property of the Scuola, and outside their power to dispose of. The Envoy being departed, his Serenity turned to the Councillors and said he would tell them a story : "Once on a time the King of Hungary came to Venice and begged the body of St Paul the Hermit from the priests of S. Zulian. Unwilling to offend, they feigned to satisfy him, but gave up instead the body of one of the Grimani, and so, added Loredan, to this day the body of Grimani is worshipped in Hungary as the body of St Paul.[1] *Item*, pursues the annalist, the Envoy said there were the bodies of seven of the holy apostles at Toulouse, and if the Seigniory desired they could have one. The Seigniory did not desire it, for the relics at Toulouse then had, and even to our own day still have an equivocal reputation, and the trouble caused to the late Cardinal-Archbishop of Westminster by his rash acceptance of the sham relics of St Edmund the Martyr from Toulouse in 1901 for his new cathedral, will be fresh in the mind of the reader—the bones, we believe, never travelled beyond Arundel, where they now lie.

On October 10, 1503, the Spanish Ambassador sounded the Collegio as to the investiture of a Spanish cardinal with the Abbey of Ravenna, to whom the Prince replied that since the Venetians had no benefices in Spain, it was not seemly to ask such favours. Turning to his colleagues, his Serenity said : "Priests were all alike, always wanting more ;

[1] In Sanudo's catalogue of the sixty-seven principal relics possessed by the Venetians, the body of St Paul the Hermit at S. Zulian is included, but with the remark, *non si vide :* it cannot be seen.

it was nothing but give, give, *da quaesimus, dona quaesimus, presta quaesimus.* But the meetings were sometimes dull and tedious. On June 23, 1499, two ambassadors from France attended the Collegio, one clothed in black, embroidered with gold *à la française*; the other in black, trimmed with crimson. They sat near the Doge, and the senior delivered a *loculentissime* oration in Latin, quoting Petrarch, *Venetia est mundus*—and it was long, very long!

Curious traits of superstition and credulity occasionally contrast with the astuteness and sagacity of these hard-headed magistrates and statesmen. On February 27, 1499, after oaths of secrecy had been taken by the members of the Collegio, a petition addressed to, and the replies given by, the "spirit of Ferrara" on behalf of the Seigniory was read: "Are we to have war or peace with Milan? Shall we lose Pisa? Will the King of France descend into Italy this year, and will he be victorious?" At the opening of the New Year, 1513, the Ten deliberated on a prophecy by an astrologer of the revolutions pending during the ensuing year: "I saw it," writes Sanudo, "and it was in the vulgar tongue, and it pleased me." At the Privy Council meeting of April 30, 1502, a letter was read from Verona concerning signs and wonders in the heavens, aëry combats, fiery serpents, and other portents. The writer believed the end of the world was come: "And I, Marin Sanudo, believe it not at all, but be it true, or *bel trovato,* I make note of it." On the same day a monstrous horse with six feet is shown at Venice and everybody goes to see it. Strangely enough, the grave fathers of the Republic, too, extended their interests to freaks and monstrosities. In July 1506, the birth was notified to them of a horrible winged and hairy monster of which our diarist gives a fearsome representation, drawn from a picture of this *cossa horrendissima*, which was successively shown to the Doge, the Chiefs of the Ten, and the senators. Echoes of the Lutherean controversy are heard in the Senate. On August 26, 1520, the Patriarch's Vicar presented a Papal Bull

to the Council damning the *scienza* and the works of Fra
"Marin" Luther, the German. None is to read or possess
his books under pain of excommunication. License was
given to the Vicar to repair to the shop of the book-
seller Zordan Tedesco, at S. Maurizio, together with the
Secretary of the Ten, and seize and confiscate all his stock.
"Yet," chuckles Sanudo, "I have one, and it is still in my
library."

Nothing emerges more clearly from the pages of these
records than the fact that the real rulers and saviours of the
Republic ·during the appalling crisis of the League of
Cambray were the indomitable Council of the Ten. Much
has been written of their despotism and terrorism; but
despotism implies force, terror an army. And what was the
Council of the Ten? Only a few Venetian gentlemen with
a handful of guards to carry out their behests. They had
no military instruments, no barracks, no standing army, and
their ultimate support lay in the goodwill of the people, and
more especially in the men of the arsenal. Too much stress
has been laid by many historians on the irresponsibility of the
oligarchy which ruled Venice after the Serrata. It is
evident from Priuli that public opinion, even in the sub-
missive people of the lagoons, was a force to be reckoned
with, for the diarist complains bitterly of the intolerable
curiosity and liberty of the vulgar, who enter into matters
that should concern the Senate alone; and of the imprudent
speeches of those who wish to enter into public life before
their time, impelling the government many times to a course
of action that aimed more at pleasing the multitude
(*l' universale*) than at the profit and utility of the Republic.
The politicians were thus led to give way to the opinions of
the ignorant and to abandon measures of more politic
wisdom. When the storms from over the mountains burst
upon Venice; when all the Collegio grew pale as death, one
saying one thing, one another, concluding all was lost; when
day and night the piazza and the loggie were crowded with

gentlemen waiting to hear the news; when the Doge, walking in procession, was seen trembling with fear and supported by two Councillors; when at the festival of the Sensa, everybody was in tears, the piazza empty, and our Doge dazed and more like one dead than alive; when all was thought to be over, and, none providing, ruin lay before us, the intrepid chiefs of the Ten never lost heart. They stood, a heroic triumvirate, firm as a tower unshaken by the winds, and by their sagacity and fortitude foiled their enemies and piloted the storm-tossed ship of State through the rocks, and brought her, strained and buffeted indeed, but safely to port. They it was who, when all men despaired, rescued the mainland provinces from the imperial, regal, and papal bandits who were leagued together for their spoliation.

No news was allowed, complains Sanudo, to filter through the Ten when rumours of the calamitous defeat of Agnadello were floating about Venice. Small tolerance was shown to spies, loose-tongued politicians, unauthorised bearers of arms, vendors of disturbing prophecies of St Bridget—all were arrested and put in safe hold until the troublous times were past.[1]

All men despaired, save perhaps the common people. He who would see angels, said Pope Gregory the Great, must have his head pillowed on a stone; and so to a poor widow of S. Trovaso, with three children, a spinner of wool, having nothing in the world, a wondrous thing happened as she lay one night on her bed of straw; for a knocking was heard at her door, and she, marvelling greatly, asked who was there. A voice replied, "Open!" She opened and saw a form, as of a woman, arrayed in white, which entered and said, "Go to the priest and bid him have a procession made with the holy Madonna of Ogni Santi on St John's Day;

[1] The chief factor in war, national credit, was overwhelmingly on the side of Venice. While the King of France raised a loan at 42 per cent., she could borrow at 5, 6, and 8 per cent.

and thus the city shall be victorious over her enemies. "How would you that I go?" asked the poor widow; "surely he will not believe me?" "Go!" said the mysterious woman, and she seemed to be pushed out of the house, and suddenly lighted candles were seen. And so the widow went to the priest, and the strange woman remained in the house. The priest, disturbed in his slumbers, bade her come again in the morning, and when she returned to her home the woman was gone. The behest of the celestial visitant was carried out, and the procession was made.

Absorbed in momentous State affairs, Marin affords us glimpses all too few of his personal life and intimate affections. A pious gentleman, he has all the practical Venetian's aversion from the regular orders, and often betrays his contempt for their members; he quotes with satisfaction a ribald song sung against the jolly, lusty, and lazy friars, who ought to go to the wars rather than skulk in processions, and relates how at the solemn celebration of the raising of the papal interdict in March 1510 and the return of the religious orders, the friars as they passed by, bearing the relics and silver vessels in their hands, were insulted by the spectators, who cried out: "Ah, *fratachioni*! ye have come back, but these are not all the relics and silver." It is with no pleasure, therefore, that the annalist notes on January 1, 1503, how he went to see Jacomo Sanudo make profession at S. Andrea del Lido, "the only Sanudo who ever became a friar in the memory of man."

From the times when Dante wrote of the *Tedeschi lurchi* to the present day, when the street arabs of Verona sing of the *sporchi Tedeschi*, the Germans have failed to win the affections of Italians, and when the Venetians were at grip with the imperial invaders, it is not surprising to find that Marin cherished the traditional sentiments towards them. When their advance had been stemmed at Padua the German prisoners began to arrive in boatloads at Venice, and everybody ran to see them moored off the Ducal Palace.

"Note.—They are barefoot. *Item.*—There are 300 Germans at Padua; they, too, are barefoot, and smell horribly." In July 1513 Marin saw a letter from Padua, in which a song was transcribed, said to have been sung before the Bishop of Trent, "which is a drunkard's song, as Germans are, and a vile rabble" :—

> "Jam lucis orto sydere,
> Statim oportet bibere.
> Unus quisque noster frater
> Bibet bis, ter et quater.
> Bibet bis, ter et secundo,
> Dum non manet nihil in fundo.
> Aqua lympha maledicta,
> Sit nobis interdicta;
> Qui ponit aquam in Falerno
> Debet sepelli in inferno : "

—and other Latin doggerel of the same bibulous tenor. The song is obviously a blasphemous parody of the beautiful evening hymn by St Ambrose which is sung at Compline: *Te lucis ante terminum.*

To house and home, wife and child, references are brief. On February 15, 1505, Marin notes : "This morning I married a daughter of the magnificent Missier Constantino de' Priuli, relict of the late Hieronimo Barbarigo," and the only detail noted is, characteristically enough, that she brought him a dowry of 5500 ducats, according to contract. On February 29, he adds : "After dinner I gave my hand publicly to Cecilia de' Priuli, my wife." Cecilia was the widow of Girolamo Barbarigo, and although she had borne her first husband a daughter, Helena, to Sanudo she was an unfruitful wife; nor was their married life a long one, for an entry, dated November 27, 1508, informs us that at noon on that day "died my most dear consort, after 49 days' sickness: God rest her soul and give her peace." Some ill-feeling seems to have existed between step-father and step-daughter,[1] since the diarist in his will recites the various

[1] Marin, however, on Helena's marriage in 1510, sacrificed a day's sitting of the Senate to attend the ceremony.

claims his estate will have against Helena, who, after the death of her mother, took away a strong-box (*forzier*) containing valuables and carried it to the house of Messer Anzolo Emo, as the wife of Messer Hieronimo Dandolo, Helena's slave Barbara, and the nuns of Sta. Croce can prove: this is to be put to her account. *Item.*—There is also due from Helena, daughter of Girolamo Barbarigo and Cecilia dei Priuli, certain sums for the board (*spexe di bocca*) of her slave called Barbara and herself, "for I, not being her father, it is unreasonable that I should be at the expense of her keep, and she has been with me about five years." Moreover, the testator had spent about 300 ducats in lawyers' and court fees on behalf of Helena in a lawsuit with the Priuli, her brothers, concerning her heritage: this, too, the aforesaid Helena is to be debited with by his executors.

On April 10, 1507, Marin accompanied Cecilia his wife to a great wedding festival at Mestre in celebration of the marriage of Vicenzo Priuli, her kinsman, to a niece of the Queen of Cyprus, and daughter of Giorgio Corner. Vicenzo, banished for five years by the Ten, had only two months to complete his sentence, but scorned to ask for favours, twice refused him on other occasions, and so the chief patricians of Venice, with their ladies, were gathered together at Mestre. As the noble guests were about to depart a violent tempest arose, and they were forced to remain. So scant was the accommodation that some were lodged in the monastery, "where was I with my wife Cecilia; *ergo*, this I note for eternal memory."

Children, however, Marin had, but not born in wedlock. In May 1530 he notes, "to eternal memory," that he married his natural daughter Candiana to Zuan Morello, "God give them good fortune," and in July 1533 the nuptials of his natural daughter Bianca were celebrated, and it was a beautiful and honourable wedding. The diarist had a short and bitter experience of a debtor's prison. Leaving his

house one dark December morning in 1519 to repair to the
Palace, he had just reached the Campo dei Morti when a
horrible mischance (*horribile caso*) befell, for "I was arrested
for an old debt by that traitor Zuan Soranzo, with whom
I have had a dispute for some six years, and he did it in
order to insult me." The debtor sold part of the Hostelry
of the Campana at Rialto to clear the debt, and issued forth
next day vowing he would not leave vengeance to other
hands. On July 27, 1517, at the hour of tierce, Marin lost
his most sweet and most dear and only sister Sanna, wife of
Zuan Malipiero, after a grievous and most painful sickness.
She died a most excellent death, "I being present, and her
soul is departed to celestial glory." She had been married
twenty-eight years and had never had a quarrel with her
husband; and so this *unica sorello uterina* was buried *honorifice*
on the ensuing day at S. Francesco della Vigna in their
mother's grave, the Chiarissima and Eccellentissima Madolina
Letizia, and, adds the sorrowing diarist, "that day little
news heard I, so heavy was my grief." In December 1531,
Marin lost a favourite brother, once a chief of the Ten. He
is now the oldest surviving member of the Ca' Sanudo;
the grey shadows fall about the solitary and widowed
statesman, and he prays God to grant him long life and, at
his end, eternal peace.

The busy historian dearly loved good cheer, and on July
25, 1506, notes: "This morning I gave a *bellissimo* dinner at
my house to some ladies and patricians, and went not to the
piazza, nor in the afternoon did any of us go to the Great
Council." On June 14, 1512, Marin was present at a
luculento dinner on the occasion of the wedding of a
Contarini. More than 120 ladies and about 200 patricians
sat down to table together, with many guests from Vicenza;
pignochada[1] was served, and there was a great display of
silver, and much dancing with masked ladies. Another
dance took place in the evening, and a tragedy and a

[1] A delicious sweetmeat made of candied pine seeds.

pastoral eclogue were performed. It was mighty fine (*molto bella*) and everybody jubilant over the ruin of the French. One delightful supper Marin gave on June 3, 1510, on board a fine war-galley commanded by a nephew of the Queen of Cyprus, and anchored off the island of Sta. Elena. On October 1, 1518, thirteen high officials, including the Pro-curators, the Papal Legate, and a chief of the Ten, celebrated Sanudo's re-election to the Senate, and it was a *bel pasto*. One of the latest entries in the diaries, March 1533, is to the effect that this doge (Andrea Gritti) gives good dinners.

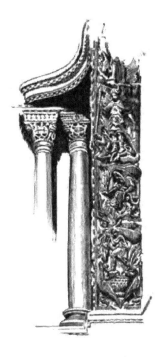

CHAPTER XVI

Startling Rumours on 'Change: a New Route to India—Proposed Suez Canal—Discovery of a New World—Bank Failures—Escapes from Jail—Famous Trials and Executions

" Ma volgendosi gli anni, io veggio uscire
Dell' estreme contrade di Ponente
Novi argonauti e novi Tifi, e aprire
La strada ignota in fin al dì presente:
Altri volteggiare l' Africa, e seguire
Tanto la costa della negra gente,
Che passino quel segno onde ritorno
Fa il sole a noi lasciando il Capricorno:

E ritrovar del lungo tratto il fine,
Che questo fa parer duo mar diversi;
E scorrer tutti i liti e le vicine
Isole d' Indi d' Arabi e di Persi:
Altri lasciar le destre e le mancine
Rive che due per opra erculea fersi;
E del sole imitando il cammin tondo
Ritrovar nuove terre e nuovo mondo."
—*Ariosto.*

LESS dramatic, but far more destructive of Venetian prosperity than the temporary assault of the League of Cambray, were certain ominous geographical discoveries with which our diarists are preoccupied. They fully grasped their far-reaching consequences, and as an experienced physician, while outwardly in flourishing health, may yet be cognisant of the weak spot in his system by which the arch enemy of mortals is to work his dissolution, so our sagacious annalists have no illusion as to the dire menace to Venetian commerce involved in the rumours that were circulating on 'Change in the early sixteenth century. One dull November day in 1502 report was made at Rialto that some caravels had returned

from Colicut to Lisbon, laden with spices, and the said news gave our merchants much to talk of. A month later a long letter reached the Seigniory from Lisbon, which confirmed the report, and it was known that four spice ships had arrived there on September 12, 1502, by the Cape route from India after a voyage of eighteen months and three days. *Basta*, doubt is no longer possible, and a new fleet has set sail. Pepper,[1] that important staple of Venetian trade, had been falling from 130 to 68, at which latter figure the Germans at the Fondaco de' Tedeschi had been buying: it was a *priesio roto*, a ruinous price. In January 1503 further advices informed the merchants of new arrivals at, and departures from Lisbon, and it soon became known that the German *Compagnia Grande* was to open a factory there.

Again, Marin hears on 'Change that a whole fleet of spice ships had sailed up the Tagus, yet disbelieves the rumour because it emanated from the Germans at the Fondaco, but on St Mark's own very day the news was confirmed—a *pessima* event for the city. Priuli notes that the news grievously afflicted the merchants, for it meant the disappearance of the Venetian market (*la piazza di Venetia disparata*), and the riches of the Republic, of us merchants, and of every citizen, turned to ashes, nor could the city be any longer called *La Dominante*. But while the senators and merchants were wringing their hands, the vigilant Ten were taking counsel how to meet the disastrous innovation. Envoys were dispatched to Cairo to work upon the Sultan's fears, and on March 1504 the Franciscan Guardian of the Holy Sepulchre at Jerusalem was closeted with them again and again. *Nescio quid* is the disappointing entry in Sanudo's diary; but we are able to supplement his information from documents published by Professor Fulin, which demonstrate that the far-seeing Ten had put their mark on the spot,

[1] The four caravels that reached Lisbon from India in October 1531 brought of pepper 18,870 units, of cloves 597, and of ginger 341 units.

and indicated the one and only measure which would effectively have checkmated the Portuguese,[1] and which only in our own day has found fruition. In this very year, 1504, the decemvirs advised that the most opportune way to frustrate their rivals was this: *videlicit*, that with facility and brevity a canal might be digged from the Red Sea which would open directly into this sea (the Mediterranean), and a fortress might be erected at either end, so that none could enter or leave without the Sultan's permission; but for some unknown reason their envoy's instructions were cancelled, and the project was rendered abortive.[2] It would be interesting to speculate what would have been the effect on subsequent commercial history if this wise proposal had been carried into effect. The Venetian new year of 1507 was ushered in by many signs and wonders in the heavens, but, drily records Sanudo, three things real enough were seen in our city: great warehouses, but few bales of merchandise; many ships, but few departures; many banks, but few monies.

The discovery of new land to the west, though less immediate in its apparent consequences, is not unnoticed. In 1497 a letter from Sier Lorenzo Pasqualigo, dated in London, August 23, to his brothers Alvise and Francesco, in Venice, advises them that our Venetian who went in a ship from Bristol in search of new islands hath returned, and saith he found *terra firma* 700 leagues hence, and that it is the land of the Great Cham. He coasted for 300 leagues, found no natives, but brought the king some snares and needles, and discovered two islands on his return voyage. The delighted king promised him ten armed ships, and allowed all prisoners (save traitors) to volunteer for the new voyage, giving him money to make good cheer. "He hath a Venetian

[1] The effects of the new discovery were far-reaching: Southampton was paralysed, and in 1530 the Corporation prayed to be relieved from certain taxes, owing to the King of Portugal having taken the trade of spices from the Venetians.—RAWDON BROWN.

[2] See Archivio Teneto, Vol. II., Pt. i., pp. 175-213.

wife and children at Bristol, and is called Zuan Talbot, the great admiral. Much honour is done to him, he goeth about clothed in silk, and the English are running like mad after him: *etiam* many of our scamps. And the inventor of these things erected on the lands he discovered, a great cross with the flags of St Mark and of England." Need it be said the Venetian was Giovanni Cabot, or Ca' Botto, father of Sebastian Cabot? On November 7, 1502, advices from Spain report the arrival of the caravels from the land of the Papagai and the discovery of more than 2000 miles of coast; and on December 28 a letter from Portugal was read in the Collegio to the effect that one of the caravels sent by the king had returned from the west, bringing seven strange brutish creatures, and reporting the discovery of many mighty rivers.

The reaction of these discoveries and the crushing burden of the war expenses [1] fell heavily on the mercantile and patrician houses of Venice. Malipiero relates that on March 3, 1499, Andrea Contarini forced his way by the porter of the Collegio and entered uttering great exclamations, saying he was a noble of Ca' Contarini, his revenue was reduced to 16 ducats a year and he had nine children on his shoulders; for sixteen years he had held no office, and was unable to earn a living by any profession, and now his house had been sold over his head by the fiscal authorities; he entreated pity and that the Seigniory would not send him to the *porteghi*.[2] The Doge, turning to the Councillors, said: Signori, this Pisan war is ruining the city: let the officers make the rich pay and deal leniently with the poor who have not wherewithal to live.

A month prior to this incident Sanudo and the Savii were summoned to the Doge's room to confer on grave

[1] The drain caused by the wars is strikingly exemplified by the grievous levies made on Venetian capitalists; 37 *decime* were exacted for the war of Ferrara; 18 at the descent of King Charles; 5 for the Austrian war; 10 for the war with Florence.—MALIPIERO.

[2] The porticos or loggie round the piazza and elsewhere, the refuge of the homeless poor.

matters with the chiefs of the Ten: Andrea de' Garzoni
the banker had attended before the Seigniory, with tears in
his eyes, saying he must close his doors. The house of the
Garzoni, founded in 1430, was one of the four banks known
as the four columns of the Temple, and the Ten had decided
that for the honour of the city it must be propped up, and
that the procurators of St Mark must advance money: and
so gold to meet present claims was brought to the palace in
sacks and delivered to the Garzoni, the Savii being bound
to secrecy by solemn oaths. Sanudo, however, prudent man,
acting on his privileged information, warned his brother to
withdraw 500 ducats belonging to their mother, and saw them
safely brought home in bright Hungarian pieces just before
the bank failed. Secrecy was hard to maintain, and already,
in 1496, the Ten had appointed three inquisitors to examine
into the scandal of councillors gossipping about the affairs of
the state on the piazza. "But the inquisitors sat more for
terror than for aught else, so that in this city those fellows of
the Senate should hold their tongues." The tottering condition
of the Garzoni bank was soon known, and, on February 1—
Marin well remembered the day, for he always prided himself
on being first at the Collegio, and was annoyed at finding
Batista Zustignan had preceded him—the Capi of the Ten
entered with grave faces and the Savii were ordered out."
The bank had failed owing to the furious withdrawals,
crowds of creditors were clamouring at the offices, and,
although it was late, none of the Garzoni had appeared.
On the 4th the Capi again entered, the Savii were excluded,
and Andrea de' Garzoni, his sons and grandsons, were intro-
duced displaying *gran dolore*, Andrea, an aged and most
worthy merchant, imploring the Doge to grant him time to
realise his assets: the bank had paid out 128,000 ducats
since Christmas, and an angry crowd was clamouring outside
the palace as he spoke. On March 18 the second of the
great banks, that of the Lippomani, was in trouble; 30,000
ducats had been withdrawn that day, and the Seigniory

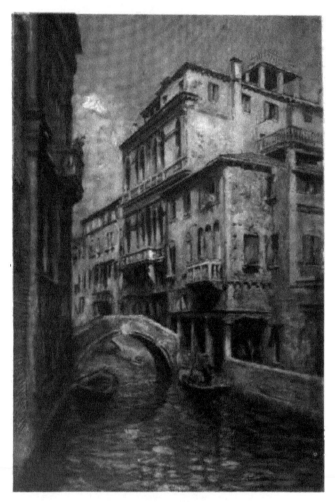

PALAZZO WIDMAN.

advanced 10,000 ducats to help them; but to no purpose, they too failed, to the great shame of our city. It was worse, says Malipiero, than if we had lost Brescia. On the 27th the Capi, notes Marin, entered "in great fury and sent us all out of the Collegio": it was about the bank of the Pisani. Sier Alvise was sitting as usual before his day-book when a tremendous crowd of creditors pressed in, clamant for their money. Alvise flung down his pen, shouting: "One after another, ye shall all be paid." One creditor seized the pen and began to write; never had there been such scenes in living memory. The bank of the Agostini, too, was run upon, and such was the excitement that the Ten sent their officers, who cleared all the creditors out of the Pisani premises, and a cry was made by the herald of the Seigniory detailing the measures to be taken for the restoration of confidence: the Agostini paid out no less than 16,000 ducats, and after dinner 40,000 more, in gold, and other monies were placed upon their counter. Alvise Pisani, when he saw the crowd outside, shouted: "What a dirty business this of the Lippomani, they have ruined themselves and others by running away."

In March 1500 the Marconi, good and worthy citizens, failed, and the creditors of the Garzoni were called publicly to assemble at the church of S. Zuan di Rialto[1] to elect a committee of inspection; in April the creditors of the Lippomani met in the same sacred edifice and agreed to accept a promise to pay in instalments. Merchants' promises are easier made than kept, and the defaulting Lippomani were subsequently laid in jail. They were influential citizens, and their imprisonment was made less irksome by many favours, it being rumoured that the Avogadori told the Captain of the Watch that even if their wives and children came twenty times a day they must be allowed to enter. It soon became customary to open the door when their dinners were sent, instead of putting the dishes through the valve, and on September 8, 1501, three stout fellows came with

[1] Now known as S. Giovanni Elemosinario.

Q

the meal, which included a hot tart, and the door being opened to him who carried the tart, Hieronimo Lippomani rushed forth, flung a cloak over the warder's head, and, putting a knife to his throat, secured the keys. Setting free his brothers, Sier Bartolo and Sier Vettor, all three escaped in their jackets and bareheaded into three armed boats, and took refuge at the monastery of Sta. Elena. Thence they mocked at their creditors, who, after much negotiation, to the number of 600, held a stormy meeting at S. Zuan di Rialto on March 21, 1502, to consider a further offer to pay in two years. Angry declamation ensued, and moving recitals were made of the misery consequent on the bankruptcy of the house: many creditors had died of *malinconia*; maidens whose dowries had been lost, being unable to marry, had fallen to the streets; hospitals languished for their invested funds; houses had been sold up to meet the demands of the taxgatherers. They rejected indignantly the offer, and prayed the chiefs of the Ten to realise the bankrupts' estate and pay whatever composition might be possible.

The Pisani, for a time, weathered the storm, for on March 23, 1500, after the deaths of the senior partners the Magnificent Seigniors Francesco and Giovanni, a solemn mass was sung in the church of S. Giacomo di Rialto, at which all the young Pisani, dressed in scarlet, were present, accompanied by their kinsmen, dressed in silk. Mass being ended the congregation rose and all marched to the bank, where was much money, and a cry was made from the balcony in the name of God and of St Mark that although the Magnificent Seigniors Francesco and Giovanni Pisani were dead, the business was still on foot, and that all creditors might withdraw their deposits if they were so minded. And so Sier Alvise sat down and opened his daybook, but only 120 ducats were that day withdrawn. On the morrow, however, the scare was renewed, and in three days 70,000 ducats were paid out, and "so the bank paid up and goes on paying up.

Now, Francesco della Torre was cashier, and Carlo d' Orssi was scrivener." But Alvise appears later to have fallen into difficulties, for on March 3, 1504, the Doge and many councillors, senators, and gentlemen, after a solemn mass in S. Giacomo, accompanied Sier Alvise Pisani in a procession headed by fifes and trumpets to re-open his old bank at Rialto in the name of the Holy Ghost. On March 15, 1507, a new bank was established by the diarist Sier Hieronimo de' Priuli in place of the Garzoni house, and opened with the usual solemn ritual. After mass had been sung in the Church of S. Zuan di Rialto, Priuli, his kinsman, and many heads of patrician houses being present, the whole assembly rose, and they, with other gentlemen, all magnificently clothed in scarlet, marched to the blare of trumpets and the shrill notes of fifes to the offices of the bank, where lay 60,000 ducats of gold ; and there Sier Hieronimo entered and in the name of God opened his bank; and a cry was made from the Gobbo di Rialto that the most Serene Doge made known to all, that the bank was opened by Sier Hieronimo de' Priuli of the Magnificent Missier Lorenzo of the Clarissimo Missier Piero the Procurator, who had given surety, 40,000 ducats, for three years. Four banks had been recently opened to the great honour of the city. Those were spacious and glowing days difficult to realise in the drab, prosaic times of soulless corporations and joint stock banks.

The ease with which the Lippomani escaped from jail is characteristic of the age. On August 6, 1497, many criminals in St Mark's prison, under life sentences, including Marco Corner for sodomy, chose a desperate assassin, one Fioravante, for leader, fell upon the warders going their rounds and seized their weapons and keys : then setting free all the prisoners they made their way to the armoury. Unhappily for the conspirators, two Saracens, in their eagerness to escape, leaped into the rio, of whom one was drowned, and the other, shouting for a boat, was picked up by a patrol of the Ten. The officers, " seeing he was a blackamoor, sus-

pected what had happened, made him confess," and the prison was invested. The rioters were at first defiant, but damp straw was lighted to smoke them out, and having been summoned three times to surrender or be hanged, Marco surrendered and the others followed : the warders were ordered to keep stricter watch in future. But one midnight in June, Corner, Fioravante, and other desperadoes succeeded in breaking jail and escaped to the monastery of S. Giorgio, where, having disguised themselves, they separated to various parts. In August, a prisoner escaped from the Torreselle ; on September 9, twelve more culprits got loose "so that in short time the said prison had been broken three times and nothing was done." On October 3, 1499, two patricians condemned to death escaped by making a hole through the wall near the riva, by the Ponte della Paglia. In July, 1504, four men freed themselves from the Grandonia prison and took sanctuary in St Mark's: again nothing was done. On February of the next year Sanudo saw Sier Bertuzzi da Canal, guilty of fraud at the Fondaco de' Tedeschi, of which he was Vice-domino, escape naked from St Mark's prison and flee to S. Giorgio. On February 7, 1510, a reward of 1000 ducats was offered for the recapture of five Genoese prisoners who had freed themselves in spite of the Guards of the Ten. On August 5, 1512, twenty-eight criminals obtained possession of a beam, and battering with fury against the locks, forced the prison doors and escaped naked—some to the Ponte della Paglia, others to the Church of St Mark. "I saw them," said Sanudo, "all trembling with fear, but they got free ; some had been sentenced to death, others to lose hand and eye." In February of the following year an even more extraordinary evasion took place. The captain of a boat had been sentenced to be flogged from St Mark's to Rialto : as he passed the portal of the bascilica, his wife and two other women who had been hiding there, flung themselves on the executioner. The wife, dagger in hand, severed her husband's bonds and, handing him the weapon,

enabled him to escape. Another and similar rescue by women was reported from S. Barnabà. This, remarks the diarist, has happened before, and must be seen to.

In June 1519, the parish priest of S. Cassiano was sentenced to ten days in the *cheba*, or cage, suspended from loggia of the campanile, used for the exposure of priests and women, and then to ten years' imprisonment in jail. Every day, when the cage was let down for the reception of food, his mother brought him a small saw and stood by the cage feigning to talk with him until he had sawn through the wood: taking a favourable opportunity he one night let himself down by a rope and fled, and so "folk said the bird hath escaped from its cage."

One of the most memorable acts of jail breaking occurred on August 19, 1514. The Ten, closeted in their chamber, were reading a letter brought in from the Captain-General warning them that the German prisoners in the Palace were plotting to escape, when a tremendous uproar was heard, and cries of "the prisoners are escaping" were raised on all sides. The decemvirs and other of the magistrates ran to the balcony overlooking the Grand Canal, and there saw the prisoners running away, and the boatmen at the Ponte della Paglia not only refusing to help the officers and men of good-will to recapture them, but even drawing off their boats to give the fugitives a free run. The Ten ordered all avenues of exit from Venice to be watched, and sent armed boats to the Castelli, Murano, Torcello, Mestre, Chioggia, and Fusina. Enquiry was made, and it appeared that one Cristoforo Calepin, a notorious rebel, had succeeded in corrupting Hieronimo the warder, and proposed to the seven prisoners in the *Forte*[1] that when the Captain of the Watch and his two guards came on their rounds they should fall on them, hustle them into the cell, lock them in, and then hasten to release the eleven prisoners in the *Armamento*.[2] This

[1] and [2] Names by which the various prisons in the Ducal Palace were distinguished.

daring conspiracy proved successful, and the whole eighteen escaped, some in their shirts, some barefoot, and with any rag of clothing they could lay hand on. Large rewards were offered for the recapture of Calepin and another famous rebel, Hannibal Dalten. Soon it was reported that some had taken refuge in S. Giorgio Maggiore, and the officers hastened across the Canal, knocked, and demanded admission. The monks refused to open, and the Ten straightway despatched Procurator Filippi with orders to force the doors, and if the Fathers continued recalcitrant, burn down the monastery. Needless to say the terrified monks opened the church portal, and there were found two prisoners in hiding. Other prisoners were quickly caught, including Hannibal, who was discovered in bed at the hostelry of the Torre at Rialto, feigning sickness. Calepin, however, eluded all efforts at recapture until Sunday morning, the 20th, when he was found at breakfast in the house of a harlot near the Due Ponti. Vengeance swiftly followed: Hieronimo, the jailer, was hanged ; the ferry at the Ponte della Paglia, one of the oldest in Venice, abolished, and the boatmen forbidden to land passengers there, in punishment for their passive assistance to the fugitives. "And," adds Sanudo, "the boatmen there, who had never before possessed a shrine, had that very month erected a most beautiful ancona which cost them ducats, and now, just as they had set it up, they were deprived of it, and serve them right." The gondoliers, doubtless, cherished no friendly feeling towards the government, for, as Priuli informs us, crews being urgently needed in 1499 to man the galleys for Corfù, it was decided in the Senate that no ferryman below forty or fifty years of age should serve the ferries (*traghettare*) and since all such had no other means of earning a living, they were forced to take service on the galleys, 1200 men being recruited by this "good and excellent measure." The ferrymen who remained at the *traghetti*, although old and inefficient, were few, and much enriched themselves, and

we may well imagine that on their return from Corfù (their pay was only three ducats a month), the younger men were not well disposed towards the authorities who forced them thither. If the traveller in Venice will look on the left spandril of the Ponte della Paglia, he will observe a framed relief in marble of the Madonna and Child, inscribed: *Of the Traghetto of the Ponte della Paglia under the Warden S(ier) Giulio d' Alvise da Portia and the brethren S. Mathio and S. Stefano*: two gondolas are carved below the figures of the Virgin and Child, with the date 1583. The ban, therefore, was subsequently removed and a new shrine erected by the Boatman's Guild.

A remarkable and narrow escape from death was that of a certain cruel and savage pirate, who by one ballot only was acquitted by the Quarantia: he lived as a hermit in the Campo Santo of S. Stefano, and slept among skulls and bones under an altar he had contrived there, went barefoot and never ate cooked food. "And he," notes Marin, "given to so holy a life, but, *meo judicio, meninconica,* was suffered to take service on the galleys against the Turks.

Our annalist was morbidly interested in crimes, and the trials and executions of notorious criminals. Time and again he describes at great length the revolting details of punishments by which in common with those of all European states, Venetian magistrates sought to terrorise evil doers. On December 7, 1500, he was present at the Quarantia Criminale, when the parish priest of Castello was tried for the murder of Sier Benedetto Morosini and his wife and son. The prisoner's counsel pleaded benefit of clergy, and the accused, entering the *arenga,* raised his manacled hands and began an impassioned defence. Crying, *Nolite tangere Christos meos,* he claimed that although unfrocked and disgraced by the Patriarch he was yet in holy orders, and alleged precedents to prove it was unlawful to shed the blood of a priest. Then was read "and it was *bellissima,*" the sentence of the Patriarch and six Bishops, whereupon the

Tribunal by 22 votes to 9 decided to proceed. Three
forms of punishment were proposed and voted upon: (1)
That the prisoner be led along the Grand Canal, torn by
pincers, then hanged, and burned together with the gallows;
(2) That he be torn by pincers and then quartered; (3)
That he be led in a boat along the Grand Canal as far as
Sta. Croce, there disembarked, his right hand cut off and

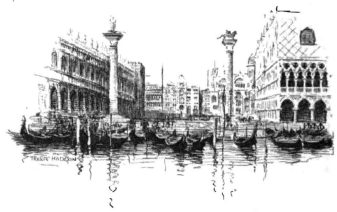

PIAZZETTA: THE TWO COLUMNS

hung about his neck, in front of the Ca' Morosini, where
he had committed the murder. Thence he should be
dragged at the tail of a horse to the Piazza, beheaded
between the columns, quartered, and the quarters suspended
at the usual places.[1] This last, the common form of punish-
ment inflicted upon murderers, and often described in the
diary, was carried by 14 ballots, 3 having been cast for the
second, and 5 for the first proposal. The spectacle of these
grave magistrates calmly balloting the degree of penal

[1] At the head of the channels that led from Venice to Padua, Mestre,
Chioggia and S. Andrea del Lido.

atrocity to be inflicted on a prisoner is not an edifying one.

The execution of the traitrous priest Bartolo, on whom a death sentence had been passed on April 16, 1514, was attended with greater difficulty. The Patriarch of Aquileia, being appealed to, would take no action in forwarding the preliminary degradation, as the incriminated priest was not of his diocese, whereupon the dread Ten met next day and commanded the bishops to unfrock him at once, and despatched their Capo and the Avogador to Castello to spur on the hesitating hierarchy : this was effective, and on the 18th the Captain of the Guards of the Ten led Bartolo to Castello, and there, in the church, the Archbishop of Saracco, in full pontificals, stripped each article of clerical garb from the priest's back, removed the tonsure, and, thus disgraced, Bartolo was handed again to the officer, who brought him back to prison. After dinner of the same day the Ten determined to "expedite the said priest at once, lest a brief came from Rome to stay the execution." Poor Bartolo was therefore hurried to his doom, to the great amazement of the people, the Scuola of S. Fantino, whose duty it was to attend prisoners to the scaffold, having been previously warned. "And I," writes Marin, "happening to pass in a boat, beheld a great crowd and an eminent gallows, whereupon I stopped to learn what the matter was, for it had been said the execution would not take place before two days ; and at one hour before sunset the priest Bartolo, clothed in white hose and with a jacket on his back, and in the habit of the Scuola, was led to the scaffold : having kissed the crucifix, a Dominican friar drew near to recall Christ to his memory and win his soul. Then the executioner smote him behind the neck so that he fell, and, again, four other heavy blows ; believing him to be dead, they tied a rope to his foot, and for half an hour tried to haul him to the top of the gallows, and at last three men climbed up and dragged him thither. And then this priest was found not to be

dead, and folk began to stone him,[1] and as the stones struck him he was seen to quiver : in little more than an hour he died, and, I think, a cruel death, even as his crimes deserved. He was a tall, spare man and well proportioned."

But the most famous of trials in the sixteenth century was that of Antonio Grimani, in 1500, whose dramatic arrest after the loss of the battle of Sapienza has already been touched upon. Arraigned before the Great Council, writes Priuli, accused and defended by the greatest lawyers of the day, the trial lasted during nineteen sittings. Eight days were occupied in reading the documents, and on the ninth rose Ser Niccolao Michiel, Avogador di Comun, and entered the *renga*, setting forth the eight chief counts in the indictment against the accused Procurator and Captain-General. To him replied Don Giovanni Campaggi, *Juris Utriusque Doctor*, who enjoyed the greatest reputation, and was a lecturer at Padua, and had 1000 ducats a year. His speech for four days held the audience spell-bound, as with lofty eloquence he strove with all his power to rebut the charges brought against Grimani by the Avogador. To whom replied Messer Marco Sanudo, Avogador di Comun, a man of highest prudence; fluent, eloquent, and of prodigious memory : he with great wit and astuteness sought to affirm the charges made against the prisoner, and was in the *renga* two days. Marco Sanudo in his turn was answered by Ser Gianantonio Minio, a noble Venetian, and the prisoner's advocate, who with much skill spoke for three days in favour of the accused, and was followed by Ser Paolo Pisani, a most worthy man, and of high intelligence. The mighty forensic contest was closed by Rigo Antonio, the doctor, a most excellent advocate, who spoke for six

[1] The cruel insensibility of the times is further shown by an extract from the diary referring to the burning of Savonarola and his companions at Florence : after the execution some unconsumed fragments of the bodies were left hanging on the chains, " and the boys threw stones at them in sport (*per ludibrio*)."

hours during two days. And if, adds Priuli, I had wished
to report all the pleadings and reasonings made by the
the Avogadori on the one side and the advocates on the
other, ten books would not suffice to contain them, for
nineteen Councils were held on this matter.

Never in Venice at any period was a more worthy and
more famous gentleman, and the principal accusations were,
that out of ambition he never would punish any noble who
was deserving of punishment, and that at Sapienza he lost
his head through fear at the sight of the Turkish fleet, and
so things went from bad to worse.

And all the advocates having spoken, Procurator Antonio
Grimani ascended the *renga*, with his long white beard, as a
criminal, and with the greatest humility and courage defended
himself, and truly moved the whole Council to pity.
Recalling the great sacrifices, pecuniary and others, he had
made during his long life for the State, his successful cam-
paigns in the Puglie, and the capture of the city of
Monopolio, the services of his son, the great Cardinal, to the
Republic at Rome, he reminded his judges that for seven
months he had lain in the Forte prison with chains upon his
feet, and entreated them to hold that sufficient punishment
for any errors of judgment he may have committed. His
half-hour's speech ended, he took his sons by the hand, and
all flung themselves on their knees before the Seigniory
craving mercy and regard for their honour. The hour was
late, and sentence was deferred to the following morning,
when Grimani·was exiled to the island of Ossaro, whence he
escaped to Rome in the autumn of 1502.

A typical example of the awful swiftness with which the
Ten struck down traitors is afforded by an early entry in the
diary of Sanudo. One March morning in 1498 Marin,
pursuing his wonted way to the Palace, heard everybody
saying : This night justice hath been done ; and as he passed
along the piazza he raised his eyes to the two columns, and
there saw hanging Antonio di Lando, our secretary, who

used to keep all our secrets, translate our cypher, and attend the Senate. All the city marvelled for that nothing was known about it, and he was hanged by night in his official dress with sleeves *a comedo* :[1] and this is what had happened : Now be it known this was done because he had revealed our secrets to one Zuan Battista Trevisan, formerly of our chancellery, but cashiered, and acting as a kind of secretary to the Marquis of Mantua. And thus it was discovered : This Antonio, *licet* he was old, and had only 180 ducats a year, kept a certain mistress called Laura Troyolo at S. Trinità, and this Zuan Battista did also visit her, and during the evenings they spoke in Latin together. Now Laura told this to her lover, one Hieronimo Amadi, who concealed himself behind the bed and heard the two speak in Latin of State secrets. And the said Laura had not the courage to turn informer, but sent her lover to the Ten, who arrested both lover and mistress, and seized Antonio at Laura's house on Sunday, who lay sick there ; and Zuan was caught in a boat on Monday morning. And so Lorenzo Venier, the Councillor, Troyola Malipiero, chief of the Ten, the Avogador of the Commune, and the Inquisitor, met, barred all access to the Palace, and put the prisoners to the question. *Fo cossa presta* ('twas sharp work) : that same night Antonio swung from the gallows. He died impenitent, and would neither eat, confess, nor take the sacrament.

No one was allowed on the piazza, and so swiftly was the execution determined on that no rope could be found ; and since all the shops were closed, a messenger was despatched, hot foot, to the arsenal, who returned with some ship's cordage, and Antonio was straightway throttled ; and while hanging, *ut dicitur*, he fell and broke his arm, and was then hauled up again.[2] No word was heard, and folk said

[1] See p. 278.

[2] According to Sir Henry Wotton, it was sometimes accorded as a special favour to a distinguished traitor that his face should be bruised out of recognition by being dragged along the ground.

he was strangled in prison. "But, *unum est*, this is how things happened, and I saw him with the rope round his neck in two knots, and his dress all muddy; and the said Antonio was left a whole day on the gallows, and at evening was buried. He had served the Seigniory for forty years, was very poor, and had a wife at Padua." Thus perished Antonio di Lando, undone by a woman.

On October 26, 1504, terror and amazement were again in the air: the Palace—a rare thing—had been closed, and the three chiefs of the Ten, the avogadori, and six councillors had been in the torture chamber until the third hour of the night, and it was said that Zenoa (the officer of the Ten) had been seen to bring along a prisoner, muffled and in slippers. Before tierce (between eight and nine) of the morning of the 30th, the Maragona [1] was heard tolling; a great crowd collected on the Piazza, and scarce had the hour of tierce been rung when Hieronomo Tron, accused of betraying Nepanto to the Turks, was hanged from the columns in the presence of the Capi. He was a long time in dying, and spoke some words; he wore a black dress over his doublet, and was left hanging till noon, when he was cut down and buried. When the execution was ended, the Palace doors were opened.

False coiners were punished with terrible severity. From Malipiero we learn that, in 1490, 12,000 lire were offered for the capture of Gasparo de' Alementi, and pardon to any person, even if banished, who should deliver him to the magistrates. Gasparo was caught at Rezo, and brought into Ferrara, where certain exiled nobles, a Soranzo, a Morosini, two Loredani, and Agostini dal Banco, formed themselves into a syndicate, bought the prisoner for 3000 ducats, and brought him in. Gasparo, the coiner, was burnt alive.

On June 20, 1519, Sanudo notes that four sacrilegious thieves were hanged at the two columns, the Piazza being

[1] See p. 3.

packed with people. One white-haired, bearded old prisoner of seventy, Sier Bertuzi, as he passed the Palace, exclaimed : "Most Serene Prince, I deserve an even greater death." Then, turning to the crowd near the portal of St Mark's, he added : "Fear not, I will not escape to the church, for willingly I go to my death." He then called to his son Taddeo, and said : "Be steadfast, my son"; and Taddeo answered : "Father, here am I, and willingly I go to this death, for I deserve it, having stolen and violated so many holy relics."

The Ten were equally severe against blasphemers. In March 1505 one was taken between the columns, his hand cut off, and tongue and eyes plucked out; in 1519 some blasphemers, including a priest, were exposed in a boat along the Canal, their crime being proclaimed, then taken to the hostelry where they had blasphemed, and their tongues cut out as an example to others. "*Fo bella parte e cossa notanda*"— (it was an excellent sentence and a notable thing). In September of 1512 some smugglers' noses were cut off between the columns.

The Ten were lenient when the case permitted. On May 23, 1509, as the diarist was making his way to the Senate, there was much excitement, for the officer of the Ten was seen leading a muffled man in slippers by the Doge's staircase, and many and various suspicions were aroused, it even being rumoured that it was Domenico Bon, Chief of the Quarantia, and all the city was full of it. The Capi and the Inquisitor and Councillors repaired to the torture-room, and the mysterious prisoner was put to the question. They soon returned, and it was reported to the Senate that the accused was Vicenzio Malipiero, inculpated of having spoken insultingly of the Doge, but that being the result of excess of zeal, he was absolved.

In 1502 the Ten were concerned with Sister Maria, prioress of Sta. Maria Maggiore, who had been arrested on August 22, and accused of having played the fool (*se im-*

pazavano) with the priest Francesco of S. Stae; he, too, a fine young fellow (*bel compagno*), was taken, and many rich clothes which Sister Maria had given him were found at his house. These the Ten ordered to be sold by auction for the benefit of the Church of S. Stae, the priest to be imprisoned for ten years, and his mistress to be banished to Cyprus and confined on bread and water. And so, appropriately enough, to the Isle of Cyprian Venus, went the fair, but frail and peccant, prioress, who played the fool with the handsome young priest of S. Stae.

On March 14 Marin after dinner saw a soldier beheaded and burnt for an unnatural crime: he was a brave fellow and died *benissimo*. Three thieves having been hanged at the Pescaria, one of them, a fine corpse, was given to the surgeons, and for some days public lessons in anatomy were given from the body in the church of S. Stefano. On August 10, 1509, the Ten decided that since the new and high gallows had never yet been used they would hang Zuan Francesco da Ponte the Paduan traitor. Crowds of spectators were present, but "no one cried *Jesu*, as our people are wont to do, when executions are consummated." On December 1, however, the new gallows was busy enough and the scene of one of the most pathetic and dreadful political executions in the annals of that stormy time. Four noble Paduans—Alberto Trapolin, a man of great learning, formerly governor of Padua, whose grandfather was hanged at Padua during the troubles with the Carrara in 1437; Doctor Bertuccio Bagaroto, lecturer on Canon law, rich and famous, who was paid 300 ducats a year by the Seigniory; Jacopo da Lion, Doctor of Laws; and Ludovico the Count, newly knighted by the Emperor, who had been condemned for treason, lay in the cells of St Mark's prison; to whom, that chill and dark December morning entered the Captain of the Guards of the Ten and bade them prepare to die. Ludovico and Jacopo fell to weeping bitterly; Trapolin exclaimed; *fiat voluntas domini*, and entreated that

confessors pleasing to them might be sent. The ill-fated gentlemen, wearing their beards and clad in the long black habit, marked with the red cross, of the Guild of S. Fantino, with ropes round their necks, were led forth accompanied by Franciscan priests, and all four seemed well disposed. Trapolin was the first to suffer and on the steps of the ladder recited many prayers and psalms. No fear of death had he and even asked the hangman, "Wouldst thou that I cast me down"? Then the Count, almost dazed, climbed to his doom and said but few words. Bagaroto followed, dressed in ermine, and died protesting his innocence and commending his son to the Seigniory. Doctor Jacopo, who had bidden the Count as he slowly mounted the ladder, die as a valiant knight, was now to end the tragedy. Raising his eyes to gaze at his dead companions he broke down piteously and sobbing· went to his doom. They were cut down at the first hour of the night, placed in a boat with fourteen lighted candles, and ferried to their burial at S. Francesco della Vigna. Many Paduans were on the Piazza and many ladies came in boats to witness the executions. And the Marquis of Mantua (with what dreadful and anxious foreboding we may well imagine) put out his head to see, from the windows of his prison in the Torreselle.[1] The sentence was published at Rialto, the high gallows removed by night, and "folk said they ought to have been despatched secretly for it was no time to raise such great excitement; others were pleased and of these I, Marin Sanudo, was one."

On August 3, 1511, the first instance of a woman, one Bernadina, a murderess, having been subjected to capital punishment, similar in its detailed atrocity to that inflicted on the parish priest of Castello, is recorded.

Be it remembered, however, to the honour of Venice, that she was the first state in Europe, not merely to tolerate, but to fee, counsel for the defence of alleged criminals; that

[1] See page 215.

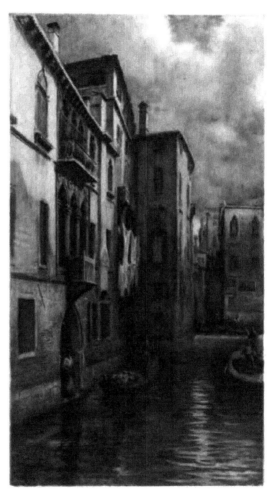

BALCONY FROM PONTE DELL' OLIO.

she appointed a surgeon to be present at the "questioning" of prisoners and witnesses lest the excessive application of the torture might endanger life ; that her criminal code was the least cruel of any in Christendom ; that she steadily preserved the secular jurisdiction over heresy and sorcery : indeed during the perusal of the diaries whence we have drawn our pictures of Venetian life, we do not recall one single reference to an execution [1] either for heresy or witchcraft, and it was precisely during the period covered by our diarists, that in transalpine lands that veritable reign of terror, so graphically described by Lecky, was raging, and tens of thousands of unhappy wretches were sent in batches of scores, and even of hundreds, to the stake. Hugh Miller [2] has told of the vivid impression made on him by the recollections of an old lady who, as a child, was taken in her nurse's arms to witness the execution of a witch—the awestruck yet excited crowd ; the miserable aspect of the poor, fatuous old woman, whom the fire was kindled to consume, so little aware of her situation that she held out her thin, shrivelled arms to warm them at the blaze ; and how when the charred remains of the victim were sputtering and boiling in the intense heat, a gust of wind suddenly blew the smoke athwart the spectators, who felt as if suffocated by the horrible stench. This was near Dornoch in Scotland in the year 1722.

[1] Punishments recorded for the practice of sorcery are : whipping, exposure in the pillory, and banishment.

[2] "My Schools and Schoolmasters."

R.

CHAPTER XVII

Dangers of the Streets—Bull-baiting—Rowdyism—Exalted
Guests of the Republic—Public baptism of converted Jews
—Open air and other sermons—Earthquakes—Persecution
of the Jews

> " To-night we'll wander through the streets and note
> The qualities of people."
> —*Shakespeare.*

THE impunity with which thieves and assassins plied their
horrible trade in a labyrinthian metropolis such as Venice
may easily be imagined, and will, in part, explain the severity
of the penal laws, which, on the Roman principle, *pœna ad
paucos : timor ad multos*, aimed at terrorising the many by the
awful punishment of the few. In a city intersected by a
network of dark, narrow canals crossed by unprotected
wooden bridges—often only a few planks—and threaded
by tortuous, badly-lighted and mostly unpaved streets, crimes

were readily perpetrated and detection was difficult. The
dim and infrequent *cesendoli*[1] instituted in 1128 were supple-
mented in 1450 by a few lamps kindled under the arcades
until the fourth hour of the night, and three years later the
Salt Office was ordered to find money for the *cesendoli* of the
Rialto; but no general system of lighting was initiated prior
to 1719, when lamps were placed along the Merceria, which
in 1720 were extended to the whole city. The first streets
to be paved—those near the churches, known to this day as
Salizzade—were laid down in brick in 1264; the paving of
the Merceria in stone was not effected until 1676, and even
now some of the outlying campi and calli are unpaved
Malipiero chronicles the beginning, in 1487, of the first
stone bridge, and Sanudo the completion, in 1509, of a new
bridge at the Merceria, in marble of beautiful workmanship,
which was much praised. In January 1507, the collapse of
a stone bridge, which fell on a passing gondola and killed
the occupants, is chronicled. In 1409, the dangerous nuisance
caused by vagrant Tantony pigs was abolished by the Great
Council, who forbade the monks of S. Antonio to suffer their
pigs to wander about the city to be fed by the charity of the
faithful. Many were the enactments passed, and severe the
measures taken by the Ten to regulate the wearing of arms
by citizens and nobles. On April 30th, 1502, they sentenced
Troian Contarini to twenty-four turns of the strappado (*corda*)
for many acts of violence, and especially for having used
indecent words to the wife of Sier Francesco da Pesaro at
the festival of the Sensa: "he was steadfast" notes the
diarist. Deaths under this racking torture are recorded, and
an entry concerning the "questioning" of Savonarola at
Florence informs us that after seven *scossi di corda* his flesh
was torn under the armpits (*si havera aperto sotto il braccio*).
On June 20th, 1502, the Ten proclaim that, inasmuch as so
many wounds had been inflicted and so many murders com-
mitted in the streets of late, it was unsafe to walk about the

[1] See p. 78, note 1.

city, and more stringent laws were necessary. The Signori di Notte were exhorted to exercise greater vigilance, and to report if any gentlemen importuned them to restore their weapons, and if any resisted search at night they were to be hanged *immediate*. The law is excellent, remarks Sanudo, if observed. In August 1509, so increasingly numerous had assassinations become, that the Decemvirs ordered henceforth all knives to be made without points. On Sunday the diarist was passing along the Campo Sta. Maria Formosa, at the hour of high mass, when he beheld Sebastiano Raimondo and other gentlemen strike down the son of —— Coresi, and leave him dead on the ground. Sebastiano, a half-witted fellow, went home quite unconcerned to dine, and in the afternoon took his seat in the Great Council: his kinsmen, however, persuaded him to leave the hall. Priuli, in his entry for July 14th, 1509, bitterly complains of the excessive violence and insubordination of some young nobles who, as soon as Padua was recovered from the Imperialists, came in boats to the city to sack the houses of the inhabitants, and were so *imbestialiti* that they acted worse than the vilest mercenaries, and revolted against all control.

Another source of terror to peaceful folk was the habit of the young patricians, to detach bulls from a herd and hunt them through the narrow streets. Bull-baiting in the Campi was a common sport during Carnival and other festivals, the favourite Campi being those of S. Giovanni in Bragora, Sta. Maria Formosa, S. Geremia, S. Giacomo dall' Orio, Sta. Margarita and S. Polo. The young nobles were especially proud of their skill in decapitating a bull and of surpassing professional butchers in deftness of hand. When a Caccia dei Tori was organised, the patrician families and well-to-do citizens whose houses fronted the Campo would send invitations to their friends, the poorer tenants let their front rooms, and around the Campo tiers of wooden benches were raised. To the blast of trumpets the bulls were led in to a fenced inclosure by the Tiratori, richly clad in scarlet doublets, black velvet

breeches, and, if they belonged to the Castellani faction, in red caps; if to the Nicolotti, in black. The first bull was then led round the arena by the Tiratori, the dogs, usually fierce Corsican bulldogs, were unleashed and the baiting began; the furious onslaught of the dogs and the savage defence of the bull being followed with feverish excitement by the spectators who goaded on the dogs with shouts of encouragement and marked every act of courage or skill with loud applause. On the occasion of princely visits the piazza was chosen for the baiting, bears being sometimes provided as well as bulls. Marin describes a famous bear baiting on February 20, 1519, to witness which the French Ambassador left the Council Chamber. Dances followed the exhibition, and our diarist notes that at the Caccia of fourteen bulls, given in the piazza in February 1532, the famous dancers La Carpesana and La Ferrarese,[1] and a Saracen did very well. On the last Sunday in Carnival a baiting took place in the Cortile of the Ducal Palace for the entertainment of the Dogaressa and her ladies, who gazed from the loggia on the sanguinary spectacle. An English traveller writing in later days qualifies the scene as a sickening one: the poor bull on being turned loose in the courtyard was immediately set upon by an unmerciful number of dogs, and "you saw dogs, bull and barkerollo all in a heap within his serenity's court."

Games of *pallone*, a form of tennis, were played in the Campi by young nobles, and jousts and tournaments held in honour of exalted guests. One Sunday in February 1548 a most superb pageant was organised in the Campo S. Stefano, which the Bishop of Padua and the Abbot of Bibbiena honoured by their presence, when the handsome and gallant young Duke of Ferrandina, Captain of the Imperial Guard, won all hearts by his manly bearing and prowess, but met a tragic end at a ball given the same evening at a palace at Murano. A quarrel having arisen between a Giustiniani and

[1] See p. 296.

a Corner concerning a patrician lady, Modesta Venier, swords were drawn and in the scuffle, Duke Ferdinand, who was masked, received a mortal wound in the head; as he fell, the unhappy Captain lunged out with his sword and accidentally stabbed his dearest friend, Faustino Diedo; both perished miserably. During Carnival Sunday a pig was hunted and killed by blind men in the cortile of the Fondaco dei Tedeschi, and Sanudo utters a wail over the omission of the customary pig-sticking in the Piazza in 1510, owing to no pigs being procurable from the Friuli, and so " this good old custom was neglected."

The city was not without her sixteenth century hooligans. On the receipt of the news that the pope had been detached from the League of Cambray and become the ally of Venice, a mad outburst of popular excitement was witnessed on the piazza. The crowd, getting out of hand, seized on a mass of timber which had been stacked for the repair of the Campanile and made of it two huge bonfires, which they kept burning till midnight by smashing the wooden booths occupied by the bakers and greengrocers round the piazza and flinging them on the fire; these being consumed all the benches under the arcades were appropriated to feed the flames, amid cries of Marco! Marco! The officers were powerless, boys carried a painted S. Mark round the piazza, other fires were kindled in the chief campi, so that "not a bit of wood was left in Venice." "And I saw," adds Marin, "the Ca' Barbaro in Sta. Maria Formosa, its windows all illuminated with more than 500 paper lanterns, Roman fashion, and never did I behold so fair a sight."

The Venetian *popolani* were by no means averse from venting their ill-will on the exalted guests of the Republic. As Duke Hercules I. of Ferrara was leaving the Ca' del Duca di Ferrara[1] one rainy day in April 1499, after his unsatisfactory conference with the Seigniory at the close of the Florentine war, the gondoliers at all the ferries, as he passed along the

[1] Subsequently the Fondaco de' Turchi.

Grand Canal, cursed him loudly shouting Magnaza, Magnaza!
(Malediction) and when he reached the Rialto bridge no one
would lower the bascules to let his vessel pass. After
waiting in vain Duke Hercules was constrained to send some
of his own men to work the levers, and so he left with the
ill-will of all.

The lavish hospitality of the Republic towards her
princely visitors became proverbial, and many are the
festivals described in Sanudo's pages at which, in his bright
dress of crimson velvet, he played no small part. One of the
proudest days, which he notes to eternal memory, was his
thirty-ninth birthday, May 22, 1499, when, with other
patricians, the young Savio went to welcome the French
ambassador, who confidentially gave him many details of the
appearance of his royal master[1]: his most Christian Majesty
was forty-eight years of age, handsome, gracious, kind, fond
of hunting, easy of access, wise, and looks to it that his
men-at-arms receive their pay, and that the money is not in-
tercepted by his four generals. His Majesty eats alone and
is fond of the queen, who is a wise queen, and she it is who
sees that the king dresses neatly (*polito*); but she is ugly.
The more important visitors were lodged at the House of the
Estes of Ferrara (the Fondaco de' Turchi), ambassadors at
the Ca' Dandolo (now Hotel Danieli) or at the inn of the
Leon Bianco (now Ca' da Mosto). The Privy Council voted
sums of money for expenses, 20 ducats a day having been
apportioned for the entertainment of the Cardinal Legate,
who arrived from Rome in December 1500 with 70 " mouths."
On this occasion, writes Marin, we Savii had not been advised
of his coming and things were badly managed. Guests
sometimes disappointed their hosts, and a supply of trout,
carp, and eels delivered at the Ducal Palace for the enter-
tainment of the Duke of Ferrara on March 5, 1499, were
sold by auction, and the tapestry stripped from the columns
of the Ca' del Duca di Ferrara because he failed to come,

[1] Louis XII.

whereat there was much talk in the city. When the Pope's son, Cesare Borgia, Cardinal of Valencia, left the Ferrara mansion on September 25, 1499, it was found that his "Spaniards" had stolen two carpets and some sheets belonging to the Seigniory. Early one August morning of 1500 there came to the Council, bursting with impatience, Pino Pender, who kept a lodging house for Germans at S. Bartolomeo and informed the Doge that no less a personage than the envoy of the King of Hungary was staying at his inn; whereupon Sanudo and another Savio were straightway sent to visit him, *nomine domini*: the messengers learned that he was a painter on his way to France, to inspect (*veder*) some ladies for the king who was about to marry.

Other guests outstayed their welcome and among them this very French bride, which the painter had seen and doubtless limned on canvas for the Hungarian King[1]; for on July 14, 1502, it was decided to allow the Queen of Hungary 100 ducats a day during her stay in Venice, and to prepare *honorifice* the Ca' di Ferrara for her reception: sixteen houses of 14, 16, and 20 beds each were rented for her suite. On July 31, Marin found himself at Verona, awaiting her arrival, after an anxious and laborious time spent in organising a fitting welcome. The whole passage from Padua along the Brenta to Fusina was a veritable triumph. At Fusina, Doge and Seigniory and officers of State, the arsenal authorities, the highest patricians, in gorgeous dresses, fifty-three fairest ladies arrayed in all the gay gear of rich costumes, glittering with jewels, advanced to meet her on the Bucintoro, and as the vessel slowly glided along the Canale di Fusina to the Piazza she sat down at the Doge's right hand to a luxurious banquet of 150 covers: a dazzling cortege of festal barges and gondolas followed the Bucintoro to the Ca' di Ferrara. Three days of regattas, banquets at the Ducal Palace, jousts, bull-baitings, visits to the Treasury of St. Mark, Calza festivals, masquerades, and, last but not least,

[1] Uladislaus II.

the usual walk along the Merceria amid all the display of Oriental splendour in the shops, made the stay of the Hungarian Queen at the marvellous city of the lagoons seem like a fairy vision: "never," she averred to the Doge, "had she felt before what it was to be a queen."

The hot August days passed, and sweet it was to linger on the waters of the Adriatic and enjoy the festal greetings and luxurious enjoyment of a favoured Venetian guest; but expenses were increasing and there were 600 mouths to be fed; 400 ducats were daily paid out by the Treasury, much substance had been wasted, and still no word of departure: it was even rumoured that the Hungarians had orders not to bring her majesty away until the promised dowry of 40,000 ducats had been paid by the King of France. On August 12 the councillors, with grave faces, debated what was to be done in view of the continued drain upon an already severely tried exchequer; one angry councillor proposing to limit the queen's allowance to 100 ducats a day. This inhospitable motion was not carried, and at length, to the great relief of the Seigniory, on August 19 the Queen of Hungary took her departure.

The solemn state receptions by the Republic, whose tedious details are noted with elaborate care by our diarist, proved at times a heavy infliction on some of her guests, and it was to escape a repetition of the boredom suffered at an earlier and formal visit that the accomplished, vivacious, and acquisitive Isabella d'Este, Marchioness of Mantua, determined to travel *incognita* to Venice with her sister-in-law, Elizabetta, Duchess of Urbino, and really enjoy the delights of the Queen of Cities. The fulfilment of a vow to the Santo at Padua—the usual pretext for a jaunt to Venice— was put forth, and on March 3, 1502, the ladies arrived at Chioggia late in the evening, and so successfully *incognite* that, having failed to order rooms in advance, they, even as many a modern visitor to Venice, found all the inns full, and were forced to disclose their identity to the podestà in order to find a roof to cover them. Arrived at Venice next day,

they put up at the Ca' Trevisan at S. Stae, next to the palace of the Queen of Cyprus, where the Ambassador of the Duchy of Urbino lived : presents of sweets to the value of 25 ducats were handed them by the messengers of the Seigniory, and to their great disgust they learned that all Venice knew of their coming. By the publication of Isabella's letters[1] to her consort, Gonzaga, the modern reader is able to follow these exalted ladies through a hurried tour round the chief sights of Venice, and share their impressions of the wonderful things they beheld. The party, according to Sanudo, who dates the arrival wrongly as February 17, consisted of Elizabetta Gonzaga di Montefeltro, Duchess of Urbino ; the Marchioness of Mantua ; Madonna Emilia, wife of Count Antonio, brother of the Duke of Urbino ; the Marchioness of Cotrona, and the Protonotary, brother of the Marquis of Mantua. "They went about the city," writes Marin, "disguised, saw everything, and departed." Marchioness Isabella enjoyed her Venice better than before ; it seemed more beautiful than ever, and the Duchess, amazed and overwhelmed, confessed it was even more marvellous than Rome. On the morrow of their arrival, the company set forth betimes, and, after hearing mass at the Miracoli, betook themselves to S. Zanipolo and the Scuola di S. Marco ; they then went home by another way and had dinner. Dinner ended, again they fared forth *subito* to S. Mark's, thinking to find but few people there ; but they were deceived, and then, not to waste time, an ascent of the Campanile was made, whence, after receiving the greatest pleasure from the view, they descended, entered a gondola, and crossed to S. Giorgio Maggiore. Re-embarking, they proceeded to the Misericordia, took a turn along the Grand Canal, and so home. The Marchioness appears to have had some business matters to carry through on behalf of her lord, who, as is the wont of princes, suffered from chronic pecuniary hunger, for we learn that on arriving at the Ca'

[1] *Mantua e Urbino*, Luzio and Renier, 1893.

Trevisan she had some talk with Franceschino and Monsignore "about the matter of the jewels," the latter pretending that he had found "a friend" who would advance 3000 ducats, and was acting secretly. The former believed that by paying the 3000 ducats capital and half of the 450 interest the business might be managed: they had sent for the Jew, and neither the Marchioness nor Monsignore would fail in diligence.

On March 15, Isabella writes to her lord that although for her part she cared not to remain longer in Venice, yet as the Duchess would have no opportunity of seeing the state procession of the Doge and the Seigniory before Sunday of the Olives,[1] she had consented to stay on for that ceremony, as she could not in honour oppose the wishes of her companion. In a touching conclusion, she prays her consort to give a hundred kisses in her name to her dear little boy, "so that when I am returned it shall not seem strange to him if I kiss him."

Isabella strove valiantly to evade the customary official reception by the Doge, and sent her messenger to make excuse for her private entry to the city praying his Serenity to pardon her for not appearing officially, since her dresses were not fitting for a public interview, and to permit her to remain as a private traveller, that she might run over the sights more freely; for when she was at Venice before, she was so honoured and caressed that she had no time to examine the excellences of the city. The Doge and his Council lent a most gracious ear, and all present demonstrated by gestures and murmurs their great satisfaction and joy. An order to view the treasury of S. Mark and the Arsenal was given; they were to see all they desired, and their pleasure and convenience were to be consulted in every way. Meanwhile the ladies and Monsignore, after hearing mass at the Ca' Grande,[2] set forth in a gondola to Rialto,

[1] Palm Sunday: the blessing of olive branches on that festival is still performed in Italian churches.

[2] The Ca' Corner, p. 167.

where they disembarked by the Fishmarket, crossed the
bridge, and walked the whole way through the Merceria to
the Columns of S. Mark. So many people had assembled
that scarce could they move, and the pleasure was so
extreme that the walk tired them not at all, and indeed
the most fatigued of the party was Monsignore. At the
Columns they took a gondola and went home, where they
found four Savii agli Orden, who made long and flattering
but wearisome speeches on behalf of the Doge, to which
Isabella gave suitable replies. These gone, Messer Alvise
Marcello entered, following whom came Messer Filippo
Cappello, and familiar gossip ensued. After dinner, still
insatiate, they fared to the Convent of the Vergini, where
they heard the nuns sing, and visited their cells: on again
reaching the Ca' Trevisan, Alvise Marcello was awaiting their
arrival to advise them that the morrow had been fixed for
their visit to the Treasury of S. Mark. Early they were
astir, and Alvise attended them to the Scuola of the Carità,
and thence to S. Mark's, where they saw the Pala d'Oro
and the Treasury; crossing to the Palace, they visited the
armoury and the Hall of the Great Council, and concluded
a long morning's sight-seeing by again strolling along the
Merceria—this time prepared in its utmost splendour of
rich and rare merchandise—to the Rialto, and so home
by gondola. After dinner, the excellent Alvise was again
at her service, who conducted the eager tourists to the
Arsenal, where they were greeted and caressed with even
greater warmth. Honouring Alvise's house by a visit, they
went on to see the sepulchre at S. Antonio, and on their way
home called on the Queen of Cyprus, their neighbour, "and
so," concludes the indefatigable Isabella, " this day is ended,
and if your Excellency will consider the journeyings we have
performed, you will esteem us to be the most vigorous ladies
(*gagliarde*) that ever travelled about the world. I pray you,
kiss our sweet boy for love of me." This letter is dated
March 17, and on March 21 the distinguished party started

to fulfil their vows at Padua, the Marchioness having dispatched to her lord, on the 17th, some presents from the Seigniory, which she prays him to accept and enjoy for love of her: they were — eight wax candles exceeding 8 lbs. in weight; eight large pieces of gilt march-pane; twenty-nine boxes of sweets of various kinds; four pots of preserved ginger; four pots of syrup; four large baskets of fish; two bundles of wax candles, 20 lbs. in weight. More than twenty years later, in May 1524, another vow to the Santo at Padua brought Isabella d'Este to her beloved Venice, when, remarks Sanudo, she had all the pleasure she desired in our city, and went on foot from Rialto to the piazza, and *si feva tenir a do per li brazi per reputation* (for the dignity of her position she had herself supported at either arm by two attendants). On this occasion, therefore, the now widowed Marchioness wore the Venetian stilted clogs (*pianelle*[1]), and leaned on the shoulders of two of her women as she walked about the streets of the fair city.

A favourite Easter holiday spectacle was afforded to the Venetians by the public baptism of converted Jews, which usually took place in the Campo S. Polo on Easter day. The sermon preached at the baptism of 1509, by Friar Ruffino, is noted as a fine one, and "a good collection was made." More important converts were christened in S. Mark's, for in 1533 Jacob the Jew, son of Anselm the banker, was baptized there in presence of the Doge, who was clothed in white tabby and a mantle of white damask with gold *fiorini*, of the whole officers of the State, and a goodly company of ambassadors. But Jacob, we fear, like other converts from Judaism, was not without reproach, for in July 1523 it is noted that Jacob, son of Anselm of the bank, was arrested by the Ten on some charge connected with a valuable diamond.

Lenten sermons were also given in the Campo S. Polo,

[1] See p. 277.

one *de tentatione diaboli*, preached on February 28, 1501, by Friar Raphael in the presence of the Doge and his court and the ambassadors of France, Naples, and Ferrara, having lasted two hours. His serenity and council were at times constrained to listen to unwelcome truths from courageous preachers: on Christmas day 1498 a friar from S. Francesco della Vigna stood in the pulpit at S. Mark's and dared before the whole Seigniory to speak about justice and paying the sailors: and it was a *bella predica*. In the preceding year the Public Health Department having forbidden sermons in churches because of the danger of infection from plague, the Doge nevertheless ordered the customary Christmas sermon to be preached at S. Mark's, and Friar Timoteo da Lucca gave a *bella predica*. Among other words he uttered before the Doge and the ambassadors of Spain, Naples, Milan, Ferrara, Rimini, Pisa, were these: Sirs, ye close the churches for fear of plague, and ye act prudently, but, if God so will, it shall avail you naught except ye reform and remove the causes that bring this plague upon you: for the horrible sins that are committed here daily, the blasphemies of God and the saints; the usurious contracts daily made at Rialto; the selling of justice everywhere in favour of the rich and to the prejudice of the poor, and even worse things, cry aloud to heaven. Then, directly addressing the Doge, he continued: Serenissimo Prince, I know you are not ignorant of these things, and that you know all about them better than I: Provide therefore! I say provide! and thus you will stay the plague. Then he asked pardon, and concluded with some occult pleasantry as to making the cap fit, or to the Ducal house of commerce[1]: and "he said this with good grace so that everybody laughed, and having descended from the pulpit the Prince gave him a good greeting."

Over zealous preachers who touched on political matters

[1] *Io so Sermo. Principe che vostra Serenità fa far di belli capelli et bruschi : io ne venirò a tuor uno.*

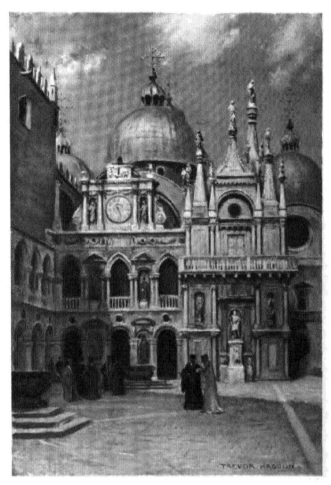

DUCAL PALACE, CORTILE.

were, however, sternly rebuked. The lenten preacher at Sta.
Maria dell' Orto in 1504, one, Friar Bonaventura of the order
of S. Job, among other foolish things, said the Seigniory
was not afraid of papal excommunication. The Ten heard
of it, straightway banished the friar, and dispatched their
secretary, Zaccaria de' Freschi, to put him in a boat and see
him as far as Chioggia. On Palm Sunday 1501, a friar,
preaching at S. Salvadore, said Italy would be torn by wars
until 1505, when the French would be routed in Tuscany,
and spoke about the Pope and the sovereigns of Spain; the
Capi of the Ten ordered him to preach no more. Another
preacher was peremptorily commanded to confine his sermons
to sins and eschew politics.

An entry in Sanudo for March 1511 brings vividly
before us, in all its horrors, one of those terrible geologic
catastrophies which sometimes visited the lagoon city. After
bewailing the extravagant splendour of two festivals given
by the Eterni at the Ca' Corner and at the Ca' Pisani,
notwithstanding the financial distress and general grief of
the citizens, the diarist tells how that, three hours and a
quarter before sunset of the 26th, a terrible earthquake
shook the city: houses seemed to totter and fall, walls
gaped, the Campanile bent down, high buildings collapsed,
and the waters in the rii, and even in the Grand Canal,
seemed to boil as if fire was beneath them. This lasted the
space of a *miserere* and was *oribilissimo*, and the bells in the
Campanili, and especially at S. Mark's, rang of their own
accord—a thing *spaventosa* to hear. The Senate was in
session, and scarce was the first letter read when an appalling
noise was heard, the Senate Hall began to quake, and all
rose in terror, flinging themselves down the wooden stairs,
helter-skelter, and with such celerity that some of the
senators were carried from the top to the bottom without
touching the stairs with their feet. The four kings of
marble fell from the façade of S. Mark's, and some of the
columns in the church; Lady Prudence fell, too; the top of

the Palace above the balcony of the Hall of the Great
Council toppled over together with the statue of Justice,
but S. Mark did not fall. Half of the marble parapet, with
the lilies carved upon it, fell at the foot of the great stone
staircase in the courtyard, and many said it was an augury
and that the lilies of France should fall to ruin, and that
God willed it for the weal of Italy, so long scourged by
these barbarians: "some said the fall of the statue of
Justice was an augury, too, and if auguries existed in those
days they meant—Beware, Venice, Beware! be prudent for
dies mali sunt; behold the *divo Marco* remains intact over
the Palace, so shall this city be faithful to Jesus Christ and
preserve the Catholic faith; she shall be the defender of the
Church and lover of justice, and if she has fallen, raise her
up again. But many said there was no figure of Justice
over the balcony at all, though I think there was."

The Campanile was so injured that next day tierce could
not be rung, nor half tierce, nones, nor vespers: such thing
had never happened before, that the canonical hours were not
sounded. The loggia of the Campanile where our patricians
assembled was destroyed by falling masonry; some of the
mosaics in S. Mark's fell; the iron crucifix on S. Giacomo
di Rialto fell; many campanili were cracked or felled;
chimneys, houses, churches were destroyed, and scarce a
building remained uninjured. Everybody was dazed with
terror; some fled to the open campi; others to the streets;
some flung them down in prayer; others knew not what to
do. "And I, Marin Sanudo, was at home and ran out to
the street—a foolish thing in such *terribilità*—and many
women died of fright. Now the four marble kings were not
kings at all but saints: Constantine, Demetrius, George, and
Theodore [1]; they are of Greek marble and looked like kings."
The priests, chanting litanies, led processions round about
the city with many candles, and it was a *grandissimo tremor*
to behold. Night fell and some folk slept in boats, some in

[1] The four reliefs still on the façade of S. Mark's.

gardens, some in the campi. The entry, evidently written under great excitement, is full of repetitions, and after noting that Petrus Contarinus composed a sonnet on the occasion, concludes by a curious relation of the action taken by the Patriarch, who, after declaring the earthquake to be a punishment for the sins of the people—the recital is too frankly brutal for translation — proceeds to confirm his declaration by stating that—we euphemize his words—such was the prevalence in Venice of the vices for which the cities of the plain were destroyed that the sisters of Rahab had recently sent to inform him they were unable to earn a living by their profession. His eminence commanded a three days' fast on bread and water and processions and litanies night and day. Our diarist's comment is character-istic: " for these things I praised him in so far as good morals and religion are concerned, but in regard to remedies for earthquakes it could avail nothing, for they are natural things." On the 28th, as Marin was dining at Sta. Elena with some patrician friends, another shock was felt; the terror was renewed, and such was the demoralisation of the city that the Great Council failed to meet on the ensuing Sunday—the 30th—nor did the Senate meet for some days; when it did, the Procurators of St Mark reported that they had discovered a casket which no one knew of, and which being opened was seen to contain 3000 gold ducats of the time of Doge Francesco Foscari, and jewels worth 2000 more : this treasure trove was set apart for the repair of the Campanile.

The immediate effect of all the religious emotion evoked by the terror and exploited by the Church appears to have been little more than an outburst of fanatical persecution of the Jews, who were made to atone vicariously for Christian depravity. On April 2, Friar Ruffino was again in the Campo S. Polo denouncing with fiery eloquence the presence of Jews in the city, which was full of them, and it would be well to seize what they possessed and sack their houses. The

s

bankers Anselm and Vivian heard of this incipient *Juden-hetze* and complained to the Ten, who severely reprimanded the Friar: on the 8th an order of expulsion was issued, and the Jews—there were 500 of both sexes in the city—were to quit Venice within one month. All, *cujus cumque generis*, were to leave, and meantime no Jew was to issue from his house under a fine of 50 lire and a month's imprisonment; none save two in each parish, who might quit their houses between the hours of maragona and tierce [1] for the needs of the said Jews, and also between the two hours before sunset: half the fine was to go to the informer and half to the magistrate who convicted the offender. Those Jews, however, were excepted, who, being bankers, had come to the city by permission of the Seigniory: they might remain until such time as might be necessary for the disposal of their property and of the pledges held by them to the best advantage of themselves and of those to whom the pledges belonged. Citizens were warned that no hurt must be done to the persons or property of the Jews under penalties of fine and imprisonment. The fanatical friar Ruffino was neither silenced nor satisfied, and preaching in S. Mark's on Good Friday the 18th, after dwelling on the blessedness of the Contemplation of the Passion of his Lord and of the Holy Cross, and reciting *minute* the details of the Passion, again declaimed violently against the Jews, saying it was lawful with a good conscience to hunt them all out of the city and seize their property. But the Jews, or at least the Jewish bankers, were still flourishing in Venice a few months later, for on September 28, a forced loan was exacted from them, and doubtless they weathered this and many another storm of Christian fanaticism with their usual astuteness, command of capital, and consistent policy of non-resistance.

[1] 6 and 8 A.M.

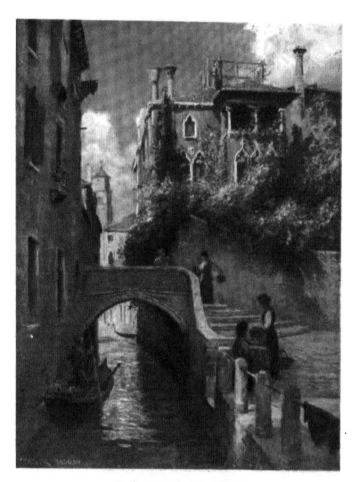

BACK OF PALAZZO DARIO.

CHAPTER XVIII

The Sumptuary Laws—Magistrates versus Women

" In that day the Lord will take away the bravery of their tinkling ornaments about their feet, and their cauls, and their round tires like the moon, the chains, and the bracelets, and the mufflers, and the bonnets, and the ornaments of the legs, and the head-bands, and the tablets, and the ear-rings, the rings, and nose-jewels, the changeable suits of apparel, and the mantles, and the wimples, and the crisping-pins, the glasses, and the fine linen,and the hoods and the veils."—*Isaiah*.

As the ill-fortune and financial burdens of the Republic increased and the need for money became more and more urgent, the Fathers of the city essayed a task of greater magnitude than any that had fallen to the lot of earlier statesmen. And in vain: for the sons of those who, by their wit and courage had humbled the pride of Genoa were worsted in an attempt to curb the extravagance of wives and daughters. In 1470 ladies were forbidden to wear pearls under a penalty of three yearly fines of 50 ducats, and in 1476 the Great Council had promulgated certain sumptuary laws concerning the dress of women and the furniture of houses " for the good of all our gentlemen and citizens." Canon Casola, who, " although a priest, and in the way of the saints," appears, as he strolled about Venice in 1494, to have allowed his eyes to rove and dwell upon matters which ecclesiastics are warned to avoid, informs us that those Venetian ladies who could afford it, and those also who could not, dressed very splendidly and wore many rings on their fingers with great balass rubies and diamonds, and that they, especially the pretty ones, tried as much as possible to expose their breasts and shoulders so that he marvelled their clothes did not fall from their backs; they painted their faces a great deal and also the other parts they showed, and

not being afraid of flies biting them, were in no hurry to cover themselves if a man came upon them unexpectedly, nor did they spend too much in shawls to cover them.[1] But the general run who were not among the number of pretty girls went out covered up and dressed for the most part in black so that he thought they were all widows.

The worthy Canon on his return journey from the Holy Land in the same year was taken by the Milanese ambassador to visit the wife of a nobleman of the Delfini family, who lay in child-bed, that he might behold the splendour and great magnificence of the Venetians: neither Queen of France, nor any French noble, nor even " our most Illustrious Duchess," the ambassador assured him, would have displayed so much pomp. It was estimated that the ornamentation of the bed-chamber . had .cost two thousand ducats and more; the fireplace was all of Carrara marble, shining like gold, and carved so subtly with figures and foliage that Praxiteles and Phidias could do no better; so richly were the ceiling and the walls decorated with gold and ultramarine that Casola's pen was not equal to describing them; the bedstead alone was worth five hundred ducats, and indeed so many beautiful and natural figures were there, and so much gold everywhere, that he knew not whether in the time of Solomon there was such abundance as he saw displayed: the most wonderful ornaments of the bed and of the lady, that is the coverings and the cushions and the curtains, he thought better not to describe as he would not be believed. One thing, however, he must tell even if he should not be believed, though for certain the ambassador would not let him lie: In the said chamber were twenty-five Venetian damsels, each more beautiful than the other, who had come to visit the invalid. Their dress was most decent and in the Venetian style: they did not show, however, less than four fingers' breadth of

[1] As late as 1579 Fynes Moryson, describing the costume of Venetian women, remarks " they were proverbially said to be tall with wood, fat with ragges, red with paint, and white with chalke."

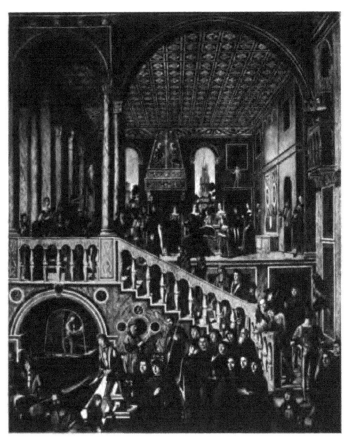

PALACE INTERIOR, A.D. 1500 (CA.)—
MIRACLE OF THE HOLY CROSS: MANSUETI

bare skin below their shoulders before and behind, and had so many jewels on head, neck, and hands, gold and precious stones and pearls—that in the opinion of those present the jewels must have been worth a hundred thousand ducats. Their faces too were very well painted and so was the rest of their bare skins. The observant Canon, after staying a good while and contemplating the room and the persons in it, departed fasting, " for the Venetians evidently thought the refreshment of the eyes was enough." Out of doors the women wore high shoes called *pianelle*—some he saw for sale as high as 20 inches (half a Milanese cubit)—and though small in stature they seemed like giants, and were supported by slaves as they walked. The greater part of the hair they wore (so much was curled over their eyes that they appeared rather men than women) was false, and "this I know," says the Canon, "because I saw quantities of it on poles for sale in the Piazza, and further I enquired about it, pretending to buy some, although I had a beard both long and white."[1]

The characteristic dress of a fifteenth-century Venetian lady may be seen in the file of *decolletées* matrons to the left on the fondamenta near the old bridge that spans the Rio di S. Lorenzo in the *Miracle of the Holy Cross* (no. 568 in the Accademia), painted by Gentile Bellini six years after Pietro Casola was at Venice : their rich bodices and slashed sleeves are adorned with gold and pearls and studded with jewels; strings of pearls are about their necks; they wear long earrings and chatelaines instead of girdles. The nearest to the spectator, wearing a richly jewelled diadem, is said to be a representation of the Queen of Cyprus.

On April 23, 1503, Sanudo notes that, at the wedding of a cousin of his, a law made on the previous day was enforced that forbade more than forty ladies to sit down at any marriage feast, and if more had been invited they were to be dismissed. On January 3 of the following year, the Senate took the business in hand and fulminated at

[1] Translation by M. Margaret Newett. See p. 131, note.

great length against the excessive expenditure on dress, wedding and other banquets at private houses. Ladies were warned that they might wear one string of gold beads only of the value of 25 ducats and no more, and one plain gold chain, not exceeding 100 ducats in value, which must be stamped with the official seal. Sleeves and bodices might be woven of drawn gold and silver, not exceeding the worth of 30 ducats, "and whereas a certain ugly fashion of sleeves hath been introduced, called elbowed sleeves (*manege a comedo*) wherein is used three cubits of gold brocade or silk of excessive cost, and is a fashion most unseemly in ladies, be it enacted and commanded that the said fashion of sleeves be wholly banned so that they be no more worn or made." The measure of stuff to be used is specified, and if any dressmaker is convicted of making such sleeves, she shall be fined 10 ducats, the wearer 25 ducats, and the dress confiscated. Certain luxurious couches and other furniture now being made is a thing beyond all others damnable: they are prohibited under penalties of a fine, confiscation, and imprisonment on the user, and a fine on the master who makes them.

Since these abominable sleeves *a comedo* are destined to cause great trouble to the Senators, some description of their form and origin will here be pertinent. Cesare Vercelli, said to be a brother of the great Titian, in his *Habiti Antichi e Moderni* (1590) engraves the figures of two Venetian gentlemen wearing short tunics and sleeves *a comedo*—sleeves most voluminous not to say baggy at the elbow, and fitting fairly closely round the wrist.[1] The costume was imitated from the French at Cyprus, and is said to have been introduced to Venice because the patricians, especially the older among them, found the old fashioned long, toga-like costumes, with wide drooping sleeves *alla dogalina* almost reaching to the ground, too heavy for walking: the skirt of the garment was therefore shortened, and the sleeves gathered up at the wrist. The magistrates

[1] They were used as a receptacle for handkerchiefs, gloves, papers, etc.

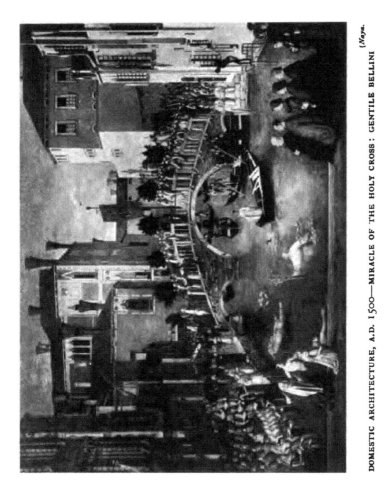

DOMESTIC ARCHITECTURE, A.D. 1500—MIRACLE OF THE HOLY CROSS: GENTILE BELLINI

[Naya.

appear to have objected, not to the wearing of the sleeves by gentlemen, but to the exaggerated form affected by ladies. According to the younger Sansovino, the young noble when he came of age wore sleeves *alla dogalina*, and, when he entered the Grand Council, sleeves *a comedo*. The editor of the later edition of the *Habiti* (1664) says that sleeves *a comedo* were worn by ladies in his days, whereas the old Venetian ladies were wont to dress in crimson velvet and silk with long close-fitting sleeves.

On October 15, 1504, the Senate is again troubled by this formidable evil of female dress, and having been concerned with the latitude of sleeves, is now perturbed by the longitude of skirts; long trains are forbidden both to women and young girls; no dress shall be worn longer than *raso terra* (touching the ground) under pain of fine and confiscation to the wearer, and of imprisonment to the maker. "*Insuper*, certain women of our city have begun to dress in German fashion (which truly seems to betray lack of taste), and since, if this is not prevented, all our women will follow on in the same fashion, we decide to forbid such altogether, nor shall this fashion be worn in any manner or degree. *Item*, no dress shall be worn of any other fashion than that of the present day. *Præterea*, although we have already prohibited the unseemly and shameless fashion of sleeves *a comedo*, nevertheless our women have invented another mode of sleeve, broader and uglier than before": increased penalties are therefore threatened, and various specific rules are issued as to limitations of size and material, and the use of gold and silver and other fittings. In October 1505 Priuli writes that he cannot refrain from saying something concerning our Venetian women, who, according to their unstable custom, change the fashion of their dress, and in these days began to wear sleeves in the French manner. He, too, is concerned with their excessive breadth and the weight of gold and rich embroideries of *grandissimo valore*. The Senate is determined to set limits to the folly of these

women and to curb their appetites. But alas for the
patriotism and obedience of women! Anonymous letters
were found even on the Palace steps denouncing by name
certain ladies who were ruining the State by their extrava-
gance, and, after many unsuccessful attempts to deal with
this crying evil, a proclamation was made from the edict
stones at S. Mark's and at Rialto in January 1508 against
extravagance and luxury in dress: slaves are promised their
liberty and servants their full salaries if they will denounce
their mistresses.

A year passes, and another new proclamation, hot from
the Senate, is cried forth: French fashions are now subtly
corrupting our youth of both sexes, and none of our ladies
shall henceforth presume to wear bodices and shifts *à la
française*, which we, the Senate, have before prohibited by
law, but which law hath not been observed. *Grandissime*
penalties are to be inflicted, for the French name is hateful
to us. "But," writes Sanudo, "it was *mal à propos*, for
all our young fellows, too, are wearing these doublets and
shirts *à la française*, and spend xx. ducats and more to buy
new ones." Passing by other futile attempts, we reach the
month of February in the year of Grace 1511, when the
Senators peremptorily command that the sumptuary laws
shall be obeyed *inviolabiliter*, and appoint the Magnificent
Seigniors, Missier Nicolo Michiel, Doctor and Cavalier, and
Missier Tomà Mocenigo, Procurators of Missier S. Marco,
and charge them to look to it that their orders be enforced.
And so these Magnificent Seigniors, being invested with
supreme authority and power to prevent inordinate expendi-
ture, proclaim that none shall henceforth plead ignorance;
neither man, woman, boy, or girl shall be exempt; all shall
obey *ad literam*, and the magnificent commissioners will visit
with exemplary punishment any and every transgressor.
Then follows a long categorical proclamation limiting the
cost of female finery: no pearls or jewels of any kind shall
be worn on the head, neck, or other part of the person,

save one necklace of pearls not exceeding the value of 50 ducats. Those irrepressible sleeves are limited to two cubits[1] of stuff, if it be of cloth of gold or silver: if of plain cloth or silk of one colour, four and a half cubits may be used. The said sleeves shall not be slashed or open in in any part, and shall not be embroidered. ETIAM, *they shall not be* A COMEDO, nor in any new fashion. No fringe is to be used, and dresses must be of one colour, plain and simple. Eighteen cubits of stuff may be used and no more, and the cost thereof shall not exceed 2 ducats the cubit. Pelisses shall not be trimmed with fur of wolf, deer, or beaver on the arms and back, neither with gold, silver, or any kind of embroidery. Kerchiefs and aprons must be plain and without gold or silver embroidery. Chains in lieu of woven girdles are forbidden; the whole value of finger-rings worn shall not exceed 400 ducats. *Etiam*, their Magnificences declare *that all new fashions are banned*, ITA *henceforth no new fashion that may be imagined or told shall be suffered*. Minute decrees follow limiting the decoration of chairs, couches, and other furniture. No sheet or pillow-case shall be embroidered with gold or silver or silk; no quilt shall be worked with gold or silver or adorned with jewels, nor made of velvet or satin or tabby, but if made plain they may be of taffety or *samite* (an inferior kind of silk cloth). No gold decorations in rooms shall be permitted except gold put on by painters. *Præterea :* bodices and shifts *à la française* and ruffles are forbidden ; hose, clogs or shoes, whether worn by man or woman, must be plain. All these decrees (of which we give but a summary) are to be observed, and the magnificent Commissioners will pardon no offender, and *immediate* anyone falls under the law she or he shall be punished, or the Senate will exact the penalties from the Commissioners themselves. Full powers of search are conceded, lists of offenders shall be

[1] *Braccia*, the modern equivalent of the Venetian *braccio* of silk is ·638721 of a metre, or about 25 inches.

exhibited to the Doge monthly; our officers shall make diligent inquisition, and if any offenders are discovered, they shall be stripped of their unlawful dresses and jewels, which shall be confiscated, and they shall be punished *irremissibil-mente* without fear or favour. Any slave, male or female, who shall give information of infringements of the law shall be made frank and free, and any manservant or maidservant, bond or salaried, shall receive full salary and be rewarded with a portion of the fine.

 Surely now these potent and minatory seigniors shall be obeyed and our rebellious women stayed in their shameful extravagance. Ah no! in June of that very same year Priuli bewails the scandalous extravagance of our women in the matter of dress, banquets, and viands, such as never were known to our ancestors even in the height of their prosperity, and this, despite the urgent need of money for public purposes, and the disastrous ills that afflict our fatherland: these ladies abandon all womanly temperance and modesty. A year elapses since the proclamation, and in April 1512 rumours reach the Senate that certain ladies to the number of fifteen are about to form a *Compagnia* (Guild) and celebrate weddings by a new fashion of dress, wearing red caps decorated with medallions. Look to it, ye stern senators! Aye, our patience is now exhausted, and three new Proveditori shall be chosen because they are Men of Terror, HOMENI TERRIBILI; they shall provide and enforce the law against our undutiful women. And so these terrible fellows try their wits. On May 8, at a full meeting of the Senate certain decrees were approved, which are not transcribed because they were printed, but of the debates some notes are given, which discover to us the grave fathers of the Republic solemnly debating whether false sleeves shall be permitted to the shifts of their wives and daughters. These the terrible Proveditor, Vettor Morosini, proposed should be absolutely prohibited: Sier Nicolo Grimani, how-ever, moved that they might be worn to the measure of two

cubits; whereupon Sier Vettor strode to the rostrum and violently declaimed against the motion; him followed Sier Vettor Michiel, who said our women were becoming more and more abandoned; at first they danced with a kerchief, now they dance with masks and issue forth, even in the Campi, and dance the *ballo del cappello*, which by order of the Senate had already been forbidden: he prayed the Seigniory and the Collegio to provide. Sier Giacomo Pizamano, chief of the Quarantia, rose and supported Grimani in the matter of the sleeves of the shifts, but with the addition that, *sub pæna* to their husbands, our women shall not be suffered to dance these *balli del cappello* either at their own houses or in the Campi. On a ballot being taken, 113 ballots were cast for the last resolution, which was carried. And now these HOMENI TERRIBILI discharge their heaviest ordnance against the rebellious sex: the new and useless fashion of our women who wear certain *chemisettes* of transparent and finest (*subtillissimo*) cambric of great price under or over their silk bodices is wholly banned; another damnable and *vituperosa* custom having been introduced that highly offends divine majesty and gives evil example to modest virgins who stand behind the blinds (*zelosie*) to watch the dancing at our festivals, to wit, a certain most unseemly dance of the *baretta* (*cappello*) and other lascivious and damnable French dances which are performed by our depraved youth; this too is wholly prohibited, and heavy penalties are threatened to those who oppose our officers or fling bread or oranges at their heads, in order to drive the said officers away when they come to examine the tables.[1]

Now shall our terror-stricken women submit, but lo! on August 25, 1512, four short months after the appointment of their dreadful Proveditori the perturbed Senators are again constrained to take cognisance of the continual increase of reckless expenditure and the flinging away of money and substance to satisfy the unbridled appetites of our

[1] Cited by Romanin.

women and men. They neither fear nor reverence our Lord God; they maliciously evade the statutes and confound the magistrates; they contemn our most solemn laws against extravagance and luxury in dress, the most disobedient being the very wives and sons of our own nobles. These nobles shall now be held responsible for the sins of their wives and sons: they shall be summoned to our Palace, the penalties shall be exacted, and the most magnificent and most terrible Proveditor, Vettor Morosini, proposes to take instant execution on their goods and persons. Morosini seems to have been as good as his word for we learn that in the following September his house in S. Polo was defiled and a reward of 1000 ducats offered for the discovery of the culprit. On April 12, 1513, the dread Morosini addressed the Senate: he had observed ladies at a wedding at the Ca' Gritti wearing a new and most unseemly head dress and proposes it shall be forbidden; a further proclamation is launched against the women of this city who, by the unseemliness of their coiffures, publicly offend God and shame our most holy progenitors. Lest, therefore, the cries of God's servants reach heaven and divine wrath be kindled upon us, any of these our women who shall have the temerity to contravene the law shall be fined 100 ducats, to be levied on whosoever —father, husband, brother, uncle, or other relative or guardian—shall have the said woman in his charge; and if the offender be a public woman she shall be whipped from S. Mark's to Rialto.

Fatta la legge, pensata la malizia runs an Italian proverb: no sooner is the law made, than the evasion is found. On December 27, 1522, another senatorial decree, which by the fury of its language betrays the futility of their efforts, denounces the damnable and most wicked custom of our women who make to themselves dresses half of silk, half of cloth of gold, one newly-wedded wife having had on her back a dress of cloth of gold *tutto*, to the great scandal of the Republic and the ruin of husbands and fathers. And

since it is the office of a well-ordered state to provide *immediate* for the extirpation of these evils, another volley of regulations is shot forth, rewards to informers are increased, and tailoresses and dressmakers menaced with imprisonment.

We turn the pages of our diaries and in March 1530, meet with an order that *primum et ante omnia* the decrees of 1512 are to be obeyed, and the rusty old ordinances against the wearing of ornaments of jewels, gold and silver, are renewed : sheets, pillow-cases, curtains, cushions, are again to be stripped of their adornments ; those abominable sleeves *a comedo* are denounced and trains are to be curtailed ; expensive girdles, chatelaines, chains, bracelets, paternosters, furs, kerchiefs, and other pieces of feminine artillery are once more forbidden, and none shall wear any new fashion unless first approved by the magistrates. Grievous to relate, these fulminations were so ineffective that the Doge, in January 1532, was constrained to warn the Proveditori to look to the laws against extravagant expenditure on dress, and on May 8, 1533, almost the last decree included in the diary of Sanudo, is a long printed screed of seven pages against our undutiful women. Our elders, after much diligence and accurate study, will now provide against this intolerable evil which offends the majesty of God and threatens ruin to the State : therefore, further and more stringent decrees are levelled against the abuse of ornaments on furs, gloves, hose, shoes, bedding, sheets, quilts, cradles and—O most excellent seigniors !—against wedding presents, which shall not consist of more than six silver spoons or forks of the value of one ducat. Offenders if they have no money shall suffer imprisonment, the strappado and the pillory ; alphabetical lists of convictions shall be published at the Ducal Palace, at Rialto, in St Mark's and other churches. Three times a week our commissioners—three Proveditori and two Sopraveditori—shall sit, and time and again this unedifying and unequal trial of wits between the magistrates and the women of the Republic is

renewed. At length, in October 1562—we summarise from
seven printed pages in Mutinelli—the statutes having become
so numerous and confusing it was determined to reduce them
to order so that they be understood. The enactments
concerning dress, banquets, furniture, gondolas, and coaches
were modified, and particular regulations as to meals were
made. No more should luxurious patricians load their tables
with costly viands,

> " And candied apple, quince and plum and gourd,
> With jellies soother than the creamy curd,
> And lucent syrups, tinct with cinnamon;
> Manna and dates, in argosy transferr'd
> From Fez; and spiced dainties, everyone,
> From silken Samarcand to cedar'd Lebanon."

At banquets, whether wedding, society, private or public,
and finally, at every meat meal whatsoever, not more than
one service of roast and one of boiled shall now be given,
wherein there may not be more than three kinds of flesh
or fowl, and at wedding repasts, game, whether aërial or
terrestrial, cockerels, pullets and pigeons, are wholly pro-
hibited; at fish [1] meals, two sorts are permitted, which may
be roast, boiled, or fried, with side dishes, salads, milk foods
(*laticini*), and other usual and ordinary things, and one
serving of the usual tart, marchpane, and common sweets;
trout, sturgeon, lake fish, pastry, confectionery and all other
kinds of sweetmeats, are banned, and it is especially for-
bidden to give flesh and fish, or other marine things, at
one and the same meal; oysters may be served at private

[1] Canon Casola complained that although there was abundance of fish at
Venice, during all his stay he never saw a fine one nor ate a good one. The
meat exposed for sale in the miserable butchers' shops was so wretched
it drove away the wish to buy. The bread, however, was unequalled in
any other city, and tempted even a man who was surfeited to eat: the
bakers' shops were countless and of incredible beauty. The abundance of
fruit and vegetables was incredible, and he ingenuously confesses that
on trying to count the wine shops "the more he counted the more confused
he became."

PALAZZO PAPADOPOLI

dinners only when no more than twenty guests are present;
cooks and scullions shall notify to the officers of the *Pompe*
when, where, and whom they are to serve, and within
three days after the banquet shall deliver an account of
the dishes they have served, under severe penalties; and
hosts are freely to admit the officers to inspect their
kitchens; no festoons shall be suspended over door or
window at wedding feasts, nor drums, nor trumpets
sounded, nor salvos of artillery fired. No earrings, nor
fans shall exceed the value of five ducats, and since it is
but seemly and decent, any bodice or cape, or other
garment worn over the shoulders shall be closed in
front so that the breast be covered: combs or brushes
shall not be adorned with gold or silver or jewels; all
new fashions invented since October 15, 1504, are pro-
hibited, and half fines are promised to secret informers, the
guilty persons to be banished from Venice for five years.
But even as, according to the philosopher, the power and
genius of Lycurgus, lawgiver of Sparta, while successful in
imposing a rigorous discipline upon and winning absolute
obedience from Spartan men, were impotent before the
obstinate resistance of Spartan women, so these exalted and
mighty magistrates of Venice continued to beat the void and
fulminate in vain against the impalpable and subtle force of
female vanity, pride, and love of finery. One fatal flaw in
these enactments was that the Doge's family, dwelling in
the palace, was exempted from their operation; so, too,
were ambassadors, their wives, and distinguished foreigners.
On occasions of great public festivals in honour of exalted
guests the laws were held in abeyance, and special
exemption was granted to favoured brides. A wedding
banquet, given in June 1517, *bellissimo e signorile*, at Ca'
Grimani, was honoured by the presence of 350 guests, the
bride being dressed half in white, half in cloth of gold:
Marin was present, and remarks that this costume was
contrary to law, but that licence had been granted by the

Commissioners of the *Pompe*. On February 23, 1522,
the diarist notes that at a banquet at Ca' Mocenigo, the
Doge's granddaughter was arrayed in cloth of gold, while
the other ladies wore only plain silk: it was too much to
expect of flesh and blood, feminine flesh and blood, that
this intolerable partiality should not excite envy and dis-
obedience. The Seigniory itself, while forbidding under
severe penalties the wearing of pearls and jewels, yet
organised official lotteries in the name of Sta. Maria and
Messer S. Marco, in which balass rubies and pearls of the
value of 500 to 2500 ducats were offered as prizes.

Despite the stringency of the laws and the vigilance of
the magistrates the mutations of fashion were accelerated
with the advance of the sixteenth century, and in 1590 the
author of the "Habiti Antichi" bewails the hard lot of a
writer on female costume, which is subject to greater change
and variation than the moon, and even while he is describing
the fashions now called new the ladies are setting about the
invention of others. Sansovino, writing at the same period,
echoes the same plaint, but believes these female fashions
have been reduced to an honest and tolerable limit, adding:
"truly the riches of Venetian women in dresses and linen
cannot be told; all their things, silk, as well as linen, are
embroidered, fringed and striped with silver and gold, and
by the needle, brought to such beauty and delicacy that
everyone admits the like cannot be found in any other land."
It must not, however, be inferred that this display and
magnificence was part of the intimate, normal and habitual
life of a Venetian patrician family. Casola found these
splendid Venetian seigniors frugal and very modest in their
manner of living at home, and the author of the "Worth of
a Penny" (1647) asserts that the greatest *magnifico* in
Venice will think it no disgrace to his *magnificenza* to go to
market to choose and buy his own meat, what him liketh
best. Moreover, many of the jewels and pearls worn at
public festivals, or at weddings and other festive occasions,

were borrowed for the occasion from the goldsmiths and jewellers. Nor was the fine furniture of a Venetian household merely the exceptional appurtenance of a great palace. Sansovino, noting that he saw the household effects of a noble mansion sold by auction, which would have been deemed excessive in any great duke of Italy, remarks, that there was no householder in Venice, however poor, who had not chests and bedsteads of walnut; carpets, pewter and copper utensils; silver forks and rings, and chains of gold.

T

CHAPTER XIX

*Scenes in the Nunneries—Corruption of Conventual Life—
Dissolute Young Nobles—Calza Festivals — Famous
Courtezans—Cardinal de' Medici at Venice*

> " Credendo quivi ritrovarlo, mosse
> Con maggior fretta le dorate penne ;
> E di veder ch' ancor Pace vi fosse,
> Quiete' e Carità, sicuro tenne.
> Ma dell' opinion sua ritrovosse
> Tosto ingannato che nel chiostro venne :
> Non è Silenzia quivi e gli fu ditto
> Che non v' abita più fuor che in iscritto.
>
> Nè Pietà, nè Quieto, nè Umiltade
> Nè quivi Amor, nè quivi Pace mira.
> Ben vi fur già ma nell' antiqua etade ;
> Che le caccin Gola, Avarizia ed Ira,
> Superbia, Invidia, Inerzia e Crudeltade.
> Di tante novità l'angel si ammira,
> Andò guardando quella brutta schiera,
> E vide ch' anco la Discordia v'era."
>
> *—Ariosto.*

SISTER Maria was not the only nun who gave trouble to the
magistrates. In 1491 several patricians were prosecuted
for immoral conduct with the nuns of Sta. Anna, and a
Balbi and a Tagliapietra were condemned for similar crimes
at the convent of the Spirito Santo. In 1501 the nuns at
Venice succeeded in obtaining permission from Rome to
leave their convents for lengthy vacations, whereupon orders
were sent by the Seigniory to the Vatican that such orders
must be cancelled. In 1509 some young nobles entered
the convent of La Celestia, already, in the fourteenth century,
notorious for scandalous doings, with music, and danced the
whole night long with the nuns ; and in 1525 the Patriarch
determined to make a visitation there, and had one of the

290

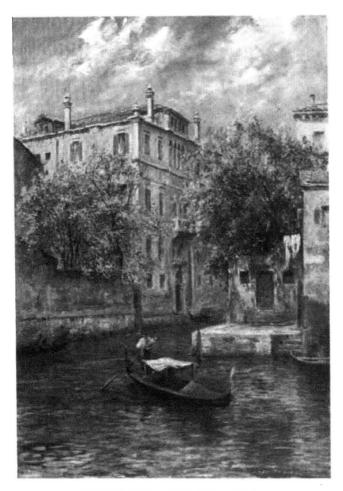

PALAZZO DONA FROM RIO S. POLO.

more notorious of the sisters seized and her tresses shorn.
On ordering two others to be imprisoned outside the convent,
the whole of the sisterhood flung themselves on the prelate,
blocked the doors, and successfully resisted him. Certain of
the Augustinian nuns of Castello, known as the Vergini,
scarcely seem to have justified this appellation, and on
July 1, 1514, happened another *cossa notanda*. So scandalous
were the scenes which had taken place in the famous con-
vent of S. Zaccaria that it was decided to close the parlour,
and the Ten *per più honesta* took action. The Patriarch's vicar
Dominie Zuan di Angelo was dispatched with some officers
to carry out their orders, whereupon the sisters, who had
gathered together a heap of stones, flung them at the
officers, literally stoned them away, and forced the Patriarch
himself to intervene. The Ten, on being informed of the
outrage, ordered the windows to be blocked up. On
February 15, 1513, the Patriarch's presence was urgently
required at the Convent of S. Biagio, where was great
scandal, the nuns in their quarrels having flung books at
each other's heads. His Eminence discovered that some
were living immodestly, and that Sister Faustina had in her
possession a rich pelisse of white damask trimmed with
ermine given to her by her lover, one of the Savii agli
Orden. Priuli, who wields a trenchant pen, is severe in his
strictures on the corruption of convent life in his day. "I
will not shame me from telling the truth, even though it be
of my fatherland," he writes. "Many monasteries of nuns
called *conventuali* should rather be termed lupanars; the nuns
lived *luxuriose*, were fed with every delicacy, and indulged
in every refinement of perfumes and music and song. The
brief obtained from the Pope for a few ducats enabled
them to leave their convents for months and do what they
would—a thing shameful, scandalous, full of all ribaldry,
and so the Senate determined they should cease this abomin-
able and evil practice and return to observe divine worship."
In February 1502 the Ten were concerned with these same

convents, "which might he termed public lupanars, and sought to dissipate the raging lust of the nuns." But in vain, for these enjoyed great favour in the councils, and many a one who ruled the Seigniory of Venice had daughters or sisters in these and other similar *bordelle*, and were quite content, and blocked all attempts at reform. In June 1509, Priuli is sure the cause of the many public calamities is this same relaxed discipline of conventual establishments, where even the daughters of the most conspicuous families were educated with base luxury; they are rather *postriboli* than *cenobi*, nor was there a nun who was not a harlot, avarice no less than lechery ruling them; not even the tenderest damsels of twelve years of age were safe from the sacrilegious and lavish seducers who frequented the convents. In March 1511 he again returns to this greatest of crimes against the Divine Majesty; these brazen-faced avowed strumpets were kept by Senators, even by some weighed down with years, and by sons of the chief patricians. Many decrees were made and repeated in these and past times to repress the evil, but since the very legislators themselves were often the guilty ones—they, their relatives and sons, and friends—the merited chastisement was never inflicted. The diarist (September 26, 1511) excepts the holy Franciscan Observantines, especially the Poor Clares of Murano, the nuns of S. Francesco, of Corpus Domini, and other houses of good repute in the Dominante; nuns of holy lives nearly all of whom were noble Venetian ladies.

That such scandals were rife is perhaps not surprising when we note an entry in Sanudo, dated March 3, 1499: "Three *heremite* took the veil (*vestite*) at Sta. Maria Maggiore with much ceremony and were accompanied to the convent: they were three public women who had been converted." Moreover it was the custom, at least in Sir Henry Wotton's day, for not more than one brother to marry; and since owing to the extravagant dowries customary in Priuli's time many nobles were unable to dower more

than one daughter, and since there was no career but the convent open to those who did not marry, the elements of corruption are obvious enough. Sanudo, too, bewails, in 1498, the increasing value of dowries, in some cases amounting from 3000 to 10,000 ducats, and in 1503 he notes to eternal memory that wedding portions and banquets were more expensive than ever, no dowry being esteemed sufficient unless it exceeded 4000 ducats, and that as much as 100,000 ducats had been given in ten weddings, enough to wreck the fortunes of the families.

These insolent violations of the cloister by dissolute young nobles and other less heinous breaches of public order were a source of much anxiety to the magistrates. In April 1489, six young patricians were fined and banished for two years for snatching the kerchiefs from some young damsels who were worshipping in the Church of S. Giovanni Grisostomo, and in 1503 a large reward was offered for the apprehension of certain young bloods who went about at night smashing gondolas. In 1509 some ladies were returning home by night with their brother in a gondola, when near S. Simon Piccolo they were summoned by certain youths disguised as officers of the Ten who in the name of that awful magistracy commanded the boat to stop. They then seized, robbed, and violated the ladies, and smashed and flung the gondola into the water. In 1522 the Ten offered a reward of 500 lire for the apprehension of a band of young fellows who went armed to the door of the house where Julia Lombarda, a *somptuosa meretrice*, lived, battered the door down and insulted her. In January 1532, the Tribunal, moved by the increasing insolence of our young patricians, decreed that if any forced their company on a dinner party, ball, or wedding, and being adjured by the words, *Vadi con Dio*, would not go away, they should suffer a fine of 100 ducats and banishment for two years. But the most curious incident of this nature is that described by Sanudo as having taken place on January 26, 1508. The Guild of the Calza,

known as the Eterni, had been invited to the Ca' Grimani
in order to celebrate the marriage of one of their members,
who was a Morosini, to a daughter of the house. There
had been much delay in giving the wedding dinner and
dicitur, they were scurvily treated and there were no
ladies. *Adeo*, all the Compagnia came dressed in costume,
but without their mantles, and marched round the Piazza
after having wreaked much damage in the Ca' Grimani and
seized two silver bowls, which Pre Stefano and Domenico
Taiacalza carried in front of the procession; and a proclama-
tion was made at Rialto by the said *bufoni*, that whereas they
had been this day evilly treated and without ladies, they had
therefore taken the bowls in order to sup on the proceeds.
And so they pawned them: one for candles the other
for the hostelry of the Bell, where they ate a fine supper.
This famous and fashionable hostelry of La Campana[1] was
the property of the Sanudo family, and marvellously profit-
able, bringing in, with its three shops below, a revenue of
800 ducats yearly. The folly of making sham cries at Rialto
was not a new one, for the diarist relates that he was present
when the official crier (the Commandador) was summoned
before the Doge, who administered a *gran rebuffo* and
deprived him of his office for having made a proclamation
at Rialto, amid universal laughter, that the Compagnia of
the Electi had publicly expelled Zaccaria Valaresso for his
failure to give the usual supper at his house. Sanudo was
also present in the Senate when a young Morosini was
charged with having kissed a lady and stolen a jewel from
her person: whereupon Andrea, his father, rose, who was
then Avogador, and exclaimed in a loud voice, emulating
Brutus of old: "Hang him! Let him lose his head!"
And so he was condemned.

Amid all the public anxiety and the oppression of fiscal
burdens, the sumptuous entertainments organised by the rich
young nobles who formed the various guilds of the Hose

[1] It still existed in Rawdon Brown's time.

showed small abatement. Sanudo notes that the Carnival of 1498 was a most sweet and festive one, in spite of our enemies, and that two great entertainments were given—by the Modesti at the Ca' Loredano and by the Electi at the Ca' Pesaro[1]: although our glorious Republic was spending gaily, he writes, "to eternal memory," the whole city made great festival. Canon Casola was impressed by the tall, handsome patricians, astute and subtle; and so proud on account of their great dominions, that when a son is born to a Venetian gentleman they say themselves, "a lord is born into the World": nothing could exceed the splendour of their magnificent official garments. Another fifteenth century writer declares that the young patricians, as they sat on the benches at Rialto, seemed lords of lands or castles, and to have been born in Imperial realms. Venetian ladies were so richly arrayed and so fair that they appeared to have come direct from Paradise. Sanudo towards the close of his diary carries his memory backwards, and recites the titles of the various Calza Guilds formed in his day, from that of the Cortesi whose foundation he had just seen celebrated by a grand mass at S. Stefano, when, notwithstanding the Sumptuary Laws, Sier Quirini-Stampalia, the Master, sat apparelled in crimson damask, with a cloak of crimson satin and wearing a gold chain about his neck worth a thousand ducats; his head-dress a black biretta of Spanish fashion, set with a beautiful jewel.

The titles of these many Guilds of the Hose, which Sanudo remembered to have been established in his day, are of interest, and may here be transcribed. They were the Cortesi, Floridi, Reali, Valorosi, Triumphanti, Ortolani, Zardineri, Immortali, Fortunati, Eterni, Fausti, Modesti, Electi, Prudenti, Potenti, Fraterni, Perpetui, Stragazai, Liberali, Triumphali, Principali, Semprevivi, Fideli, Felici, Puavoli, Regali, Signorili, Soprani, Ziati, Solenni, Pigna, Zenevre, I Belli, Illa Conservare.

[1] See p. 89.

In 1512 the Zardineri played a comedy in Ca' Lippomani at Murano and our diarist with many other patricians went to hear it and liked it well. The Campagnia wore white hose and Gasper Contarini was master of the revels. Twelve *done scosagne* were brought over from the city dressed, however, quite honourably in silk. After a luxurious supper a comic interlude was performed; a collation with tarts followed, and they danced with the ladies all night so that when the festa ended it was broad day and "I returned home without having slept a wink which was a great thing, but indeed the festa was mighty fine to behold." The Immortali were much praised for a wondrous festa given at Ca' Foscari on the Grand Canal at S. Simione during the Carnival of 1520. A platform was erected at the level of the balconies, and the Canal bridged by boats; eighty ladies in gorgeous dresses of satin and gold danced on the platform, and in the evening a great masquerade (*mumaria*) with torchlights and lanterns was given. There were figures of sea horses and a great giant, and a serpent like the Laocoon; fireworks and cannon were let off, and jousts run. The burning of Troy was performed and a devil issued from the stage with great flames. No less than 350 guests sat down to supper; abundant riches were spent and never in the memory of man had there been such a *bella festa* known. "And this I write to the glory of our city which is so excellent though men are evil." On February 13, 1532, a *bella festa* was given at the Ca' Cappello at Murano although it rained: La Carpesana and La Ferrarase [1] performed some of their famous dances, and a newly arrived French *danseuse* executed terpsichorean feats on high stilts, beat time with castanets and danced on one leg and did divers rare things.

Nothing affords more striking exemplification of the immense resources of the Republic than these ever recurring public and private entertainments. During the wars of the League of Cambray "when our state was spending 60,000

[1] See p. 261.

ducats a month, God help us," many festas were given; and
although folks thought all the silver in Venice had been sent
to the mint, the publication of the League with the Pope in
1511 was celebrated with such solemnity and pomp, and the
procession so richly furnished with silver that the foreigners
present were amazed. The tapestry and embroideries of
gold were of infinite value, and the whole Church of S.
Mark was draped with cloth of gold and many gorgeous
flags and standards ; and the Ducal Palace and the Piazza
too were decked with a profusion of tapestry and arras of
great value—a stupendous and magnificent spectacle, says
Priuli, so that in the memory of man such a sight had never
been beheld in Venice, nor had ever such wealth of rich
tapestry been exposed.

On April 27, 1513, writes Marin, *accidit cossa notanda.*
This morning Sier Ferigo Foscari having wedded the
daughter of Sier Zuan Venier, who was the daughter of a
daughter of the Serenissimo, and a dinner having been given
to many guests where *etiam* I was, the best men of the
groom, who were called the Eterni, took each a lady by the
hand about four o'clock, and accompanied by the bride and
heralded by sound of trumpets and fifes and other instru-
ments, and led by Polo the *bufon*, went through the Piazza
of S. Mark into the courtyard of the palace and there
danced with great festivity : this done they returned to the
house. On May 2, the marriage was formally celebrated,
and nothing was done at the palace that day after dinner
because of the wedding banquet. A most excellent repast
was provided, and among the distinguished company were
the ambassadors of Rome, Spain, and Hungary. Ninety
ladies sat down in the long hall, and at the tables in the
various rooms 420 were seated, and everything was arranged
in the most beautiful manner, and it was a most beautiful
dinner. The banquet ended, an elaborate and richly-
mounted comedy-ballet was performed, with political tableaux
and topical scenes. The musical entertainment was provided

by lyres, flutes, cornamuses, horns, trumpets, *violeti* and other Hungarian instruments; various ballets, morris-dances, and *pas à deux* with *salti forti* (high kicks?) were the interludes between speeches in Latin, Spanish, and German; allegorical scenes followed, with sea-monsters, pigmies, all detailed at great length by the diarist, but too tedious to transcribe. We will rather imitate the diplomacy of the Spanish envoy, who pleaded the demands of urgent correspondence, and took his leave early in the evening. Sanudo stayed until the third hour of the night, when a period was put to the performance, and left complaining that the room was very hot because of the crowd present. On February 25, 1528, a pastoral eclogue, mighty fine, was performed in the Ca' Lippomani at Murano, where once Cardinal Grimani lived, in the presence of Cardinal Trani, the Primocerio of S. Mark's, and many patricians, "among whom, by chance, was I, Marin Sanudo"; and a festa was also held on the island in the house of the Priuli, where ladies danced until the tenth hour of the night, all arranged by some Compagni, who subscribed six ducats each, and there was dancing every evening.

The pleasure-loving city of the lagoons was no less famous for her *filles de joie* than for her festivals, and lists are extant of the most *honorate e principali cortigiane* in Venice, with the honorarium expected by each: indeed, the favours shown to an exalted guest appear to have included an introduction to the most celebrated of the time, and S. Didier ("*Ville et Republique de Venise*") declares that it is doubtful whether there are more courtezans at Rome or at Venice. Veronica Franco, who made a facile conquest of Henry III. of France, was an accomplished poetess, and composed two sonnets to her royal lover, who bore away her portrait, by Tintoretto, among his effects when he left the city. She was a ravishing singer, a patroness of the arts, and her house, in the parish of S. Giovanni Grisostomo, the ridotto of the most learned and grave, as well as the most fashionable and dissolute society of the day. Veronica,

towards the end of her career, repenting of her profession, became a model of piety, and, with the help of some of her patrician admirers, founded and endowed a home for repentant *peccatrici* in a Casa di Soccorso at S. Nicolo Tolentini, which, after some mutations, was finally established in the parish of Sta. Maria del Carmine, where the Fondamenta and Ponte del Soccorso still recall its existence. Tassini, who found an entry in the register of deaths at S. Moisè, dated July 22, 1591, of the decease of the Signora Veronica Franco, aged 45, believes the cultured Venetian Aspasia to be thus qualified, who, from two wills executed by her, is known to have been the wife of Paolo Panazza, and to have given birth to a son, Æneas, by Andrea Tron, son of the Clarissimo Messer Paolo Tron. A clause quoted by the author of the "Curiosità" from her second will, grants dowries to two modest damsels (*donzelle da bon*), except two *meretrici* be found who would renounce their evil life and marry or take the veil (*monarcharse*) : then the said *meretrici* were to be dowered and not the damsels—probably on the principle that there was more joy in the convent over two repentant *peccatrici* than over two damsels that needed no repentance.

A significant entry in Marin's diary proves that even high dignitaries of the Church were not averse from imitating the vices of secular princes. On October 18, 1532, Cardinal Hippolito de' Medici came to see Venice *incognito* with a suite of forty-five : his expenses were paid. "October 20, 1532. After dinner, Grand Council. The Cardinal de' Medici, with Monsignor Valier and two others, was on the stairs *incognito* to see the Council pass down, and in the evening he went to sleep in the house of a *cortesana*, named La Zaffetta."[1] October 20 was a Sunday.

[1] Probably the Angiola Zaffetta of a letter from the Aretino to Titian (Venice, 1547), in which the painter is invited to sup on a brace of pheasants with the Signora Angiola Zaffeta and his host, and so keep old age, that spy of death, at a respectable distance.

It does not appear to have been a *cossa notanda*, nor an abnormal incident in a young cardinal's Sunday in Venice. His eminence's tastes were known to his compatriots, for we also read that "Lorenzo Strozzi, the Florentine, invited to the Ca' Bernardo, on the Grand Canal, about twenty of our fair ladies and dancing girls to entertain the Cardinal de' Medici, but 'twas all in vain, for the Cardinal did not come."

E quinci sien le nostre viste sazie.

CHAPTER XX

*The New Learning at Venice—Public Lectures and Patrician
Students—Rival Professors—The Decline of Wealth
and Power—Characteristics of later Patrician Society
—Conclusion*

"In polity the humble may rise, but not the fallen : states live but once."
—W. S. Landor.

A GRAVE misconception would be conveyed to the reader's
mind if undue importance were attached to the *chroniques
scandaleuses* of the Venetian annalists, or any general con-
clusions drawn as to the ethical standard of the time. It
would be easy for a future historian, turning over the
pages of nineteenth and twentieth century newspapers—
the modern equivalents of these fifteenth and sixteenth
century diaries—to draw, indeed it would be difficult to
avoid drawing, a terrible picture of the moral depravity
of our times as the diurnal record of murder and brutality,
of forgery and fraud, of adultery and impurity, was revealed
to his eyes. The alert and censorious statesman and magis-
trate, from whose daily records we have chiefly sketched,
had the modern journalist's *flair* for good copy, and more-
over, the political and ethical philosophy of all ages has
seen in the calamities of States, a chastisement by the
gods of a people neglectful of their altars; or the eye of the
Lord on a sinful nation, raising up enemies against her,
and visiting with war, plague and pestilence a wicked and
froward race. The moral sense of patriotic and God-
fearing magistrates is quickened as the strokes of fate fall
upon their fatherland, comprehensive charges of corruption
are levelled against a whole community, and fiery denuncia-

tions are shot forth against the luxury of those that " lie upon beds of ivory and stretch themselves on their couches, that eat the lambs out of the flock and the calves out of the midst of the stall, that chant to the sound of the viol and invent to themselves instruments of music, that drink wine in bowls, and anoint themselves with the chief ointments."

Yet, amid the tangle of selfishness, cruelty, licence, and pride that over-runs so many of the pages of these diaries, there emerge, like sweet, refreshing springs salient in a *selva selvaggia ed aspra e forte*, gracious and touching traits of affectionate and poetical qualities inherent in the temperament of the Venetian people. We have already seen that a compassionate cry of *Jesu!* burst from the lips of the crowd, and sped the guilty soul to her last account, when the executioner dealt his fatal blow, and that to a poor widow couched on straw came celestial messengers telling of salvation to the fatherland in her direst need. Another charming custom of these old lagoon folk is discovered by a casual entry in Sanudo's diary of the death of a most fair and gentle youth, one Agostino Corner, who in 1508 fell a victim to fever in the nineteenth year of his age : " Now he being a virgin was buried with a green garland around his head." Among the people it was believed that by night angels descended to the *campi-santi*, and with golden censors incensed the graves of the saintly unknown dead.

Many of the young-patricians of the period we are reviewing were ardent students, eager for knowledge, and passionately enamoured of the new learning of which the Venetian nobility were pre-eminent and generous patrons. Venice was the first state in Italy to endow public lectures in algebra and to found chairs of mathematics as applied to navigation ; a public school for the teaching of the humanities to the youths of the Ducal Chancellery was established by the Senate, in 1446 ; public readers expounded the Scriptures in Latin, and translated passages of ethical import into the vulgar tongue. The Seigniory gave bursaries

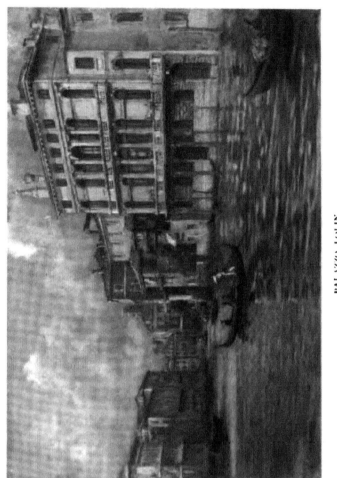

PALAZZO LOLIN.

to enable poor students to travel to Paris and other University cities, was careful to foster learning, and much concerned with public education; she was wise and tolerant in dealing with advanced thought, and employed Giordano Bruno and Galileo to lecture at her University of Padua. On Michaelmas day 1503 Marin repaired to the Hospital of S. Mark [1] to hear the new lecturer, Dominie Hieronimo da Forlì expound Pliny; a great crowd was present, and the master displayed profound science and excellent learning, and read with much facility. So great was the impression made on the audience that on November 17, a deputation of young patrician students and others " who had pleasure in learning " waited on the Seigniory and exhorted that body to appoint the most learned Dominie Hieronimo, who for twenty-four days had been giving experimental readings, to a permanent lectureship. In November 1505 note is made that the usual classes and lectures on Logic, Philosophy, and Theology had begun at the Church of S. Giovanni di Rialto. On Sunday, July 20, 1511, the candidates for the Chairs of the Humanities attended before the Chancellery and expounded Virgil, Pliny, and Tully. Two were heard in the morning, and one after dinner; in the evening they disputed, "which was a beautiful thing to behold." On November 5, 1512, the same diarist notes —a curious juxtaposition—that two thieves were hanged at S. Mark's, and the lectures on philosophy began at S. Giovanni di Rialto under Dominie Sebastian Foscari in the presence of many gentlemen and friars. On October 5, 1520, a certain Venetian youth of . . . years of age named Terentio Zancho, "who dresses in foreign fashion and studies in *jure civili* at Padua," gave a lecture in the *auditorio* at S. Mark's because he wished to be balloted in the place of his preceptor Rafael Regio, and he made an oration *molto latina*. Then he said he would read Cicero's oration *pro Milo*, and at length he dealt with the matter of

[1] The building is shown in Bellini's picture referred to on p. 26, note 3.

divination, damning much the conclusions put forth by Dominie Marin Bazichemi, lecturer on rhetoric at Padua, who was also a candidate and was present, and though the orator challenged him, would not reply. The ambassador of the most Christian king was there, together with doctors and other learned men, "and I, Marin Sanudo being invited, did go." On December 8, 1527, the Church of S. Bartolomeo was prepared as usual for the opening of the academical lectures and hung with tapestry from the Ca' Pisani: many professors were present together with the Milanese ambassador, the Procurators of S. Mark, doctors, senators and parents, "among whom was I, Marin Sanudo; and Francesco Pisani made a *bellissima* oration, very learned and very long, and it was past one hour of the night before he finished."

Books were precious things in those days and were often formally presented to the Doge. In 1459 Malipiero notes that Zorzi Trapesonda, an illustrious man, presented a Latin translation of Plato's "Laws" to the Seigniory, and was appointed reader in Rhetoric at a salary of 150 ducats a year, and on Easter day, 1498, when Doge Barbarigo II. was returned from S. Zaccaria, Marcantonio Sabellico, the renowned historian, flung himself at his feet and presented to him a Latin work called the *Eneade* and divided into nine books, containing the history of the world from the beginning to the decline of the Empire, "a most worthy book which he had dedicated to our most Serene Prince who received it willingly and praised him much for his labours." The book was printed and sold at three ducats. In November 1499, Antonio Kolb, a German, who had printed a map of Venice at great expense, which he sold at three ducats, applied to the Privy Council for permission to export copies, which permission was granted, and on October 17, 1502, Marin himself (*me fauctore*) had the privilege of proposing that Marco Aldo Romano (Aldus), his friend, be permitted to print books, *opere e cosse e letere nove* which with one voice was accorded by the whole Council. So famous a centre

was Venice for books that our diarist notes an application
made by Cardinal Wolsey in 1526 for copies of Greek works
for his students' library at Oxford. Indeed, the art of book
illumination was much practised in Venice as the following
extract from a lecture given by Richard Thomson in 1857
at the London Institution proves.

" It is probable that a considerable degree of the improve-
ment shown in the Italian illuminations of the sixteenth
century must be attributed to the powerful patronage of the
Venetian nobles, who employed the best artists of the time
to execute the frontispieces of the volumes containing the
patents by which the doges appointed them to the govern-
ment of any of the dependent states of the Republic. These
volumes are usually known by the name of *Ducali*, or rather
Diplome or *Libri Ducali*, and consisted of thin small folio
vellum MSS., bound in scarlet, gilded and stamped with the
Lion of St Mark and the motto of the Republic. At the
commencement of each is placed a large frontispiece con-
taining a half-length portrait of the nobleman receiving
the dignity, kneeling in a stately architectural background
before the Madonna, St Mark, the personification of Venice
as Justice, seated on a lion-throne, or sometimes the reigning
Doge. The designs are usually enclosed within rich
cartouche frames of brown gold bronze, and comprise the
opening words of the Diploma in gold Roman capitals, on
a blue or crimson ground . . . they are generally executed
with considerable ability, and very highly finished in the
manner of Guilio Clovio. From the superior taste of the
designs and the style of drawing, several of these paintings
have been attributed to Paolo Venonese, Francesco Padoua-
nino, and even to Titian; and it is not at all improbable that
the originals were sometimes supplied by even the most
eminent artists, and copied into the volumes by the best
Miniatori of the time."

The gentle professors of the humanities were sometimes
indiscreet, for in 1495 Malipiero notes that Zorzi Vala (the

u

famous scholar Giorgio Valla) was arrested by the Ten for having written letters to Zuan Giacomo Triulci in France concerning State affairs, which letters had been intercepted. Nor were the violent passions that sway uncultured folk absent from the peaceful halls of learning. On January 26, 1513, the Ten were called to adjudicate between two excellent professors of the Humanities: Dominie Raphael, who was lecturing in Terra Nuova,[1] and in receipt of a public stipend, and his rival, Dominie Marin Becicky, who lectured at S. Provolo to certain students who paid him honoraria. Now, the said Marin was accused of having seduced some scholars from the aforesaid Raphael, who had made plaint to the Ten. The magistrates listened patiently to the claims of the rival professors, and decided that both might continue their lectures, " for this city is free, and they cannot prevent Dominie Marin from lecturing," a most proper and tolerant decision.

During the festival of the Sensa, Sanudo, with his friend Dominie Gasparo della Vedoa, went on May 10, 1518, to Terra Nuova "to listen to a Florentine improvisatore called *lo Altissimo*, but whose real name was . . . Having gathered round him a large number of hearers, he mounted a chair and recited poetry *al improviso*. One played the lute and he recited, beginning first with praises of this city; then he continued by saying a notice had been posted on the Scuola that he should treat *de Anima*, and so he proceeded to deal with that subject, but in my opinion it was all composed and written down (*fate a man*) at Florence, because he spoke well. Then he sent a box round, questing for money, and received a certain sum, saying he would recite *al improviso* again."

The hostile elements, premonitory of future ill, that we have seen looming on the political horizon towards the end of the fifteenth century did but gather strength; slowly the

[1] The site of the present Royal Gardens opposite the Salute.

fruitful streams of Oriental commerce on which the wealth and power of Venice depended were diverted to other channels; a once mighty and dominant state, she saw her strength wane and younger rivals rise to irresistible power; in the picturesque phrase of Howell, it became her policy to "sow a piece of Fox tayle to the skinne of S. Mark's Lyon," and she strove to retain by astute and subtle policy what she could no longer defend by force of arms. But she did not surrender her primacy in the East without many a gallant fight. The Lion of St Mark as he beheld the hunters closing around him, ever and anon shook his mane and roused himself in a vain effort to thrust them back; but the old monarch's growl had lost its terror, and inspired no more fear than futile Salmoneus, imitating Jove's thunder by driving about with brazen cauldrons attached to his chariot. Venetian ambassadors at transalpine courts saw their pre-eminence contested, and were at length forced to give precedence to the envoys of states that once were suppliants at the Seigniory's feet. A letter from Marcantonio Corner, the Venetian ambassador at the English Court, dated March 12, 1609, and published in the Venetian State papers, de-scribes how he detained the king (James I.), as that monarch was hurrying to a cock-fight, and vigorously and eloquently maintained the claims of Venice to rank with crowned heads. In the same year a despatch from Rome affords a vivid picture of the heat and passion evoked by these struggles for prece-dence. Giovanni Mocenigo writes that at the beatification of Ignatius Loyola, the Jesuits, desiring to add splendour to the ceremony, invited the envoys of France and Spain, unknown to each other: the ambassador of Spain arriving first, assumed the highest place, and his colleague of France, entering later, flew into a towering rage, called for a chair to be placed at the high altar, and seated himself there.

Gradually as the hopelessness of the contest became evident, the Venetian noble forwent the active and enter-prising life of his ancestors and turned to enjoy; his

very mercantile temperament was against him; his attitude towards zeal and enthusiasm and new ideas was that of Mr Worldly Wiseman, and the merchant's contempt for idealism rendered any reaction impossible against the new conditions. For imagination and idealism, even in states, are precious qualities, and the historian has seen the hard-headed Venetian oligarchy that boasted of the solid gain of a string of ports won from the fourth Crusade, while the Frankish knights brought back only a string of ballads, pale to insignificance before her despised idealistic ally, and a Frankish army, whose irresistible might was born of a passionate ideal of human liberty and human rights, sweep over her millennial State like the advancing tide over a castle of sand. Moreover, the power of Venice was a maritime one, her best fighters were the old sea dogs who scourged the East and held the Mediterranean as a Venetian lake; her terrestrial fighting was done by mercenaries, and it soon became evident that the "Seigniory's sword cut better in her own kitchen than abroad." The Venetian State was a recognised market for food for cannon, and our own George II. sold to her 6700 of his Hanoverians for her wars in the Morea.

The old bride of the Adriatic, rudely divorced from her lord by the victorious Turk, set herself to attract by meretricious adornments; the city became the centre of sensuous abandonment, and enjoyed a reputation similar to that of Paris under the second Empire and of Monte Carlo combined. The second brother of old Duke George of Hanover, says Thackeray, constantly visited Venice, and led a jolly and wicked life there, the most jovial of all places at the end of the seventeenth century, and military men after a campaign rushed thither, as the warriors of the Allies rushed to Paris in 1814, to gamble and rejoice, and partake of all sorts of godless delights.

The reader of English who desires to pursue the subject through these later ages will find ample material in the

writings of Fynes Moryson, Coryatt, Sir Henry Wotton, James Howell, Evelyn, Mrs Piozzi, Lady Mary Wortley Montagu, and many another traveller attracted by the interest and beauty of the Adrian queen of cities, in the translated memoirs of Carlo Gozzi, and of Goldoni, who, in his comedies, some of which have been Englished, more than any other writer has depicted with wondrous art and sprightly vivacity the gay insouciance of the social life of the decline;—its round of elegant frivolities; its suppers, its card tables, its powdered and perfumed gallants and fair, frail and painted beauties; its sycophants, parasites and cicisbeos;—its masquerades and carnivals; the life of its gambling hells, theatres and coffee-houses, and all the gilded dissipation of an irresponsible society, which shrivelled like hollow pasteboard and tinsel before the fiery breath of an armed democracy.

We have put a period to our brief and fragmentary study of Venetian life in the early Renaissance centuries in an atmosphere of polite learning and philosophy. Many an erudite scholar and master has already harvested over the ground and gained fine and ripe sheaves of formal history:

> " And we come after, glenyng here and there,
> And are ful glad yf we may fynde an ere
> Of any goodly word that thei han left."

BIBLIOGRAPHY

Anderson, W. J. *The Architecture of the Renaissance in Italy.* 1896.
Archivio Veneto, *passim.* 1871-1906.

Beylié, L. de. *L'Habitation Byzantine.* 1902.
Boerio, G. *Dizionario Dialetto Veneziano.* 1829.
Brown, Rawdon. *Ragguagli sulla Vita e sulle Opere di Marin Sanuto.* 1837-1838.

Casola, P. *Voyage of.* Translated by L. M. Newett. 1907.
Cattaneo, R. *L'Architettura in Italia dal Secolo VI. al Mille (Circa).* 1888.
Cicognara, Diedo and Selva. *Le Fabbriche e i Monumenti di Venezia.* 1838-1850.
Coronelli, V. M. *Guida de' Forestieri nella Città di Venezia.* 1744.

Fergusson, J. *History of Architecture.* 1862-67.
Fulin, R. *Giordano Bruno e Venezia.* 1864.

L'Anonimo. *Notizia d'Opera, etc.* Edited G. Frizzoni. 1884. English Translation by P. Mussi. 1903.
Levi, C. A. *La Collezioni Veneziane.* 1900.
Lewkenor, Sir L. *The Commonwealth and Government of Venice.* 1599.
Litta, Count P. *Celebri Famiglie Italiane.* 1819-1858.
Luzio e Renier. *Mantova e Urbino.* 1893.

Malipiero, D. *Annali Veneti.* Archivio Storico Italiano. Tom. vii. 1842.
Molmenti, P. *Calle e Canali di Venezia.* 1890.
Molmenti. *La Storia di Venezia nella Vita Privata.* 1905-1906.
Moryson, Fynes. *An Itinerary, etc.* 1617.
Mutinelli, F. *Annali Urbani di Venezia.* 1841.
Mutinelli, F. *Lessico Veneto.* 1851.

Paoletti, P. *L'Architettura e la Scultura in Venezia.* 1893.
Priuli, G. *Diarii.* MS. copies in the Marciana and the Museo Civico at Venice. Vol. I. is printed in Muratori. *Rer. Ital. Script.* Tom. xxiv. 1723-1751, under Marin Sanuto, and entitled *De Bello Gallico.*

Romanin, S. *Lezioni di Storia Veneta.* 1875. *Storia Documentata di Venezia.* 1853-1861.

Ruskin, J. *The Stones of Venice.* (4th Edition.) 1886. *The Seven Lamps of Architecture.* (4th Edition.) 1883. *Examples of the Architecture of Venice.* 1851.

Sansovino, F. *Venetia Città Nobilissima.* 1581.

Sansovino, F. *Delle Cose Notabili della Città di Venetia.* 1596.

Sanudo, Marin the Younger. *Diarii.* 1879-1903.

Selvatico, P. *Sulla Architettura e sulla Scultura in Venezia.* 1847.

Selvatico e Lazari. *Guida artistica e storica di Venezia.* 1852.

Street, G. E. *Brick and Marble in the Middle Ages.* (2nd Edition.) 1874.

Tassini, G. *Alcuni Palazzi.* 1879.

Tassini, G. *Curiosità Veneziane.* 1897.

Temanza, T. *Antiqua Pianta di Venezia.* 1781.

Vecellio, C. *Degli Habiti Antiquie Moderni.* 1590.

Zanotto, F. *Il Palazzo Ducale di Venezia.* 1841-1861.

INDEX

A

PRINTED BY
TURNBULL AND SPEAI
EDINBURGH

Ingram Content Group UK Ltd.
Milton Keynes UK
UKHW020645260623
424053UK00006B/451